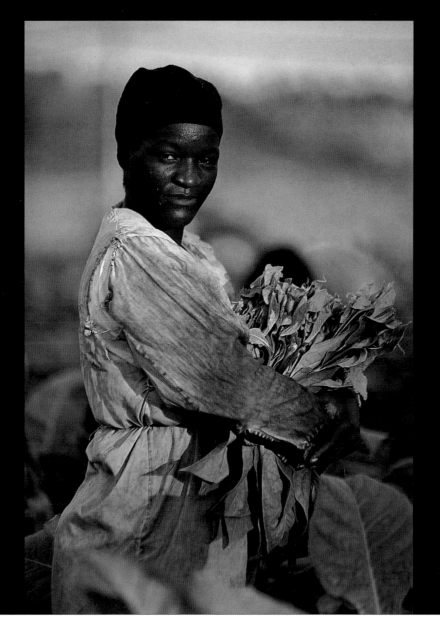

Cuba

LA ISLA GRANDE

WHITE STAR

PUBLISHERS

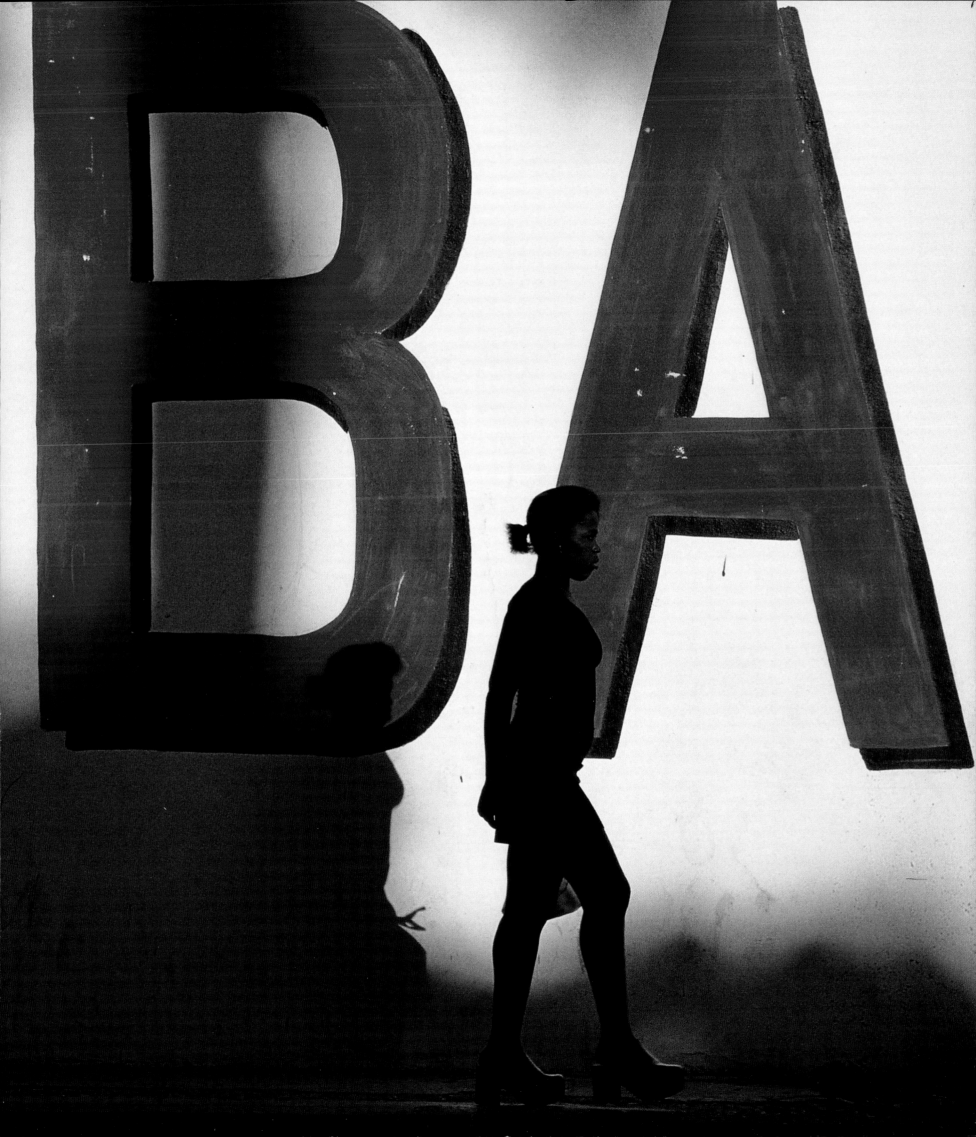

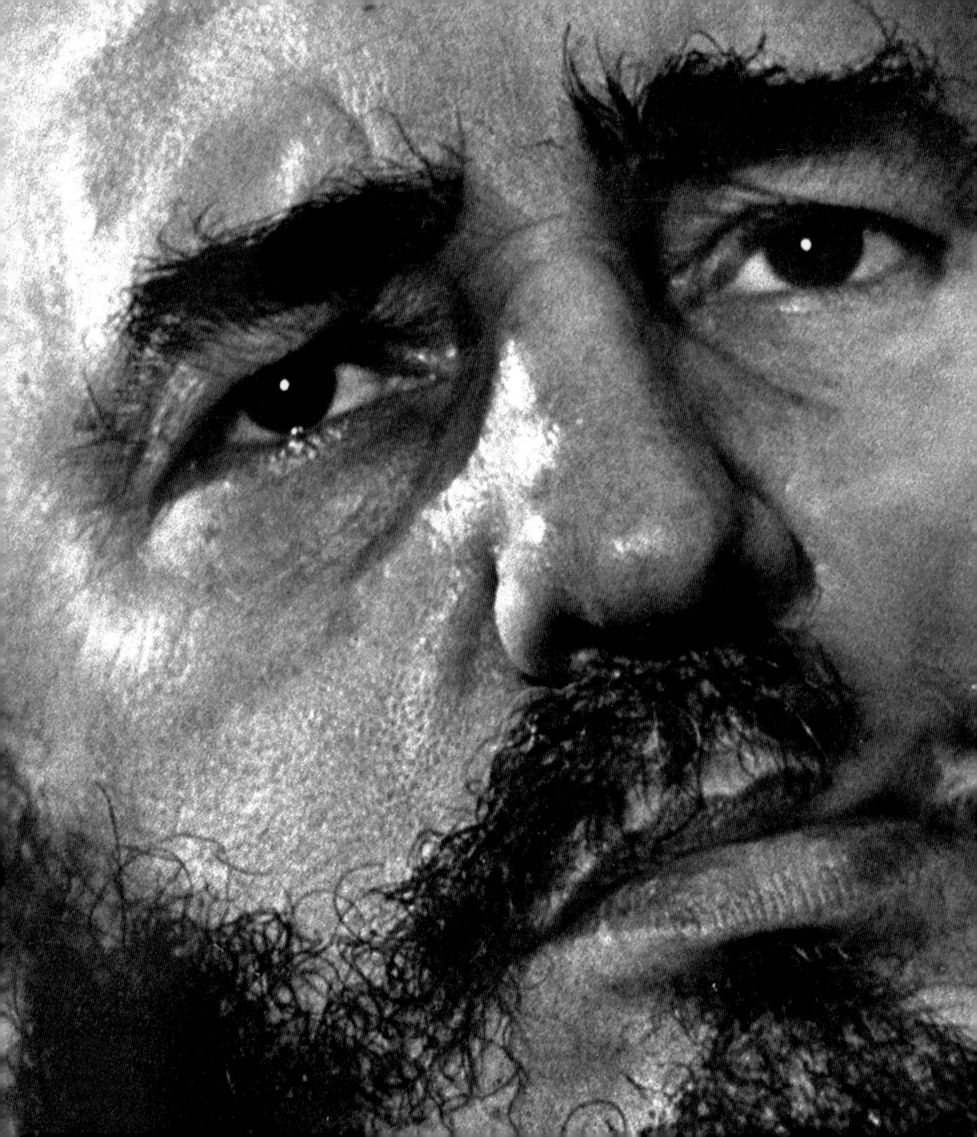

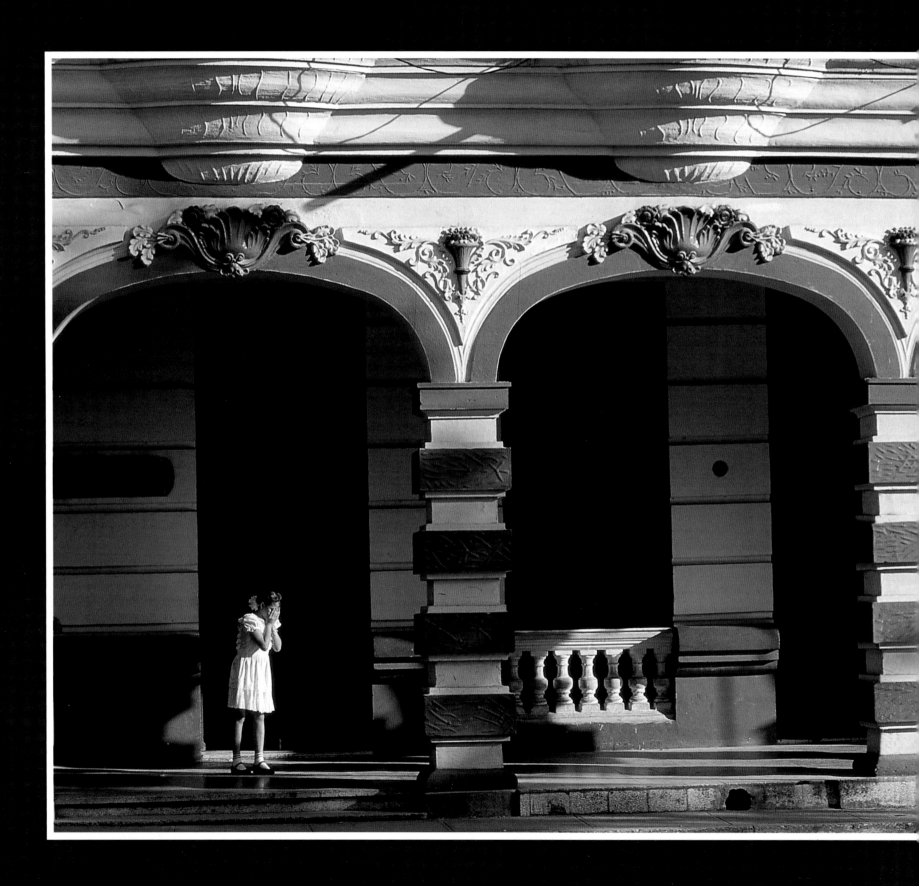

EDITED BY
Martino Fagiuoli

EDITORIAL PROJECT
Valeria Manferto De Fabianis
Laura Accomazzo

GRAPHIC DESIGN
Clara Zanotti

TRANSLATION
Kevin Maciel, C.T.M., Milan

6 AND 7 The delicate and perhaps overabundant friezes in Cuban architecture, as well as the intense, almost violent colors, aptly reflect the conflicts and passion that are part and parcel of the island's soul.

CONTENTS

ISBN 88-8095-755-4

REPRINTS:
1 2 3 4 5 6 06 05 04 03 02

Printed in Italy by
Grafiche Fover, Foligno (PG)
Fotolito Fotomec, Turin

8 BOTTOM IN THIS SPECTACULAR VIEW FROM SPACE, TAKEN FROM THE WEST, THE SLIM, SLIGHTLY CURVED ISLA GRANDE CAN BE SEEN TO THE LEFT. ABOVE LIES THE DOMINICAN REPUBLIC AND MORE TO THE CENTER, JAMAICA.

8-9 LYING IN THE CARIBBEAN, CUBA IS THE QUEEN OF THE PRECIOUS ISLAND BARRIER THAT ENCLOSES THE GULF OF MEXICO.

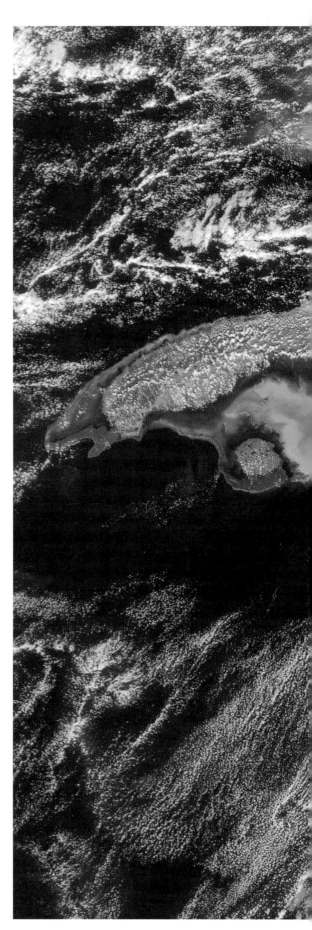

PREFACE

TEXT BY ALFREDO GUEVARA

"LAND! THE FINEST LAND I've ever set eyes upon," wrote an enraptured Christopher Columbus in the pages of his onboard log, charmed by his own delirium as a poet of the seas and the mythical Indies. The existence of that land of exceptional beauty confirmed that the world was round, and in its round map the navigator could first enter a beach that was an island, followed by the tracing out of that island's coastline. Surrounded by an immense sea, the

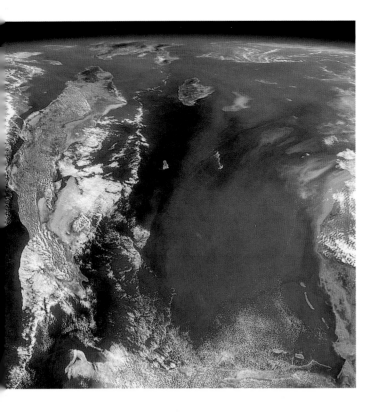

frontier of an archipelago that emerges close to other islands and the coast of a continent that other travelers had known, stretching out toward an unknown north. The fact that this particular piece of land was anchored in the Atlantic, at the edge of the tropical zones, made it the closest departure point for Europe, or more precisely to Spain (and later for what was one day to become the U.S.), but there was more to it than that. In the other direction, this was the closest land to the Gulf of Mexico and Florida, the Aztec empire, and the world of the Mayans, then, even further to the south, Peru and the empire of the Incas. Cuba was about gold and silver, the conquest of man, the wish to make these lands the subjects of the gods. It was in this way that kings, deities, or representatives of the gods themselves arrived with their swords and crosses. This was how the island of Cuba, immersed in the Atlantic that traces out its profile, similar to the boundary line that marks the limits of the Caribbean, became the key to the New World.

Key to the New World, crossroads, and meeting point, floating theater of the first act of plunder, during which gold and silver, those deep and splendid symbols, showed that man, with his ideas and firm convictions, with his spirit of

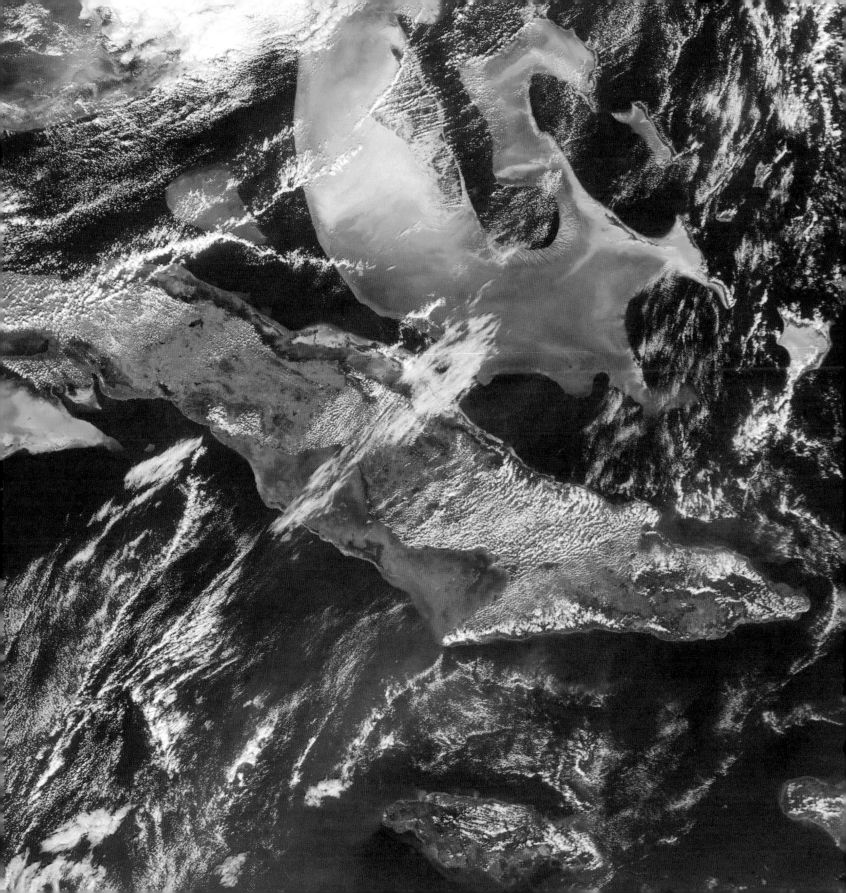

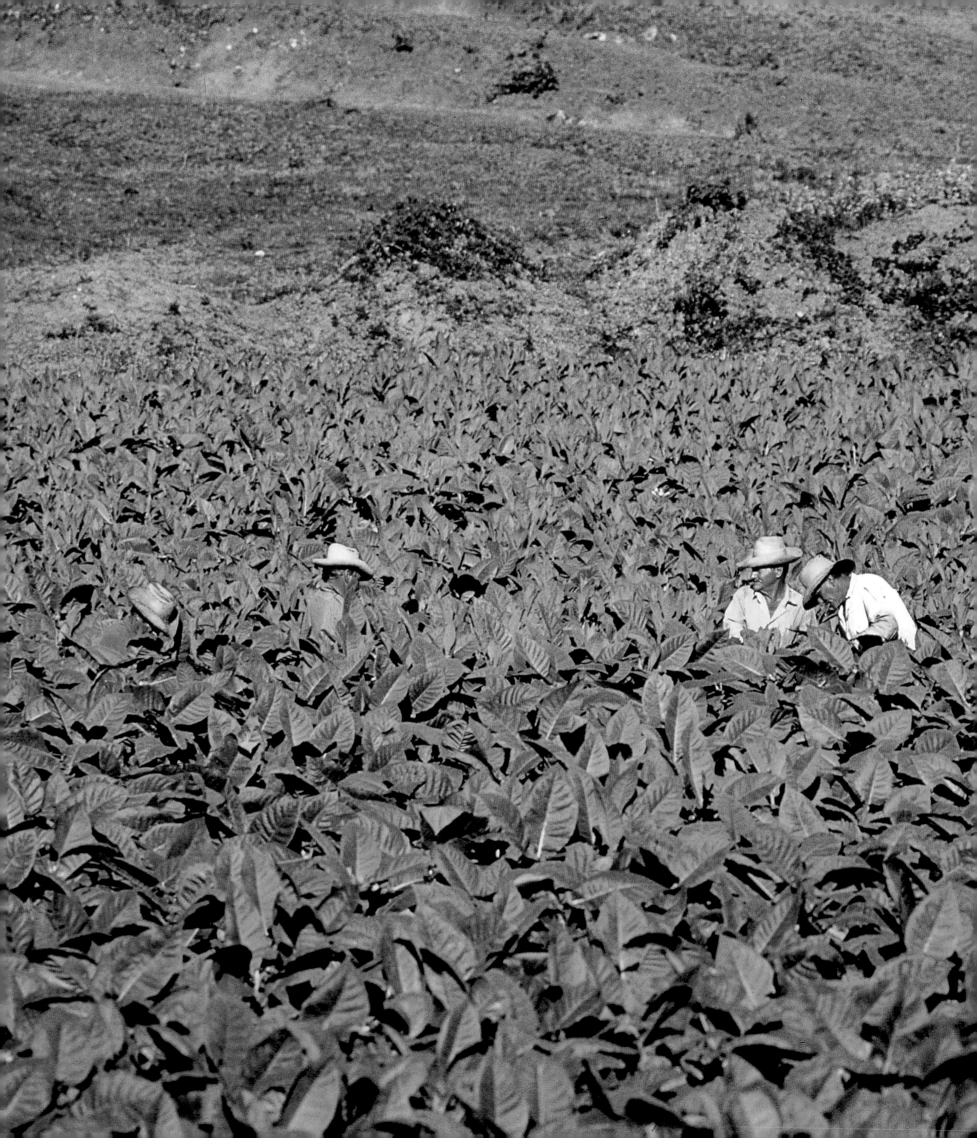

10 THE FACES OF THE *VEGUEROS*, THE EXPERT CULTIVATORS WHO SPECIALIZE IN TOBACCO PRODUCTION, EMERGE AMID THE BLUISH GREEN FOLIAGE OF THE PLANTS.

11 BOTTOM FORMERLY THE REFUGE OF REVOLUTIONARIES AND COUNTERREVOLUTIONARIES TOWARD THE END OF THE 1950S, THE SIERRAS HAVE NOW RETURNED TO THEIR NATURAL CALM, ESPECIALLY BECAUSE THEY HAVE HAPPILY ESCAPED EXPANDING CULTIVATION AND INDISCRIMINATE USE OF THE LAND.

adventure, the courage that led him to challenge the abyss, was and nearly always is a bearer of ambitions and hidden miseries, a wild beast who concealed his real identity behind a holy cause: the conversion of the natives, the savages, those who were different, to Christianity. But at the time Cuba was just an island in the middle of the sea, a meeting point of all these complexities and contradictions, flooded by good and evil, by experience, from all directions. The idea and trade came together to form a people of colonizers who one day discovered they were different from others, forged out their own distinctive features and consolidated their own experiences, their homes, and their places in nature, by creating an image that sets them apart and defines them as "criollo," or Creole, leading them to say, "I'm different."

In the forest alive with noise and murmurs, little nocturnal rodents, *jut'as*, dogs that don't bark, parrots, and other birds so small as to seem like insects, there's an interweave of colors of vegetation and creatures, a huge variety of plumage and skins, transformed by the forest, hiding its elusive forms and confusing the traveler with its mixture of sameness and diversity. The forest guards immense treasures, mahogany and cedar, hibiscus and ebony, which have given an eternal magic to the buildings of Havana and Europe. The various fabrics form a weave of purity, the cyclone annihilates everything before it, while at the same time teaching us that the symbol of the tropics is its trees, which discreetly bend in its force and know how to throw down a challenge to it.

The first Creole, that

different person who went on to become Cuban, forged out his identity by challenging the cyclones, the tempests from the sea, so similar to creatures of nature, while other disturbances were created by men, and still are. The course of the centuries has highlighted the differences—pirates, slave traders, and colonial empires, some dressed as Little Red Riding Hood, their words distorted, concealing the teeth of wolves, deceiving when they can.

The Cuban people have learned something from everybody, from different cyclones, one by one, and have woven this purity in their souls that it's so hard it seems like mahogany, resistant and beautiful.

The country is small, but it's varied and unique. It has no fear of diversity, and it knows that it takes care of the seed from which the fruit has grown over the centuries, forging its identity from all its various experiences.

There's also the Cuba of the cultured, those who studied its most authentic roots, examined its history and circumstances, looked toward the far horizons. They discovered the precise day of the surrender and identified two anxious aspirations that joined to form the very spirit of the Cuba that now announces its presence to the world: independence and the liberation of the slaves. The two most powerful forces known to history, a national identity that wants to make its mark, and the social revolution, combined under the same flag, became as one in the Creole and African blood, in the mulatto nature of the soul, which makes Cuba a perfect synthesis of a Hispanic spirit that's unique in America, it doesn't matter

whether its Galician or Basque, Andalusian or Catalan, Castillian, from Majorca or the Canaries, and the Yoruba, Mandinga, Congo, and Lucum'e. It isn't the skin that counts—blacks are white and whites are black, and all are Cubans. This is the true magic of this half-caste people, half-caste not in the skin one can see, but in the variegated spirit which arrived more or less everywhere, but in Cuba found the space to stretch its wings and, at last, take its rest.

The heart of the Cuban, no matter whether he's in Miami, Mexico, Madrid, or the Canaries, and irrespective of the reasons behind his presence there, has been pierced by a sword: his land, "the most beautiful," is always there, and nowhere can it be taken from his soul, as it forms part of his image and essence. It's this identity that's never been conquered that has prevented any other empire from making Cuba—or its consciousness—a satellite state. That socialism was real, real beyond a doubt, less surely socialist, but it's left no trace. And for this reason the renewed project follows its course in silence, agonizing, inventive, and creative at the same time, sowing the future in the foundations to finally complete the gestures of a warrior—to defend the seed of a human, integral world, whose integration makes it all the more human.

For this reason, the smile is more open, the suppleness of the palm is transformed into another flexibility, which crosses the veins and takes life onto a new level, musical perhaps, or maybe to make a connection, alternating silence and noise, showing that there's another

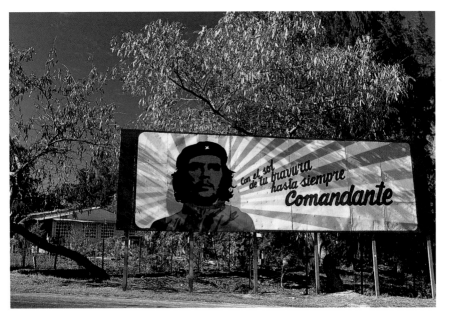

definition of tenderness in this shy rhythm. Maybe this is why, without denying the force and beauty of the sea and its waves, the insistent roar so reminiscent of the warrior, José Martì in his *Versos Sencillos*, or simple verses, sang almost in silence, "The mountain stream/Pleases me more than the sea." Could it be David who takes from its cool freshness the smallest of the small, the nucleus that could create a universe? From the most minute of objects, the fruit has become flesh, a universe that merges into another horizon, transforming the Cuba of the heroes of the Moncada, of Fidel, of the gesture of the Sierra into the most profound of gestures, which make woman, man, and any child and old person the god of this paradise, of the beach and forest, the mountain, the city, and the rock of this Eden immersed in an infinite, disturbing beauty, in the cool freshness emerging like dew from this "mountain stream."

From dawn onward, the Cuban stretches out his hand, holds out a white rose that he'll give to anyone who stretches out his own. This also explains the words of José Martì in their profundity: "I cultivate a white rose/In July and in January/For a sincere friend/Who gives me his open hand/And for the cruel one who tears out/The heart with which I live/I cultivate neither thistle nor weed/I cultivate a white rose.

This is the country we see here in images and words, the country of open friendship, which, in its most exalted voice, holds out a rose, a white rose.

Alfredo Guevara

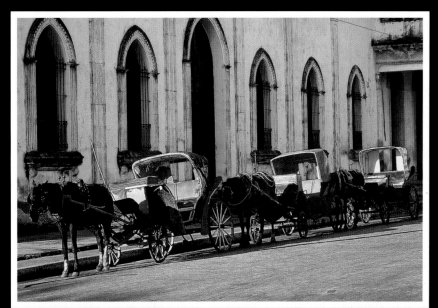

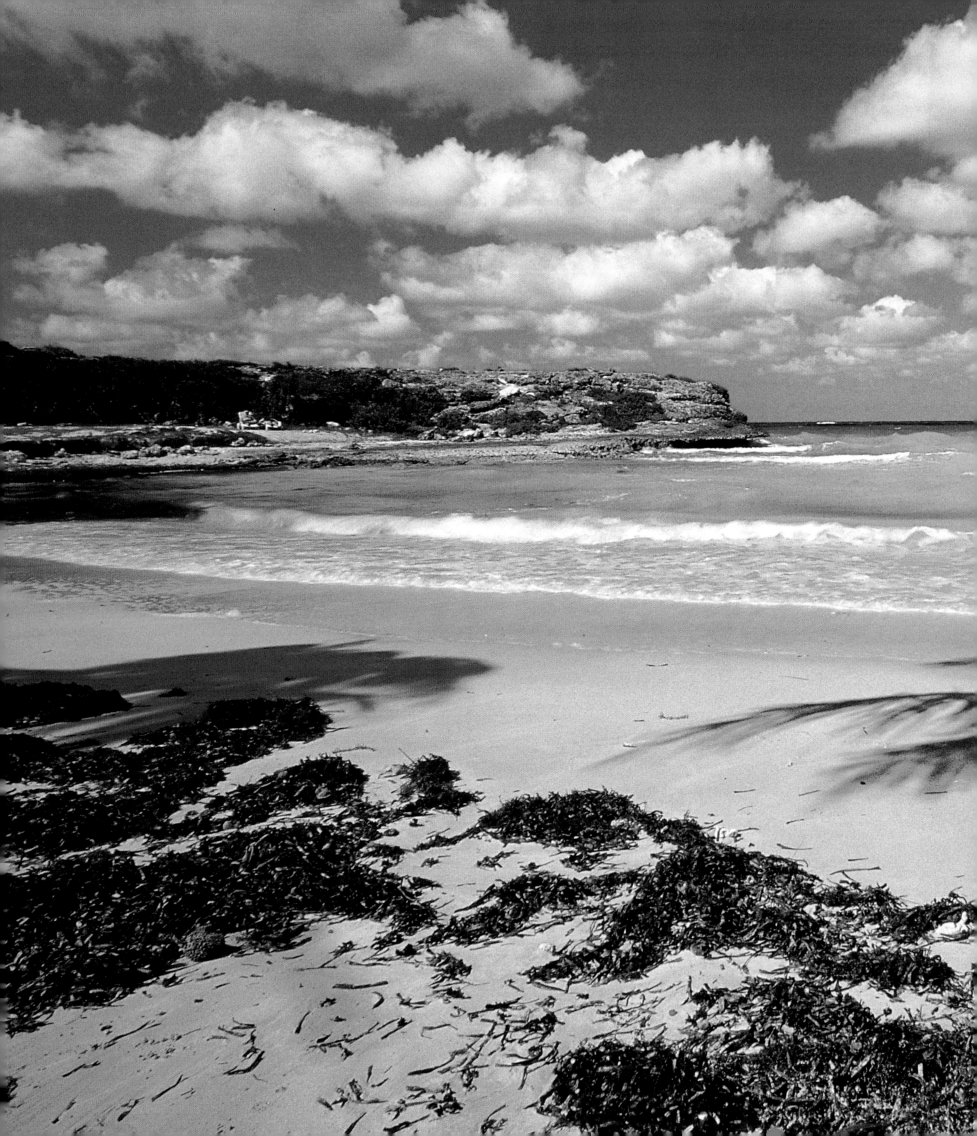

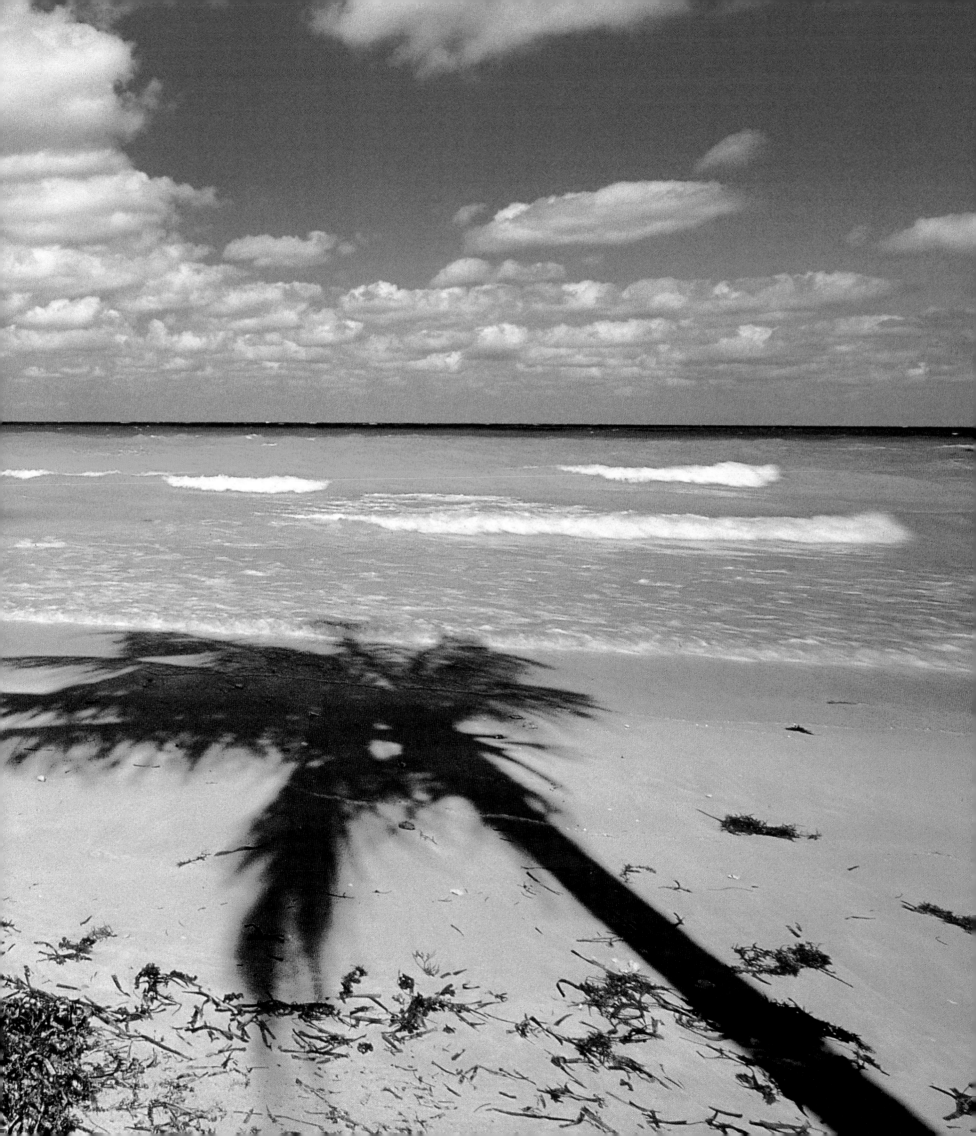

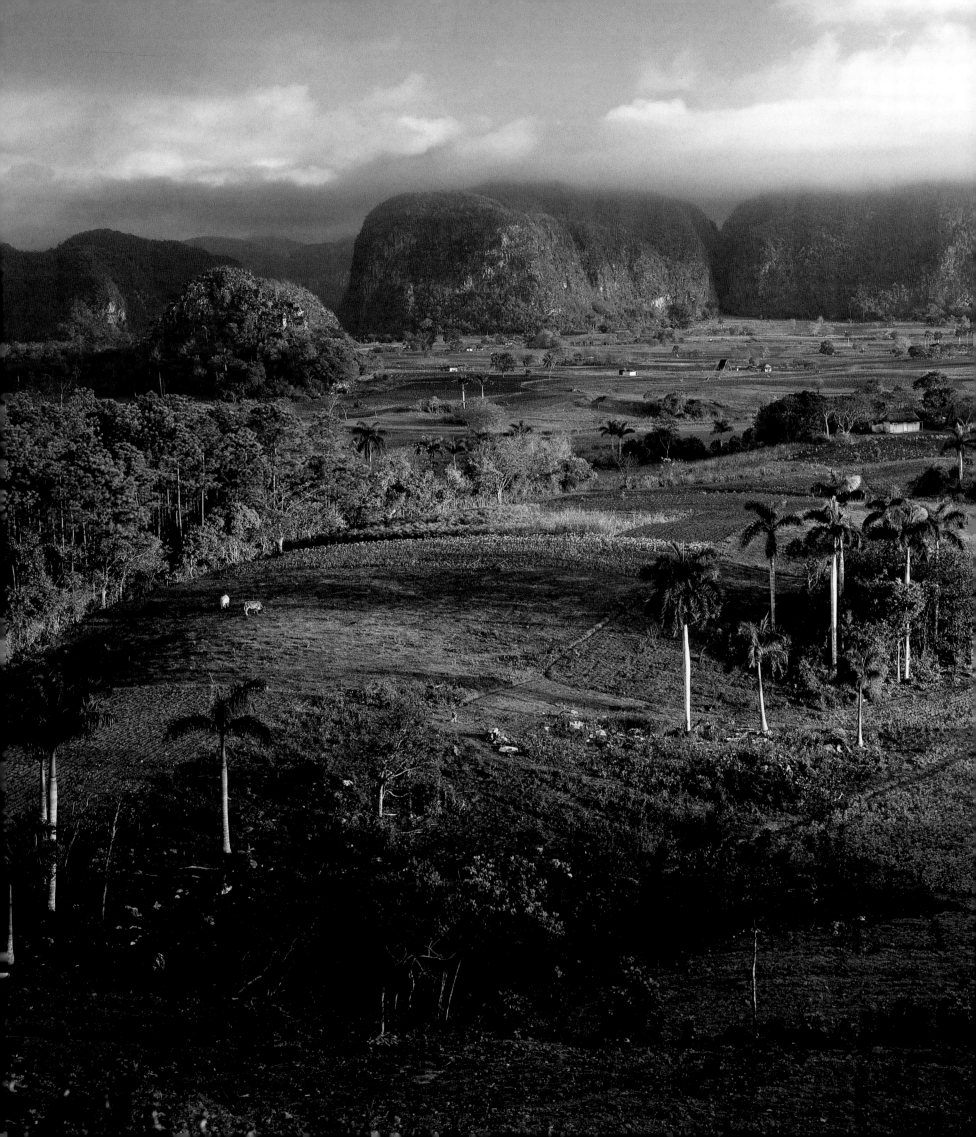

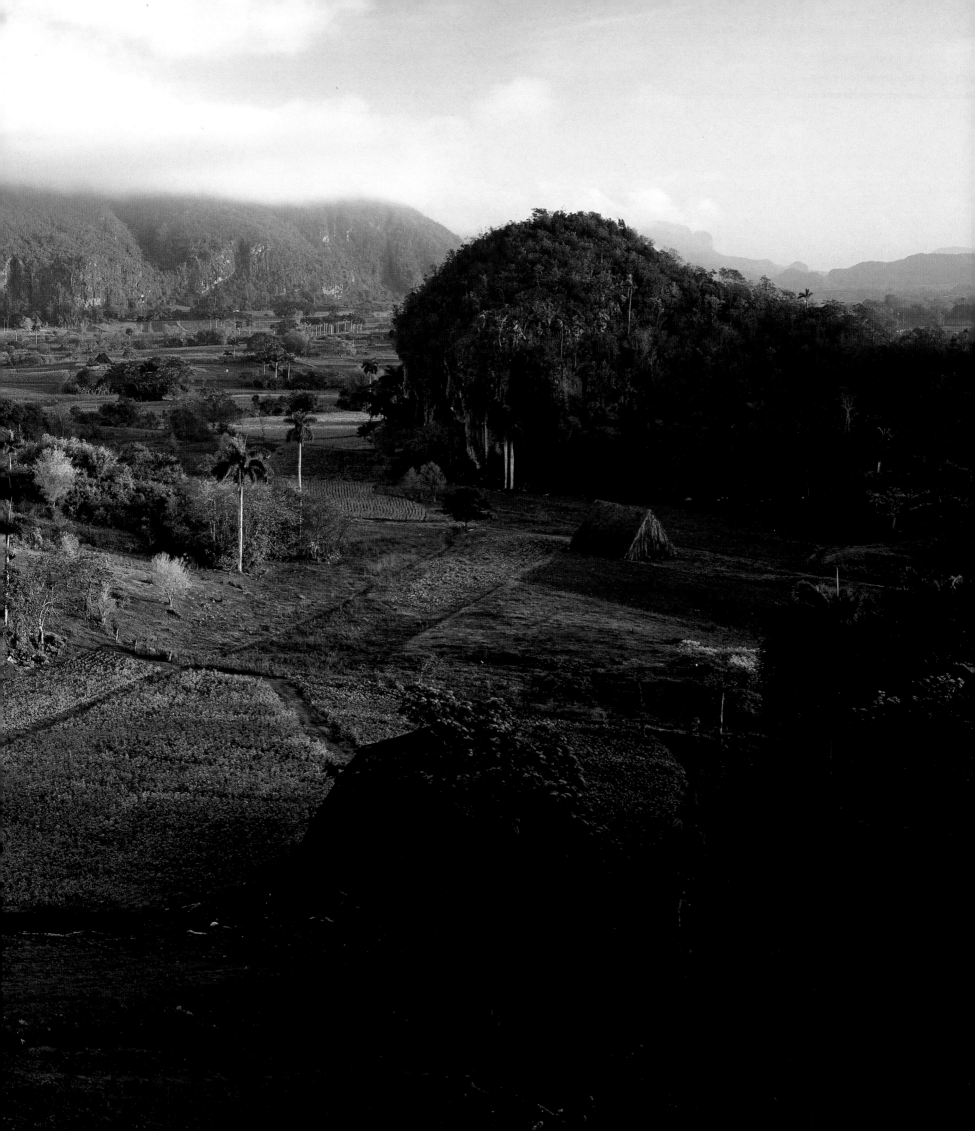

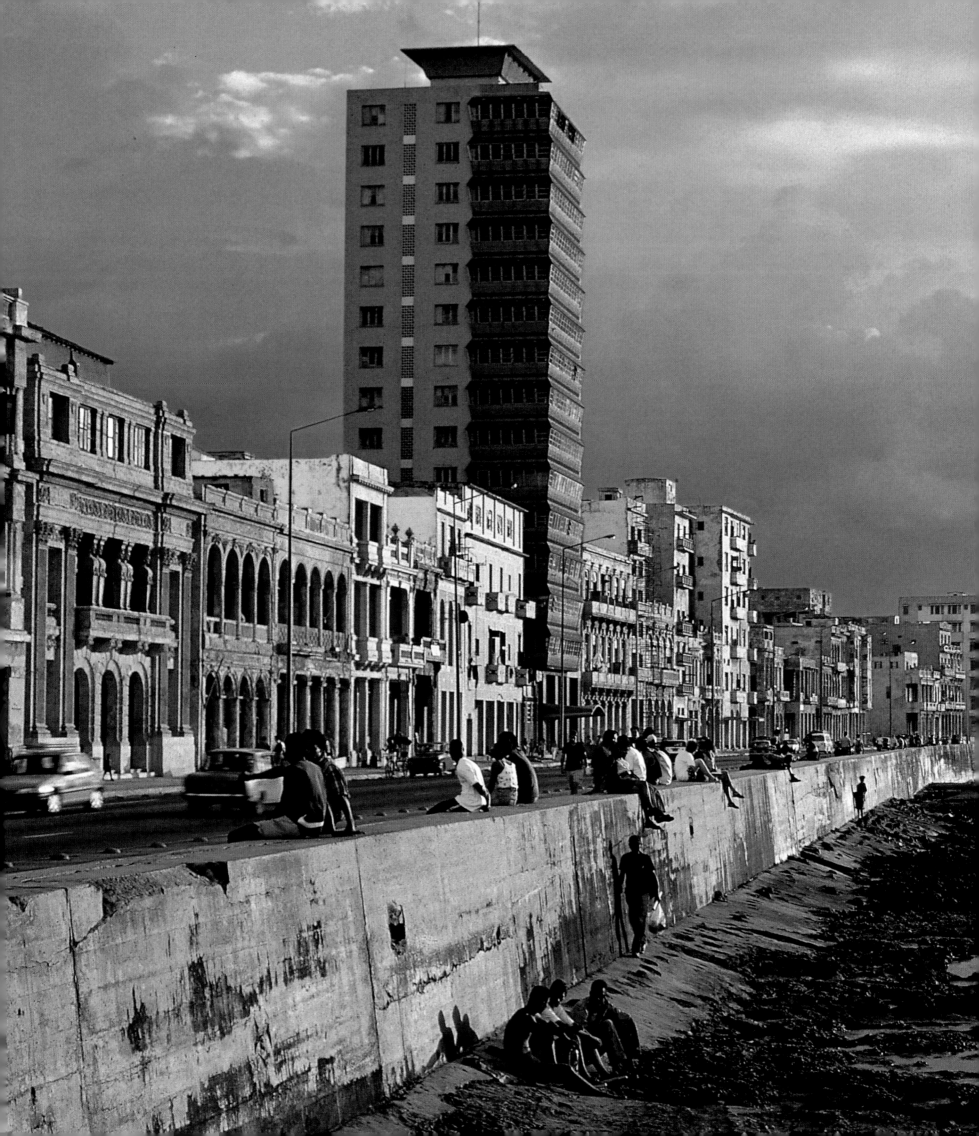

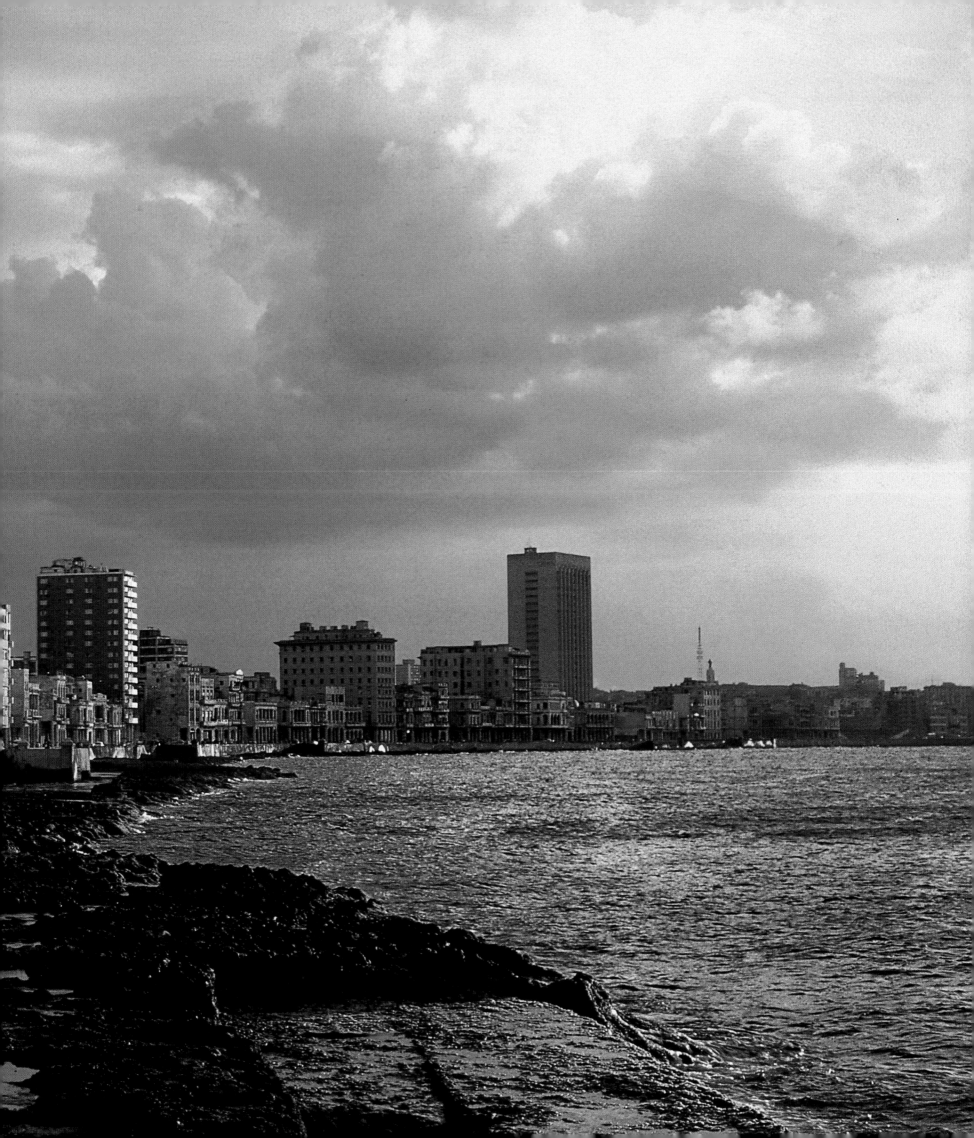

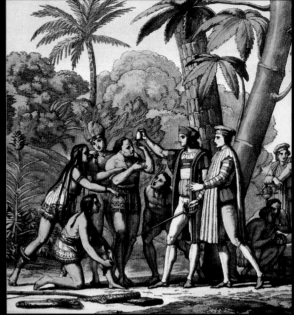

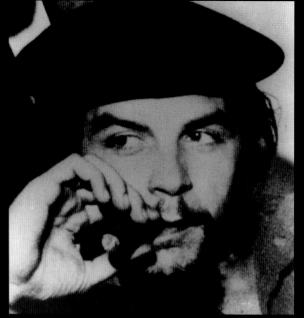

THE ROOTS OF CUBA

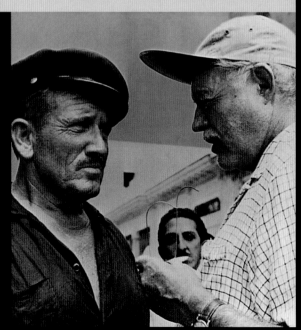

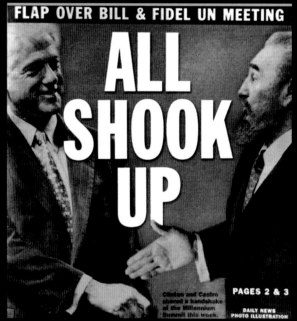

FLAP OVER BILL & FIDEL UN MEETING

ALL SHOOK UP

Clinton and Castro shared a handshake at the Millennium Summit this week.

PAGES 2 & 3

DAILY NEWS
PHOTO ILLUSTRATION

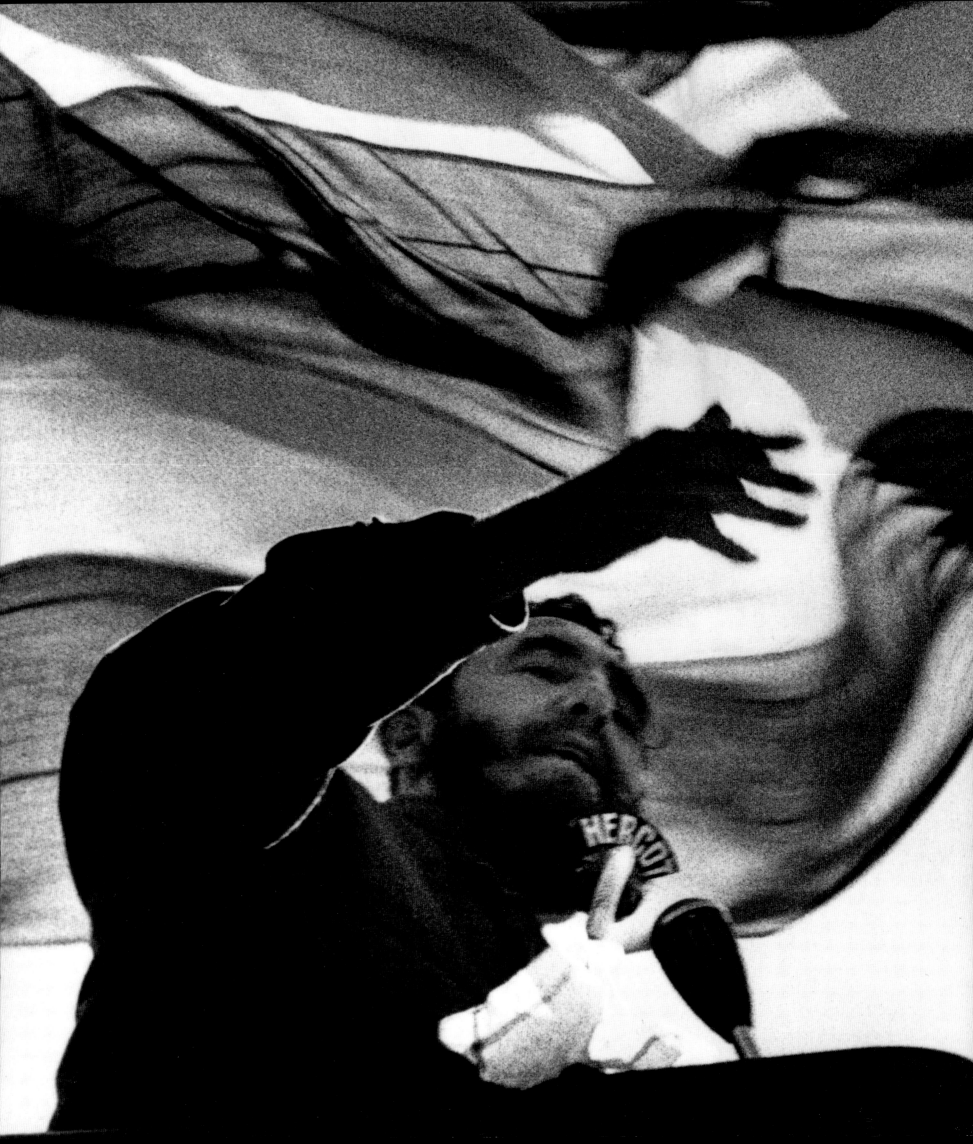

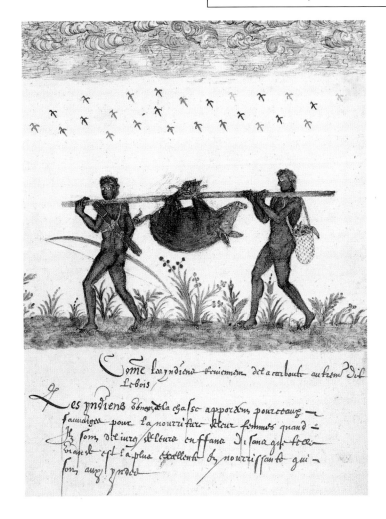

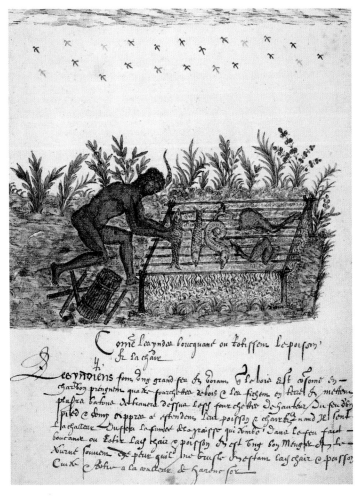

22 AND 23 Columbus, Guevara, Hemingway, and Castro. It is men of genius and visionaries, charismatic and impassioned, such as these who have not so much written the history of Cuba but made a legend of it.

24 LEFT AND RIGHT One of the favorite meats of the Tainos was the flesh of the manatee, a large marine mammal, and the iguana, which was generally reserved for chieftains and religious festivals.

25 TOP The Tainos developed a rather complex social structure, at the head of which were the *cacique* (chief) and the *nitainos* (nobles).

25 BOTTOM Giovanni Leardo's globe of the world, dating back to the fifteenth century, represents one of the many attempts of the period to trace out the surface of the planet.

The Mayan priests scrutinized the sky of Uxmal and saw stars mysteriously dying out. The emperor of Tenochtitlán ordered Aztec warriors to provide new prisoners to sacrifice on the highest altar of the Templo Mayor to placate the gods—the soothsayers had announced times full of shadows and foreboding.

Blissfully unaware of all this, Cuba was quite happily basking in the tropical sun, nestled in the warm waters of the Caribbean.

Siboneyes and Tainos peopled the island for thousands of years. All of them were of Arawak stock (*Taino* merely means "peaceful people"), and they reached the island in waves, navigating on rafts from island to island, from the northern coast of South America. They were hunters, fishermen, and fruit gatherers. But to complete their diet, they cultivated corn and yuca, with which they prepared *casabe* (bread). Cuba was not Paradise on earth; women died in childbirth and men fought over prey, very much like everywhere else on the American continent. But the land was generous. Like a mother capable of looking after even the laziest of her sons, Cuba offered plentiful food and fresh water, a favorable climate, shady woods, and caves for hiding from lightning and rain. Moreover, the island was free of animals dangerous to man. Various tribes shared the island without too much trouble. The island was rich in rhubarb and pineapples, strong aloe wood and mastic gum, as well as cinnamon and nutmeg. It even offered the rarity known as tobacco—the best in the world, as the world would discover later.

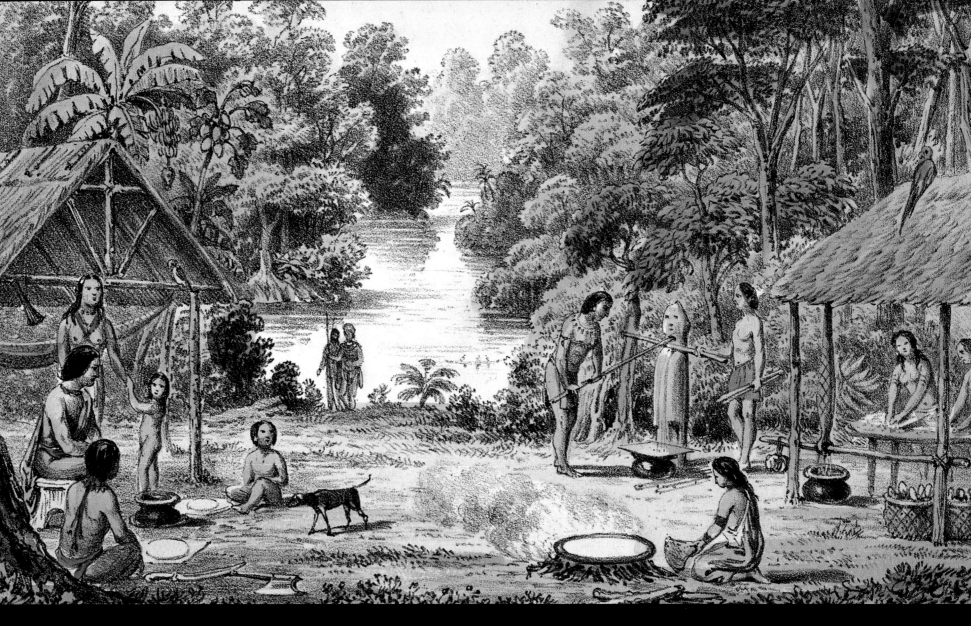

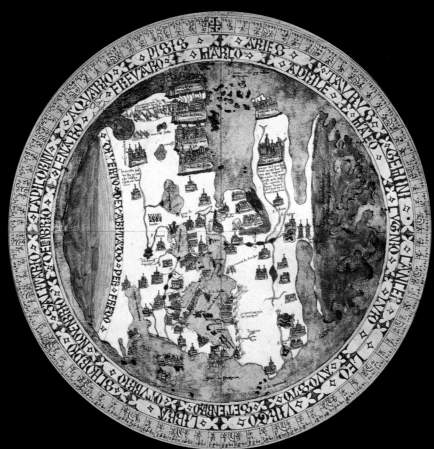

SERICA

serici montes

c de luna
R de finos
manoua
oaque cano
jamaicha
spagnola

ASIA

bunaga

SINARVA SITUS

serra domi
bono des.

c. della serpe
canai
carombaru

itna baxa .

p. de confida

c. ANHIETE
CVRI

belle
p. gora
b.
amgra
teragnia
p. de basimentos
retrete
belporu

MONDO

One day, apparently just like any other, an enormous canoe, with a large number of sails, that seemed almost to fly, appeared on the horizon. Crosses, clanking weapons, and men with faces as white as Toa flowers got out of it. The indigenous population watched from among the trees in the distance, then slowly stepped forward. It was in this way that Tainos natives first discovered the Spanish, who brought with them smallpox, the Inquisition, Catholicism, and slavery. According to the Europeans, this took place on October 28, 1492, but to the Tainos it could have been on just any winter's day, when it was just a little warmer than in summer. The venue is known as Cayo Bariay, not far from what is now called Guardalavaca. It is a small, enchanted bay, surrounded by a thick curtain of forests that extends toward the inland highlands as far as the eye can see. When they met, each was totally uncertain about who the other was. Introductions were of little use: this is the *cacique* (the leader), this is the Almirante, this is the *behique* (the shaman), this is the priest, and this the cross of God, these are the *nitainos* (the wise men), those are the sailors. That evening around their fires, both the new arrivals and the natives tried to make some sense of the other, and both made gross mistakes. The men on the caravels believed that they had reached Cipango and its gold deposits. The Cubans believed the new arrivals were some sort of divinity or new immigrants. But they were not too bothered about this: tobacco and pineapples were plentiful.

26 TOP LEFT During their ceremonies, the Tainos decorated their bodies with black and white geometrical patterns and other decorations in red.

26 TOP RIGHT On October 12, 1492, Columbus reached what's now known as San Salvador in the Bahamas.

26-27 BOTTOM This map, drawn in 1505 by Christopher Columbus's brother, Bartolomeo, once again shows the New World as an appendage of the Asian mainland.

27 TOP Born in 1451 somewhere between Liguria and Portugal, probably in Genoa, Christopher Columbus died in Valladolid in 1506.

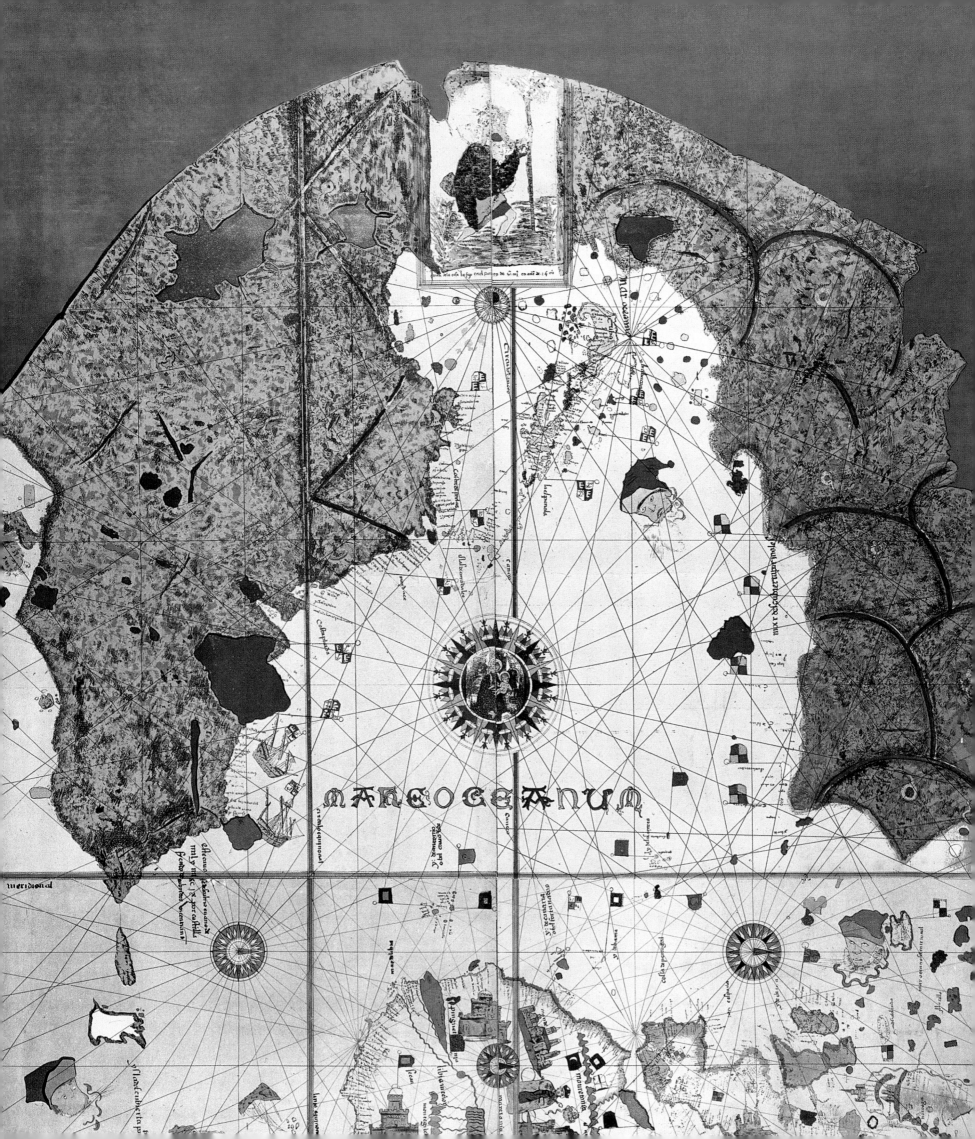

MARE OCEANVM

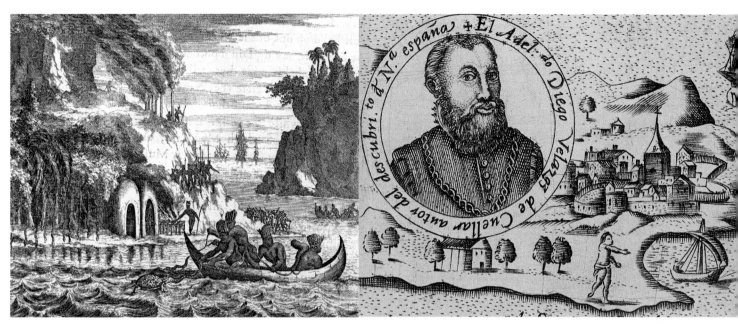

29 BOTTOM In this map, Cuba takes on the form of Cipango, as it appears in the map of Pozzo Toscanelli, a work which formed the basis for Columbus's adventures.

Columbus was quite lost in his dreams and nightmares. Yet, he paid Cuba the gallant compliment that he had in mind from the very outset but had denied to San Salvador and Hispaniola, saying it was "the most beautiful land that human eyes have ever seen." Since then, the phrase would adorn nearly every book, article, pamphlet, essay, catalog, or brochure that was even remotely related to the island. For five weeks, he followed the island's coastline from Puerto Padre Bay up to Point Maisi. After Cape Bariay, he landed at Gibara and the beach of the future settlement of Baracoa where he planted a cross, the rather meager remains of which are now on public view at the local cathedral. The Almirante then set sail for his troubled return to Europe, passing along the western coast of Hispaniola, where the Santa Maria was shipwrecked against rocks. The return journey, following the northern Atlantic route, lasted for a full fifty-six days, and it was only on March 28, 1493, that Columbus reached Palos with the unshakeable certainty that he had reached Asia, sailing westward. During his second voyage, in 1494, he returned once again to

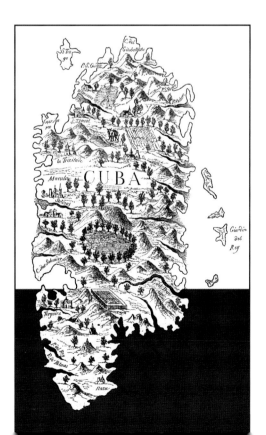

Juana (as he had baptized Cuba in honor of Prince Juan) and explored the island's southern coastline, also following the shores of what is now known as the Isle of Youth. He refrained from sailing around the island, although his pilot, Juan de la Casa, was convinced this was possible. The Almirante stubbornly preferred to believe that he had directly reached the Asian mainland.

The idyll, the mirror-play, and the honors did not last long: the Spanish were after gold. After transforming Columbus into some sort of poor cousin deserving of a ship from time to time to follow his own personal obsession, Spain promptly placed the conquest of the New World in the able hands of professionals. After consolidating Spain's settlements in Hispaniola in 1510, Diego Velásquez landed in Cuba in Guantanamo Bay with 300 men and immediately set about transforming Cuba and Cubans into the property of the Spanish crown. In keeping with a pattern to be repeated systematically during the Spanish conquest of America, the real war started with the massacre of 2,000 indigenous natives who had organized a welcome feast.

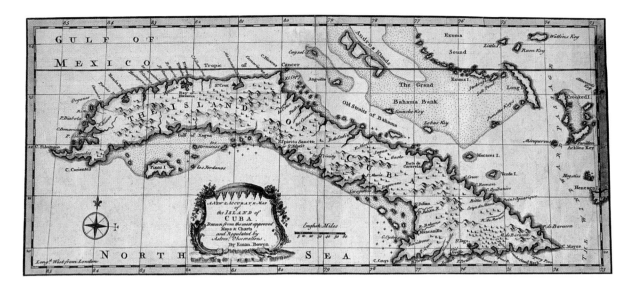

HATUEY

It did not take long for the Tainos to rebel: Their chief, Hatuey, led a resistance that lasted long enough and was successful enough to transform him into a local hero. He was the first in a long line of idealistic leaders that Cuba would produce in later centuries. For three months he laid siege to the Spanish cornered in a wooden fort on a hilltop on the northeastern coast before being forced to withdraw. The site would later become Baracoa, colonial Spain's first city on the island. After the defeat of Hatuey's rebels (Hatuey himself was burned at the stake as a heretic in 1511), the Tainos quite literally fell apart in the rather inhospitable embrace of a world that was no longer theirs. Those who managed to escape forced labor ended up dying in the Sierra de Cristal mountains or in even more remote areas at the very western and eastern tips of the island, which would also later

fall under Spanish control. The Tainos died by the thousands of smallpox, syphilis, the common cold, and probably of broken hearts. Despite the impassioned appeals of Bartolomé de las Casas, the local population of about 100,000 (some sources say 300,000) natives living on the island at the time of the arrival of Columbus's caravels was reduced to a mere 5,000 in forty years. The very memory of the Taino people was erased. All that remains is some graffiti, pottery, and a little jewelry. Between 1511 and 1515, Velásquez founded the seven cities that heralded the modern history of the island. First came Baracoa, followed by Bayamo, Trinidad, Sancti Spiritu, L'Avana, Camagüey, and Santiago (the island's capital until 1607). Cuba became wholly Spanish. The *conquistadores* started to divide the lands, waters, forests, and the few remaining natives between them.

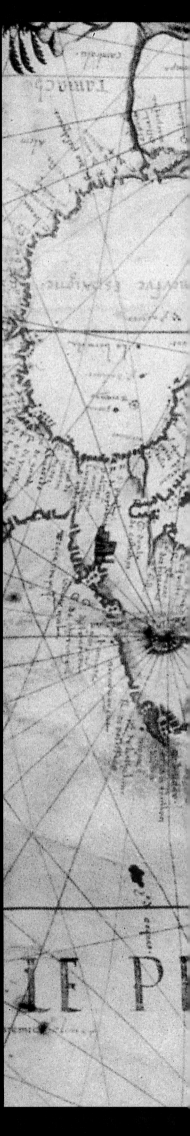

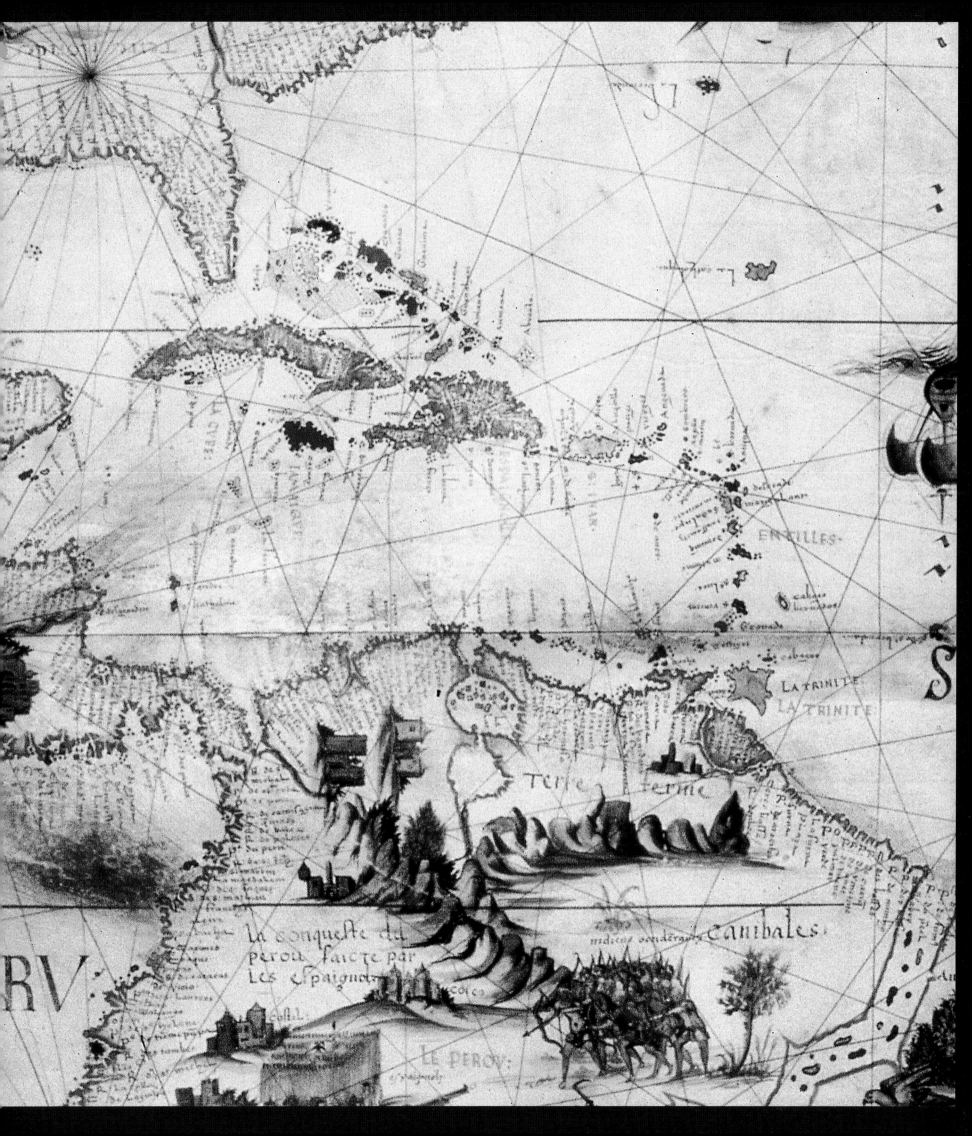

ENTILLES·

LA TRINITE
LA TRINITE

Terre ferme

indiens occidentaux Canibales

PERV

La conqueste du
perou faicte par
Les espaignolz

LE PEROV·

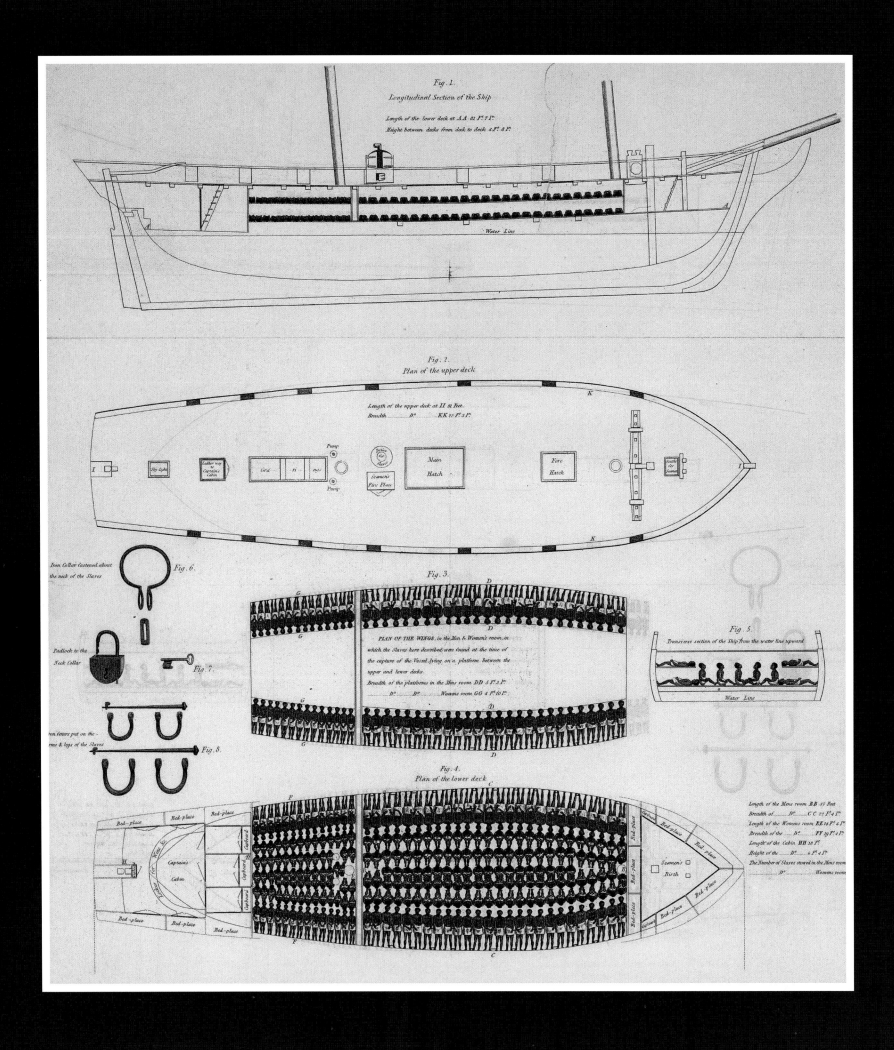

Fig. 1.

Longitudinal Section of the Ship

Length of the lower deck at A.A. 81 F.⁵ 7 I.⁵

Height between decks from deck to deck 4 F.⁵ 8 I.⁵

Water Line

Fig. 2.

Plan of the upper deck

Length of the upper deck at II 81 Feet.

Breadth D.⁰ KK 22 F.⁵ 3 I.⁵

Sky Light

Ladder way to Captain's Cabin

Gratings

Pump

Pump

Bottom for Slaves

Seamen's Fire Place

Main Hatch

Fore Hatch

Grating for Seamen

Iron Collar fastened about the neck of the Slaves

Fig. 6.

Padlock to the Neck Collar

Fig. 7.

Iron fetters put on the arms & legs of the Slaves

Fig. 8.

Fig. 3.

PLAN OF THE WINGS, in the Men & Women's room, in which the Slaves here described were found at the time of the capture of the Vessel, lying on a platform between the upper and lower decks.

Breadth of the platforms in the Mens room DD 5 F.⁵ 3 I.⁵

D.⁰ ... D.⁰ ... Womens room GG 4 F.⁵ 10 I.⁵

Fig. 5.

Transverse section of the Ship from the water line upward

Water Line

Fig. 4.

Plan of the lower deck

Bed-place

Bed-place

Bed-place

Cupboard

Cupboard

Locker for Wine &c.

Captains Cabin

Cupboard

Cupboard

Cupboards

Bed-place

Bed-place

Bed-place

Bed place

Bed place

Seamen's Birth

Bed-place

Bed place

Length of the Mens room BB 37 Feet

Breadth of D.⁰ C C 22 F.⁵ 4 I.⁵

Length of the Womens room EE 14 F.⁵ 4 I.⁵

Breadth of the D.⁰ FF 19 F.⁵ 4 I.⁵

Length of the Cabin. HH 10 F.⁵

Height of the D.⁰ 6 F.⁵ 4 I.⁵

The Number of Slaves stowed in the Mens room

D.⁰ Womens room

ANOTHER CUBA

32 THE SLAVES WERE CRAMMED INTO THE LOWER DECKS OF THE SHIPS IN WORSE CONDITIONS THAN THOSE GIVEN TO LIVESTOCK. THE SLAVE ROUTES BROUGHT FIFTEEN MILLION AFRICANS TO AMERICA BETWEEN THE FIRST HALF OF THE SIXTEENTH CENTURY AND THE FIRST HALF OF THE NINETEENTH.

33 LEFT FRANCISCO HERNÁNDEZ DE CÓRDOBA (SHOWN ON HIS ARRIVAL IN SANTIAGO DE CUBA) WAS LATER SENT BY DIEGO VELÁSQUEZ TO EXPLORE MEXICO'S YUCATAN (1517).

33 RIGHT THE GALLEONS, SUCH AS THE MAGNIFICENT *NUESTRA SEÑORA DE GUADALUPE* SHOWN HERE, WERE USED UNTIL THE SEVENTEENTH CENTURY AS TRANSPORT VESSELS AND WARSHIPS.

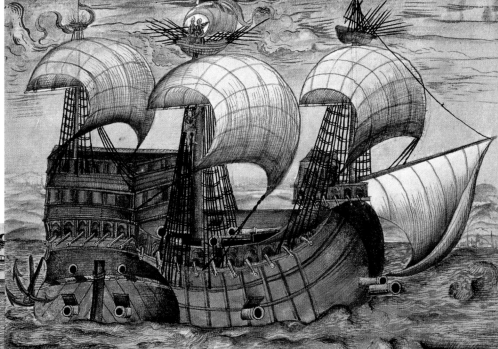

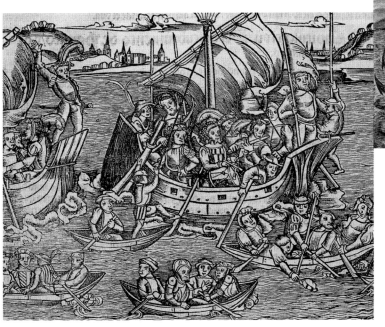

Cuba was rebuilt from scratch. Its population started speaking the language of Andalusia, Galicia, Castille, and also Africa. In fact, after the disappearance of the reluctant indigenous labor force, the colonizers who gradually took over from the adventurers and mercenaries started "importing" African slaves. The slaves were shipped by Portuguese merchants who controlled the ports of Guinea, Nigeria, Congo, and Angola. The first slaves started arriving in 1517, launching a shameful trade that would end only in the mid-nineteenth century.

In the meantime, Cortéz "discovered" Mexican silver and Pizzarro set off to get his hands on the Peruvian variety. Cuba only offered dense forest teeming with mahogany, cedar, fruit trees, and royal palms, rather meager when compared to silver. A large number of Spaniards therefore abandoned the island, leading to a sharp decrease in the local population. By the end of sixteenth century, the island's inhabitants included just a few hundred whites and about the same number of natives. Only the number of blacks increased.

Cuba seemed to have been relegated to the farthest confines of history, but its destiny was to suddenly change once again because of the pirates who, with French and English support, stepped up their attacks on Spanish galleons headed homeward overflowing with silver, first plundered at Guanajuato, and later at Potosí. To protect the ships and their precious cargo, Philip II ordered his captains to proceed in convoys, under naval escort. At first the ships of the fleet that crossed the Atlantic twice yearly were based at Puerto Plata, on the southern coast of Hispaniola. But the discovery of the Bahamas channel, which allowed for much safer sailing, changed things. The magnificent Havana Bay, accessed through a narrow and easily defendable canal, was transformed into the base for the fleets coming in from Mexico, Panama, and Cartagena, as well as the ships headed for Cadiz. And it is back to Havana that the ships returned with their hold full of new colonizers, furniture, textiles, and arms to be traded for the riches of America. Even Philippine spices were carried on the voyage across the Pacific up to Acapulco and reached Cuba via Veracruz. Havana thus became both the island's capital and a crucial crossroads for the economy of the empire of Charles V. Cuba was reborn with Havana.

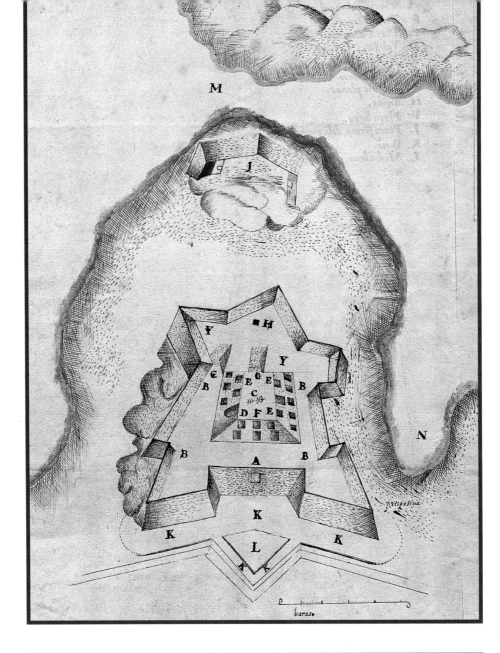

34 A PLAN OF CASTILLO DE LOS TRES REYES DEL MORRO, BUILT BETWEEN 1583 AND 1630 TO A DESIGN BY THE ITALIAN ARCHITECT BATTISTA ANTONELLI, TO DEFEND THE PORT OF HAVANA.

35 THE TOBACCO (TOP) AND SUGARCANE PLANTATIONS WERE EXPANDED IN CUBA FROM THE SIXTEENTH CENTURY ONWARD TO SATISFY GROWING DEMAND IN THE EUROPEAN MARKETS. THE *TRAPICHE* (BOTTOM), THE MOST ARCHAIC FORM OF SUGAR COMPANY, USED A LARGE NUMBER OF AFRICAN SLAVES AS LABORERS.

SUGARCANE AND TOBACCO

The seventeenth century brought with it the Baroque style and the plague. Sugarcane was introduced to Cuba at the end of the sixteenth century, either from the Canary Islands or from the South Pacific. Sugar cultivation requires large surfaces of land, large amounts of labor for harvesting and pressing, as well as a hot and humid climate. Cuba had everything, and whatever Cuba lacked could easily be imported from Africa. The Court of Madrid granted concessions for the new plantations. The island's population soon ballooned to 50,000, half of whom were of African descent. Sugarcane was first processed in *bateys*, the earliest rudimentary refineries, whose large workshop-dormitories were transformed into melting pots. The mixing of races that took place in the *bateys* was followed by cultural blending. Africa and Spain were brought together without either of them really wanting it, leading to a mixture of blood, music, language, and gods. It was this melting pot that gave rise to the new Cuban nation. In the meantime, the Creoles, or children of Spanish noblemen born in Cuba, started asserting themselves and imposed ideas more related to the way of thinking of Cubans than of *peninsulares* (noblemen born on the Spanish peninsula). Rules and taxes imposed by the Spanish crown were felt as a burden by everyone. Throughout the century, Cuba would remain the main American base of Spanish naval operations, but its coasts were also frequented by all sorts of free operators that infested the Caribbean at the time. Centers such as Trinidad flourished thanks to smuggling and piracy, while the Isle of Pines was used as a hideaway by pirates. The seventeenth century also saw the reopening of the tobacco trade that was banned in the sixteenth century as a temptation from Hell. The tobacco trade focused around Seville, where the Cuban cargoes arrived before resale throughout Europe. By the end of the century, it was common knowledge that the world's best tobacco came from Cuba.

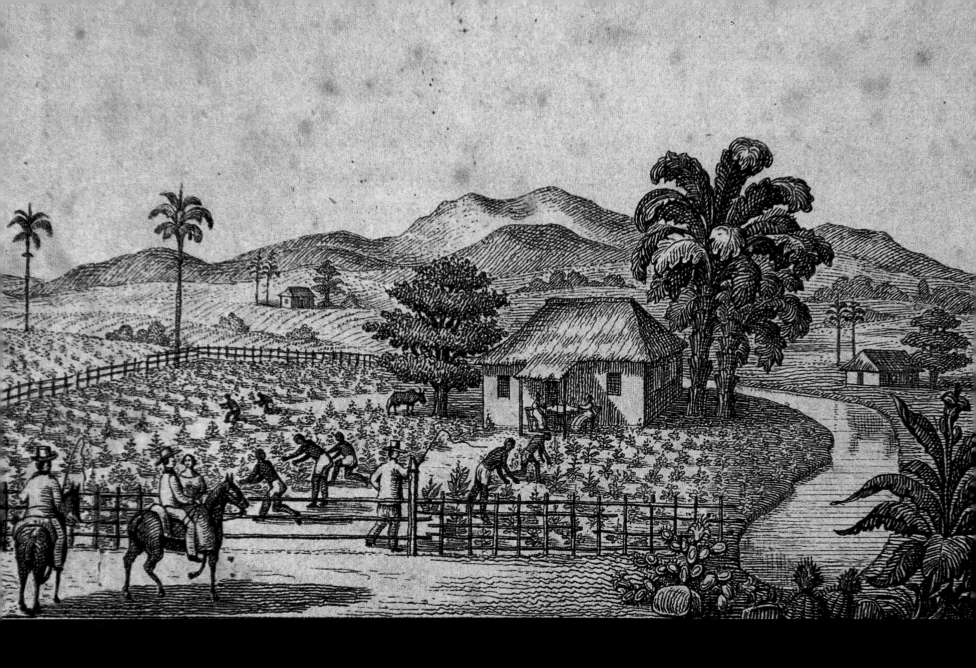

THE ENGLISH AND THE STEAM ENGINE

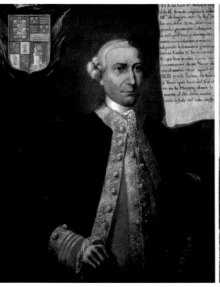

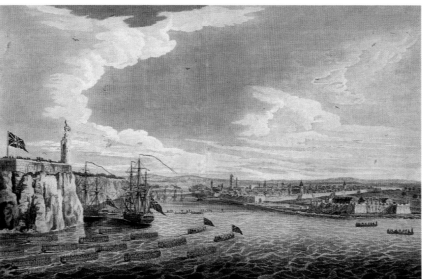

The 1697 treaty between Spain, France, and England that put an end to piracy in the Caribbean set the table for a new century in Cuban history.

The island's economy took off: The prices and plantations of sugar, coffee, cocoa, and tobacco multiplied at a breathless rate during the eighteenth century. All this newfound wealth brought with it renewed bitterness over the Spanish trading monopoly, especially after the seemingly insatiable Real Compañia de la Habana was founded in 1740.

Spain started losing her maritime supremacy to France and England ever since her invincible armada was defeated and shipwrecked in the North Sea in 1588. By the eighteenth century, Spanish hegemony over the oceans was merely a memory.

In 1792, after a siege of two months, the English Navy (and merchants) occupied Havana for almost a year. The presence of cargo ships from Liverpool and Birmingham broke Spain's trading monopoly and freed Cuba's economy from Madrid's increasingly tight stranglehold. As Spain gradually lost its political and military might, a new chapter opened in the history of Cuba.

Even after Madrid sold Florida to London in order to recover Havana, things were simply no longer the same. Smuggling and illegal exportation of sugar and tobacco (mainly toward the English colonies that were to become the United States) flourished. During the single year of English occupation, nearly 11,000 African slaves were smuggled through Cuba, mostly to be shipped to the cotton plantations of Virginia and the Carolinas.

36-37 THE POWER OF THE ENGLISH FLEET SENT OFF TO CONQUER HAVANA EASILY GOT THE BETTER OF THE SPANISH NAVAL DEFENSES.

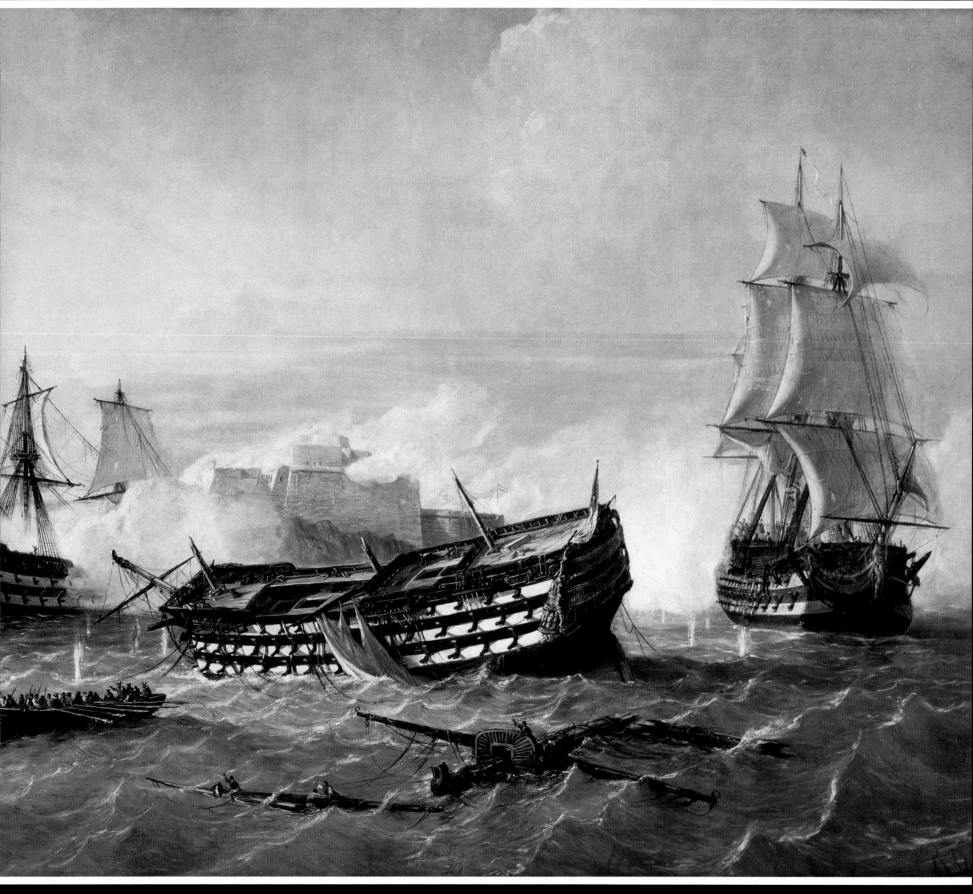

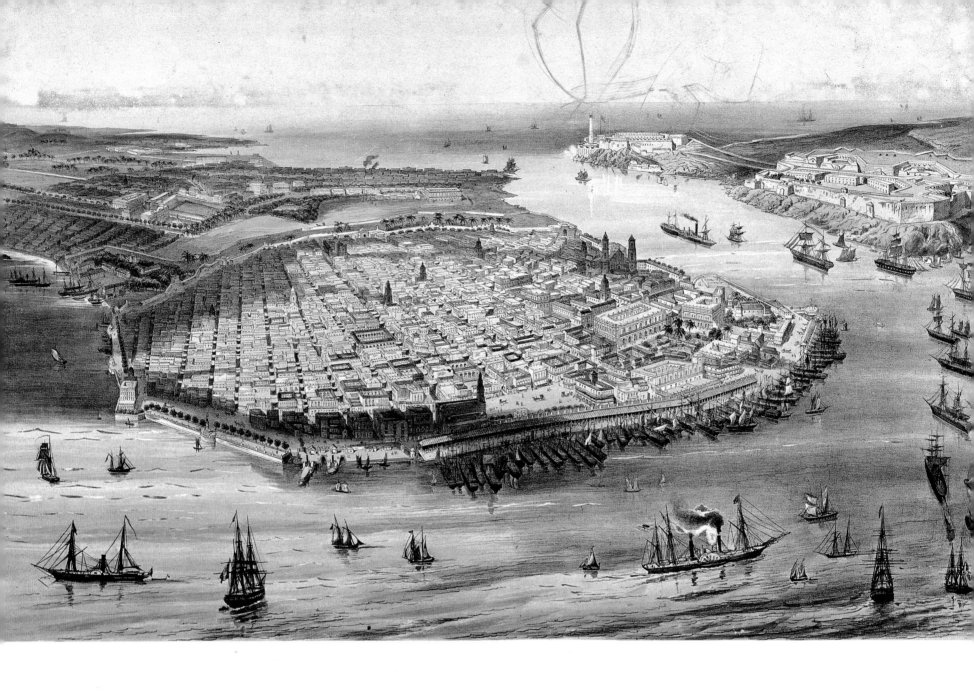

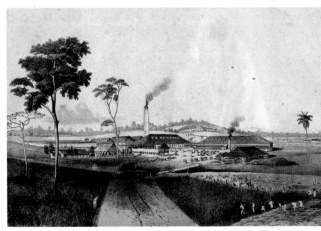

38 TOP Havana in the nineteenth century: One can already see the expansion of the city outside the eighteenth-century walls.

38 BOTTOM LEFT The *INGENIO* was the industrial evolution of the *TRAPICHE* sugar refineries. The railway and steam mills changed the entire sugar production process.

38 BOTTOM RIGHT Cockfighting was very popular until the middle of the twentieth century.

The rebellion of the slaves on Haiti at the end of the century led to the arrival in Cuba of a new wave of rich, landowning immigrants with their pockets full of money accumulated through the sugar and coffee plantations of Hispaniola. Cuba became the sugar refinery of the world. Encouraged by English investments, exports increased by five times over ten years, and in 1770 allegedly reached 10,000 tons.

The advent of the nineteenth century was accompanied by improved technology. In 1840 Cuba was introduced to both the steam engine and the railway. The first water-driven mills, known as *ingenios azucareros*, were set up for the processing of sugarcane, productivity boomed, and the demand for labor fell. As a result, just before the 1850s Spain succumbed to English pressure to abolish the slave trade that was banned everywhere else, at least on paper, since the beginning of the century. But by then, Cuba was an Afro-American country to the extent that, at the time the trade was abolished, the island's black population outnumbered its whites (in the mid-1800s, blacks accounted for six out of every ten Cubans).

Music and dance are the highest expression of the new Caribbean culture—this is especially evident in the eastern part of the island. The melting and merging of various different cultures is known as "syncretism." Together with Brazil, Cuba, because of its tortuous and complicated colonial history that resulted in the mixture of indigenous cultures, as well as a wide variety of imported cultures that came with African slaves, Chinese laborers, as well as Catholic and Protestant Europeans, is a prime example of Afro-American syncretism. In the huts of the slaves used as sugarcane plantation laborers, African gods (*Orishas*) were gradually merged with Catholic saints, blurring the boundaries between pagan and Christian traditions and beliefs. Shangó was identified with Barbara of Bithynia who, like him, controls lightning, Babalú Ayé merged with St. Lazarus, and so on. The animist religions of Nigerian Yorubas and the Congos of Congolese Africa fused with Catholicism to give rise to the syncretic cults, known as *reglas*, such as the *regla-ocha* (*santería*) and the *regla de palo* (*brujería*), and secret societies such as *abakuá*. During religious rituals, musicians beat drums and tin cans and rhythms change from moment to moment until the leader decides to call the saint. Then, and only then, will Shangó come from the depths of Africa and descend into the body of one of the participants to guide him in a trance while the *santero* ensures that all the rites are properly performed.

As the sugar industry boomed and interracial unions became more frequent, the *tonada* with its Arabic overtones and the rhymes of Spanish folksongs blended with the rhythms of Guinean Africa, as well as the *passepied* and the *contradanse*, brought to the shores of eastern Cuba by French colonizers fleeing the slave uprising in Haiti.

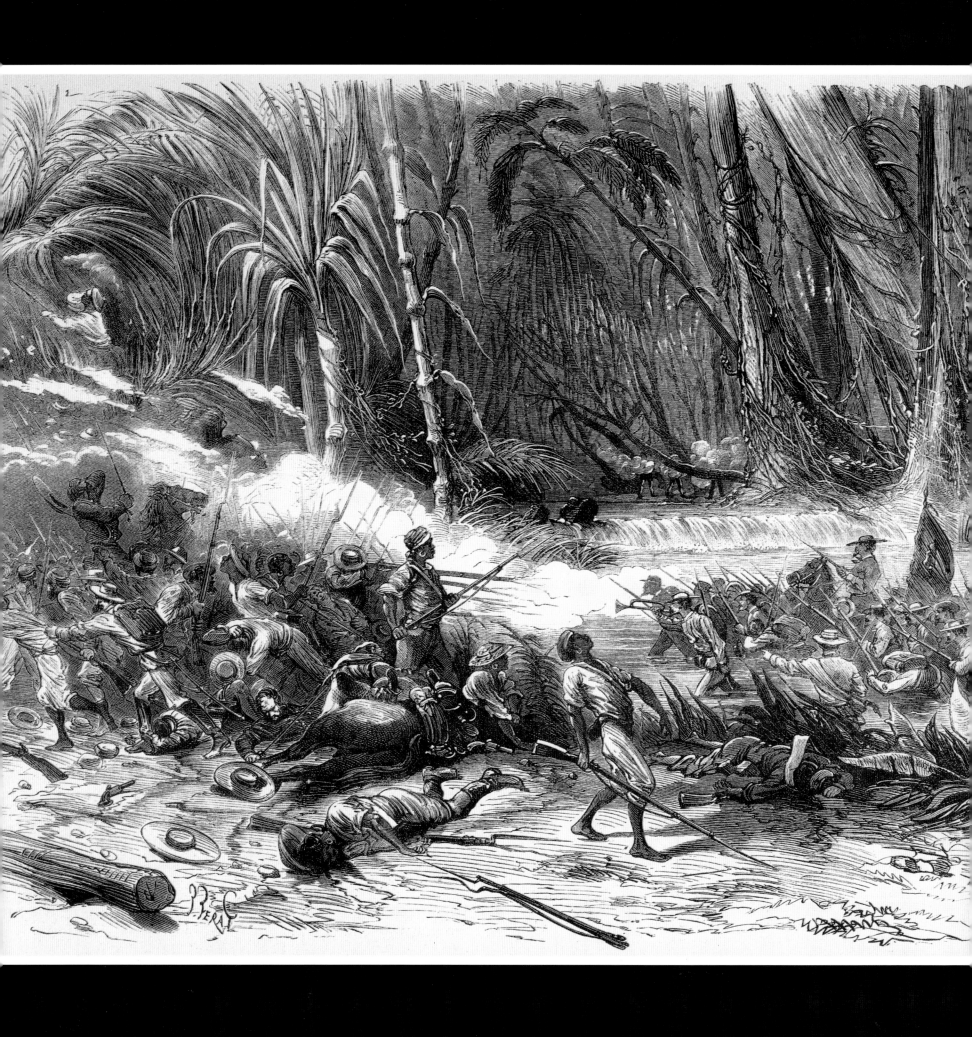

40 In the Ten Years' War (1868–1878) thousands of freed slaves fought on the side of the insurgents.

41 LEFT Antonio Maceo, the unshakeable half caste general, was known as "The Bronze Titan."

41 RIGHT Carlos Manuel De Céspedes lived for a long time in Europe and studied law in Barcelona and Madrid.

FROM SIMÓN BOLIVAR TO JOSÉ MARTÍ

In the meantime, between 1810 and 1820, Spanish America was in flames. Madrid lost her American possessions one by one after having drained them of all their wealth. Mexico, Peru, Argentina, Paraguay, Venezuela, and Colombia all entered Simón Bolívar's utopia and gained independence. The exception was Cuba, where, despite growing discontent with the trade barriers imposed by Madrid, isolated separatist uprisings were easily suppressed by Spain's colonial army. Quite a few realist exiles withdrew to Cuba from Mexico and other newly independent former Spanish colonies, making the island the military stronghold on which Spain relied to maintain a presence in America in the hopes of some day reconquering her lost empire. Spain could ill afford to lose Cuba, the world's largest sugar producer, which, in the face of skyrocketing prices, was making a steep contribution to Madrid's coffers. Halfway into the century, at a meeting at the Havana Club, a group of landowners went so far as to demand political union with the U.S., but the proposal was soon abandoned.

Cuba's real war of independence started in 1868 and lasted until the end of the century. It was sparked by Carlos Manuel de Céspedes—since considered one of the country's foremost freedom fighters—at his ranch La Demajagua, in Manzanillo. On October 10, De Céspedes freed the slaves on his plantations and read out a proclamation inciting rebellion against Spain. The main promoters and leaders of the uprising, such as De Céspedes and Ignacio Agramonte, were mainly scions of rich, landowning families. In 1869 the Republic of Cuba was proclaimed at Guáimaro, but in 1874 De Céspedes fell in battle, and in 1878 the rebels surrendered. Only the defiant general Antonio Maceo continued to resist for another two years before he too was forced to surrender. Maceo's achievement (known as the "the Baraguá protest") is considered one of the most representative episodes of the struggle for Cuban independence.

The first war of independence lasted ten years. Local revolts and a short-lived separatist uprising, known as the "Chica War" because it only lasted a hundred days, flared on the island over the following years until 1895. This period is now referred to as the "turbulent peace." In the meantime, in 1886, slavery was formally abolished, even in Cuba.

North American economic penetration started getting intense. The island was soon dotted with fully automated sugar refineries, known as centrals, requiring little labor but high investment. Since most of the venture capital came in from the U.S., the most modernized sector of Cuba's sugar industry gradually fell into North American hands. In just a few years, ninety-five percent of Cuba's sugar output and eighty-five percent of all its other exports would be sold in U.S. markets, although the country continued to be a Spanish dependency. The situation had become untenable.

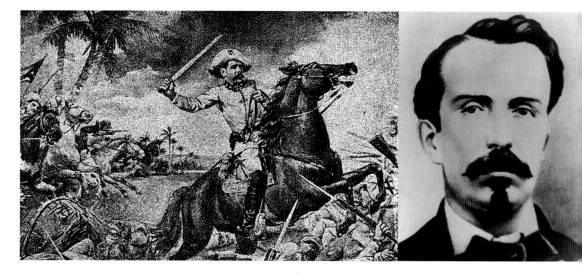

42 LEFT "You won't buy your rights with tears, but with blood" (José Martí).

42 RIGHT To isolate the rebels, Valeriano Weyler deported more than 300,000 Cuban civilians to concentration camps, where tens of thousands died.

43 Máximo Gómez Baéz reached Cuba from Santo Domingo in 1865 as commander of the Spanish reserve forces.

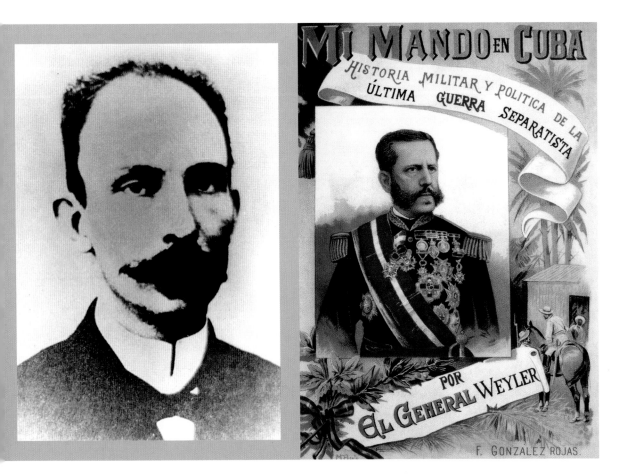

JOSÉ MARTÍ

Masó, Guillermón Moncada, and Manuel Sanguily among its members, together with several heroes of the first wars such as Antonio Maceo, in exile in Costa Rica, and Máximo Gómez, who had returned to his homeland, the Dominican Republic. Gómez was appointed commander in chief of the insurrection that broke out in the spring of 1895, even before he reached Cuba. The insurrection began dramatically with the death of his political apostle, José Martí, who fell in action at Dos Ríos, near Bayamo, in one of the first battles with the Spanish army, on May 19, 1895.

The loss to the movement was great, but Martí's long years of work paid off and his political legacy survived despite the differences that arose among rebel leaders after his death. Military records of the time suggest that Spain had deployed 50,000 well-armed soldiers,

José Martí was born in 1853 but was already at the forefront of the first war of independence. He was barely sixteen years old when he was sentenced first to forced labor and then to exile in Spain, where he earned a degree in law before visiting France, Mexico, and Venezuela. After returning to Cuba in 1879, he took part in the Chica War and was again sentenced to exile.

A poet, writer, journalist, and politician, he was a master of many trades and was known for his organizational skills. While denouncing the anachronistic Spanish dominion, he also warned against the risks posed by what he thought was the imminent U.S. attempt to take over the West Indies in order to use them as a base for the conquest of South America. Martí traveled widely throughout the continent, preparing new projects for a free and, in today's terms, democratic Cuba. In 1892 in New York, he founded the Partido Revolucionario de Cuba, which included the liberation of Puerto Rico as one of its specific goals and young revolutionary leaders such as Bartolomé

artillery, and warships, while Máximo Gómez's forces were made up of 7,000 scantily armed men and nothing more. Yet, the insurrection continued.

In October, after a few minor skirmishes, the *mambises*, as the rebels were called, marched westward. After breaking through the fortified line of Trocha in the Camagüey area on December 15, they reached Mal Tiempo, where they faced the colonial army. The battle that ensued has gone into history because of the horse charge of 400 machete-wielding *mambises* that forced the colonial forces into retreat.

The rebels controlled the eastern areas of the island for two years and battled the Spanish army on the rest of the island. Spain sent a new governor, Valeriano Weyler, who soon earned a reputation for his brutal attempts at quelling the revolt. Weyler literally massacred *mambi* patrols. But Generale Calixto García, another veteran of the first war of independence, solidly held the strategic strongholds in Oriente such as Las Tunas, Camagüey, and Holgüín.

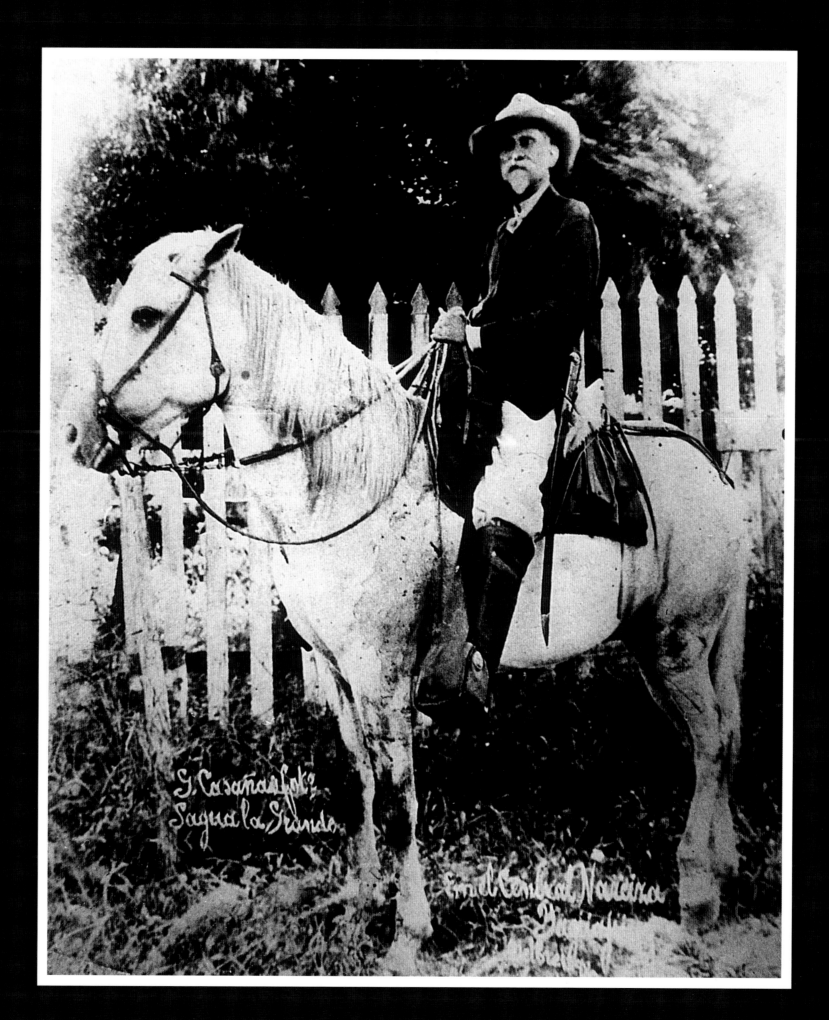

DASHED HOPES

The government in Madrid, further weakened by affairs in Spain and the rivalry between conservatives and liberals, had very few options left. At the end of 1897 it made one last desperate attempt at keeping the island by granting Cuba (and Puerto Rico) a useless constitution providing for greater local autonomy. At the time of Antonio Maceo's death in action on December 7, *mambi* forces controlled the entire island. It was at this point that the fears Martí had voiced years earlier proved prophetic. As the situation escalated, in January 1898 the U.S. sent the U.S.S. *Maine* to Cuba, ostensibly to protect U.S. citizens living on the island. On February 15, while moored in Havana harbor, the U.S.S. *Maine* exploded, killing 266 U.S. sailors. The bomber was never identified and no organization ever claimed responsibility for the attack, and to this day the event is clouded in sinister mystery. In fact, the explosion provided the U.S. with an excuse to declare war against Spain. The U.S. navy destroyed the Spanish fleet at Santiago and a marine regiment landed in the capital. By doing this, Washington effectively deprived the war of independence of its political significance and transformed the independence gained at the price of the blood of thousands of *mambises* into a U.S. military victory over Spain. On January 1, 1899, the last Spanish Captain General handed over the keys of Havana to the U.S. In practice, Spanish colonialism was replaced by a sort of U.S. "protectorate." This period has been baptized the *republica mediatizada*, born of the Platt Amendment approved by the U.S. Senate, asserting the right of the United States to intervene to ensure the independence and government of the island. Under the Platt Amendment, Cuba gave up its right to stipulate international treaties without the consent of the U.S. and was forced to grant the U.S. several military bases on its soil. Today only one of these bases still remains, at Guantanamo, and is the object of ferocious contention between the two governments. The Platt Amendment was even inserted into the new Cuban constitution and the country's very first president, Estrada Palma, availed of it to ask his northern protector for military support in suppressing labor unrest. As a result, in 1906 thousands of marines once again occupied the Cuban capital.

World War I marked the beginning of the end of European political and economic influence worldwide, especially in the North American continent, which was already aflame with the Monroe doctrine. Freed from the Spanish a century later than other Latin American countries, Cuba found itself reduced to a semicolonial province of an emerging world power.

44 For the war against Spain, the U.S. launched a powerful fleet that sailed around the coasts of Cuba and along the Atlantic sea routes.

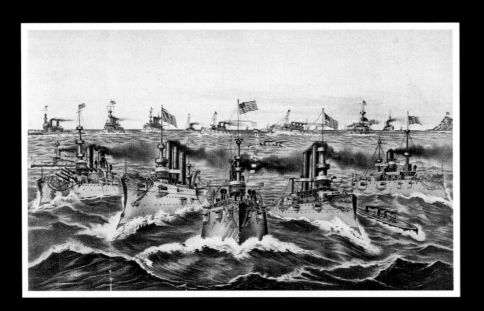

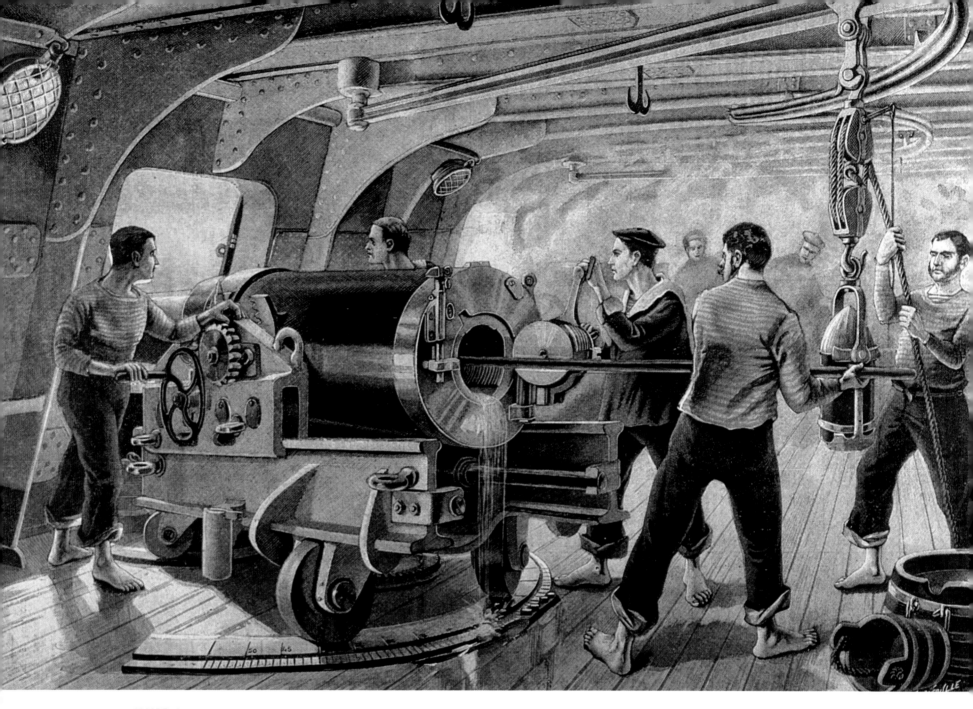

45 TOP Spanish gunboats load a weapon during the battle before the harbor of Santiago, in an attempt to force the U.S. naval blockade. It was all to no avail: the Spanish fleet was annihilated that day.

45 BOTTOM LEFT A wide range of theories were expressed over the explosion of the U.S.S. *Maine*, including the poor maintenance of the new gunpowder stowed in the *Santa Barbara*.

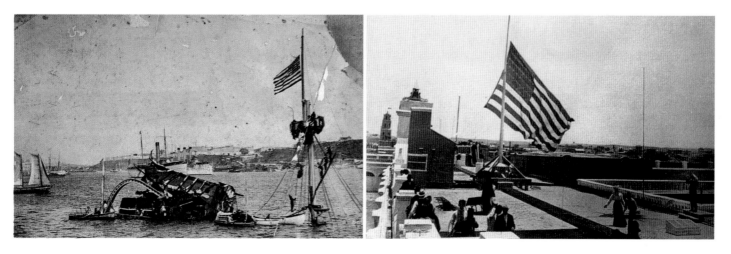

45 BOTTOM RIGHT The U.S. flag was raised on May 21, 1902, the day of the island's declaration of independence. A rather imprecise term, as Cuba was now, in fact, a dependency of the United States.

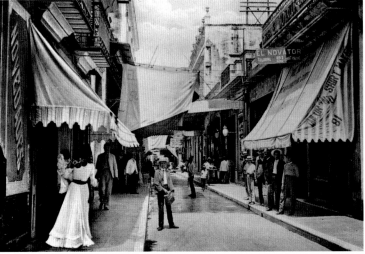

THE TWENTIETH CENTURY

At the turn of the century, the common folk danced the *son* and *danzón* that would later give rise to the *canción habanera*, the *rumba*, and the *bolero*.

A pattern was established; when Ernest Lecuona composed Malagueña in the 1930s, it soon hit the nightclubs of New York, Paris, and Rome. And later, after the fear of war had subsided, while fortunes were made, but more often lost, day and night at the roulette and blackjack tables, Perez Prado and Enrique Jorrín came up with the *mambo* and the *chachacha*. Beny Moré then took both styles on tour around the U.S., together with the already classical bolero.

At the beginning of the twentieth century, the United States was by far the new republic's largest, if not only, trading partner. Without actually imposing trade barriers, the U.S. gained a de facto monopoly over the island. U.S. businessmen invested in factories, transport, and real-estate development. Havana's nineteenth-century city center was transformed into a huge shopping center, while the colonial quarters degraded into a huge eyesore of a slum. On the coast toward the west, in an area historically protected from development, a plush, brand-new city district, which was baptized *Vedado* (reserve park), sprouted almost overnight. Linked to the historical construction ban, the name reflects the reality of the capital's newest hub: Cuba's new bosses lived in splendid Liberty-style and neoclassical villas nestled in tropical gardens. Vedado was reserved to politicians in power, U.S. businessmen, landowners, and merchants. The area was off-limits to most others, especially blacks, who were at an economic distadvantage, and most of whom were illiterate.

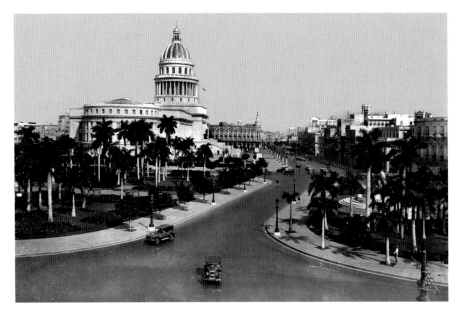

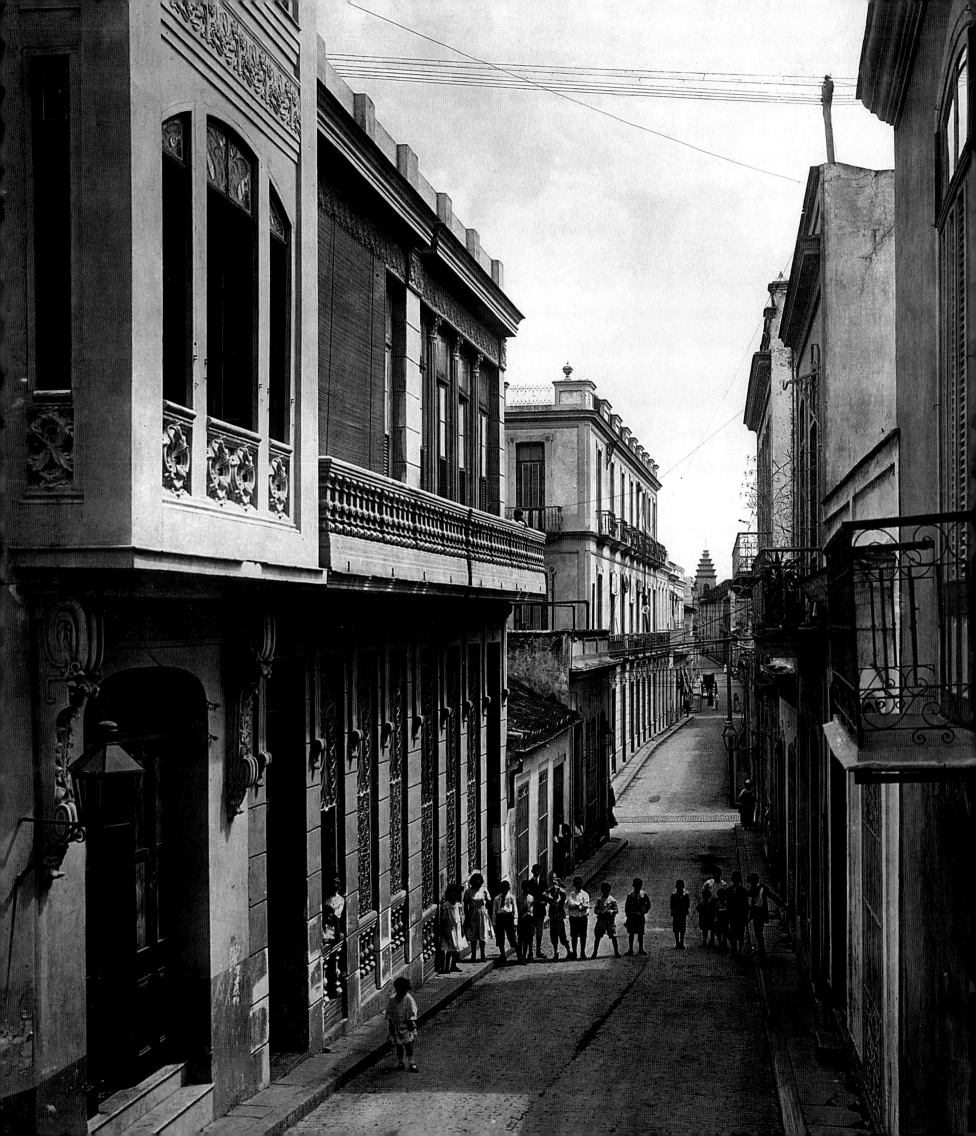

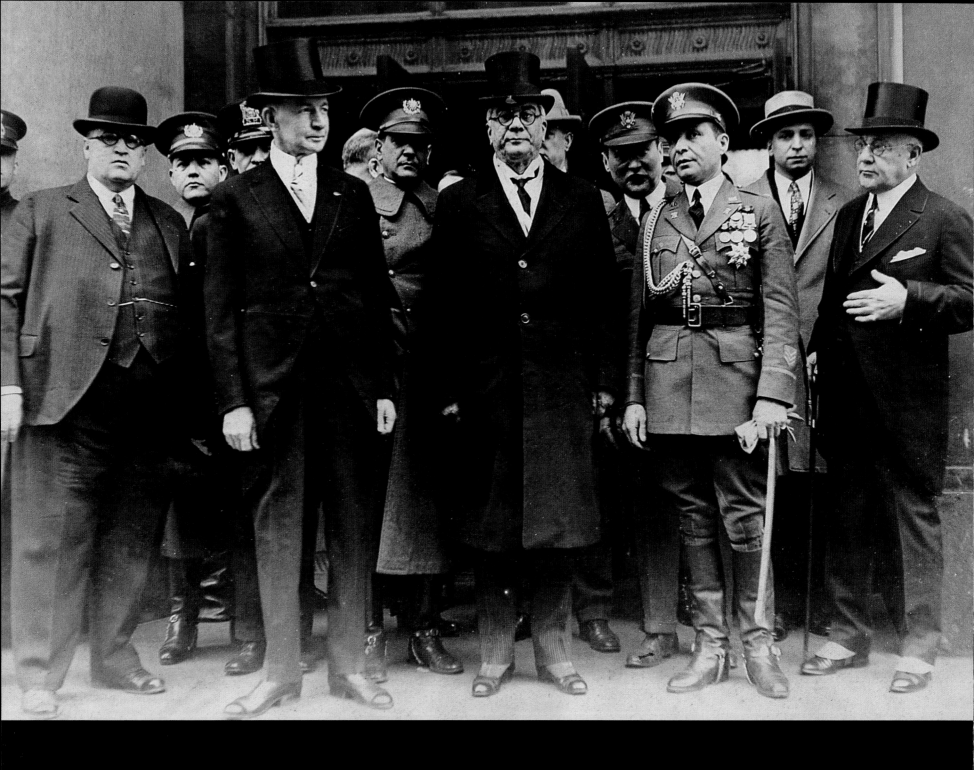

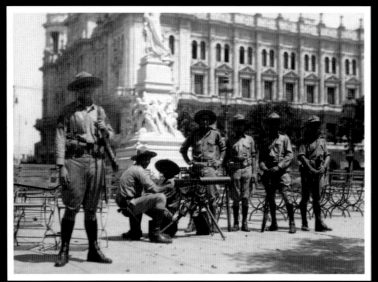

In order to drive the point home, in 1912 thousands of Partido Colorado Independiente protesters demanding equal rights for blacks and an end to racial discrimination in line with Martí's ideas were set upon by the army, resulting in many deaths and injuries. The years between the two World Wars were marked by labor and student unrest. In 1925, Carlos Baliño and Julio Antonio Mella founded the Cuban Communist Party, later renamed the People's Socialist Party. As ever taller buildings graced the capital's skyline, the country's government and civil service plunged to ever darker depths of corruption. Gerardo Machado, elected president of Cuba in 1925, is perhaps the most perfect embodiment of the political class that dominated the "repubblica mediatizada." In order to ensure his candidacy for the presidency, he arrested Mella and had him killed two months later, after having sent him into exile in Mexico. This was just the first in a long list of political assassinations that colored his regime. Nevertheless, this did not deter the U.S. from declaring Machado's dictatorship as "enviable stability of government." Using a variety of loopholes to get around constitutional restrictions on reelection, he managed to remain in power until 1933, when, faced with unrest by labor and student unions, as well as sporadic armed skirmishes with Antonio Guiteras's rebels, he fled Havana and left behind a country ruined by the economic crash of 1929, with debts amounting to $145 million. By this time, Cuba's transportation system, banking system, telephones, electric power, and a majority of the sugar industry were in the hands of U.S. corporations. By fleeing to Nassau (with five suitcases full of gold, as rumor would have it), Machado paved the path for a violent political and social crisis. The progressive professor Grau San Martin was appointed president and formed a wide-based coalition government that even included Guiteras and his radicals. This government's greatest achievement consisted in the nationalization of the electric power industry. After the death of their leader Martínez Villena, the communists were sitting on the fence. Other political factions were in conflict, sometimes even taking to arms. The army was divided, and a faction of army officers led by a sergeant named Fulgencio Batista massacred a group of military brass meeting at Havana's Hotel Nacional. The U.S. refused to recognize Machado's successor and cut off investments and loans vital to Cuba's economy. After a year of stalemate, Batista, at the behest of the U.S. ambassador Summer Wells, installed a puppet president, Carlos Mendieta. Guiteras was killed as he tried to flee Cuba. In 1934, the *sargento* was fully installed at the reins of power, and would remain there until the Castroist revolution. Batista succeeded in finding other presidents and

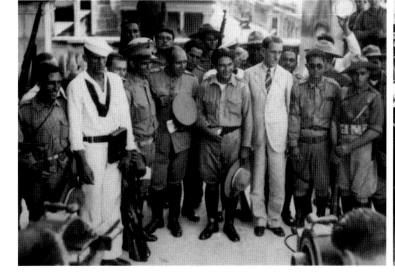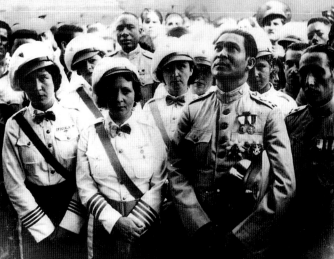

men of straw, supported by governments that, by promoting the policy of People's Fronts and other populist measures, paradoxically managed to attract the support of high-level communist leaders such as Juan Marinello and Carlos Rafael Rodríguez. But in 1944, the candidate jointly presented by the *sargento* and the communists was defeated at the polls by the old, but still alive, Grau San Martín leading a party of *autenticos*. Soon after his election, thanks to the intellectual and middle classes, he took on a conservative bent, brutally suppressing labor and progressive movements.

48 TOP CORRUPTION, POLITICAL VIOLENCE, AND CONTEMPT FOR THE LAW WERE TYPICAL FEATURES OF THE MACHADO REGIME (IN THE CENTER OF THE PHOTOGRAPH).

48 BOTTOM THE THIRTIES: THE ARMY AND SECRET POLICE KEPT THE PEACE AMONG THE PEOPLE AND DURING PUBLIC DEMONSTRATIONS.

49 LEFT GRAU SAN MARTÍN (DRESSED IN WHITE, AMONG THE SOLDIERS WHO BACKED HIM, INCLUDING BATISTA) WAS BROUGHT TO POWER BY THE SO-CALLED "SERGEANTS' REVOLUTION."

49 RIGHT FULCENCIO BATISTA AND HIS WIFE STAND (TO HIS RIGHT) ALONGSIDE THE FIRST WOMEN SOLDIERS IN CUBA.

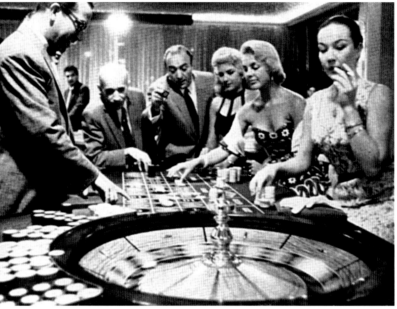

THE MAFIA'S ROULETTES AND *MUJALISM*

In the meantime, as a collateral effect of U.S. control, Cuba attracted the mob that used prohibition-era bootleg cash to gain control over gambling. Casinos were already under construction in Las Vegas in the Nevada desert, and soon Havana was overflowing with casinos next to which U.S. companies set up hotels, bars, swimming pools, and whatever else conformed with the contemporary view of having a good time in an exotic getaway, enjoying prohibited pleasures.

By this time the Second World War had just ended and the Cold War was in full swing. Although sugar prices continued to skyrocket on international markets, nearly two thirds of Cuba's production was controlled by U.S. businesses. The Cuban mobster Eusebio Mujal lent his name to the phenomenon, typical to America, known as

mujalism, in which mob-related labor unions conflicted with traditional labor organizations through provocation and assassination. The corrupt Grau regime was followed by the presidency of Carlos Prío, who further exacerbated Grau's austere conservatism.

In Cuba, *mujalism* went hand in hand with political police, U.S. secret services, the mob, and paramilitary teams specializing in the suppression of labor and student unrest. Labor union leaders and communists were decimated. The People's Socialist Party (Partido Socialista Popular) was banned. Prío's government granted U.S. corporations nickel mining concessions: the island's rich nickel deposits, concentrated in the east, provided Cuba's sole major export after sugar. Havana was rife with corruption. Prostitution and the drug trade flourished unchecked.

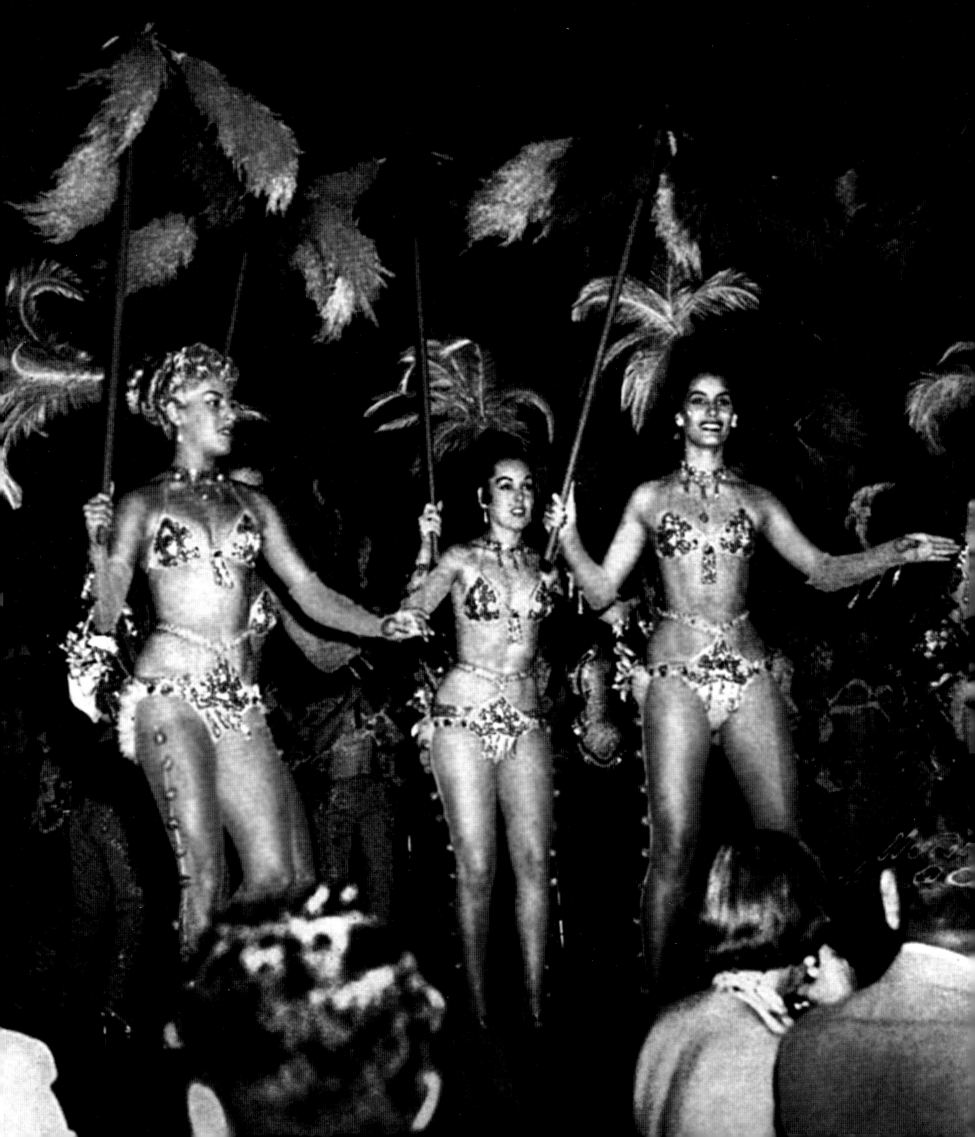

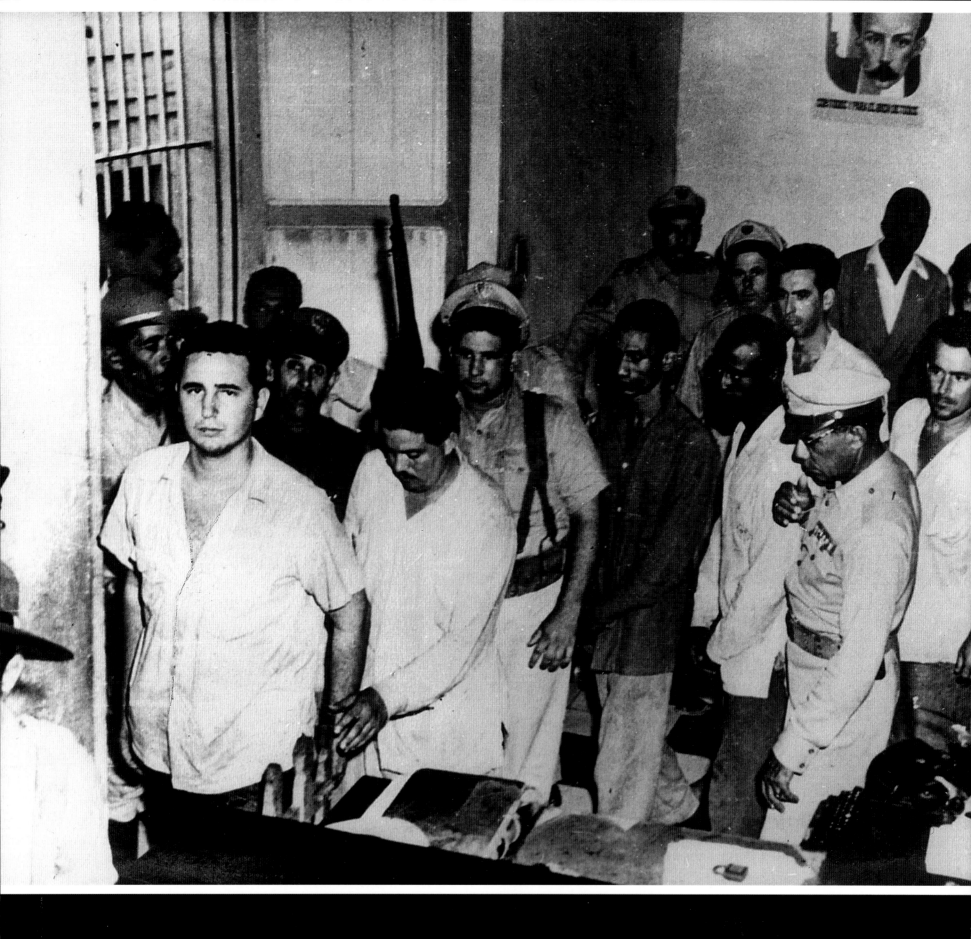

52-53 IMMEDIATELY AFTER THE ATTACK ON THE MONCADA, FIDEL CASTRO WAS ARRESTED AND SENTENCED TO FIFTEEN YEARS IN PRISON.

53 LEFT AFTER THE ATTACK ON THE SECOND CUBAN BARRACKS, THE ARMY WAS PLACED ON A STATE OF ALERT THROUGHOUT THE ISLAND.

53 RIGHT MASS ROUNDUPS, SEARCHES, AND INCURSIONS BY THE SECRET POLICE SHOWED THAT THE MONCADA EPISODE HAD SERIOUSLY ALARMED BATISTA'S REGIME.

1953: THE LAWYER'S NAME IS FIDEL CASTRO

At dawn on March 10, 1952, in the face of imminent presidential elections, Batista threw the president in power out of office. The coup was baptized the "*madrugazo,*" from the Spanish word *madrugada,* meaning "dawn." The strikes and protests against the coup, organized mainly by the university students' union (FEU, Federación Estudiantil Univeridaria), the most important opponent to the Batista dictatorship, continued for over a month. The regime suspended the constitution, closed down the university, filled the prisons, and transformed the capital into military barracks. A government was formed in April, with Washington's official blessing. A case filed before the Constitutional Court by a young lawyer and one time member of the Orthodox Party, founded years previously as an offshoot of Grau San Martín's *autenticos*, stood out among the various attempts at resisting the dictatorship. The twenty-six-year-old lawyer who filed the case accusing the government of having breached the Cuban Constitution was Fidel Castro Ruz. By filing the case, Castro consolidated his position as one of the foremost opponents of the Batista regime and

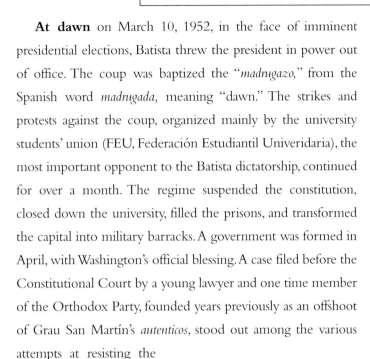

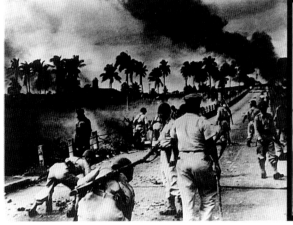

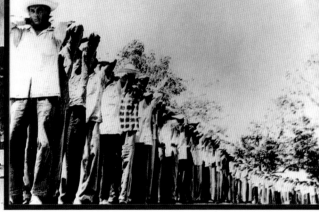

was soon at the heart of the most radical anti-Batista movements. Such was the climate that reigned in Cuba in 1953, the centenary of the birth of José Martí, whose ideas inspired the group under the new leader. On July 26 of that year, during the Santiago carnival, about one hundred youths led by Abel Santamaría and Fidel Castro attacked the barracks of Moncada in a bid to incite the local population to rise up against Batista. The carnival festivities provided excellent cover for the group, which was able to hide their few weapons in the general merrymaking and take the unsuspecting beer-soaked troops by surprise. The group met at a country house, known as Granjita Siboney, a few miles from Santiago. At dawn on July

26, a first team, led by Abel Santamaria, took position in the hospital facing the Moncada barracks so as to be able to keep their eyes on the entrance. A second team, led by Fidel's brother, Raul Castro, took position on the roof of the courthouse overlooking the courtyard of the barracks. But as a result of a series of mistakes and unfortunate coincidences, the rebels lost the advantage of surprise. The vehicles of the team that was to enter the barracks unexpectedly ran into a military formation just outside the compound. The ensuing fight alerted the thousand or so men sleeping in the barracks and the rebel attack was soon foiled, ending in a bloodbath. A large number of the rebels were captured, tortured, and executed. Abel Santamaría's eyes were gouged out of his head and shown to his sister Haidée so as to persuade her to

provide a list of all his accomplices. Of the over seventy men who ended up dead as a result of the investigation, only six fell during the actual attack. Fidel Castro, his brother Raul, and several others were not captured immediately, making it difficult for the authorities to summarily execute them. These rebels were tried and sentenced to several years of prison at the Model Penitentiary of the Isle of Pines. It was during this trial that Castro made the famous address that ended with the words, "history will absolve me!" and that would later be adopted as the slogan of the Movimiento 26 de Julio. Despite the failure of the attack, it went a long way to show that Batista's secret police were not as powerful as widely believed.

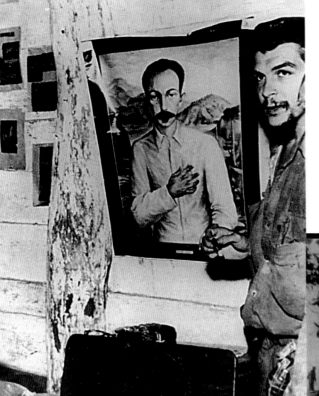

54 TOP RIGHT The *Granma* was sighted by a military fighter plane before all the arms could be unloaded.

54 BOTTOM Camilo Cienfuegos, with his brothers Castro and Guevara, is regarded as one of the mythical figures of the Cuban revolution.

55 Fidel Castro stands between Partorita Nuñez (left, in the photograph) and Celia Sánchez, who played a leading role during the war on the plains and in the activities of the revolutionary government.

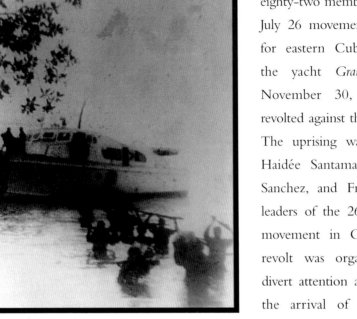

54 TOP LEFT The ideals and teachings of Martí were always an explicit point of reference for the revolutionary leaders (this photograph shows Che Guevara).

THE *GRANMA*

Batista outlawed the communists even though their Partido Socialista Popular (People's Socialist Party) firmly condemned the attack on Moncada. Freedom of the press was abolished, and in 1954 Batista won the election in which only front men and backbench politicians stood as candidates. Complacent with his election victory, Batista gave in to public pressure and amnestied the sentenced rebels in May 1955. To continue his struggle, Fidel Castro moved to Mexico, where the Movimiento 26 de Julio (named after the date of the attack on Moncada) was founded. It was at this time that an Argentine doctor, Ernesto "Che" Guevara, fresh from Colonel Arbenz's progressive experiment in Guatemala that was foiled by a U.S.-backed coup, joined the movement in Mexico. At the end of November 1956,

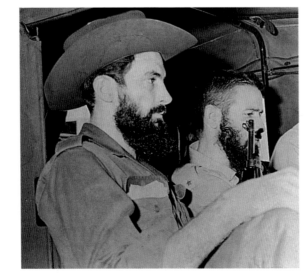

eighty-two members of the July 26 movement set sail for eastern Cuba aboard the yacht *Granma*. On November 30, Santiago revolted against the regime. The uprising was led by Haidée Santamaría, Celia Sanchez, and Frank País, leaders of the 26 de Julio movement in Cuba. The revolt was organized to divert attention away from the arrival of the men aboard the *Granma*, but navigational errors delayed the yacht by two full days. By the time the *Granma* reached Cuba on December 2, the army had suppressed the Santiago uprising and Batista's navy and air force were patrolling the coastline. The rebels landed at the beach known as Playa Las Coloradas (Manzanillo) instead of Niquero, as planned. After three days of marching toward the Sierra Maestra, the group still did not break through Batista's cordon and was massacred in a surprise attack at Alegría del Pío. Only a few of the rebels managed to escape death or capture, and against all odds this tiny team of survivors (who, protected by the local people, managed to regroup only after two weeks), sparked the Cuban revolution. The group included Fidel Castro, his brother Raul, Camilo Cienfuegos, and Che Guevara.

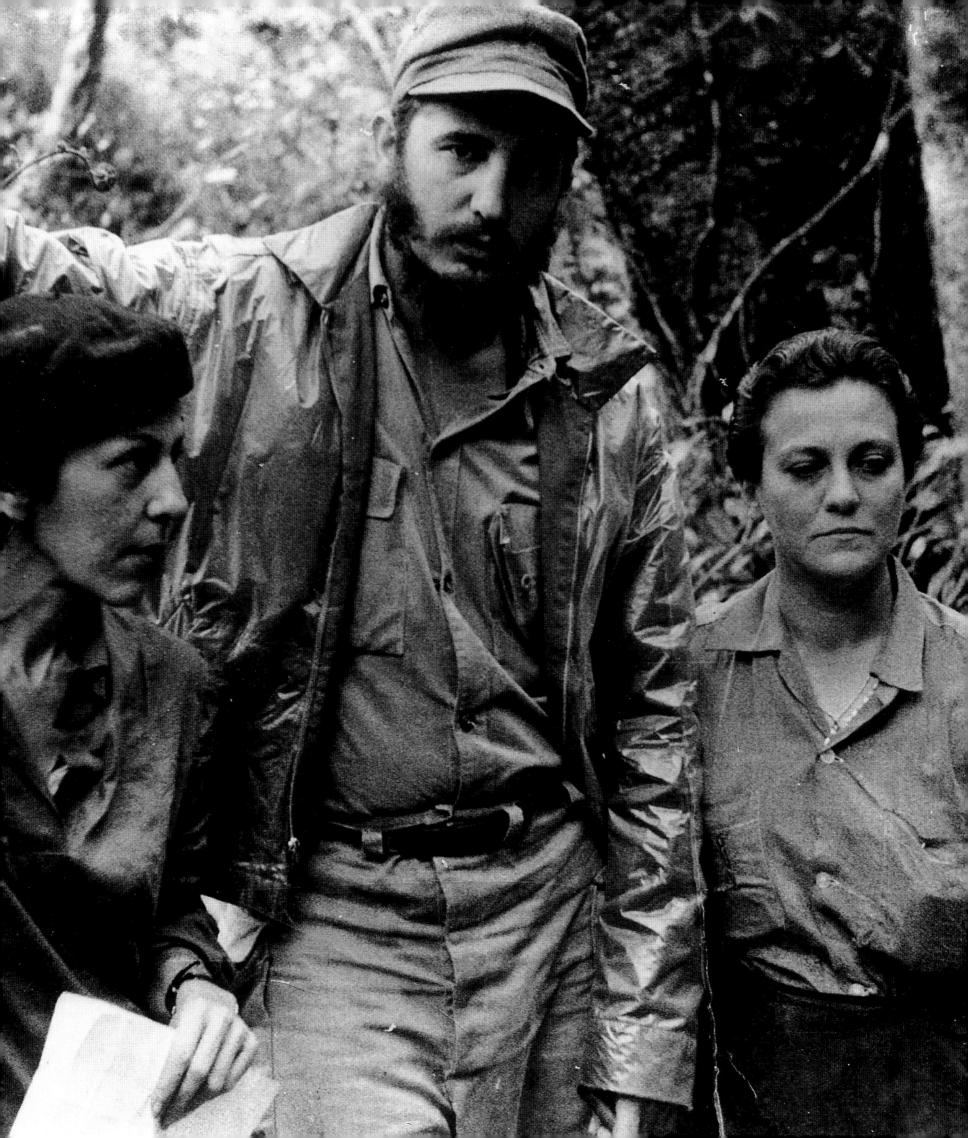

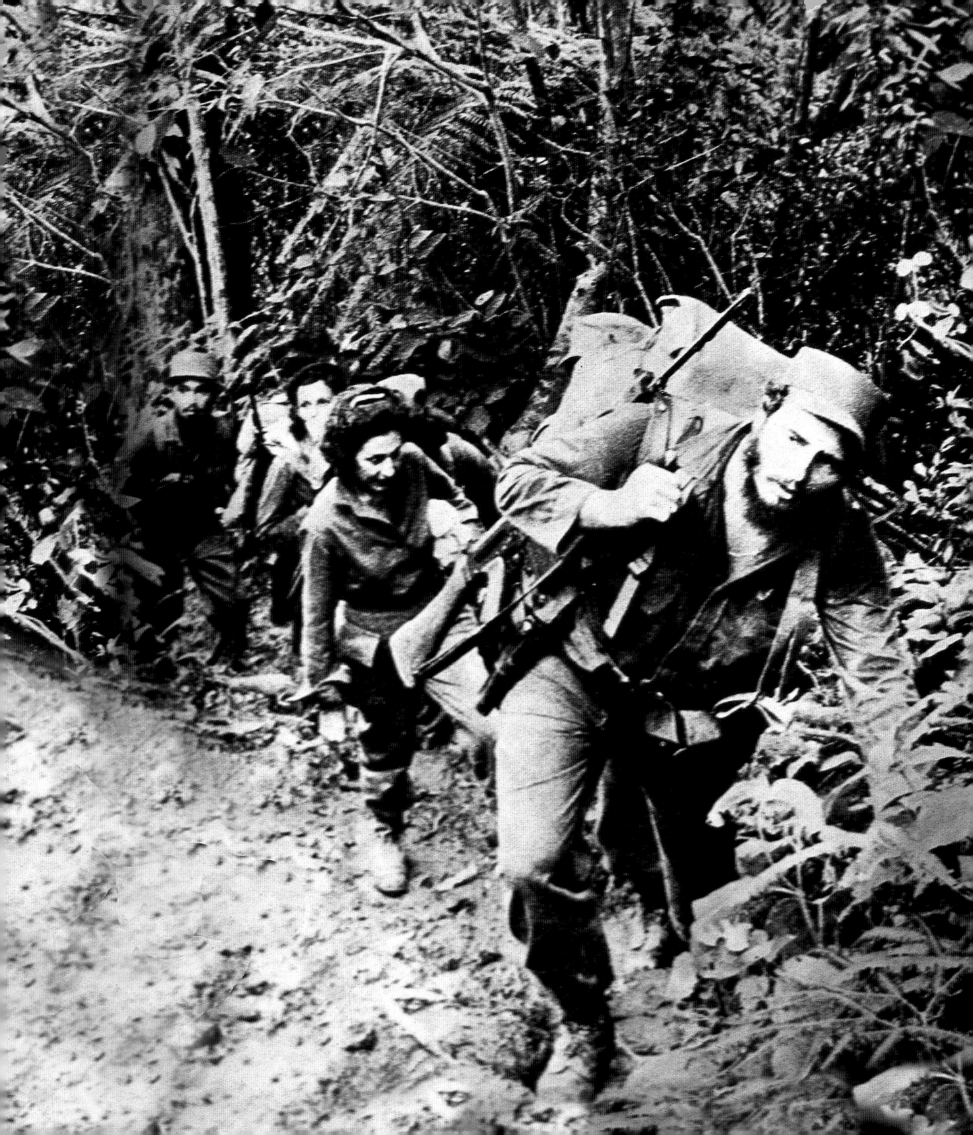

56 THE FIRST MONTHS ON THE SIERRA MAESTRA WERE VERY HARD FOR THE REBELS, WHO WERE FORCED TO MOVE ON CONTINUOUSLY TO ESCAPE THE ARMY PATROLS.

57 TOP LEFT IN THE FIFTIES, BATISTA (SEEN HERE AMONG THE GUARDS OF THE PRESIDENTIAL PALACE AFTER THE ATTACK BY THE DIRECTORIO ESTUDIANTIL) SURVIVED VARIOUS ASSASSINATION ATTEMPTS.

57 TOP RIGHT JOSÉ ANTONIO ECHEVARRÍA, LEADER OF THE DIRECTORIO, WAS CAUGHT IN AN AMBUSH AS HE TRIED TO ENTER THE UNIVERSITY DURING AN UNSUCCESSFUL ATTEMPT ON THE LIFE OF BATISTA.

57 BOTTOM 1958: FIDEL CASTRO AND HIS MEN PHOTOGRAPHED IN THE REBELS' STRONGHOLD, THE COMANDANCIA DE LA PLATA, IN THE SIERRA MAESTRA.

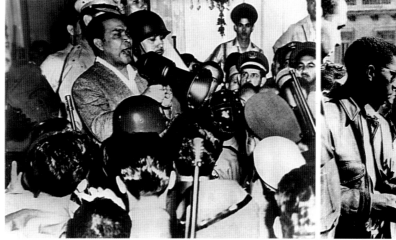
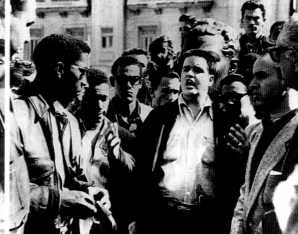

THE *REVOLUCIÓN*

Mid-January saw the first military operation. The group attacked the small military barracks at La Plata, located on the coast in the province of Santiago. In February, Castro was interviewed by Herbert Matthews of the *New York Times* in the Sierra Maestra mountains. The publication of pictures of the long-bearded rebels in the U.S. press belied Cuban Ministry of Defense reports of Fidel's death in the attack at Alegría del Pío, widely circulated in the Batista-controlled media. In March, students of the Directorio Estudiantil of Havana attacked the Presidential Palace as well as the offices of Radio Reloj, one of the country's major radio stations. In a press release read over the radio by the students' leader, José Antonio Echevarría, they declared that their aim was to eliminate Batista and put an end to his regime. Meanwhile, the dictator barricaded himself on the topmost floor of the Presidential Palace, where the rebels were unable to get to him, before the arrival of police and military reinforcements. In the ensuing gun battle, the small group of rebels was decimated and the uprising suppressed. Throughout 1957, the *barbudos* (long-bearded) rebels used

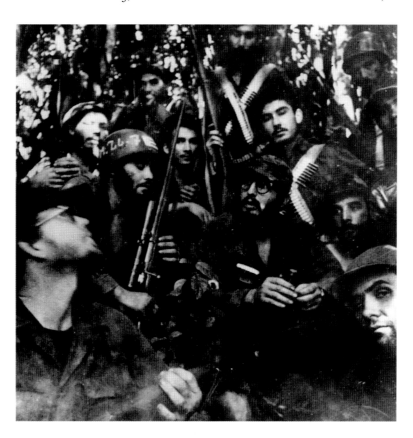

classical hit-and-run guerrilla tactics to hold the army at bay. Side by side, the rebels garnered political support all over the island. Support from peasants—forced to work on sugarcane plantations owned by U.S. multinationals at starvation wages—in the Sierra Maestra and surrounding regions was crucial to the success of the rebel campaign. And in the cities, large portions of the middle classes, sick of Batista's heavy-handedness and the domination of foreign multinationals, were easily converted to the rebel cause. In July, public outrage in Santiago at the funeral of Frank País, a victim of a Batista-backed political assassination, led to civil unrest during which the army fired into the crowd.

The following month the crews of several Cuban naval vessels mutinied at Cienfuegos and took control of the port and the city until the uprising was brutally suppressed by the air force, thanks especially to B-56 bomber reinforcements provided by the U.S. All these events were, however, perceived as sporadic skirmishes, while Batista, the U.S. ambassador, the multinationals, and the mafia grossly underestimated the real scope of the ongoing crisis.

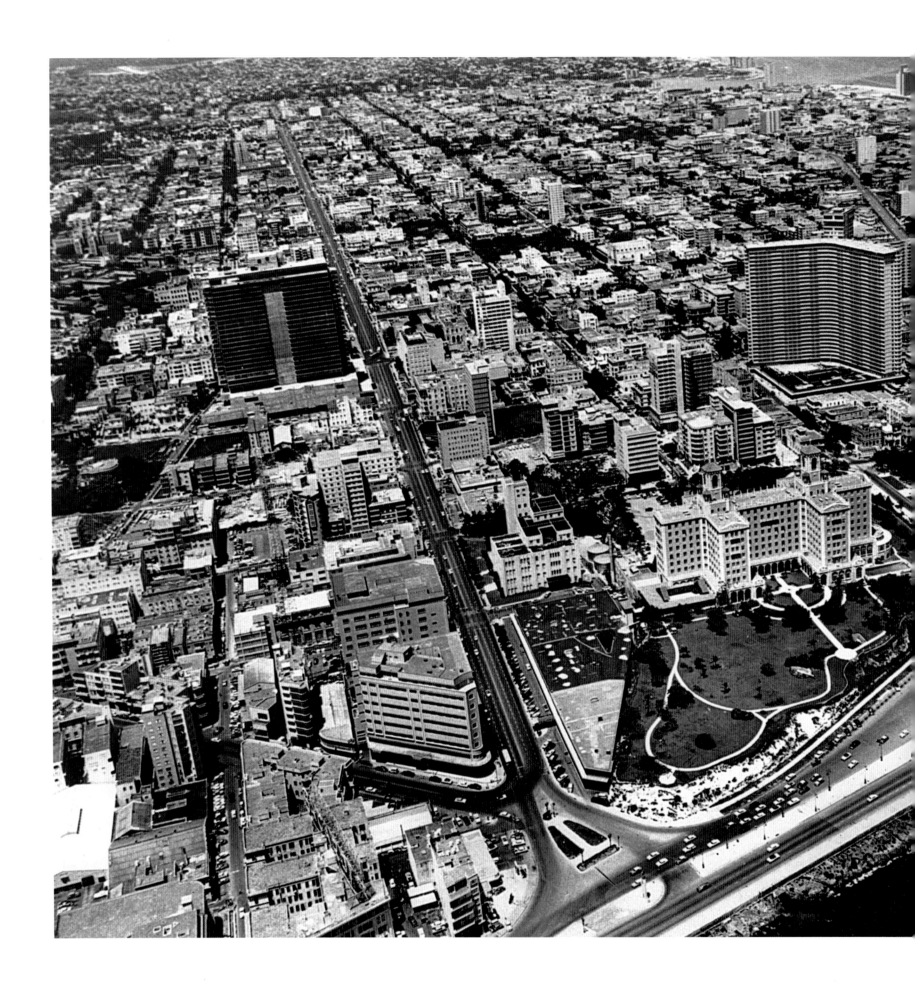

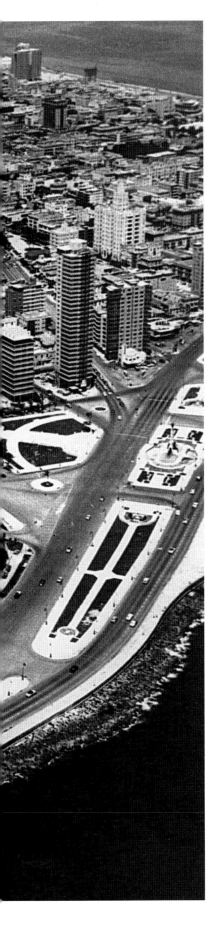

58-59 The Vedado area of Havana in January 1958. The large, dark building is the Havana Hilton, still under construction, the last of the skyscrapers built by U.S. companies in the capital.

59 TOP Hemingway moved to Cuba in the thirties. A great deep-sea fishing enthusiast, this photograph shows him smiling (right) alongside one of his legendary catches.

HAVANA

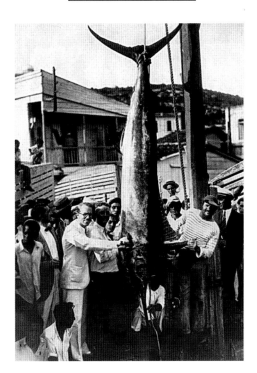

59 BOTTOM LEFT March 1959: large advertising billboards lit up the Prado, the road that connects the seafront (Malecón) with the main square (Parque Central) in central Havana.

59 BOTTOM RIGHT The Hotel Nacional, opened in 1930 at the entrance to the new Vedado quarter, was the most prestigious hotel in Havana for more than half a century.

In Havana, it was business as usual. The U.S. embassy continued its sumptuous receptions and the mob continued to open new hotels and casinos. Skyscrapers were still being built, vying for honor on the Vedado skyline, while luxurious yachts from Florida spewed hordes of tourists attracted by the exotic flavors and colors of the island. The less-moneyed or more-hurried U.S. vacationers found their way to the island aboard one of the many weekly flights to Havana's Rancho Boyero airport from Miami, New York, Washington, and a wide range of North American cities. mafia bigwigs such as Arleto Batisti, George Raff, and Mayer Lansky settled in the Cuban capital so as to better supervise the casinos of the Hotel Capri, Riviera, Nacional, Hilton, Comodore, Seville-Baltimore, the Tropicana Cabaret, the Montmartre, the Sans-Souci, and others.

Recreational drugs were freely available, from low-cost marijuana to up-market opium and cocaine. Entire city districts in downtown Havana and around the port area were transformed into huge brothels. The Hotel Nacional continued to be off-limits to guests of color; even Nat King Cole and Josephine Baker were barred from the elegant lobby overlooking the Gulf of Mexico. Ginger Rogers and Katyna Ranieri were the rage of the capital, while Hemingway wrote at his ranch, Finca Vigia, in San Francisco de Paula on the outskirts of Havana, between a bout of fishing in the Gulf and a daiquiri at the Floridita. Large shopping centers such as the Encanto and the Fin de Siglo, covering ten or more floors, dominated the city's business district from Calle San Rafel (the Boulevard) to Calle Nettuno and Avenida Galiano. The women of Latin American high society flocked to the island from Caracas and Panama to buy the latest Dior creations. All the while, the "microondas" of the police kept silent watch over the city. While the occasional terrorist bomb did create a stir, victims were few and far between.

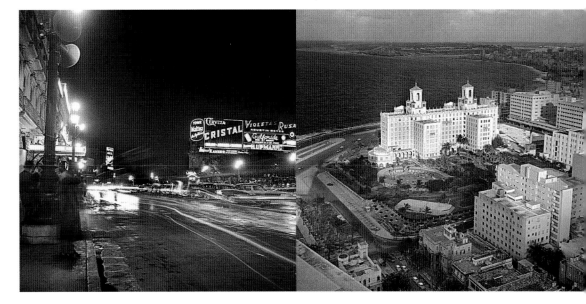

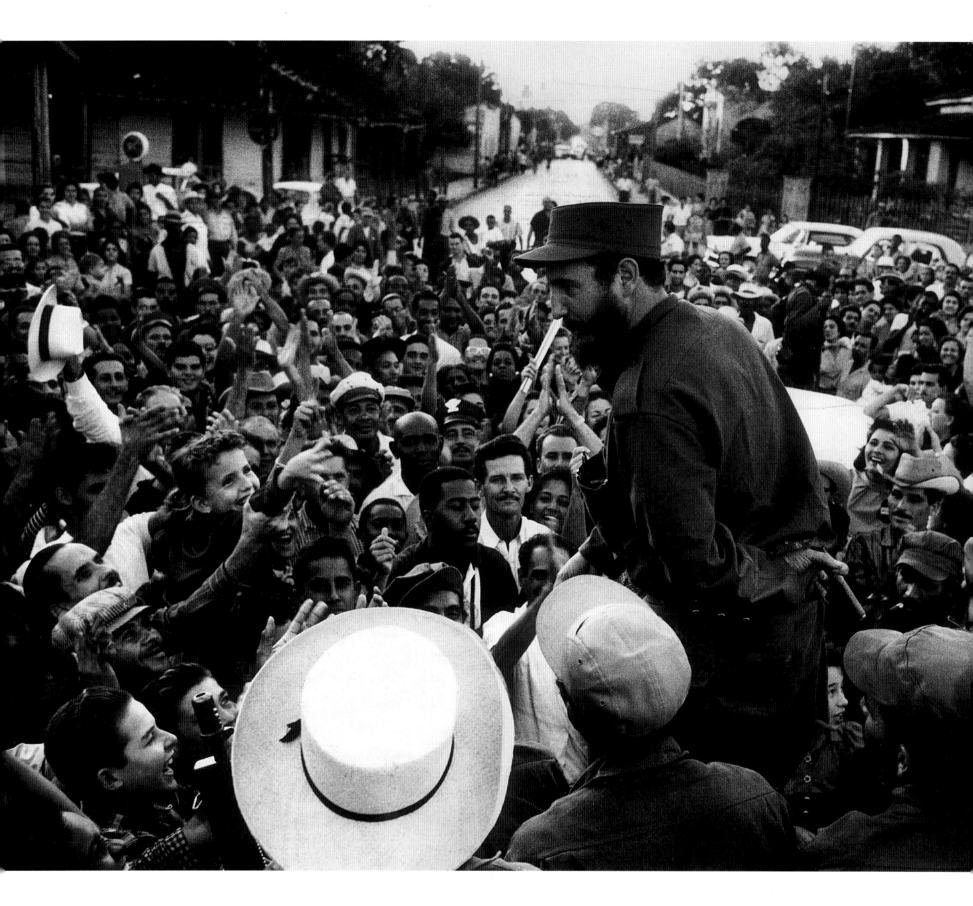

60-61 AFTER THE FLIGHT OF BATISTA, CELEBRATIONS AND JOYOUS DEMONSTRATIONS FOLLOWED THE JOURNEY OF FIDEL CASTRO FROM SANTIAGO TO HAVANA.

61 TOP LEFT ALL HAVANA CAME TO THE PRESIDENTIAL PALACE TO SALUTE FIDEL CASTRO AND THE NEW PRESIDENT MANUEL URRUTIA.

61 TOP RIGHT THE CONQUEST OF SANTA CLARA ON DECEMBER 29, 1958, OPENED THE WAY TO HAVANA FOR CHE GUEVARA AND HIS MEN.

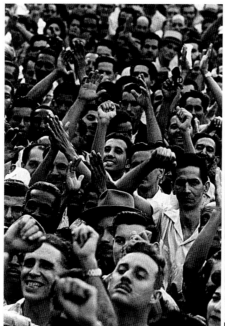

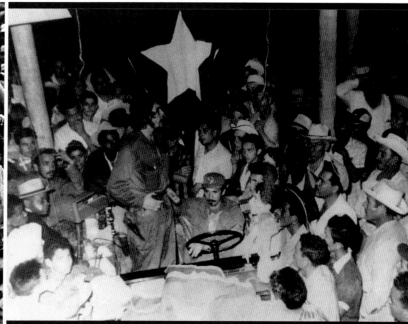

61 **BOTTOM** FIDEL CASTRO, SHOWN HERE WITH CAMILO CIENFUEGOS (RIGHT), REACHED HAVANA ON JANUARY 7, 1959.

1958

It was only in 1958 that the dictator decided to launch an all-out offensive. Operation Verano (summer), as it was called, was launched in May. Large military contingents were sent into the Sierra Maestra: 12,000 men with artillery and tanks, backed by the most modern air force in all of Latin America. A $100,000 reward was placed on Fidel Castro's head. But it was late. Broadcasting from deep within the mountains, Radio Rebelde continuously issued news bulletins of rebel victories in skirmishes with government troops. After two months, it was obvious that the military offensive was a miserable failure: a large number of troops and officers deserted to join the rebels. Massive, random air attacks on villages in eastern Cuba increased public animosity against the regime, while the July 26 movement's promised land reforms went a long way to garner support for the rebels among the country's peasants. By this

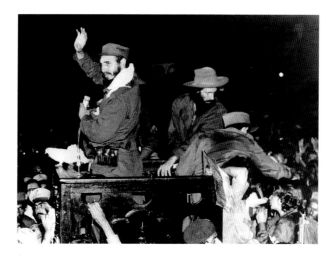

time it was clear that public opinion had tipped in favor of the new winds coming from the Sierra and the long-bearded rebels. Like the *mambi* generals during the war of independence, Castro started to prepare for the march westward. The U.S. multiplied its efforts in support of Batista, but the situation soon escalated in favor of the rebels. In a few months, Raul Castro and Juan Almeida took control of the eastern provinces, while Guevara and Camilo Cienfuegos gained headway in the west.

By the end of December, Guevara had taken Santa Clara after successfully sabotaging, on December 29, the armored rail convoy carrying 350 reinforcement troops to defend the city. On New Year's Eve, Batista fled the island for exile in the Dominican Republic. On January 2, 1959, rebel troops led by Cienfuegos and Che Guevara entered the capital. After reaching Havana a few days later, Fidel Castro addressed the cheering throngs from the balcony of Havana's Palacio Presidencial.

1959-1962: THE EARLY YEARS OF THE REVOLUTION

62 TOP LEFT AFTER THE UNSUCCESSFUL INVASION OF THE BAY OF PIGS, THE FAMILY MEMBERS OF THE CAPTURED COUNTERREVOLUTIONARIES LEFT CUBA FOR THE U.S.A.

62 TOP RIGHT IN 1961 THE REVOLUTIONARY GOVERNMENT PROMOTED A WIDESPREAD LITERACY CAMPAIGN.

62-63 ON APRIL 16, 1961, AT AN ASSEMBLY HELD AT THE CROSSROADS OF CALLE 23 AND CALLE 12 IN VEDADO, HAVANA, FIDEL CASTRO PROCLAIMED THE SOCIALIST NATURE OF THE CUBAN REVOLUTION.

63 TOP ANTONIO NUÑEZ JIMÉNEZ (LEFT, WITH FIDEL CASTRO, IN JUNE 1959), THE FIRST DIRECTOR OF THE NATIONAL AGRICULTURAL REFORM BOARD, DISTRIBUTED THE LANDS OF THE CUBAN LANDED ESTATES TO THE PEASANTS.

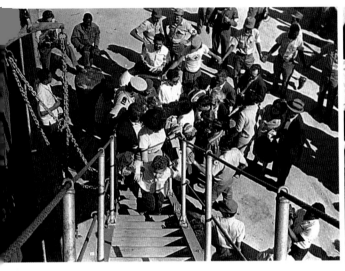

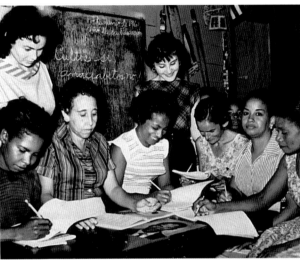

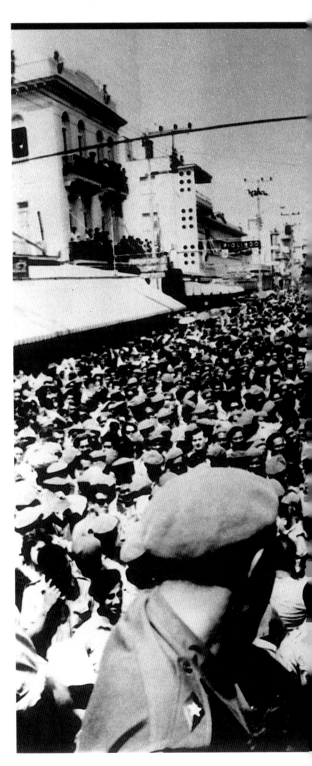

Land reforms, increases in the minimum wage, limits on landowning, and the nationalization of the country's transportation and telecommunications systems all undermined U.S. interests on the island. Between March and May 1959, Cuban Telephone was nationalized and all landholdings in excess of 741 acres were confiscated and in part redistributed among small farmers. The country's army was replaced by rebel units who had fought in Oriente. Counterrevolutionary units backed by the CIA were organized in the Escambray Sierra in central Cuba and would not be completely routed until February 1961. On October 28, 1959, returning from a mission in Camagüey where he had arrested Hubert Matos for taking arms against the new government, Camilo Cienfuegos died in a plane crash and entered the pantheon of Cuban national heroes. Many of Cuba's wealthy families fled the island for Miami, fully certain that they would soon be back. Even while they abandoned their homes and lands in Cuba, they were certain that Washington would inevitably intervene to get

rid of Castro's government. The Belgian vessel *La Coubre*, delivering a consignment of arms to the new government, was sabotaged by the CIA in Havana Bay, leaving behind a large number of victims and even more unanswered questions and parallels with the sinking of the U.S.S. *Maine*. The various attacks in Cuba's cities were suppressed by the CDR—Committees for the Defense of the Revolution (Comité de Defensa de la Revolución). The U.S. reacted by setting up and enforcing an oil embargo against the island and refusing Cuban sugar exports. Cuba responded by nationalizing the country's sugar and nickel industries, and started bartering sugar against oil with the Soviet Union. The government implemented a large-scale education campaign involving thousands of volunteer teachers and students. As a result, the island phased out illiteracy, becoming in just a few years a country with one of the lowest illiteracy rates in the world. The education campaign also brought the revolution to the remotest corners of the island.

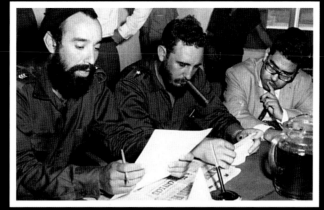

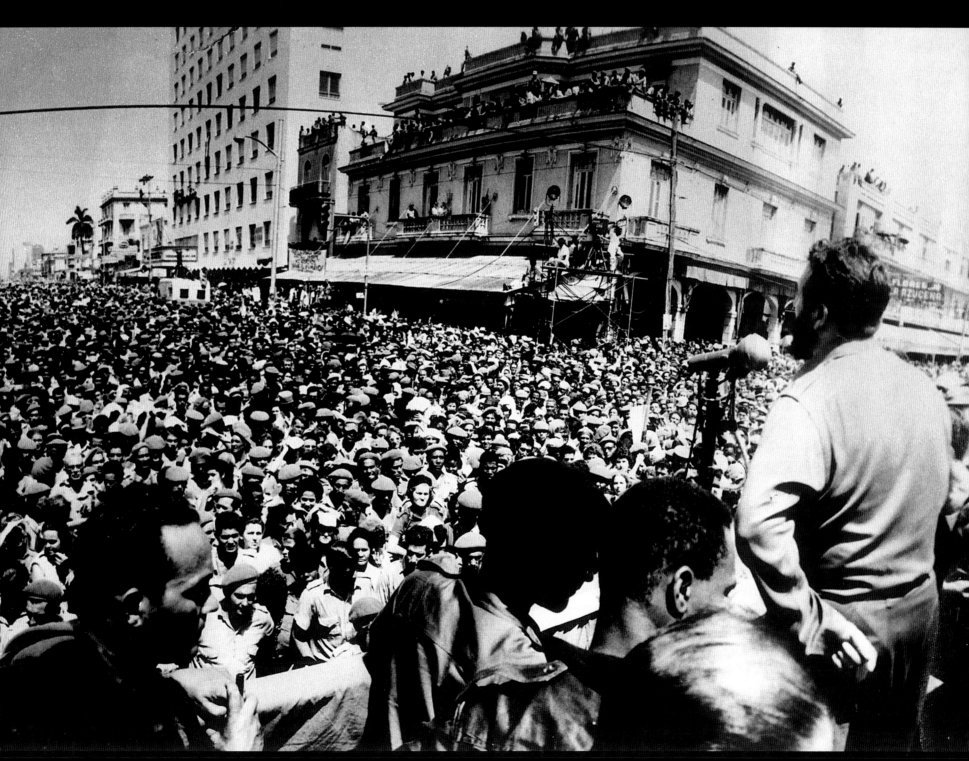

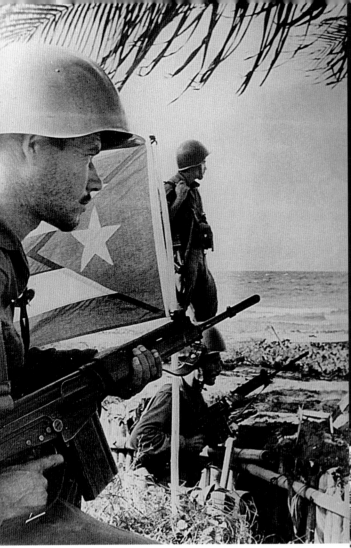

64 CENTER THE PARADE TO MARK THE SECOND ANNIVERSARY ON JANUARY 2, 1961, OF THE REMOVAL OF BATISTA TOOK PLACE ONLY ONE DAY BEFORE EISENHOWER DECIDED TO BREAK OFF DIPLOMATIC RELATIONS WITH CUBA.

64 BOTTOM AS WAS HIS CUSTOM, DURING THE PERIODS OF GREATEST TENSION, FIDEL CASTRO (HERE SEEN AT PLAYA GIRÓN) WENT OUT IN PERSON ON A NUMBER OF OCCASIONS TO CHECK THE CUBAN MILITARY POSITIONS.

65 TOP LEFT KENNEDY AUTHORIZED THE CIA TO ORGANIZE THE INVASION OF CUBA, BUT CONTRARY TO THE EXPECTATIONS OF THE CUBAN EXILES, HE DID NOT RISK THE EXPLICIT INVOLVEMENT OF THE U.S. NAVY IN THE ACTION.

65 TOP RIGHT THE ROUT OF THE INVADING FORCES IN THE BAY OF PIGS WAS TRANSFORMED INTO A GREAT POLITICAL VICTORY FOR FIDEL CASTRO, WHICH WON HIM FURTHER CONSENT AND SUPPORT INSIDE THE COUNTRY AND ABROAD.

65 BOTTOM THE U.S. BASE OF GUANTANAMO/CAIMANERA (SHOWN HERE IN APRIL, 1961) WAS GRANTED TO THE U.S. NAVY ON THE BASIS OF A TREATY SIGNED IN 1903 AND RENEWED IN 1934, WHICH CONTAINS NO EXPIRY DATE UNLESS A DECISION TO THE CONTRARY IS TAKEN BY COMMON AGREEMENT BETWEEN BOTH GOVERNMENTS.

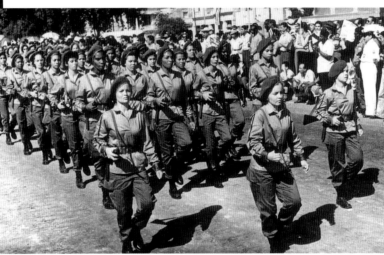

a complete economic embargo against the island. Still in force today, the embargo is the longest in modern history.

In 1962, Cuba was expelled from OAS (Organization of American States), and Mexico and Canada were the

64 TOP DURING THE CRISIS OF OCTOBER 1962, THE ENTIRE COASTLINE OF CUBA WAS PLACED UNDER THE CLOSE SURVEILLANCE OF THE ARMY AND THE ARMED CIVILIAN FORCES.

On April 15, 1961, U.S. fighter planes camouflaged to appear as Cuban aircraft bombed the island's main airports, crippling its air defenses. The following day, at the funerals of the victims, Fidel Castro proclaimed the socialist nature of the revolution. On April 17, around 1,500 Cuban exiles landed at the Bay of Pigs on the country's southern coast, expecting to raise a public revolt to oust the new regime. The exiles, trained at CIA-run camps set up in Guatemala, were also supported by U.S. fighter aircraft. The aim was to take by force a part of the marshy Zapata peninsula, set up a provisional government with the support of the public revolt, and then invite the U.S. military to intervene directly in defense of democracy.

The plan was an appalling failure and the exiles were quashed in just three days. Immediately detected, 300 exiles were killed and the rest captured. On April 25, U.S. president John Kennedy announced

only American countries to recognize the new revolutionary government. The economic embargo led Cuba to fully consolidate its trade relations with Soviet-bloc COMECON member states.

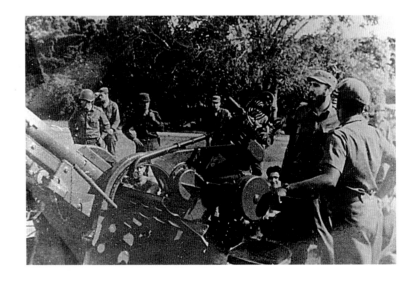

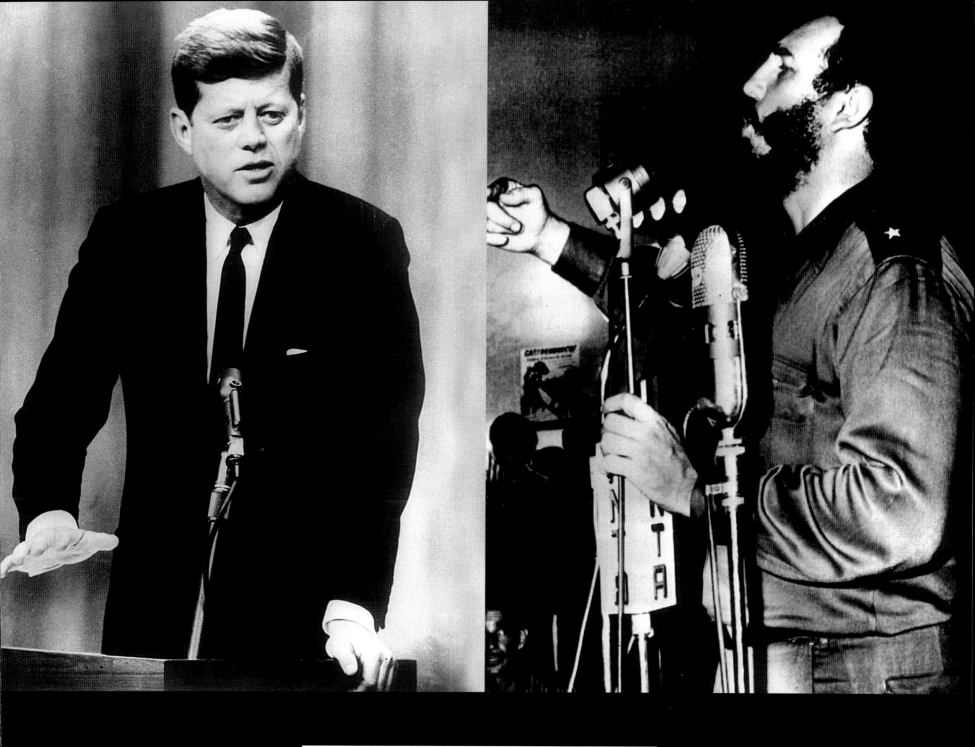
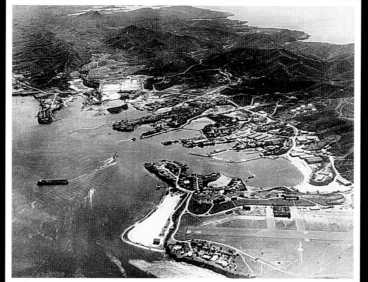

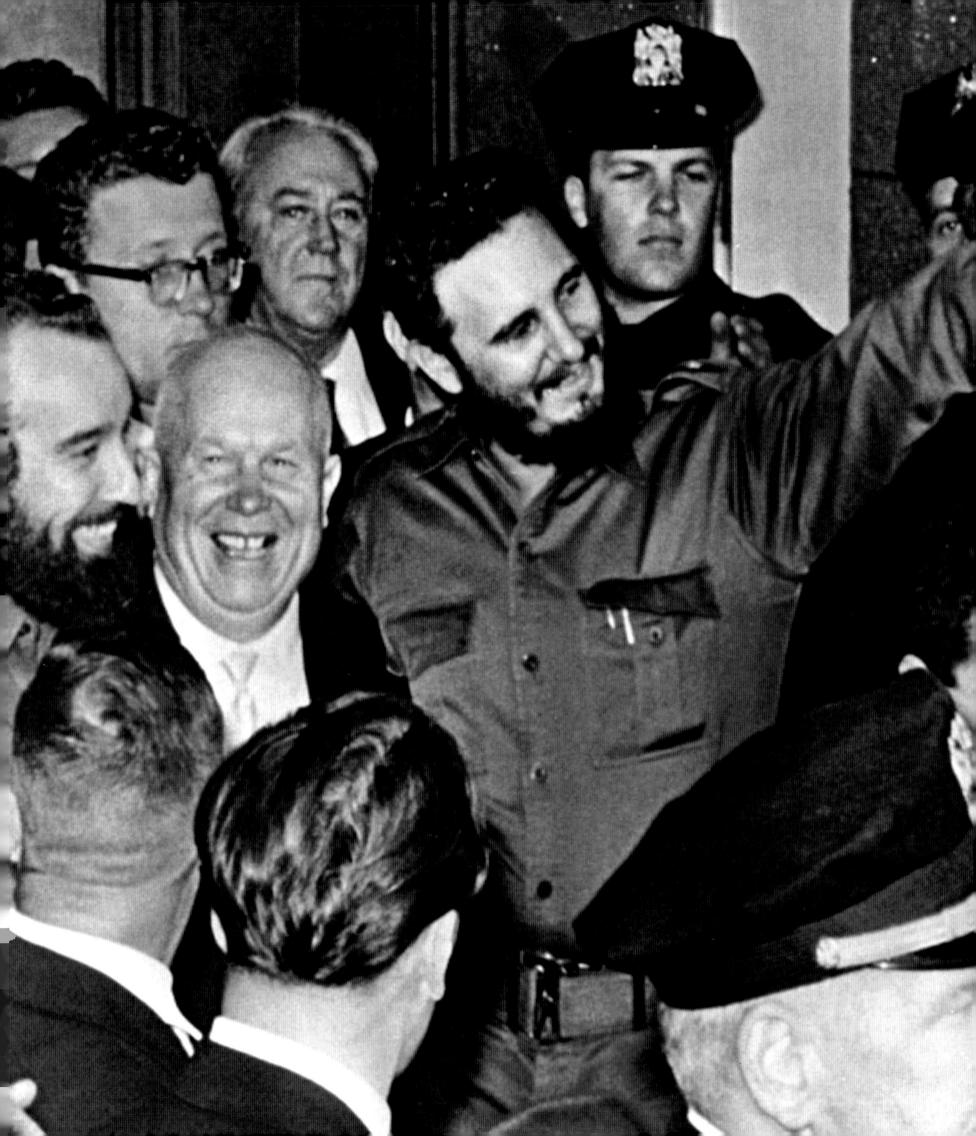

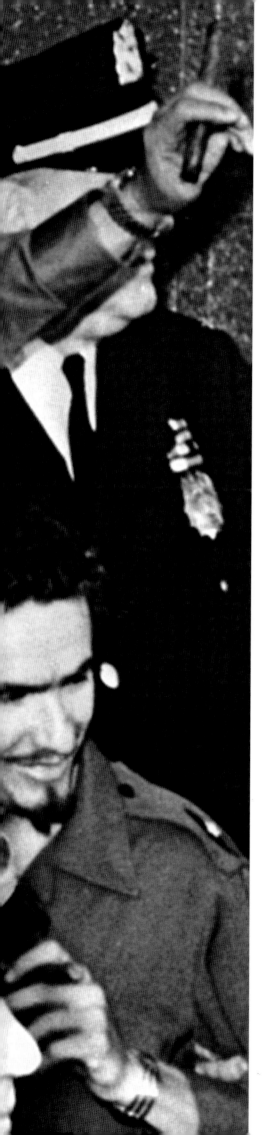

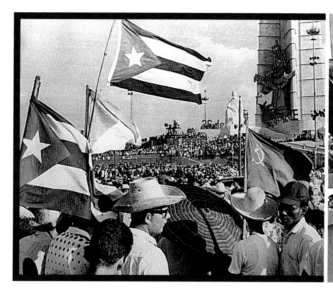 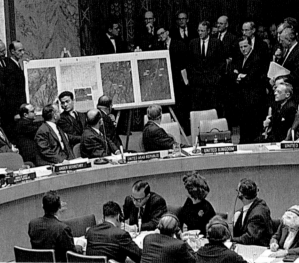

67 TOP LEFT IN JULY 1961, IN PLAZA DE LA REVOLUCIÓN, HAVANA, A MAJOR DEMONSTRATION TOOK PLACE IN HONOR OF THE SOVIET ASTRONAUT YURI GAGARIN, WHO APPEARED ON THE PLATFORM TOGETHER WITH CASTRO.

67 TOP RIGHT THE UNITED NATIONS SECURITY COUNCIL MET IN AN EXTRAORDINARY SESSION ON OCTOBER 25, 1962, TO DISCUSS THE QUESTION OF SOVIET MISSILES IN CUBA.

67 BOTTOM IN NOVEMBER 1962, SOVIET SHIPS BEGAN TO RETURN THE CUBAN MISSILES TO THE U.S.S.R.

In the summer of the same year, the grim shadow of nuclear war loomed over the Caribbean. Forty-two Russian medium-range missiles with nuclear warheads were installed in the Sierra del Rosario (Pinar del Río). In August, U.S. spy planes spotted the missile site. In October, the U.S. navy cordoned off the island, refusing to allow any ships to reach Cuba without being inspected. Half the world's armies were placed on full alert. In a dramatic televised address to the nation on October 22, Kennedy demanded the immediate dismantling of the nuclear installations. The Russians demanded the simultaneous dismantling of U.S. nuclear installations in Turkey. Caught in the middle of the fray between the two superpowers, Havana once again called for a lifting of the U.S. embargo and a stop to all anti-Cuban activities, demanding the withdrawal of U.S. Marines

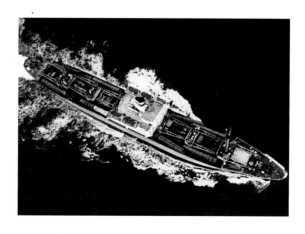

from the Guantánamo military base. However, Cuba was isolated and U.S. U-2s continued to fly over the island to photograph the Russian nuclear installations. The Cuban population was rallied and armed to protect the country's factories, communications, and coasts. Kennedy raised the tone, demanding on November 15 not only the dismantling of the nuclear bases, but also the withdrawal of Russian Ilyushin 28 bombers.

The situation had reached total deadlock and the tension between the superpowers reached a peak. The missiles would be shipped back to the Soviet Union in exchange for a commitment from Kennedy not to infringe on Cuba's borders or its sovereignty. As part of the agreement that was sealed on November 20, 1961, Cuba also returned the bombers. Never before had the planet come so close to World War III.

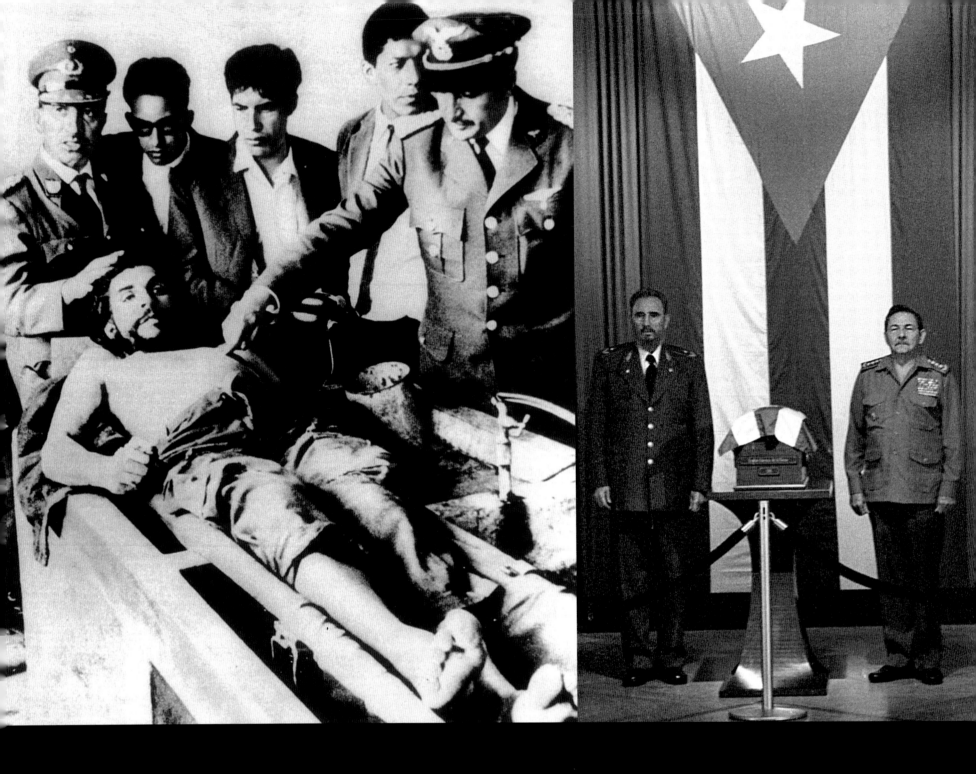

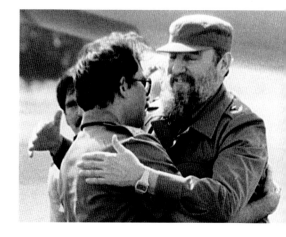

68 TOP CAPTURED ON OCTOBER 8, 1967, CHE GUEVARA WAS ASSASSINATED TWENTY-FOUR HOURS LATER ON THE ORDERS OF THE BOLIVIAN GOVERNMENT IN THE VILLAGE OF HIGUERAS (LEFT). THIRTY YEARS AFTER HIS DEATH, HIS BODY WAS RETURNED TO CUBA, WHERE FIDEL AND RAUL CASTRO POSED ALONGSIDE THE URN CONTAINING HIS ASHES (RIGHT).

68 BOTTOM IN THE FIRST CONGRESS OF THE NEW CUBAN COMMUNIST PARTY (DECEMBER 1975), A NEW CONSTITUTION WAS DRAFTED. THIS CAME INTO FORCE IN THE FOLLOWING YEAR.

69 CUBA GAVE ITS POLITICAL AND ECONOMIC SUPPORT TO THE SANDINISTA REGIME, WHICH EMERGED FROM THE REVOLUTION OF 1979. THE PHOTOGRAPH SHOWS CASTRO EMBRACING THE NICARAGUAN PRESIDENT, DANIEL ORTEGA, IN MANAGUA.

70-71 A PURE THEORETICIAN OF ARMED INSURRECTION, GUEVARA LEFT CUBA IN 1965 TO DEVOTE HIMSELF "TO THE REVOLUTIONARY MOVEMENT IN ANOTHER COUNTRY OF THE WORLD."

FROM BOLIVIA TO THE BERLIN WALL

The Cuban Communist Party was refounded in 1961. During the related ceremonies, Fidel Castro announced that Guevara had left Cuba to continue the struggle against imperialism elsewhere, in his words, "to create, two, three, many Vietnams." The next year, Che reappeared at the head of a guerrilla group in northern Bolivia. Shunned even by the Bolivian Communist Party, the guerrillas soon found themselves cornered in an impossible situation. After initial successes, Guevara was captured and killed in October 1967. A picture of his corpse laid out on a table in a hut in the Andean plateau appeared on the front pages of newspapers throughout the world. His death was perceived as a shock and marked the birth of a myth. In the 1970s, in the wake of a further wave of nationalizations and a ban on even small private shops and businesses in a bid to curb the black market, the Cuban economy was brought to its knees after the failure, in 1970, of the large *zafra* (sugarcane harvest) that had become the backbone of the nation. Faced with a stagnant economy, the government mobilized the entire nation into reaching a target of ten million tons. Although huge investments were poured into the effort and tens of thousands of volunteers offered their services, the result was a meager 8,500 tons, obtained at the cost of slowing down all the other sectors of the economy. After this failure, the government made a few timid attempts at diversifying Cuba's productive output. The first congress of the Cuban Communist Party was held in 1975 and the Poder Popular party was elected to power the next year. In those years, with Jimmy Carter in the White House, U.S.-Cuban relations became much less tense, with the opening of limited diplomatic ties and other friendly gestures. In response to a call for help by Angolan president Agostino Neto, the first of a long line of military contingents were sent to Africa. In the 1980s, the Cuban troops stationed in Angola were decisive in defending that country's lawful government that had just emerged after a struggle for independence from Portugal, as well as in protecting the fledgling African state against attempts of invasion by South Africa. At the same time, Cuban troops were also deployed in Ethiopia in a bid to assist the Menghistu regime fend off invasion by Somali troops supporting Ogaden's separatist claims. In 1979, Cuba hosted the sixth Conference of Non-Aligned Nations. By the end of the 1970s, Cuba was far ahead of the most developed Western nations in terms of education, health services, and employment rates. The 1980s heralded the tremendous changes brought about by the collapse of the Soviet Union and Communist regimes. From time to time, already-tense U.S.-Cuban relations were further exacerbated by political provocation by the Cuban exiles in Miami. In 1980, a truck forced its way through the gates of the Peruvian embassy, running over two security guards. The Cuban government reacted by announcing that it would not stop anyone trying to leave the country to seek political exile abroad. The Peruvian embassy was flooded by 10,000 Cubans. In the meantime, Castro opened the port of Mariel to a huge naval shuttle that transported 120,000 Cubans to Florida. The *Marielitos* were first welcomed by the U.S. government that later balked when it realized the huge number and rather poor "quality" of the new immigrants. In the early 1980s, Havana provided economic and political support to the Sandinista revolution in Nicaragua. In 1983, U.S. Marines invaded Granada, killing or wounding fifty Cuban physicians, technicians, and military personnel working on the construction of a new airport. Granada had opted for the Socialist path, but the U.S. intervened directly without hesitating to risk "another Cuba" in the West Indies. In 1988, Cuba negotiated an agreement between Angola and South Africa. Under the pact, South Africa agreed to withdraw all its troops from Angola and made a commitment to independence for nearby Namibia. That same year, General Ochoa, one of the heroes of the African campaigns, was found guilty of drug trafficking and executed. The Berlin Wall fell in 1989.

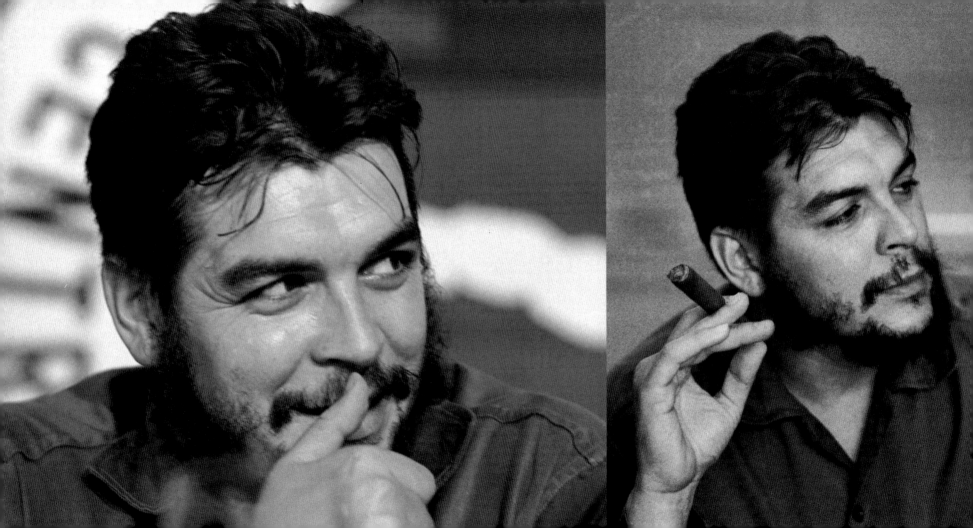

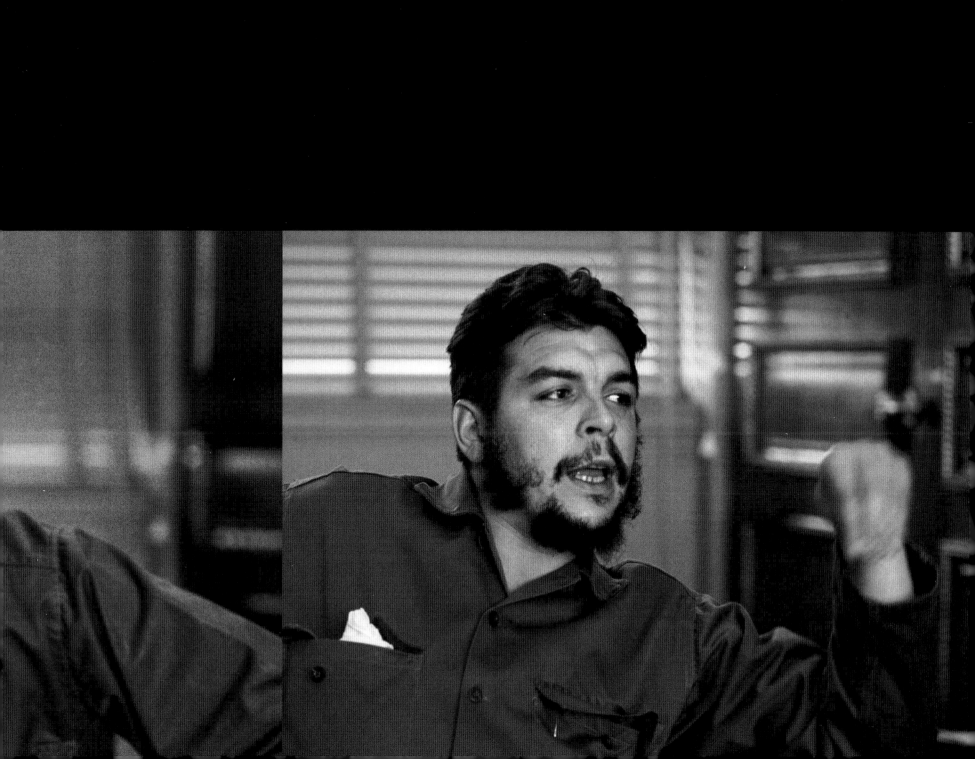

THE 1990S, THE "ESPECIAL" PERIOD, AND TOURISM

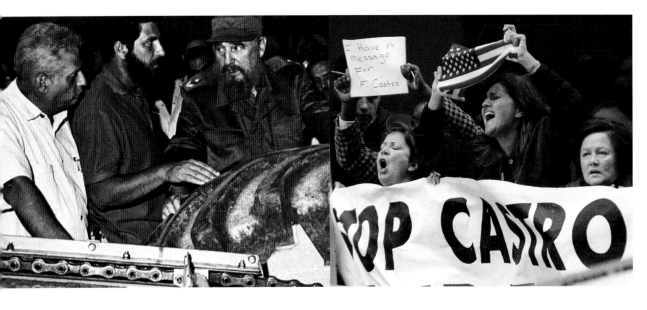

With the collapse of the Soviet Union and COMECON, which accounted for ninety percent of Cuba's foreign trade, the island's economy was plunged into a seemingly endless tunnel.

During the early 1990s long lines in front of bare-shelved shops became a common sight. The country's transportation system collapsed and hundreds of factories and offices were temporarily or permanently closed down. As food and other essential commodities, distributed under a ration-card system, became more scarce, the black market exchange rate for the U.S. dollar was pushed up to 150 Cuban pesos. In a country that once boasted one of the world's most advanced education and public health systems, it became difficult to find an aspirin, a sheet of paper to write on, or a half-gallon of milk (strictly reserved for infants). Power failures became more frequent and prolonged; as a result of its political and economic isolation, the country was literally plunged into darkness. All available resources were channeled toward the development of tourism, the only sector capable of generating the foreign exchange needed to import commodities essential for the very survival of the population and the recovery of the economy.

In 1993 and 1994 the economic crisis took on alarming proportions and in 1994, thousands of Cubans fled the island illegally, heading for Florida on improvised rafts *(balsas)*. A large number of them would never make it to the U.S. coast. On August 5, Fidel Castro had to personally take action to quell a mob protesting against worsening living conditions on the Malecón, as Havana's marina is called. The U.S. base at Guantanamo was turned into a refugee camp holding many of the exiles rescued at sea by U.S. ships. They would be admitted to the U.S. only after the U.S.-Cuban agreement in September 1994 regulating the influx of these *balseros.*

By the mid-1990s, the end of the Socialist regime seemed imminent and the anti-Castro organizations set up by Cuban exiles in Miami intensified their lobbying. These efforts were so successful that the Clinton administration ended up tightening the embargo, arrogantly imposing sanctions even on non-U.S. corporations with investments in Cuba (the Elms-Burton Act). The move came in reaction to the downing, by Cuban forces, of two light aircraft belonging to the group "Hermanos al rescate," set up by Miami-based Cuban exiles, that violated Cuban airspace and ignored all orders to return to Florida. However, despite huge economic, social, political, and day-to-day difficulties, Cuba has still managed to maintain a grasp on its dignity. Essential services such as schools and hospitals continue to run and the country's population still enjoys a minimum level of food security. Most importantly, the island has not let go of its sovereignty and still maintains full control of its destiny.

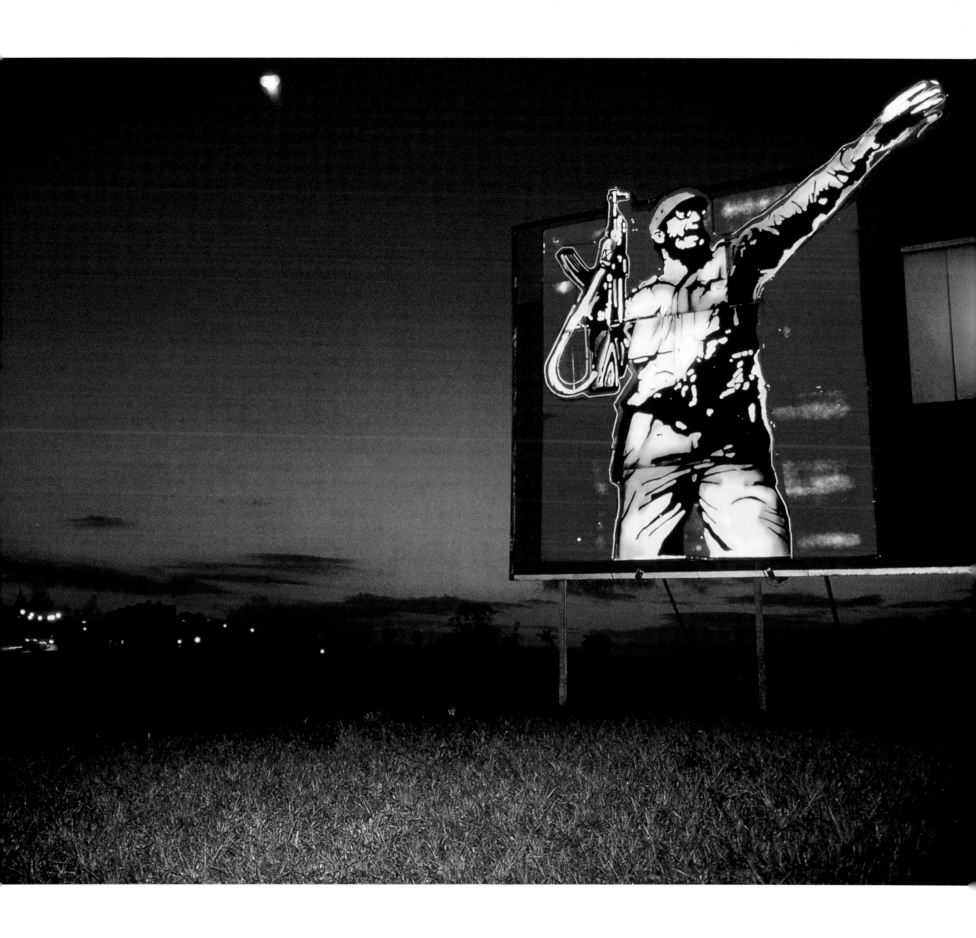

73 Banners, posters, and slogans with political and social messages fill the streets and main roads of the Cuban cities. This heroic icon of Castro lights up the night in Pinar del Río.

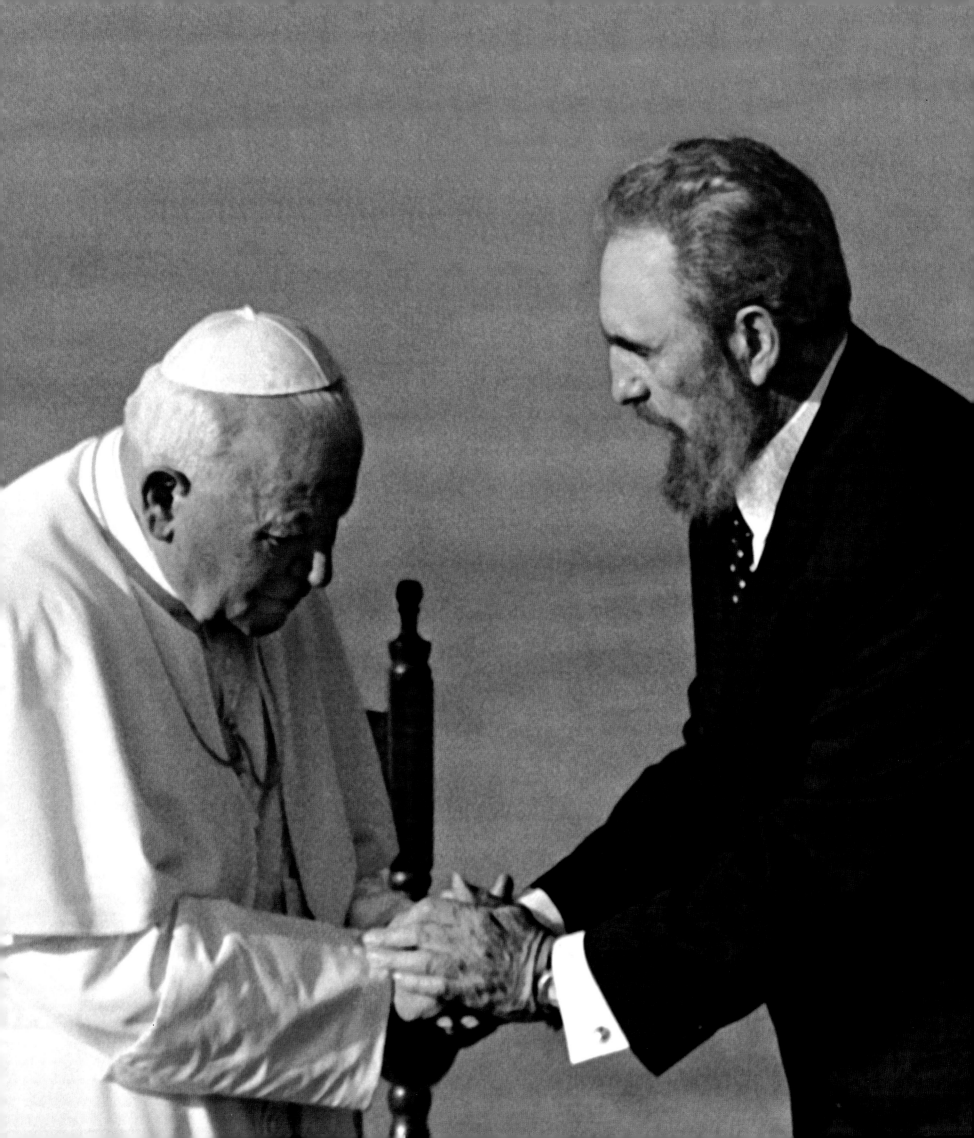

74 THE POPE'S VISIT TO CUBA WAS A MAJOR POLITICAL AND CULTURAL EVENT FOR THE CATHOLIC CHURCH, CUBA, AND LATIN AMERICA AS A WHOLE.

Meanwhile, in the summer of 1993, Cubans were allowed to legally hold foreign currency. By opening the country's doors to the millions of dollars sent from the U.S. by exiles to their families at home in Cuba, this monetary reform revitalized the economy, since most of this cash was previously excluded from the official economic circuit.

Between 1994 and 1997, parallel markets for food products and other goods were liberalized, and small private enterprises such as *paladares* (restaurants), craftsmen's workshops, taxi services, street vendors, and paid guest accommodations for tourists were gradually legalized. At the same time, the government approved reforms aimed at attracting foreign investment. Hundreds of joint ventures with European and Canadian partners mushroomed not only in the tourist industry, but also in manufacturing and in the oil, mining, sugar, and land development sectors.

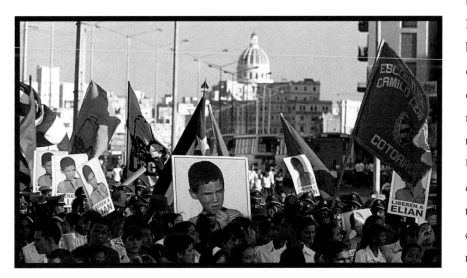

While these measures did bring economic benefits, they also led to profound social imbalances. A doorman at a fancy hotel could earn more in dollar tips than a doctor paid in pesos. Market liberalization and the booming tourist industry came hand in hand with increased corruption and prostitution, requiring repeated government intervention.

At the international level, however, Cuba started emerging from its isolation. Canada and the European Union ignored the U.S. sanctions on corporations with investments in Cuba, Fidel Castro made several official visits to Europe, and in 1996, was received by Pope John Paul II. Two years later the Pope clearly declared the Church's opposition to the U.S. trade embargo.

In November 1999, one of the precarious rafts of the *balseros* sank in the Strait of Florida. The only survivors were a couple and a seven-year-old child, Elián Gonzales, who were rescued by U.S. fishermen and taken to Miami. The child's mother died in the wreck together with her new husband. At the hospital in the U.S., Elián remembered the telephone number of his father, separated from his mother, who lived in Cárdenas. The doctors at the U.S. hospital telephoned the child's father, informing him of the situation, and he in turn called relatives living in exile in Miami to provide assistance to his son. However, the relatives, with the support of the Fundación Nacional Cubano-Americana (one of the more hard-line anti-Castro organizations in Miami), applied for and were granted custody of the child in the U.S. They then asserted that the child had no intention of returning to Cuba. This resulted in a long-drawn-out legal battle that Miami's anti-Castroists exploited fully. At the request of the child's father, Cuba took diplomatic action. By this time, little Elián had become a sort of hostage at his great-uncle's home, besieged by anti-Castroist exiles in Miami's Cuban quarter. His Cuban relatives refused to consign him into the custody of even the U.S. authorities. Fully convinced that, if allowed to leave the country, the child's father would decide not to return to Cuba, the Fundación Nacional Cubano-Americana defied the Cuban government to permit the child's father to get him from Miami. In response, Fidel sent the child's father to the U.S. together with his entire family. None of them sought asylum in the U.S. On April 24, 2000, the U.S. police were called in to forcibly recover the child from his relatives. In early May, the Court of Appeals of Atlanta reunited father and son, both of whom returned to Cuba. The story of Elián became emblematic of the complex situation between Cuba, the U.S., and the families torn between the two countries. Since 1966, under U.S. law (denounced in Cuba as the "Ley de Ajuste Cubano"), Cubans are treated differently from other illegal aliens. The moment they reach U.S. soil, they are automatically granted green cards and work permits.

75 THE ELIÁN GONZÁLES AFFAIR LED TO THE REEMERGENCE OF THE COMPLEX RELATIONSHIPS BETWEEN THE CUBANS AND THE EXILE COMMUNITY IN MIAMI.

THE YEAR 2000

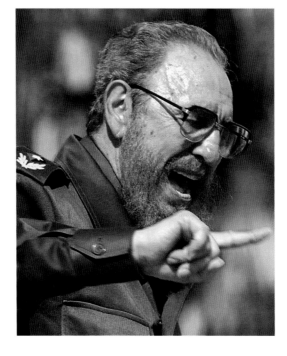

By the year 2000, together with Coca-Cola, a Cuban rhythm had become a household word the world over. Its very name suggests its multiethnic origins—*salsa* means "mixture" or "sauce" in Spanish. And Cuban musicians continue to come up with surprises. Clinton and Castro met at the U.N. to shake hands, as demanded by official protocol. Then the Cuban leader once again denounced the arrogance of the developed world that trampled over the rights of poorer nations. The exchange rate fell to twenty pesos against the dollar and every year, a million and half tourists flocked to the island. Cuba is now well on its way to recovery. Because of their architectural heritage, the historical cities of Havana, Trinidad, Baracoa, and Santiago all attract capital with the promise of rich profits in light of soaring land prices resulting from the booming tourist trade. The country concluded an important trade treaty with Venezuela for oil supplies. In early 2001, an official delegation of U.S. businessmen led by David Rockefeller visited the island. Later that year, Fidel Castro expressed his solidarity with the U.S. following the terrorist attacks against New York's World Trade Center and the Pentagon on September 11. While the emergence of a new economic and social balance is still in its infancy, Cuba can still face the future with its head high. Just a few years ago, few would have cared to bet on that.

76 BOTTOM RIGHT December, 2000: eleven years after Gorbachev, the last Soviet leader, the Russian president Vladimir Putin visits Cuba.

77 TOP An old tank is a reminder that exactly forty years have passed since the invasion attempt in the Bay of Pigs (Havana, April 19, 2001).

77 BOTTOM A photographic reconstruction shows the handshake (never photographed) between Castro and Clinton in September 2000.

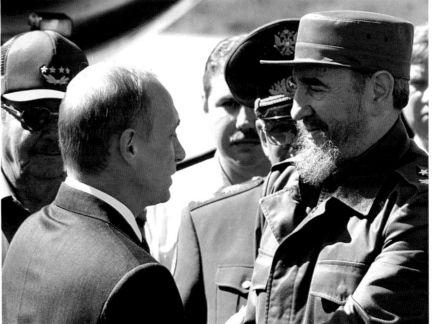

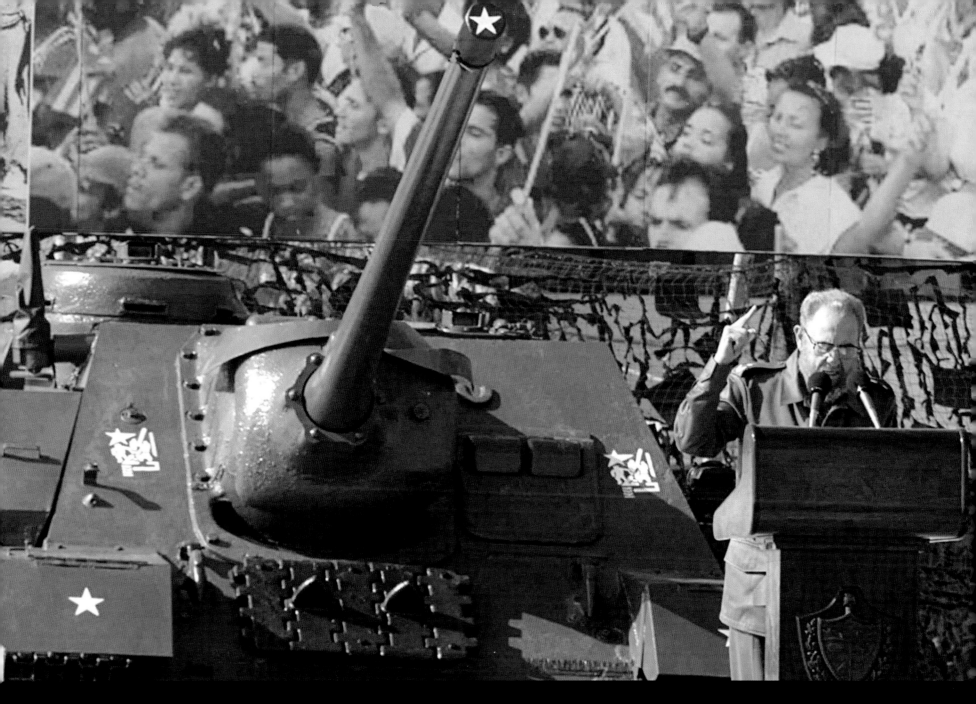

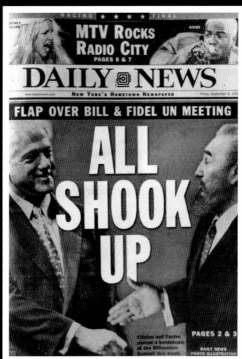

A LAND WITHOUT THORNS

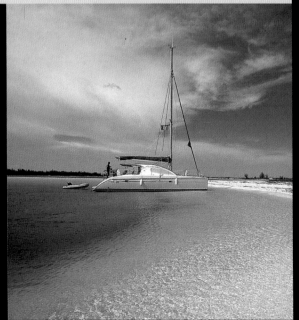
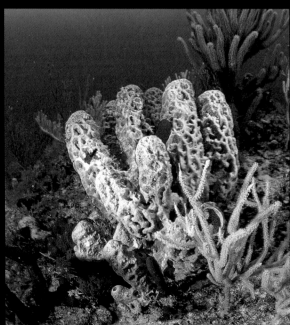

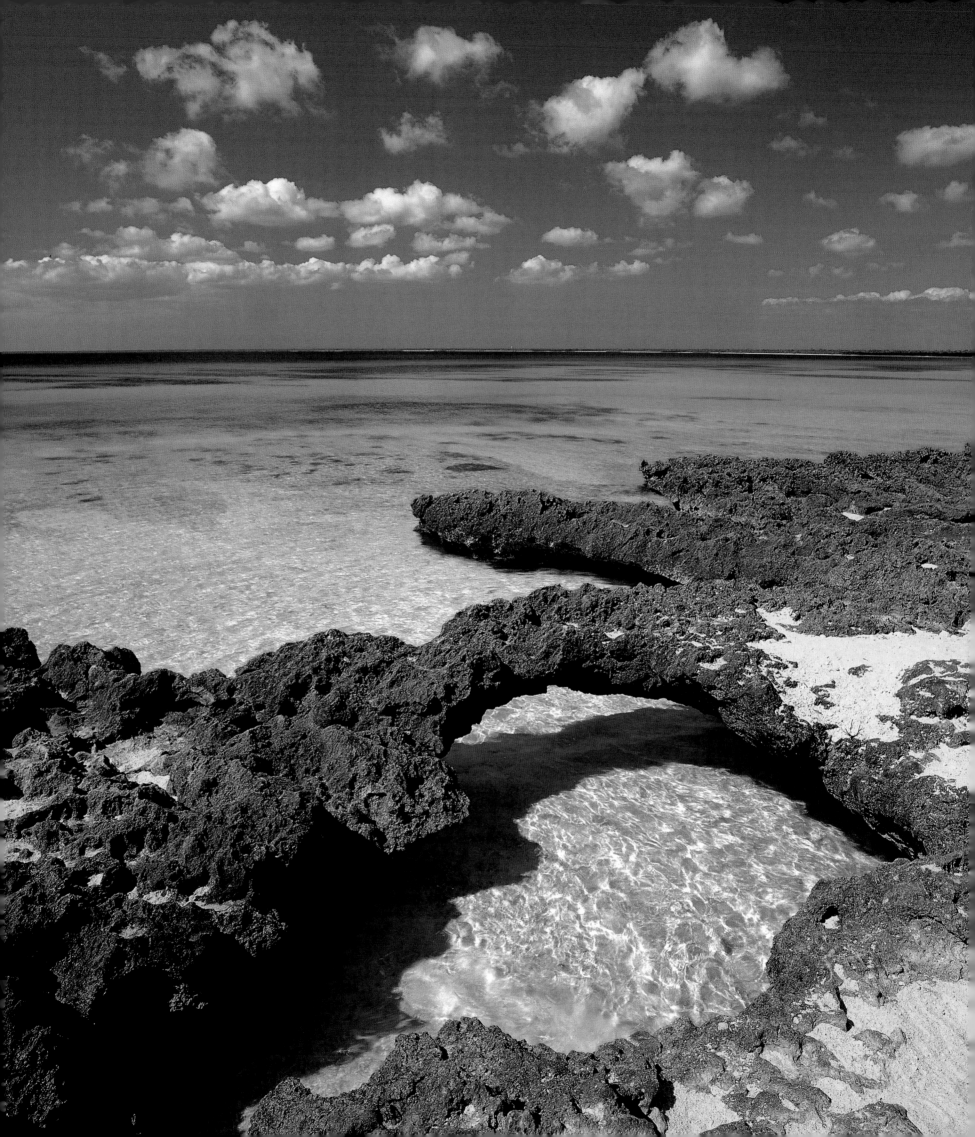

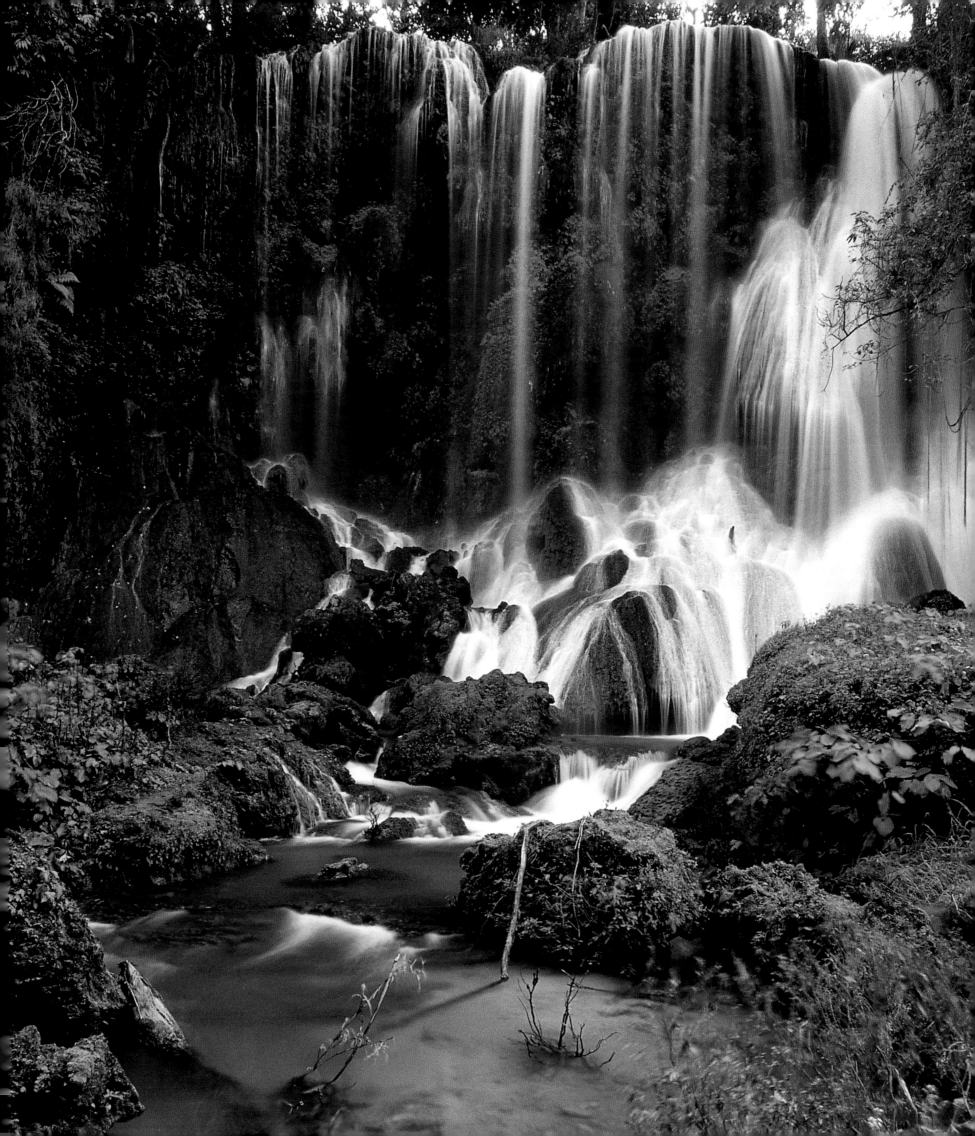

78 Land or sea? It is difficult to say which of the two is richer in life and color on this island that lies on the Tropic of Cancer.

79 The coastline in the area of Santa Maria la Gorda, in the province of Pinar del Rìo.

80 The dense vegetation of the Sierra del Escambray, which once provided refuge to Che Guevara's revolutionaries, is a peaceful Eden of waterfalls and streams.

81 LEFT A mural by Diego Rivera's students on a limestone hill *(mogote)* in the Viñales valley, inspired by the history of humanity.

81 RIGHT The flat-peaked mountain, El Junque, dominates the landscape near Guantánamo, the last and only U.S. base in Cuba.

A LAND WITHOUT THORNS

The Tropic of Cancer passes several dozen miles to the north of Havana, and in fact Cuba features not only a decisively tropical climate, landscape, and natural environment, but also a culture, customs, and a pace of life typical of the tropics.

Summers tend to be hot and winters mild, although in the past high-society women in Havana tended to emulate their counterparts in Paris and New York by wearing long furs and overcoats with fox collars at Christmas. Daytime temperatures are particularly high in the summer, but nights are cooled by refreshing sea breezes.

Even the sea is lukewarm in all seasons and it is quite common to celebrate New Year's Day between dips in the ocean.

Cuba is 777 miles long, but it features a mean width of less than thirty-seven miles, so one is never too far from the sea. Cuba is, in fact, a child of the sea.

The trade winds coming in from the Atlantic bear rain clouds that unleash their watery

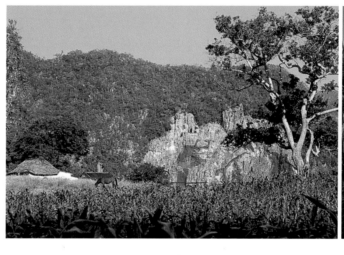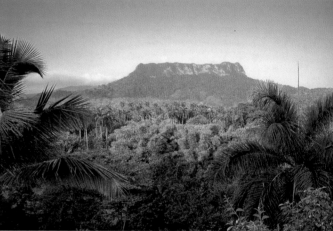

burdens over a few hours almost every day during the spring, replenishing the island's fresh water reserves and providing vital nourishment to Cuba's lush and varied vegetation. Between late August and late October the island is sometimes swept by more or less violent hurricanes that can raise waves as high as the ever-present palm trees. Cuba is also a child of the winds.

Palms are a fixed feature of the Cuban landscape—swayed by the rains or the gentle sea breezes, the island's palms seem to sing and dance. This is because Cuba is also a child of music.

The name "Cuba" actually refers to the entire Cuban Archipelago, since the Isla Grande, or Large Island of Cuba, is surrounded by over 4,000 islands and cays (locally known as *cayos*). The country covers a surface area of 42,472 square miles. The smaller islands collectively account for 1,930 square miles, half of which are concentrated in the land mass of the Isle of Youth.

The Isla Grande is an uninterrupted plain that only in the east gives way to a large, mountainous area formed by the Sierra Maestra and various other long mountain chains in the regions of Guantánamo, Baracoa, and Mayarí. Other significant high ground can be found at the western tip of the island (Sierra de Guaniguanico) and toward the center (Sierra del Escambray). Vast areas of low hills extend between Havana and Matanzas as well as between Santa Clara and Sancti Spiritu at the center of the island, and between Camagüey and Holguín, more to the west.

On the plains, the temperature fluctuates between 72°F and 79°F, rarely falling under 50°F. The warmest areas are to the east, featuring torrid, dry summers, although the temperatures become much more pleasant in the highlands. At just under 7,000 feet in height, the Pico Turquino in the Sierra Maestra (a volcanic range) is the highest peak on the island. Not far away lies the source of Cuba's longest river, the Río Cauto, that empties into the Caribbean Sea.

82 OTHERWISE PRISTINE, SOME COASTAL AND *CAYOS* AREAS (LIKE VARADERO, SHOWN AT RIGHT) ARE PARTIALLY THREATENED BY THE CONSTRUCTION OF NEW TOURIST RESORTS.

83 PURISTS BELIEVE THAT THE WATERS AROUND THE SLIM PENÌNSULA DE HICACOS, VARADERO, IN THE PROVINCE OF MATANZAS, ARE THE CLEAREST IN CUBA.

A LAND WITHOUT THORNS

The introduction of sugarcane totally transformed the original pre-Columbian landscape, often replacing dense tropical forest with monotonous, seemingly unending sugarcane plantations, interrupted occasionally by the infrastructure required for the harvesting and processing of the crops. The tropical forest that just a century ago covered more than half the island's surface accounted for less than one sixth of Cuba's landmass in 1959, although remoter areas, such as the highlands, the coastal mangroves, the warm sands of the cays, the

The rolling plains of the Isle of Youth are very similar, featuring coastal pines side by side with palms.

The Isla Grande's coastline extends for 2,300 miles (3,100 miles including the coasts of the smaller islands). The low, sandy northern coast, bordered by cays and long stretches of coral reef, emerges from the Gulf of Mexico toward the submerged table of the Bahamas, which lies several hundred feet below the surface.

On the other hand, just twenty-six miles to the west, off the southern coast, the Bartlett pit descends 23,000 feet below the surface. The southern coastline is made up of a maze of brackish water pools, mangrove forests, and canebrakes, with a few exceptions, like the Guantánamo coast, where stone quarries and high cacti combine to form a semidesert landscape with a harsh climate, or the rocky coasts at the foot of the Sierra Maestra and the Sierra del Escambray.

marshy wetlands, and the extraordinary palm forests of Baracoa have largely escaped the devastation brought on by sugarcane plantations.

Eighty percent of the island's hinterland is made up of green, rolling plains enhanced by the clean trunks of royal palms, scarlet bougainvilleas, and the flame-red hues of royal poincianas. This, at least, is the impression one gets when traveling along the Carretera Central, the country's main highway, that links Havana with all the other main cities, from Pinar del Río in the west up to Santiago de Cuba in the east. Small towns and villages dot the island except in the marshy area of Ciénaga de Zapata and on most of the cays that were largely uninhabited, at least until the development of tourism. In the countryside, especially in remoter areas, *bohíos*, wood huts thatched with palm leaves, built near cultivated fields are still common.

The cays and the sea are separated, or rather linked, by sand, mangroves, and coral reefs. On the other hand, the Isle of Youth is rockier and less sandy.

Thanks to the scarcity of human settlements along the coast and on the smaller islands, as well as the near-total absence of large industry and a rather carefully implemented environmental policy, the seabed and underwater wildlife are almost intact. While it is difficult to come up with a rigid classification, the most popular diving sites are to be found toward the west—the Isle of Youth, Cayo Largo, and Punta Gorda at Cuba's western tip. At Punta Gorda, named after the legendary María la Gorda, prisoner, friend, and lover of pirates and corsairs, divers can dip into the waters where the Caribbean Sea meets the Gulf of Mexico.

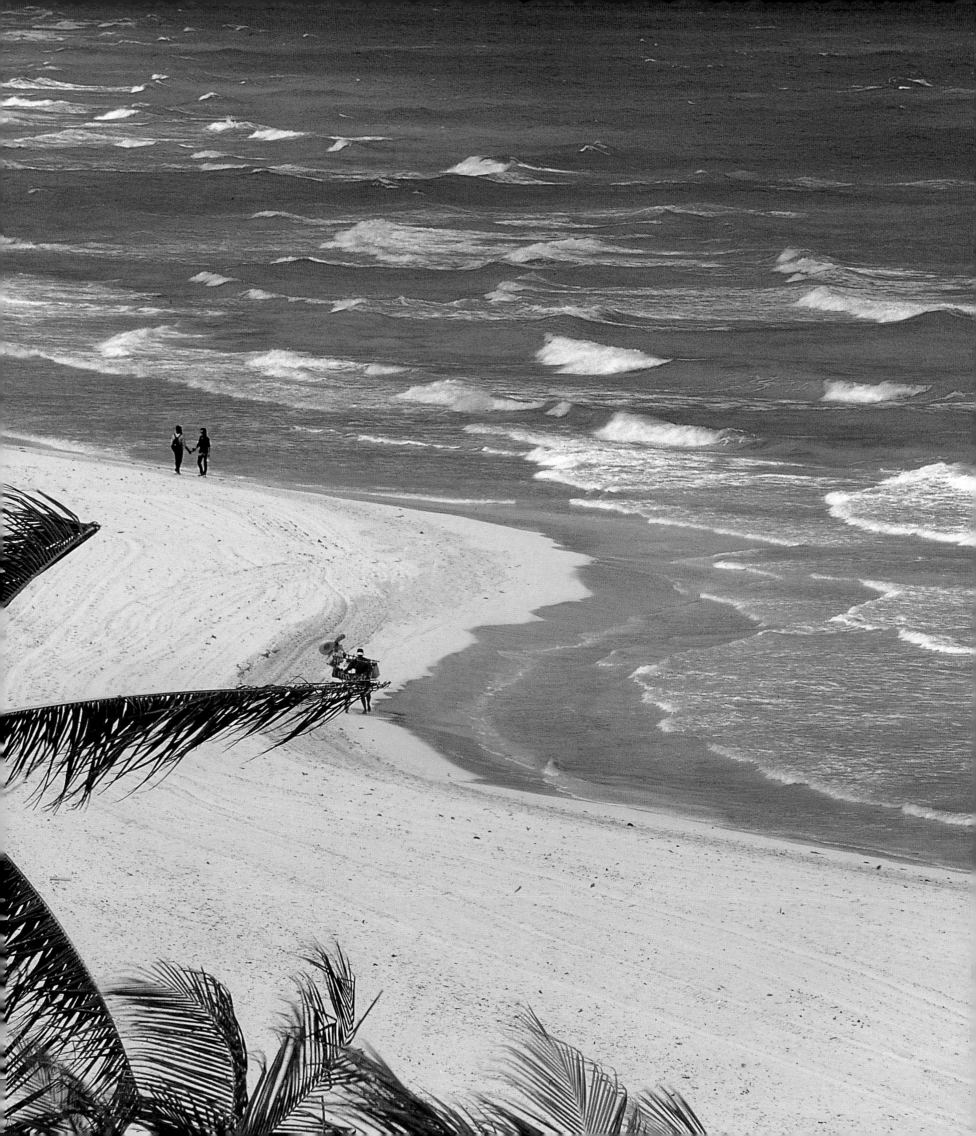

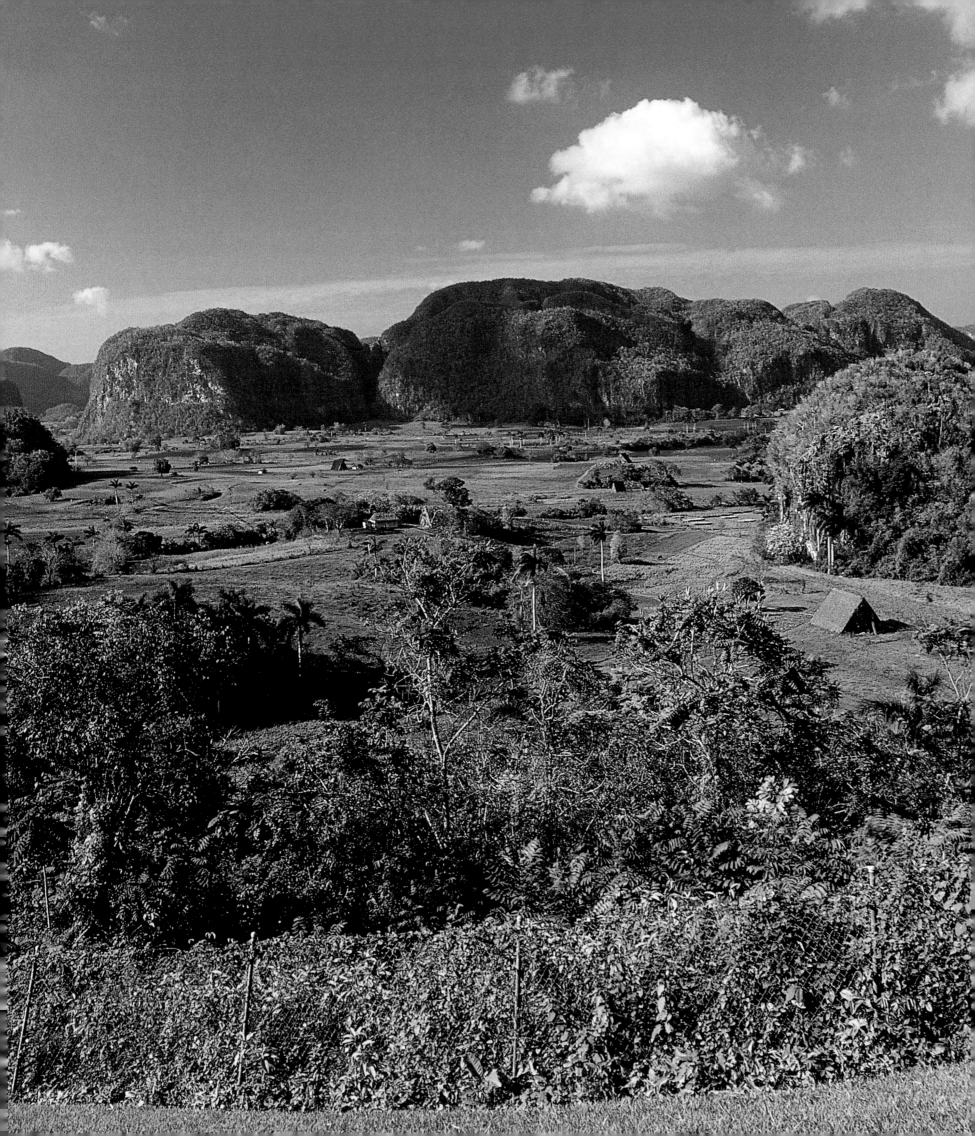

PALMS

AND SUGARCANE

In Cuba, the word "mountains" first of all refers to the Sierra Maestra mountain range that runs parallel to the southern coast west of Santiago and almost entirely covers the province. It is a rugged, wild, and intact environment with oaks and ferns as high as trees, cut by streams and mountain paths. The tropical tree coverage in the upper regions of the range lends the landscape the characteristic flavor of pine and cedar mountain forests.

It is precisely because of these features—together with its distance from the capital and the heart of political and military power—that it has historically been used as a base camp and hideaway for rebels of all stripes and colors, from black slaves fleeing the plantations to freedom fighters and the Barbudos led by Fidel Castro and Che Guevara who masterminded the revolutionary guerrilla war.

Apart from Pico Turquino, various other peaks in the central area exceed 6,000 to 7,000 feet in height, and it is this area that is now protected within one or the other of the three National Parks

established in the Sierra Maestra.

South of Santiago, a road runs up less-imposing highlands up to Gran Piedra, a large rocky mass 167 feet in length and eighty-two feet in height, that rests on a peak that towers 4,000 feet above sea level. The summit of the rock affords a wide panorama and on clear days the coasts of Haiti and Jamaica can be seen in the distance. The remains of a large number of *cafetales* (coffee plantations) lie scattered around the Gran Piedra. While the cash crop was almost totally abandoned in later years, coffee plantations—mainly owned and run by French immigrants fleeing the slave uprising on Haiti—flourished in eastern Cuba in the eighteenth century.

Apart from the small Guantanamo plain, all of Cuba lying east of the Sierra Maestra is mountainous, featuring a variety of mountain chains, including the Sierra de Cristal, the Cuchillas of Moa and Toa, and the Sierra del Purial. The highest peaks in this region reach 4,000 feet (Pico de Cristal) and are separated by the deep valleys

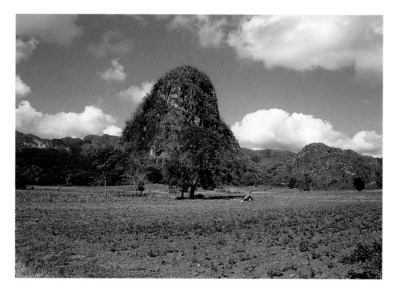

84 THE VINALES VALLEY, IN THE PROVINCE OF PINAR DEL RÍO, WAS ONCE A VAST CAVE SYSTEM. THE CEILING OF THE CAVE SYSTEM COLLAPSED, LEAVING THE PILLARS THAT ONCE HELD IT, WHICH NOW FORM THE GENTLE HILLS KNOWN LOCALLY AS MOGOTES.

85 BOTTOM A GEOLOGICAL ODDITY: A SOLITARY MOGOTE IN THE VINALES VALLEY. THIS ENCHANTED LANDSCAPE EXTENDS TO THE SIERRA DE LOS ORGANOS, CLOSE TO CUBA'S WESTERN TIP.

86 LEFT THE SIERRA DEL ESCAMBRAY, TOWARD CUBA'S NORTHERN SEABOARD, IS A PARADISE ON EARTH, FEATURING CRYSTAL-CLEAR WATERS.

86 CENTER THE PROVINCE OF MATANZAS IS RICH IN CENOTES, DEEP NATURAL WELLS FORMED BY THE COLLAPSE OF THE ROCK CEILING.

86 RIGHT THE VERY NAME OF THE RÍO MELODIOSO RESERVE PARK (SANCTI SPIRITUS) EXPRESSES THE CHARM OF THE LANDSCAPE.

87 LEFT TRINIDAD, NOW A WORLD HERITAGE SITE, HAS CONSERVED ITS COLONIAL IMPRINT.

PALMS AND SUGARCANE

cut by the large number of rivers and streams flowing toward the Atlantic. This area is still mainly intact and features a high degree of biodiversity, with a large number of endemic animal and plant species, including butterflies, birds, hummingbirds, and one of the smallest mammals in the world, the *almiquí*, an insectivore similar to the shrew. Here, the La Farola road that cuts through the mountains to link the Caribbean coast from Guantanamo to the Atlantic seaboard offers spectacular views of tropical landscapes, especially as it slopes downward to Baracoa.

If Santiago de Cuba is one of the greatest expressions of West Indian culture, the region of Baracoa is perhaps the greatest expression

are rich in cobalt, chrome, and especially nickel, one of Cuba's main exports. The depleted nickel ore colors the landscape around the mineral refineries of Moa and Nicaro with a reddish-brown hue.

The Escambray Sierra, at the center of the island in the province of Sancti Spiritus, was catapulted to international fame in the early 1960s when it was used as a base for several counterrevolutionary cells that were defeated just before they could act as reinforcements for the troops landing at the Bay of Pigs. The Escambray mountains dominate the Trinidad plain that, from a height, appears pristine green and shining against the backdrop of the Caribbean Sea. The Escambray mountains are not very high but its uninterrupted tree coverage

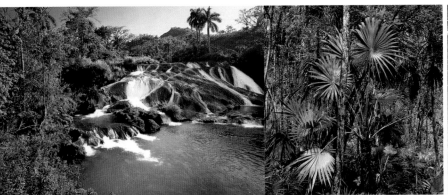

provides cooling relief from the tropical heat, so much so that various treatment spas have sprung up on the mountain slopes. The local environmental reserve park protects over a hundred native species of plants, birds, and small mammals. The third mountainous region of

of West Indian wildlife. The rain-bearing trade winds ensure that the region receives plenty of rainfall to nurture the lush vegetation that is much denser here than in other areas. Cocoa and coffee are still the main crops. Above all, Baracoa is covered by a mantle of palm trees extending in all directions as far as the eye can see, gracing the landscape with the wave-like motion of their branches in the wind. Going up the Toa, the Moa, or the Yumurí rivers, which have kept their aboriginal names and that are ideal for a refreshing swim, one enters a world of tiny villages that seem to belong to another world.

Long isolated from this rugged landscape, the small Baracoa plain is dominated by the Yunque ("anvil"), a flat-topped highland reminiscent of Table Mountain at Cape City, that rises abruptly in Humboldt National Park. The mountains facing the northern coast

the island lies in the eastern province of Pinar del Rio, which is cut from east to west by the Sierra de Guaniguanico. This mountain range is in turn divided into two parts—the Sierra del Rosario in the east and the Sierra de los Organos in the west. The first was declared a Biosphere Reserve by UNESCO in 1985. The plentiful rainfall in the Sierra del Rosario allows for dense, semitropical forest coverage. Extending about twelve miles from east to west, these mountains are the antithesis of an imposing mountain range. At their highest point, they do not exceed 2,300 feet, although this did not stop the installation of Russian missile bases in the area in 1962, famous for having inspired the rage of the U.S. and for bringing the world to the brink of nuclear war. But, Khrushchev banged his right shoe on the benches of the UN and thankfully the tension was diffused.

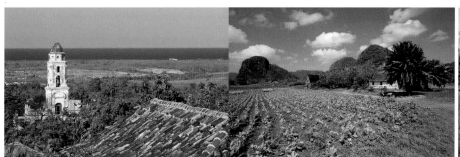

Even the Sierra de los Organos do not exceed 3,300 feet in height. As in the Sierra del Rosario, here too the landscape is speckled with rivers, waterfalls, and the ever-present orchids, providing for spectacular panoramas in the valley of Viñales, less than nineteen miles north of Pinar del Río. Viñales, another protected area, is a karstic plain covering fifty square miles, featuring a large number of elevations known as *mogotes*, just a few hundred feet high and densely covered by vegetation that complements the lush tropical landscape made up of cultivated land, palms, huts, and small ponds.

In the winter months, at dawn the peaks of the *mogotes* seem to rise from a sea of white steam. The first rays of light reveal an unreal landscape in which thick layers of clear fog gradually dissolve to expose the details of the terrain with the studied slowness of a suspense film.

Southwest of Pinar del Río lies one of the treasures of Cuba, the small region of Vuelta Abajo. Here a particularly favorable microclimate combines with the natural richness of the soil and the age-old wisdom of the local *campesinos* to produce the most highly prized tobacco in the world. The plain is monotonous and the tobacco plantations that surround the large drying sheds alternate with small rural centers devoid of interest for the tourist, although the plantations around the villages of San Luís and San Juan y Martínez produce most of the world's *tabaco da capa*, the most precious variety, the aromatic and perfect leaves of which are wound around raw cigars to lend them their characteristic shape.

From the Vuelta Abajo region and the southern extremities of the Sierra de los Organos to the Río Cauto river basin almost at the other end of the island lies a large plain featuring wide wavy topography interrupted by the silhouettes of tall royal palms. The plain extends 435 miles from east to west, only occasionally interrupted by more spontaneous and wild terrain. The plain, especially between Matanzas and Holguín, is almost entirely devoted to sugar plantations, with large *centrales azucareras* (sugar refineries) and wide expanses of single-crop plantations that is now difficult to reconvert after centuries of sugar cultivation. One need only consider that in ten of thirteen provinces (Pinar del Río, Bayamo, and Guantanamo are the exceptions) sugarcane accounts for nearly forty percent of agricultural land, and in five of these provinces the figure exceeds fifty percent. The strange smell that foreigners cannot miss upon reaching the island is not a mere illusion. As anyone who has tasted rum knows, it is the penetrating scent of sugarcane pressed in mechanical crushers at the plantations. Molasses is not sold in souvenir shops, although it is the island's most widespread product.

The fascinating Valle de los Ingenios behind Trinidad is a particularly explicit example of how sugarcane can transform the landscape. In a relatively small area (a few dozen square miles) lie the remains of about one hundred *ingenios azucareros* (sugar mills) that are now abandoned.

Sugarcane was introduced in the 1500s from the Canaries or perhaps the North Pacific and soon became a permanent feature of the island. The ever-present palms, however, have always been part of Cuba's vegetation and come in a hundred varieties of all shapes and sizes, eighty of which are native to the island.

An important exception in Cuba's agricultural landscape is the Camagüey region where the main highway, the Carretera Central, cuts through the largest cattle farms on the island. Cattle rearing is essential to ensure Cuba's food security.

Rural landscapes are ever present in the form of family plantations or crops, with small, sunny towns and villages surrounded by banana, mango, and papaya trees.

The pastoral atmosphere is occasionally interrupted by the main road network that links cities and tourist destinations, and which, after the country's economic and energy crisis in the 1990s, have once again become overcrowded with trucks and vans (for goods and passengers), buses, cars of all kinds and ages, bicycles, pedestrians, and even peasants on horseback.

88 TOP Land of plenty? The climate that sustains the plantations and orchards that cloak the gentle slopes of the Vinales Valley also nurtures wild vegetation that is impressive in terms of age and size.

88 BOTTOM The Valle de los Ingenios is named after the large number of sugar refineries, locally known as "ingenios," that dotted the region until the end of the nineteenth century.

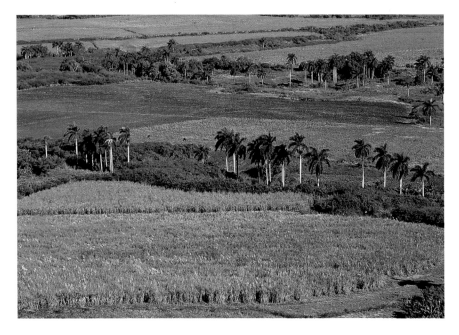

88-89 The wars of independence resulted in the abandonment of the sugar refineries in the Valle de Ingenios, where the remains of some of them can still be visited today.

90-91 El Mural de la Prehistoria, in the province of Pinar del Río, presents a rather curious socialist interpretation of evolution.

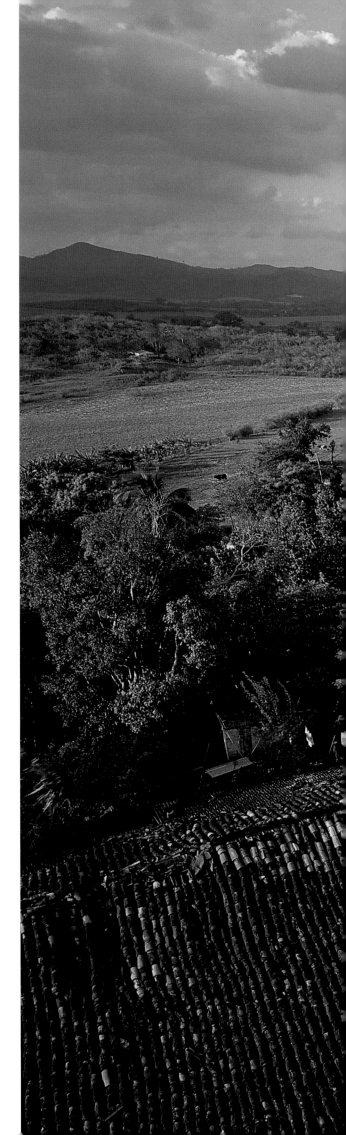

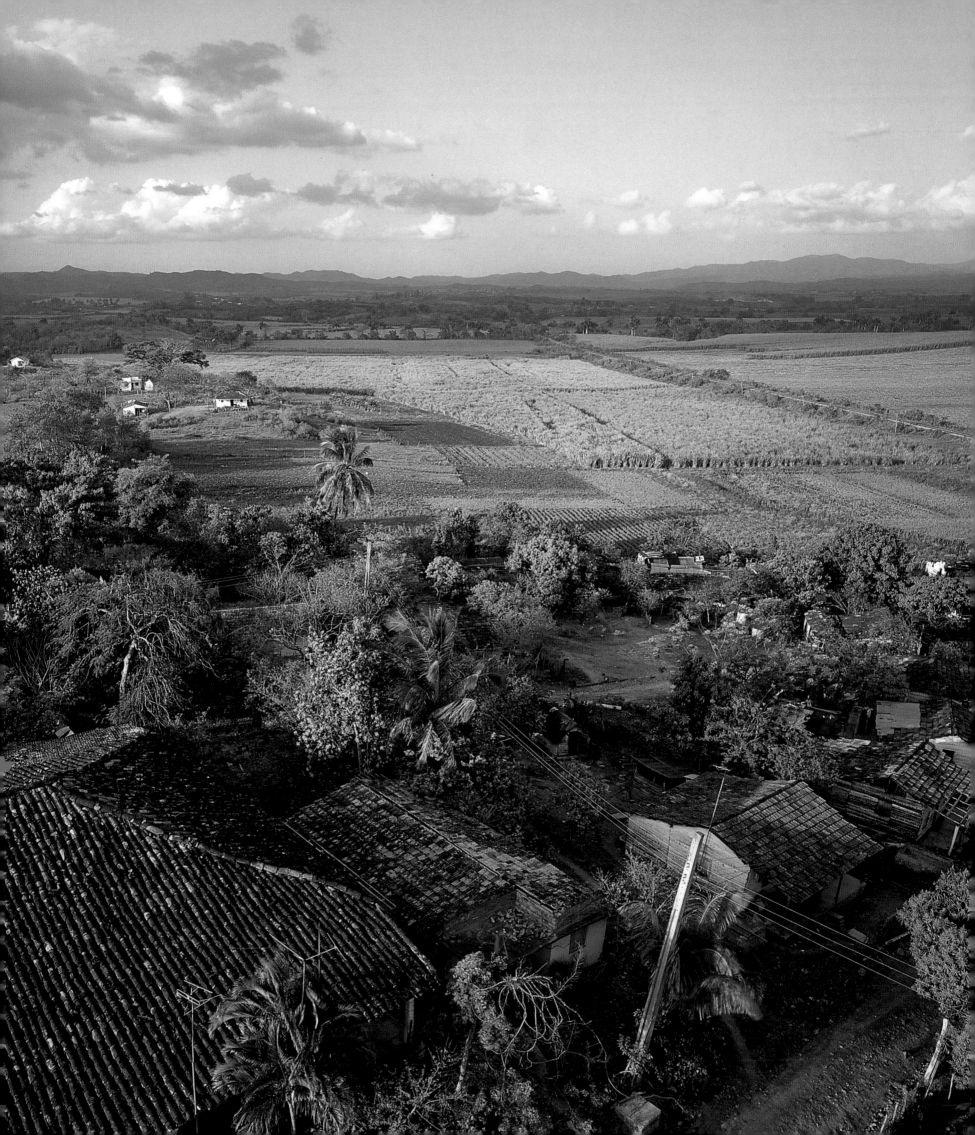

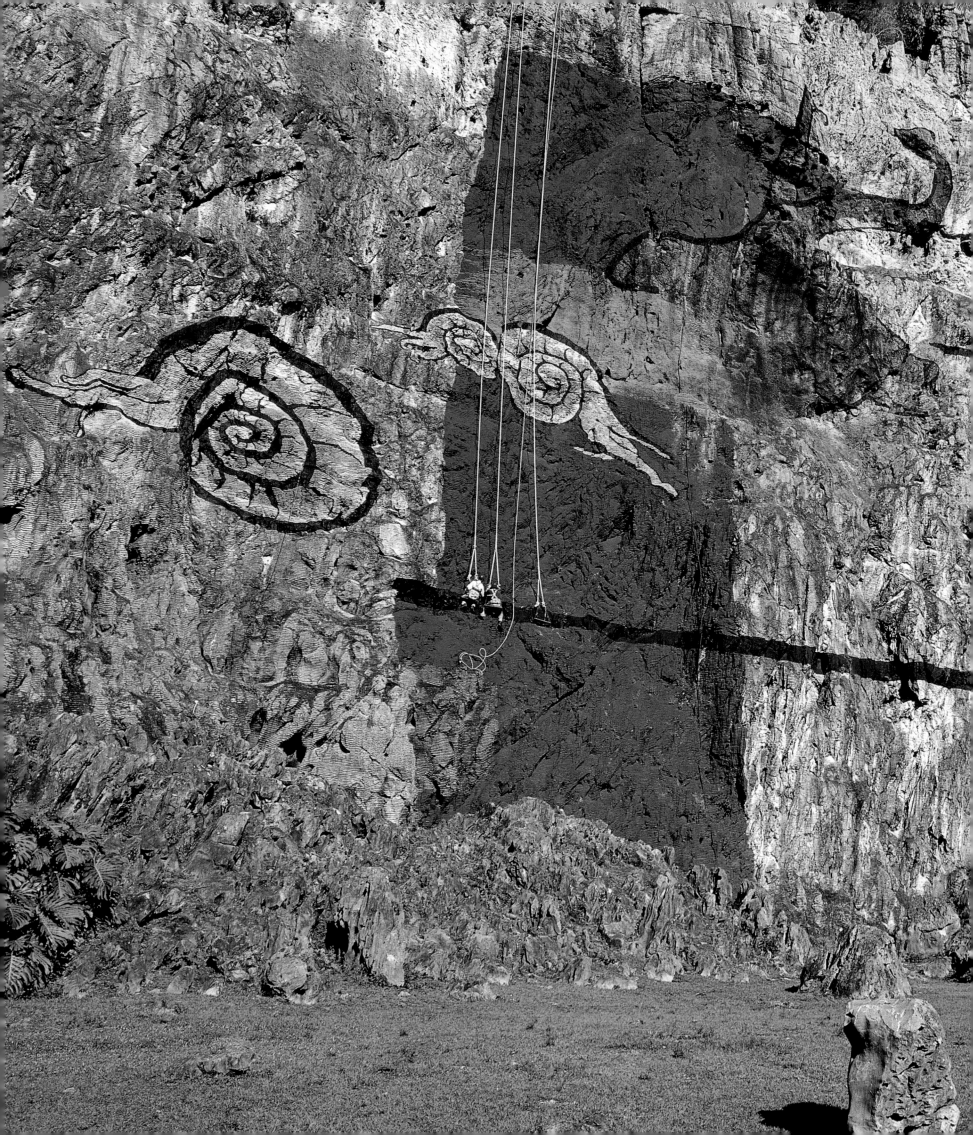

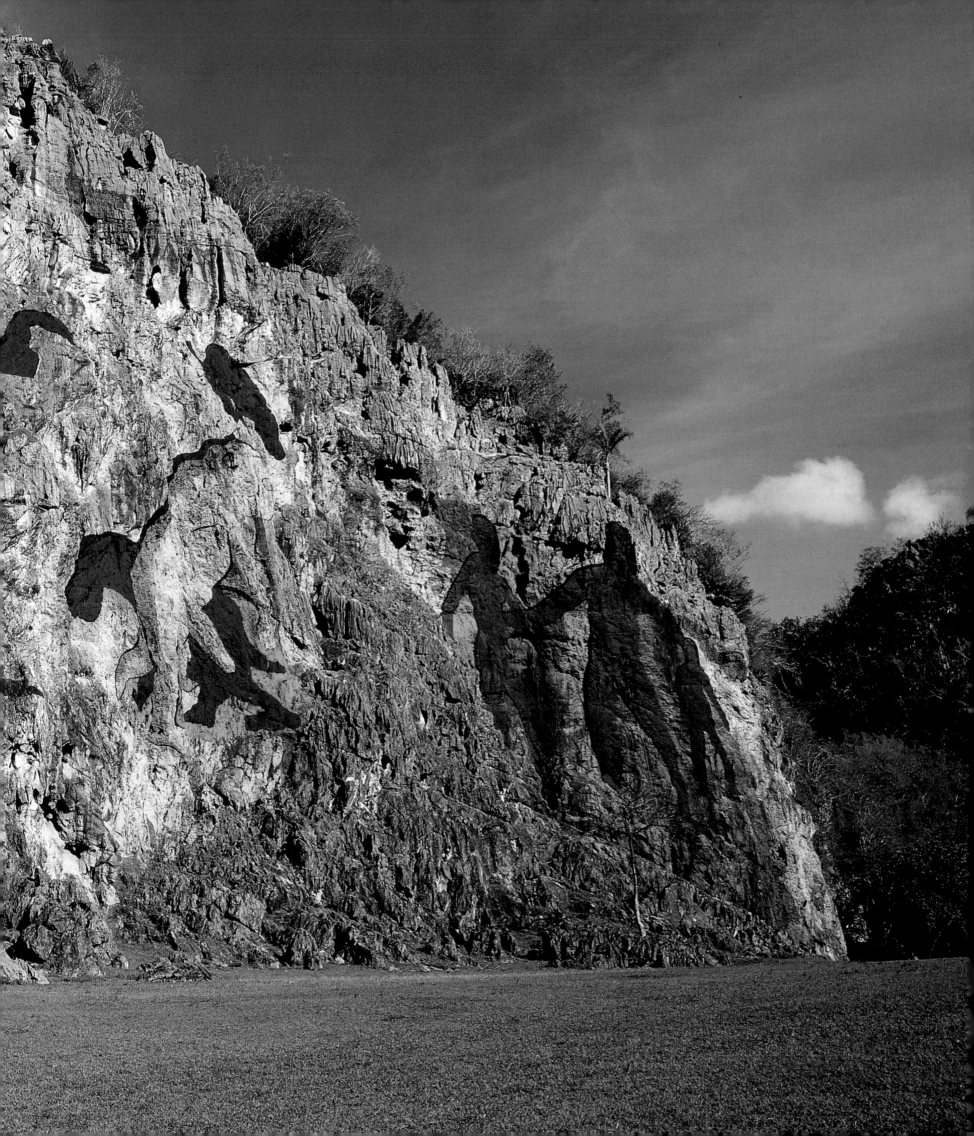

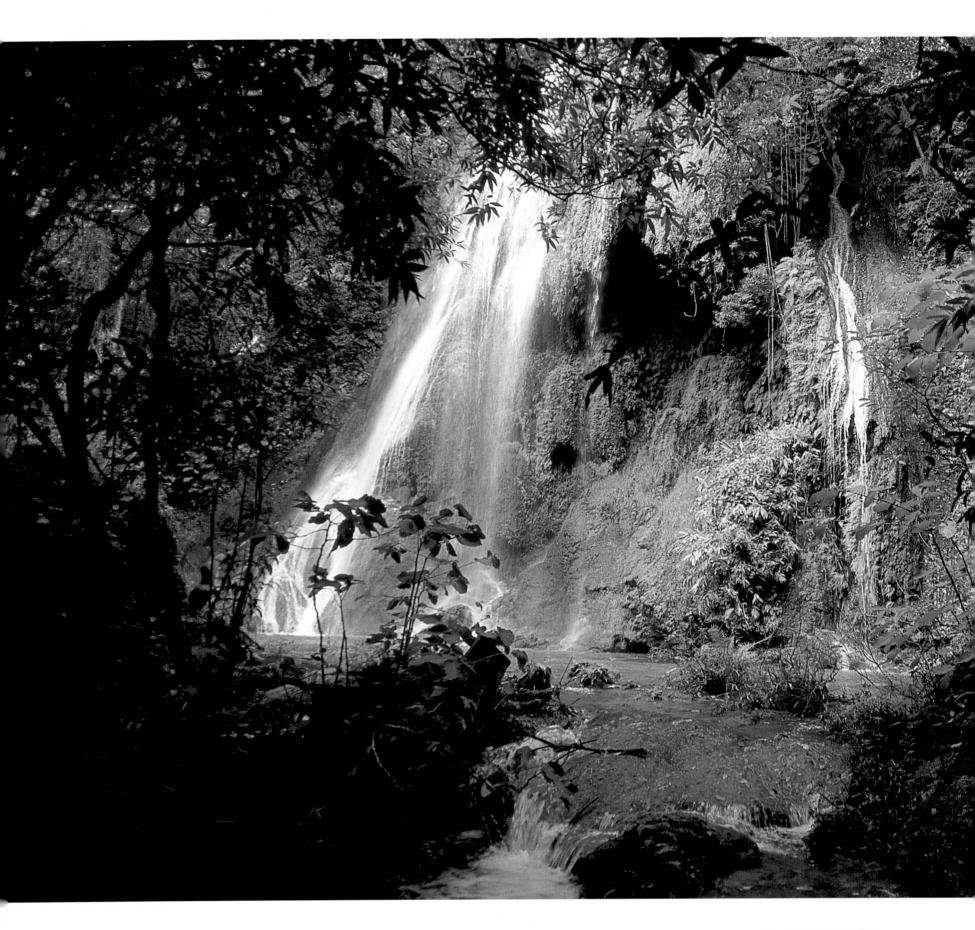

92-93 CUBA'S SUBTROPICAL CLIMATE PROMOTES PLANT BIODIVERSITY: LOW-ALTITUDE TROPICAL FORESTS (THE PICTURE SHOWS MEAN ALTITUDE VEGETATION IN THE PROVINCE OF SANCTI SPIRITUS) ARE SUCCEEDED BY RAIN FORESTS AT ALTITUDES OF 1,600 TO 4,920 FEET. AT THE SAME TIME, VAST CONIFER FORESTS ARE QUITE COMMON.

93 THE SLENDER TRUNKS OF ROYAL PALMS THAT COMMONLY GROW UP TO SIXTY-TWO FEET IN HEIGHT SWAY AMONG THE UNCOUNTABLE SHORES AND LAKES OF THE SIERRA DE ESCAMBRAY. THE MAJESTIC ROYAL PALM IS ALSO INCORPORATED IN THE CUBAN NATIONAL FLAG AS A SYMBOL OF STRENGTH. THE ISLAND'S WILD VEGETATION RANGES FROM THE MANGROVES THAT COVER THE LOW WETLANDS ALONG THE COASTLINE, THROUGH TO HUGE TROPICAL FOREST TREES, SUCH AS VARIOUS SPECIES OF FICUS AND THE VERY TALL HARDWOOD KAPOK.

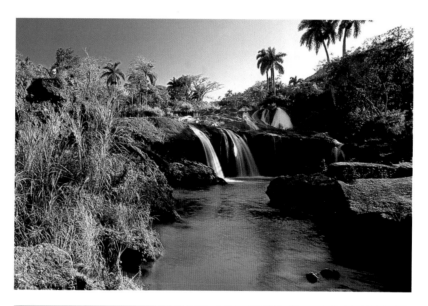

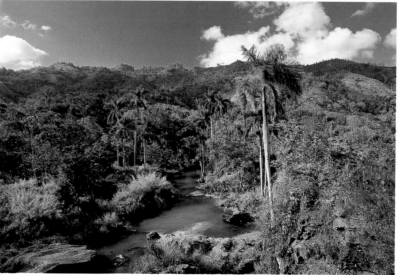

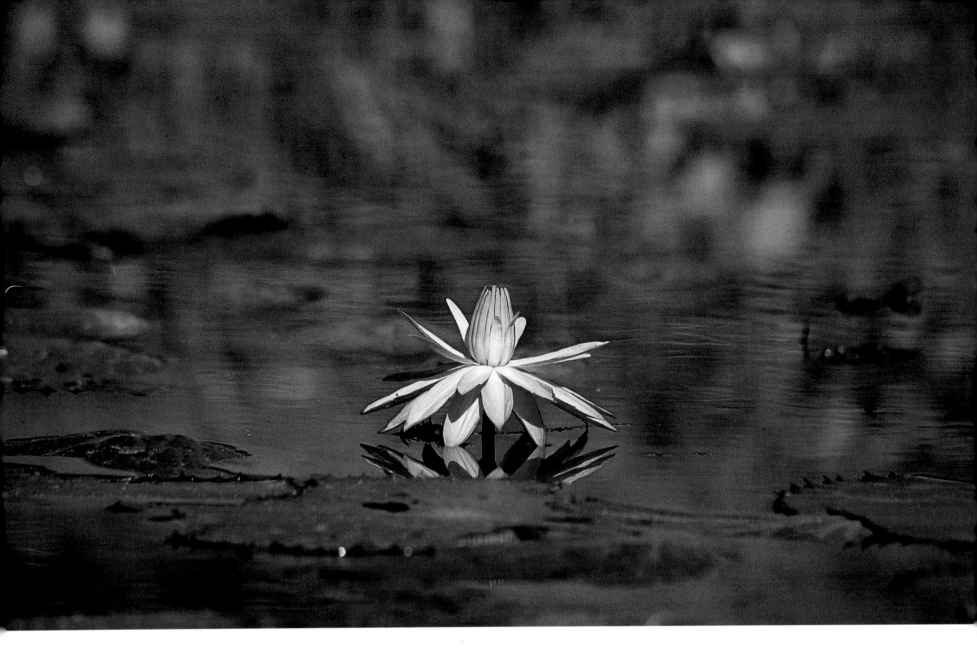

94 **TOP AND** 95 In Cuba, nature expresses itself in a variety of forms, from the delicate to the exuberant, but always brimming with mysterious charm.

94 **BOTTOM** From turtles to iguanas, reptiles are a major feature of Cuba's wildlife. At Ciénaga de Zapata (Pinar del Río) a certain local species of crocodile was saved from extinction thanks to a supervised breeding plan.

96 **AND** 97 The province of Villa Clara extends from the northern coast of Cuba up to the eastern slopes of the Sierra de Escambray. This mostly flat area is ideal for agriculture and features vast sugarcane and tobacco plantations, as well as cattle ranches that make use of the open foothill pastures to the south.

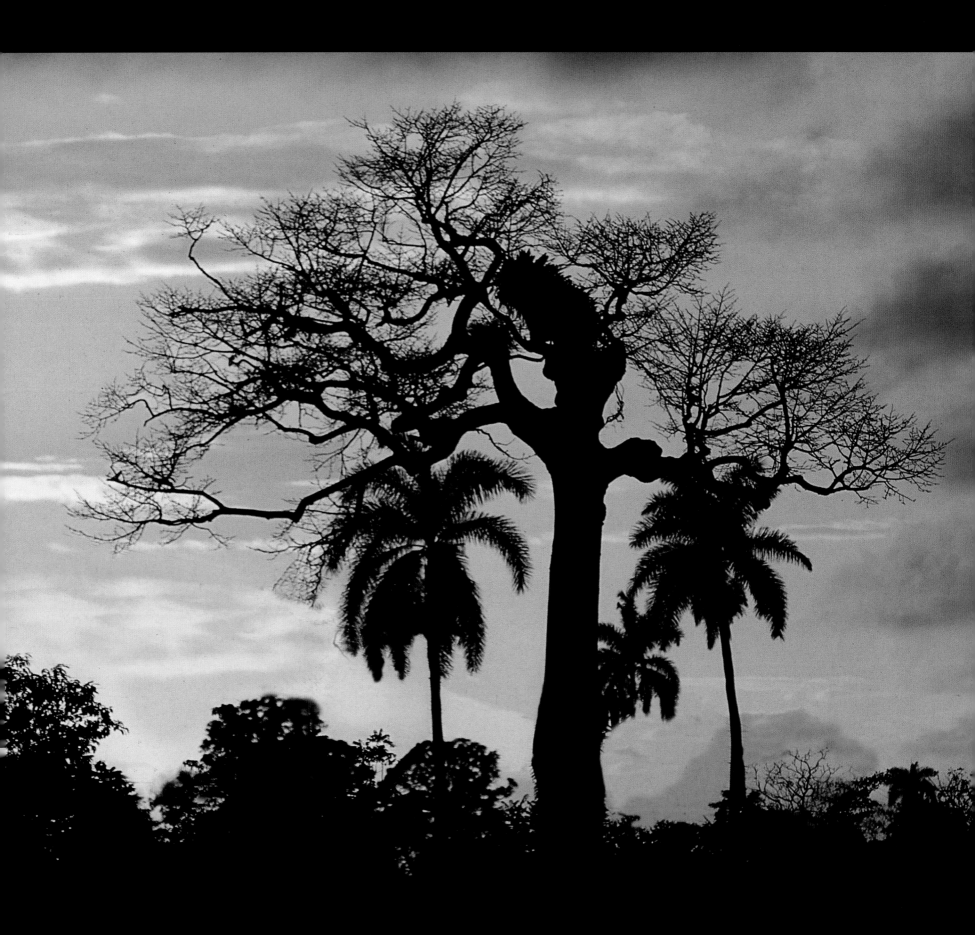

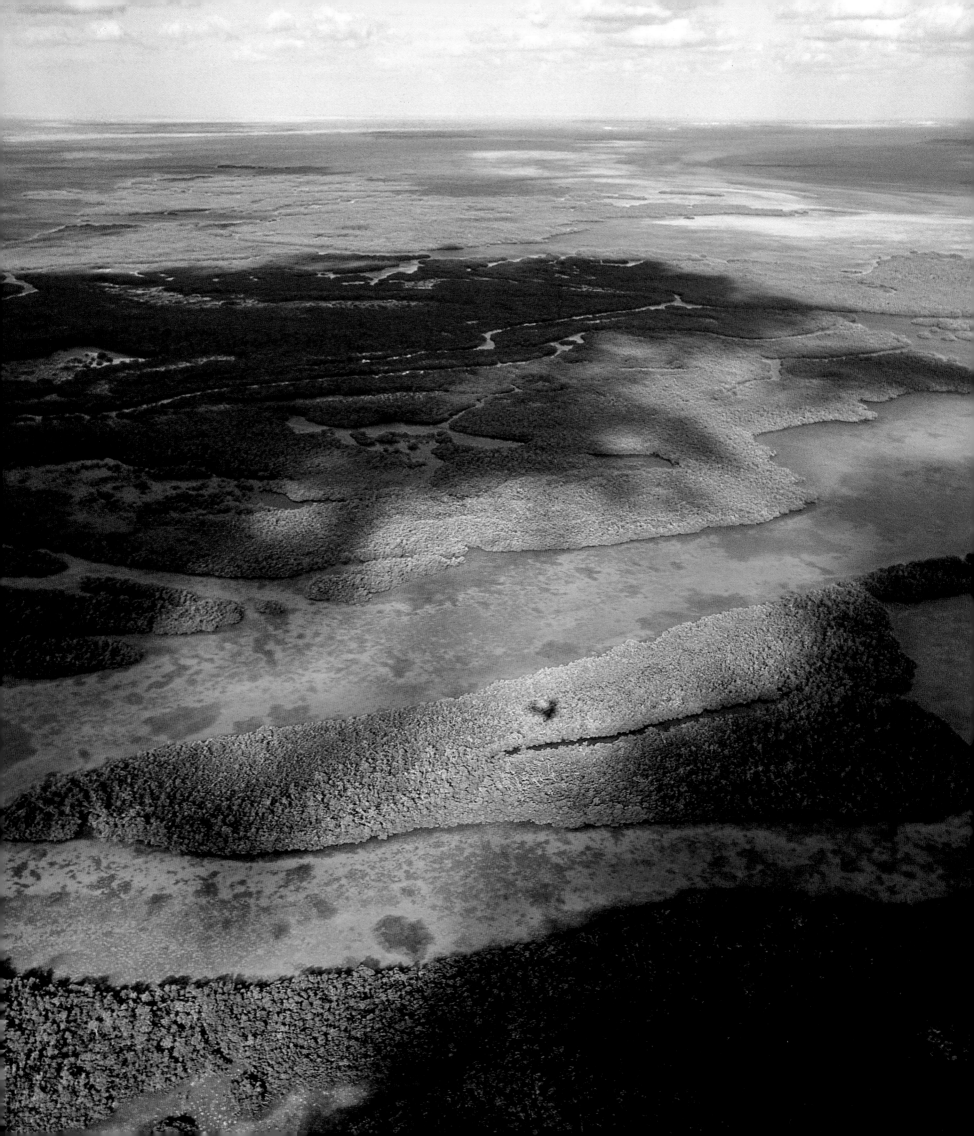

ON THE THRESHOLD
OF PARADISE

The coastline of the Isla Grande, which extends several thousand miles, is made up of long stretches of sandy beaches, interrupted by marshy wetlands and brackish water lagoons, while rocky coastlines are confined to the region of Baracoa, at the foot of the Sierra Maestra and on the Guanahabibes Peninsula at the westernmost tip of the island. The largest beaches are to the north, on the Gulf of Mexico, or protected by the cays and a coral reef that runs for nearly 250 feet off the coast, along the Bahamas Channel. The beaches of the cays are interrupted by long stretches of mangroves, rooted in salt water, cutting off access to large areas of coastline. The flat cays lie inside the reef, so that even here the sea is calm and safe.

The beaches closest to Havana are the Playas del Este, which in the summer are crowded with Havanans in search of respite from the heat.

The thin finger of land that extends from the coast about fifty miles to the east, marking the limit between the Gulf of Mexico and the Bahamas Channel, is the Hicacos Peninsula that houses Varadero, Cuba's most famous seaside resort since a certain

Mr. Dupont built a tropical villa that he baptized Xanadù in the area. The northern coast of the Hicacos Peninsula is made up of the uninterrupted beaches to which Varadero owes its fame. The beaches of very fine, pinkish sand, derived from coral, sweep toward the crystal-clear waters that are lukewarm throughout the year.

To the east of Varadero lies the archipelago of Sabana-Camagüey, made up of over 200 miles of cays of various sizes, protected by a reef teeming with underwater life and interrupted by just a few navigable passes. The mostly uninhabited cays are home to iguanas, crabs, and in the humid seasons, mosquitoes. Some of the cays are currently being transformed into tourist havens, such as Cayo Santa María, Cayo Coco, and Cayo Guillermo—the last two are linked to the Morón by an artificial causeway that cuts through lagoons populated by colonies of flamingos. Cayo Coco, one of the largest cays in the archipelago, features dense vegetation and plenty of sweet water.

Between Cayo Guillermo and Cayo Santa María lies the national park of the same name, set up to protect the wildlife and

100 LEFT Cayo Largo, east of the Isle of Youth, is a popular diving site.

100 CENTER At Playa Ancón, just southeast of Trinidad, turtles are quite common.

100 RIGHT The Atlantic wind lashes a beach at Cayo Coco.

natural habitat of the *cayos* and the seabed. This area is home to a large colony of manatees. Cayo Romano is also linked to the coast by a causeway. The cay is populated by wild animals apparently brought to the island by a shipwrecked Spanish galleon that was transporting the livestock to Cuba. Cayo Sabinal, the easternmost cay in the Camagüey archipelago, features numerous beaches interrupted by mangroves. Uninhabited and wild like Cayo Romano, it sustains hardwood forests thanks to its abundant supply of sweet water. Gazelles and antelopes are common on Cayo Sabinal.

A very narrow stretch of sea separates Cayo Sabinal from Playa Santa Lucia, on the northern coast of the province of Camagüey.

mountains empty into the sea, cutting across beaches that are different from the sands of Varadero and the cays, but equally spectacular. The colors and the atmosphere are not the same; there is not a protective coral reef off the coast, and the waves are really waves.

A little further along, Cuba ends in twenty-seven coral terraces that fall off into the deep at Punta Maisí. The highest point practically coincides with the coast. This imposing, exceptional landscape has recently been declared a protected area. An equally imposing coral terrace adorns Cabo Cruz, on the southern coast toward Manzanillo. This area has also been converted into a national park, designed to protect sea life and the low coastal forest.

The Río Cauto empties into the Gulf of Guacanayabo, closed to the south by Cabo Cruz. The river's estuary is marshy wetland that is home to numerous species of birds, flamingo colonies, and caimans. From here up to the island's western tip, the

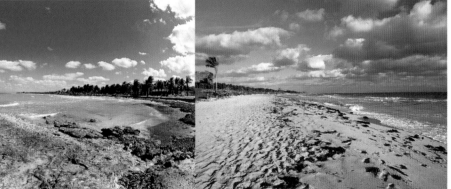

Twelve miles of very wide beaches, almost in a perfect straight line, are well protected by the nearby coral reef.

Other beaches lead to Guardalavaca, in the province of Holguín. The local beach, delightfully arched on the bay, features a wide band of vegetation made up of uva caleta trees. This is the coastline that Columbus and his sailors first spotted in October 1492. Cayo Bariay, their landing point, lies just about twelve miles from Guardalavaca. The Bahía de Nipe to the southwest is protected from the open sea by a rather special island. Cayo Saetía, in fact, has a rugged profile and is covered by stretches of savanna that lend it a typically African flavor, enhanced by the presence of zebras, buffaloes, gazelles, and ostriches brought here from Angola and Mozambique.

In the Baracoa region, the waters flowing down from the

northern coast of Cuba is mainly made up of swamps, lagoons, and coastal pools. Of the few beaches in the area, the most well-known lie along the Trinidad coast.

The marshy environment reaches its zenith in the inhospitable Ciénaga de Zapata, a squat peninsula south of Matanzas, that became the theater for the famous botched U.S. invasion of Cuba at the Bahía de los Cochinos (Bay of Pigs). Cuba's largest natural lake lies at Guamá, wedged between the vegetation and the swamps of the Ciénaga, close to a large crocodile farm that raises the descendants of the alligators that once reigned supreme over all the coastal wetlands. Besides harboring numerous species of reptiles and manatees, the wetlands are frequented by various types of migrating birds and are also home to permanent colonies of birds, including several native

species such the ferminia, a long-tailed wren with a hearty song. It is no surprise that these swamps are also the reign of millions of mosquitoes that are permanent inhabitants of the area. Periodically flooded by overflowing rivers and incoming tides, the mangrove forests that cover the Ciénaga, making the area the most significant wetland habitat of the Caribbean, are protected under what is now Cuba's largest wildlife sanctuary (270 square miles). In general, the cays of the Caribbean Sea are further offshore and smaller than those to the north. To the south, the island platform extends dozens of miles into the sea, covered by just a few feet of crystal-clear water. The cays emerge at the farthest reaches of the underwater platform, just before the coral reefs that protect them from the open sea.

There are two large archipelagos—the Jardines de la Reina and the Canarreos. The first, extending between twenty and sixty-five miles off the coasts of Ciego de Avila and Camagüey and made up of small cays, is almost totally devoid of sweet water and is completely undeveloped. These cays are the undisputed territory of iguanas, mosquitoes, frigate birds, and other avian species. The Jardines de la Reina are accessible by boat from Júcaro following a route that can sometimes be rather perilous because of the shallows and coral shoals.

The Canarreos archipelago, on the other hand, extends to the southwest of the Isla Grande. The most famous island of this archipelago is Cayo Largo, which in the last twenty years has become an absolute must for tourists in search of the ideal Caribbean getaway.

The Canarreos were originally inhabited by indigenous fishermen, who disappeared with the onset of the Spanish conquest. They then remained uninhabited for four centuries until the arrival of modern-day tourists. While lobsters and crabs abound in these waters as in the other archipelagos around Cuba, the Canarreos archipelago is famous for its sponges that are exported worldwide. The splendid seabed is teeming with underwater life, and in the morning hours at Cayo Largo it is not difficult to swim side by side with the rays that glide majestically through the water just a few feet from the shore.

The most famous diving sites lie at Cabo Francés, an arched peninsula on the western coast of the Isle of Youth. The southern side falls off in a steep embankment, alternated by underwater balconies covered with coral and frequented by carangidi and barracudas. The gentle current ensures that the plankton-rich water is crystal clear, allowing sunlight to penetrate deep below the surface. Because of the excellent underwater visibility, the abundance of marine life, uniform temperatures, and its multicolored reefs, the area is a paradise for all diving enthusiasts.

The Isle of Youth, Cuba's second-largest archipelago, lies next to the Canarreos. Once known as the Isle of Pines because of its dense pine canopy, it was heavily deforested to supply wood for the ships of the Spanish fleet and the hundreds of pirate vessels that plagued these waters. Today, the island is an international student center, inhabited by a varied community of young people mainly from around the developing world.

Off the northern coast of the province of Pinar del Río lie the tiny Colorados islands. Just beyond the reef, which is so close to the islands that one can swim to it, flows the strong Gulf Stream. The Yucatán, and to the east, the Cuban peninsula of Guanahacabibes, separate the Caribbean Sea from the Gulf of Mexico. Unfit for cultivation, devoid of roads and land routes, surrounded by waters crowded with wrecks, the region of Guanahacabibes, having seen its indigenous inhabitants as well as pirates come and go over the centuries, is now very sparsely populated. The wildest part is the fingerlike peninsula of the same name, which points toward Mexico. A thirty-four-mile-long road leads up to Cabo San Antonio, the westernmost tip of Cuba. Protected since the 1960s, the area was declared a UNESCO Biosphere in 1985. The low virgin forest is home to mammals, birds, and reptiles. The southern coast is mostly rocky, with imposing cliffs interrupted by short stretches of beach. Rain is scarce, and the sun seems hotter than elsewhere in Cuba, so much so that someone is thinking of setting up a megaresort in the area. One can only pray that the soul of Captain Morgan, the pirate who passed through the area many times, still watches over and protects beautiful Guanahacabibes.

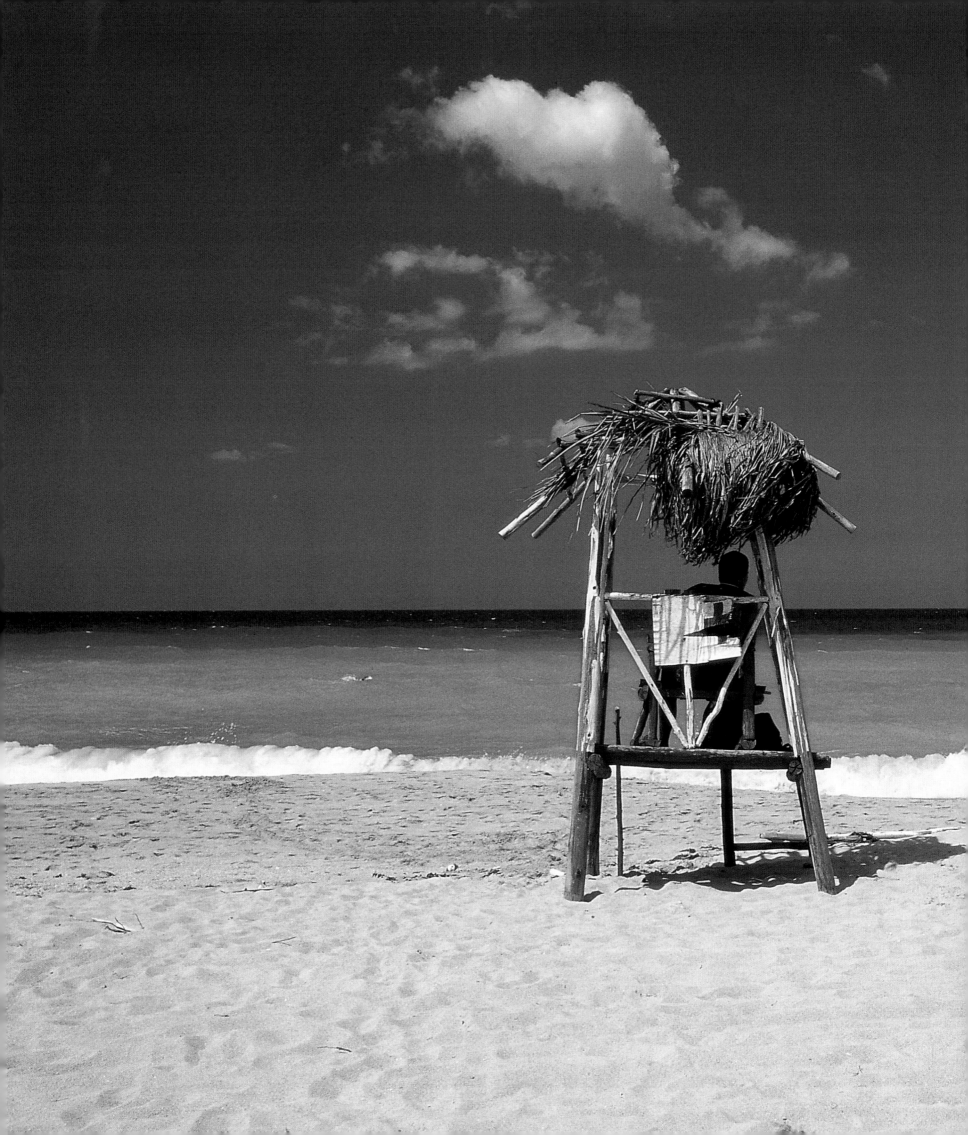

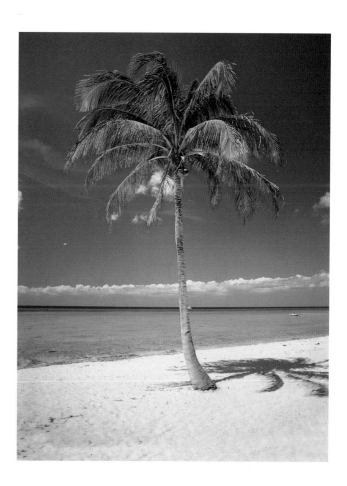

102-103 The undisturbed horizon that seems to extend endlessly into the distance from the Playas de l'Este makes it difficult to believe that the heavily plied sea routes converging at Havana are just a few miles away.

103 A solitary palm overlooks the sea where the waters of the Caribbean meet the Gulf of Mexico at María la Gorda, in Cuba's westernmost area.

104-105 Playa Paredon, at Cayo Coco. The famous cay is home to a wide variety of bird species, including the coco, after which the island is named. The name, in fact, refers to the white ibis and not to the coconut.

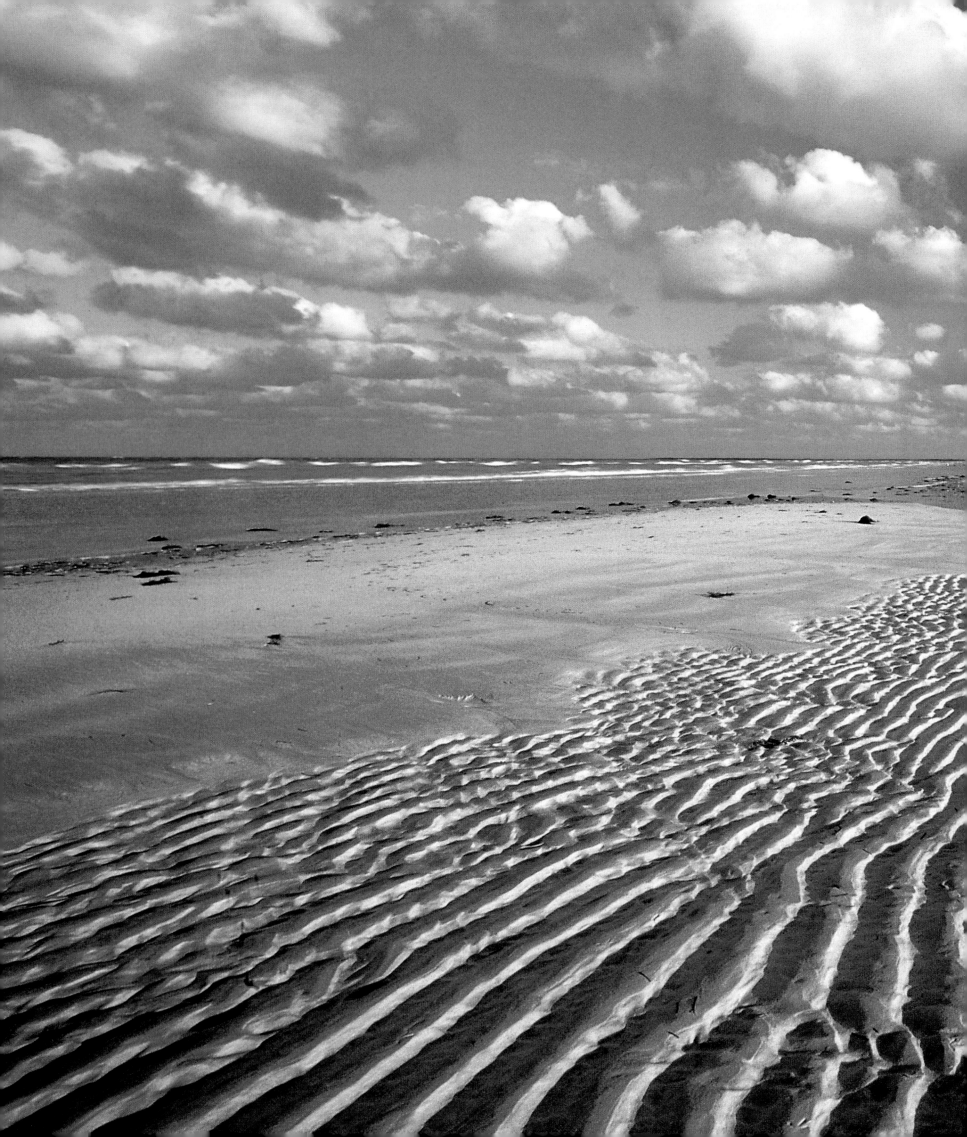

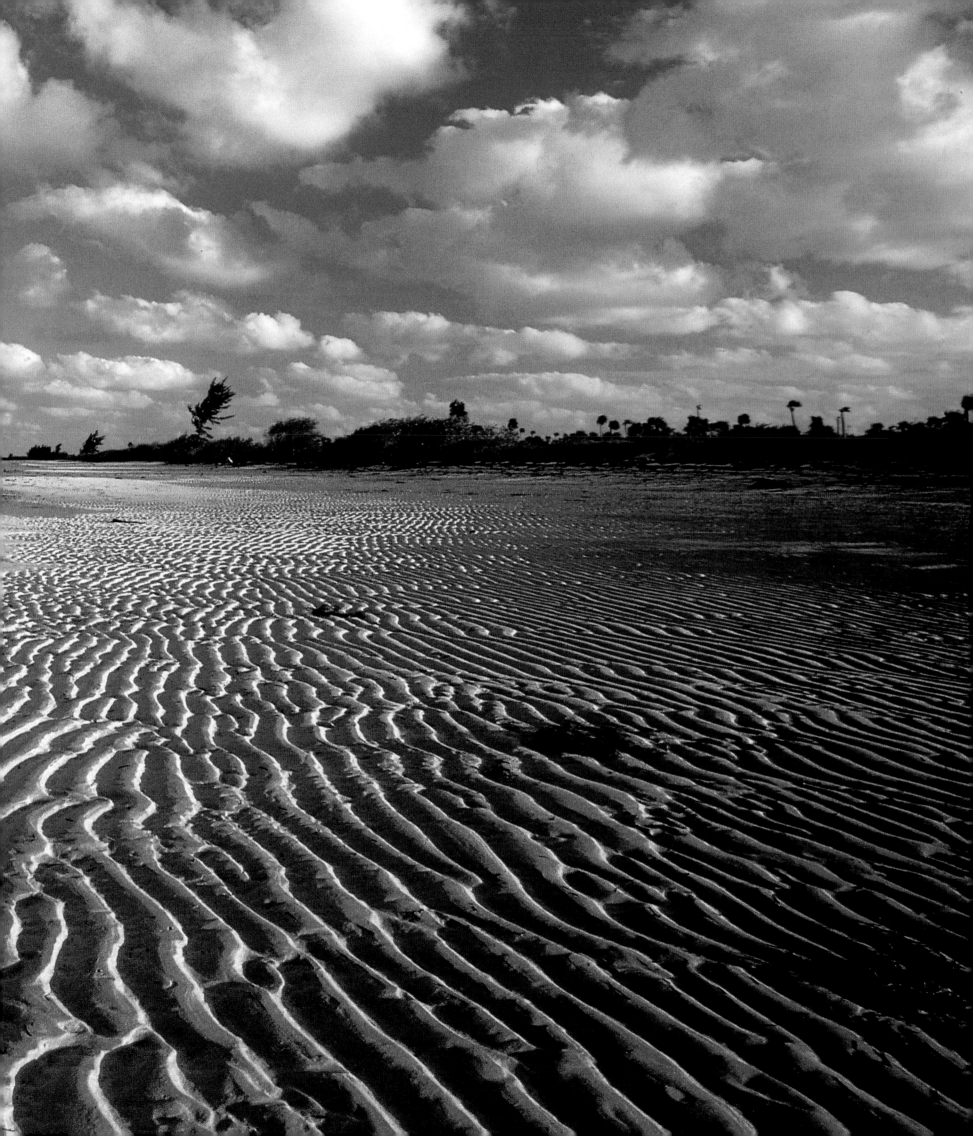

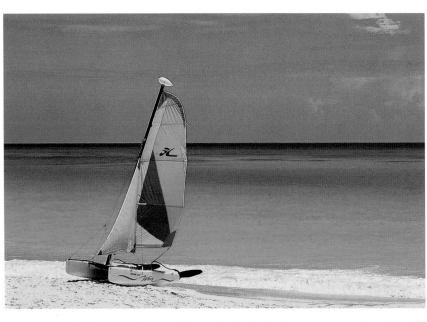

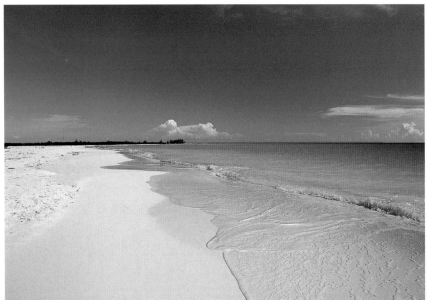

106 AND 107 A CUBAN WINTER. THE SUNNIEST AND DRIEST SEASON STRETCHES FROM NOVEMBER TO APRIL, AND WHILE TEMPERATURES VARY ONLY SLIGHTLY, IT IS GENERALLY HOTTER IN THE EAST THAN IN THE WEST OF THE ISLAND.

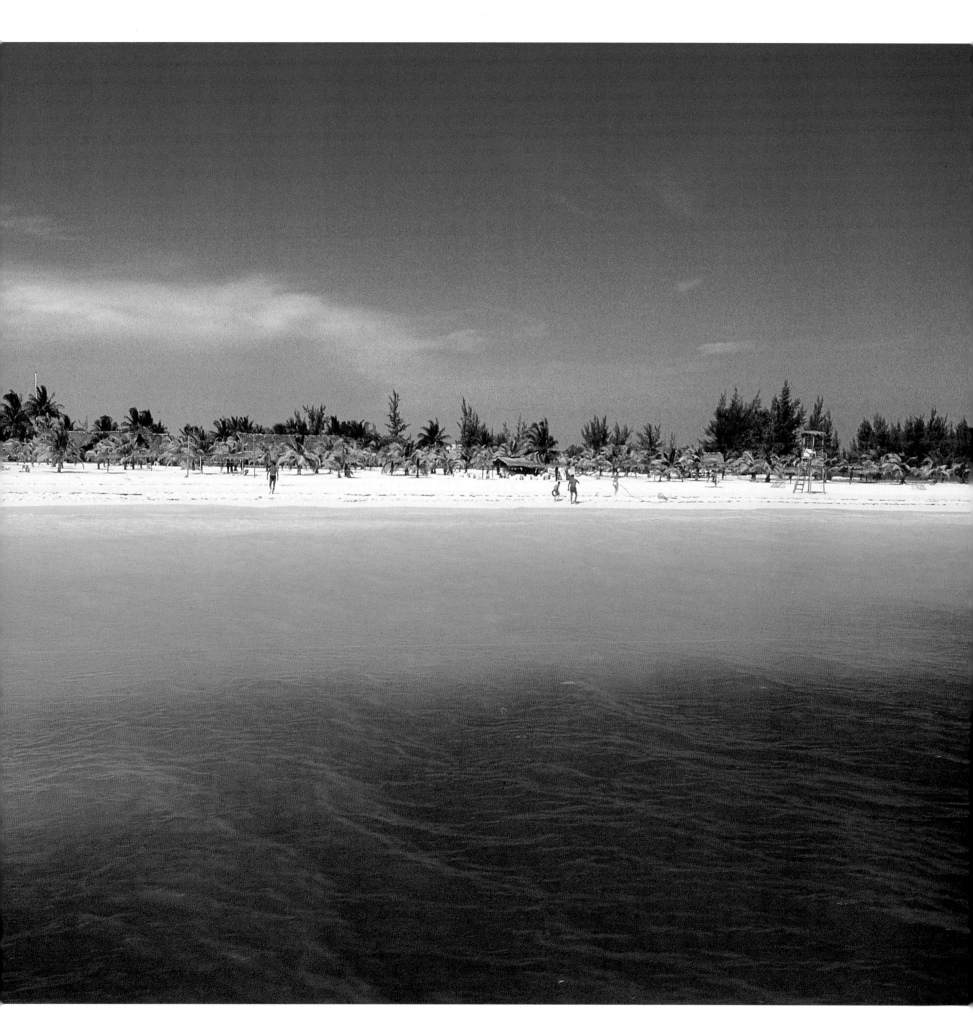

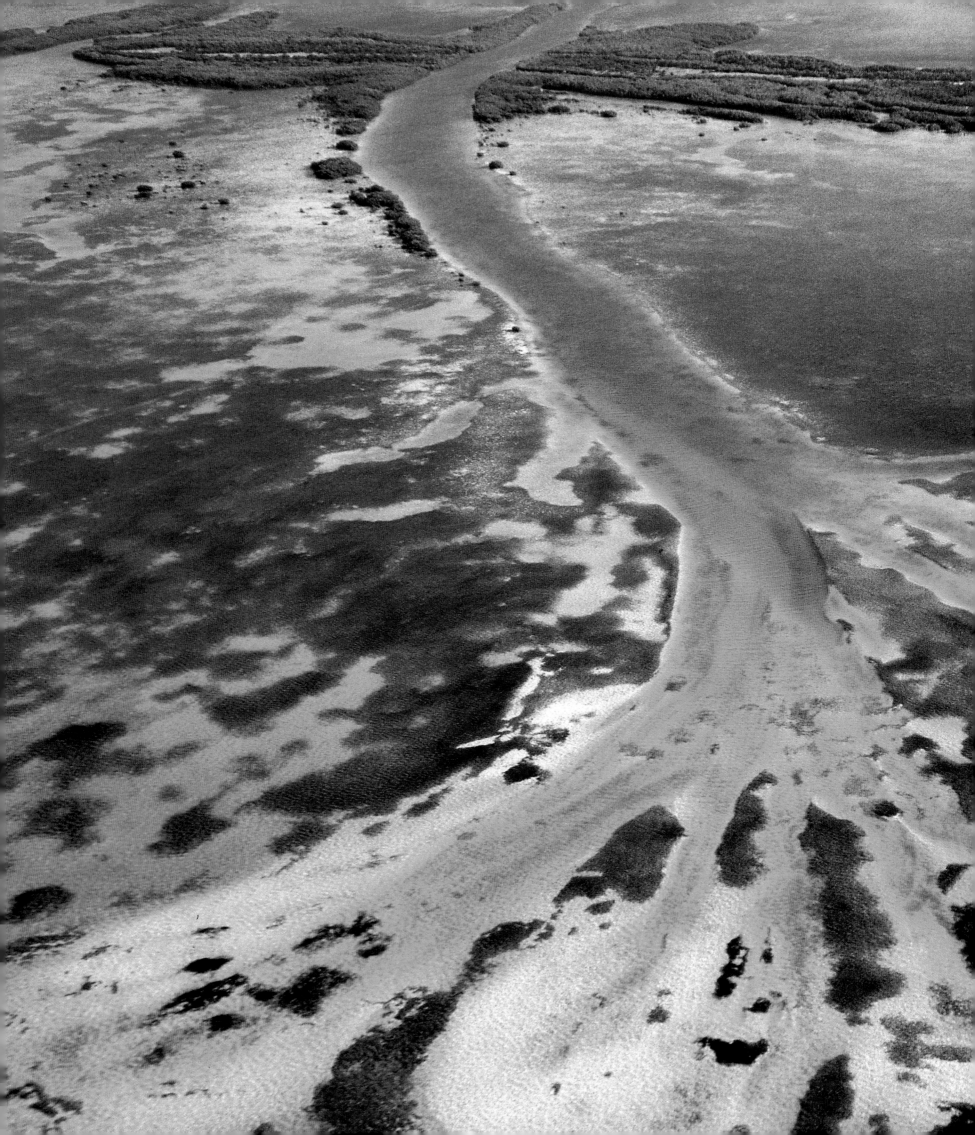

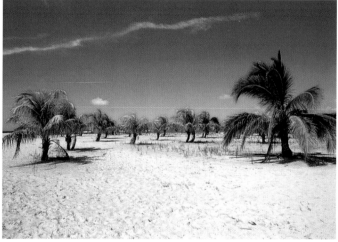

108 AND 109 THANKS TO THE SCARCITY OF
HUMAN SETTLEMENTS, CAYO LARGO (IN FACT A
FINGER OF LAND ABOUT SIXTEEN MILES LONG AND
NEVER MORE THAN SIX FEET WIDE), IS STILL
FREQUENTED BY IGUANAS, TURTLES, AND A
LARGE NUMBER OF BIRD SPECIES, INCLUDING
TINY HUMMINGBIRDS.

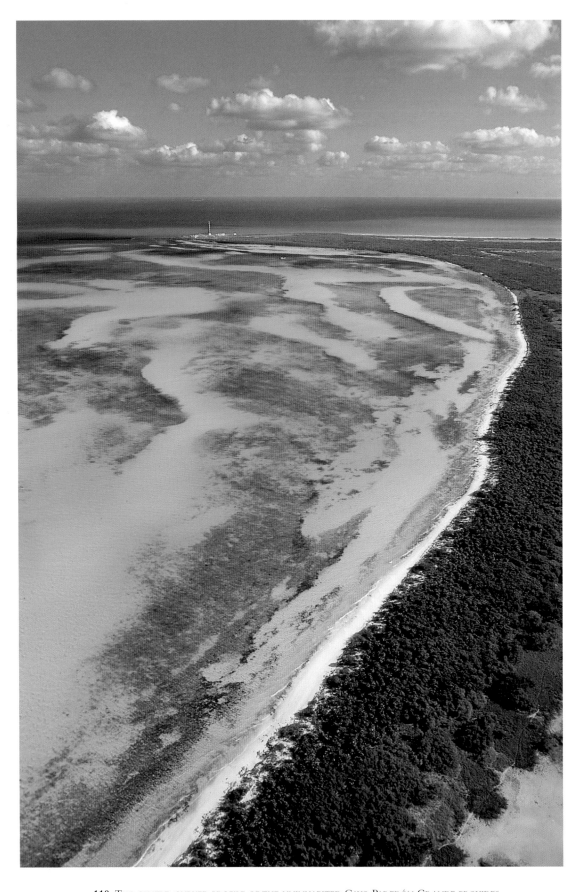

110 The gentle, curved profile of the uninhabited Cayo Paredón Grande provides
opportunities to birdwatchers and nature lovers of all stripes.

111 The mangrove marshes of the cays provide shelter to rare species, so threatened that they can be found only at two points on the planet.

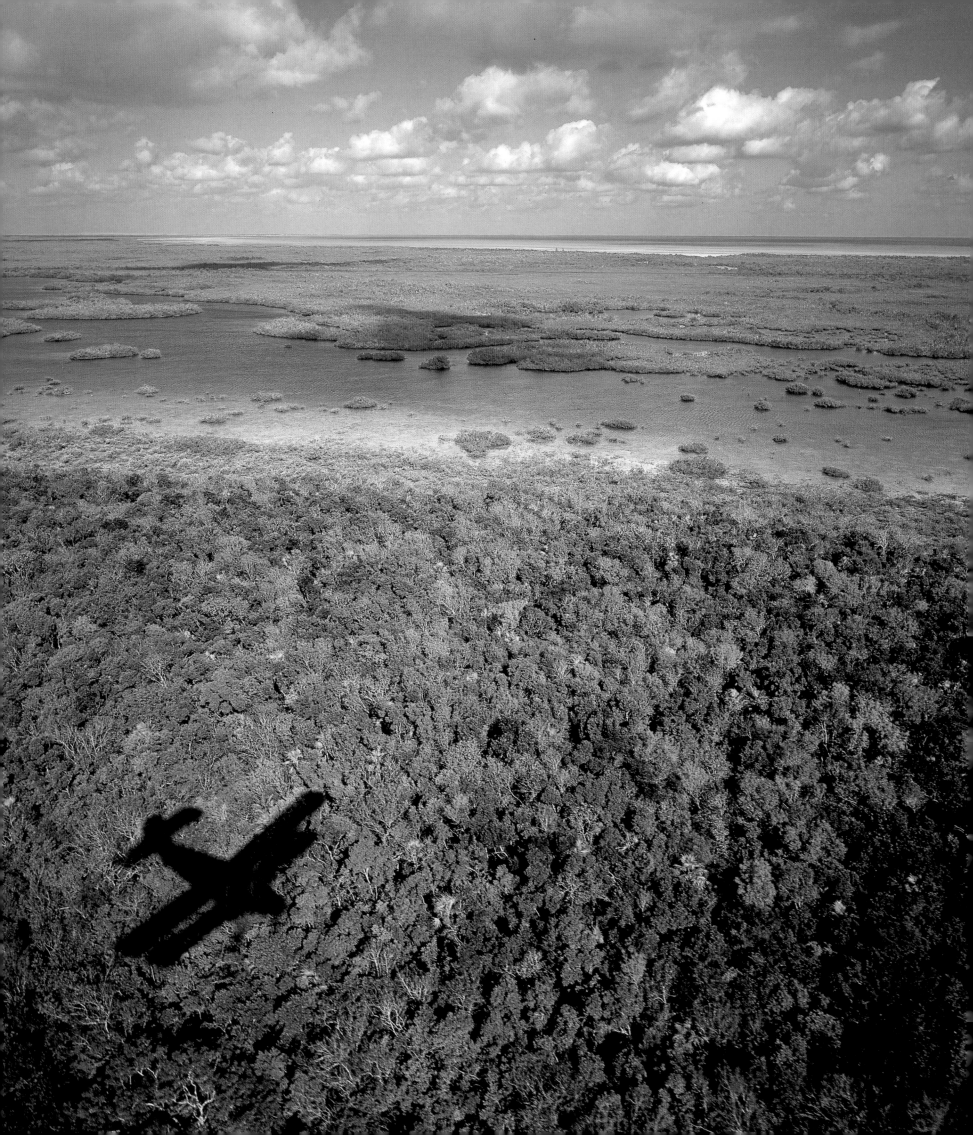

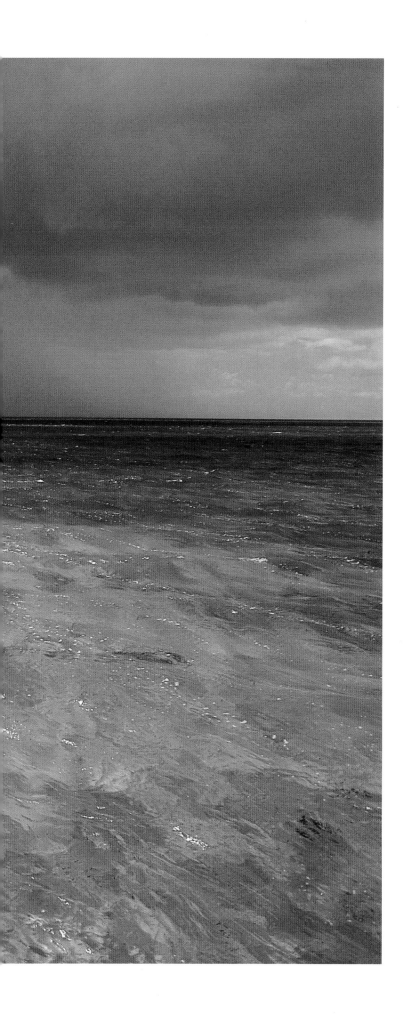

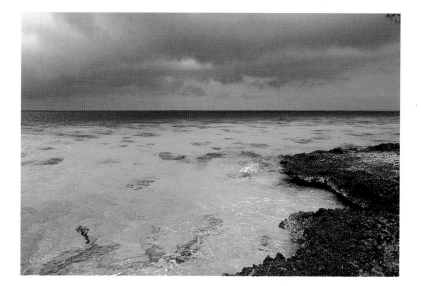

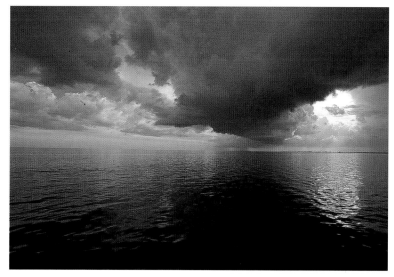

112 AND 113 THE "BAD" SEASON BETWEEN MAY AND OCTOBER IS NOT FOR THOSE WHO MAINLY WANT TO SOAK UP THE SUN. HOWEVER, THE MILLIONS OF SUN-LOVERS WHO FLOCK TO THE ISLAND DURING THE HIGH WINTER SEASON WILL NEVER ENCOUNTER THE SPECTACULAR MAJESTY OF CUBA'S STORMY SKIES.

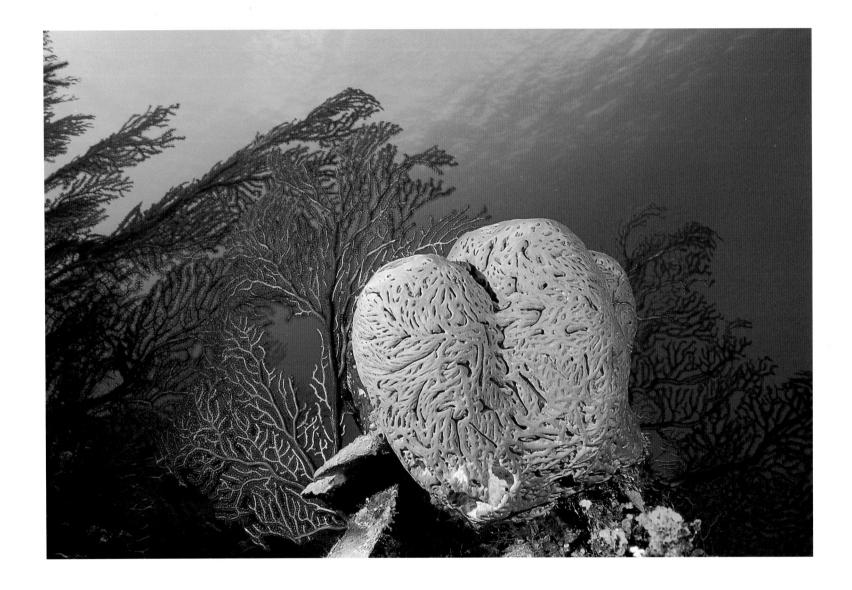

114 TOP A large yellow-tailed snapper is not intimidated by a team of divers. These brightly colored fish swim alone or in small schools close to the reef, venturing out of their dens mostly at night.

114 BOTTOM Colonies of black bush coral, widespread throughout the Caribbean, act as backdrop to a brain coral. The seas off Cuban and Florida waters are the northernmost areas where brain coral is found in American tropical waters.

115 A school of grugnitori hunting for prey among the sea fans. Schools of these predators that depend on the coral seabed for food can include thousands of individuals.

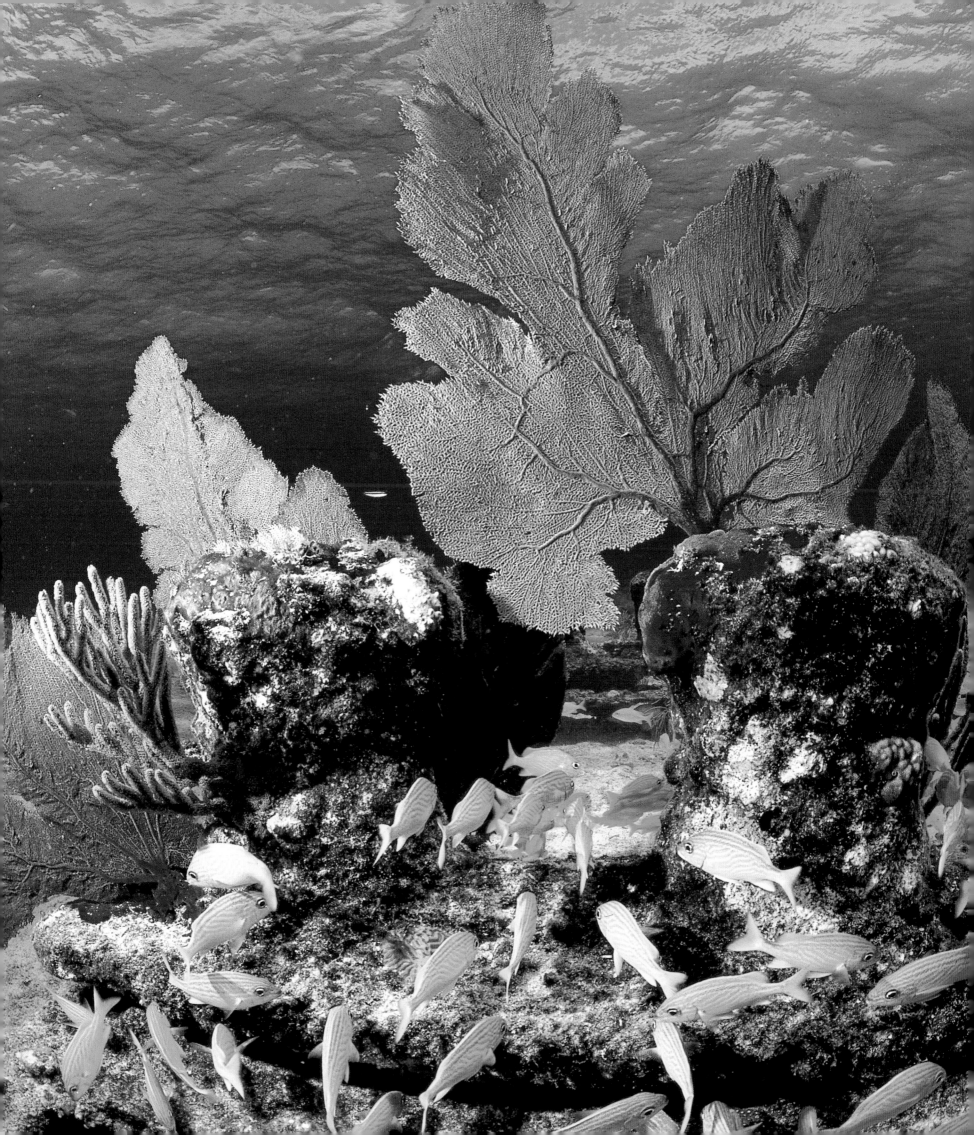

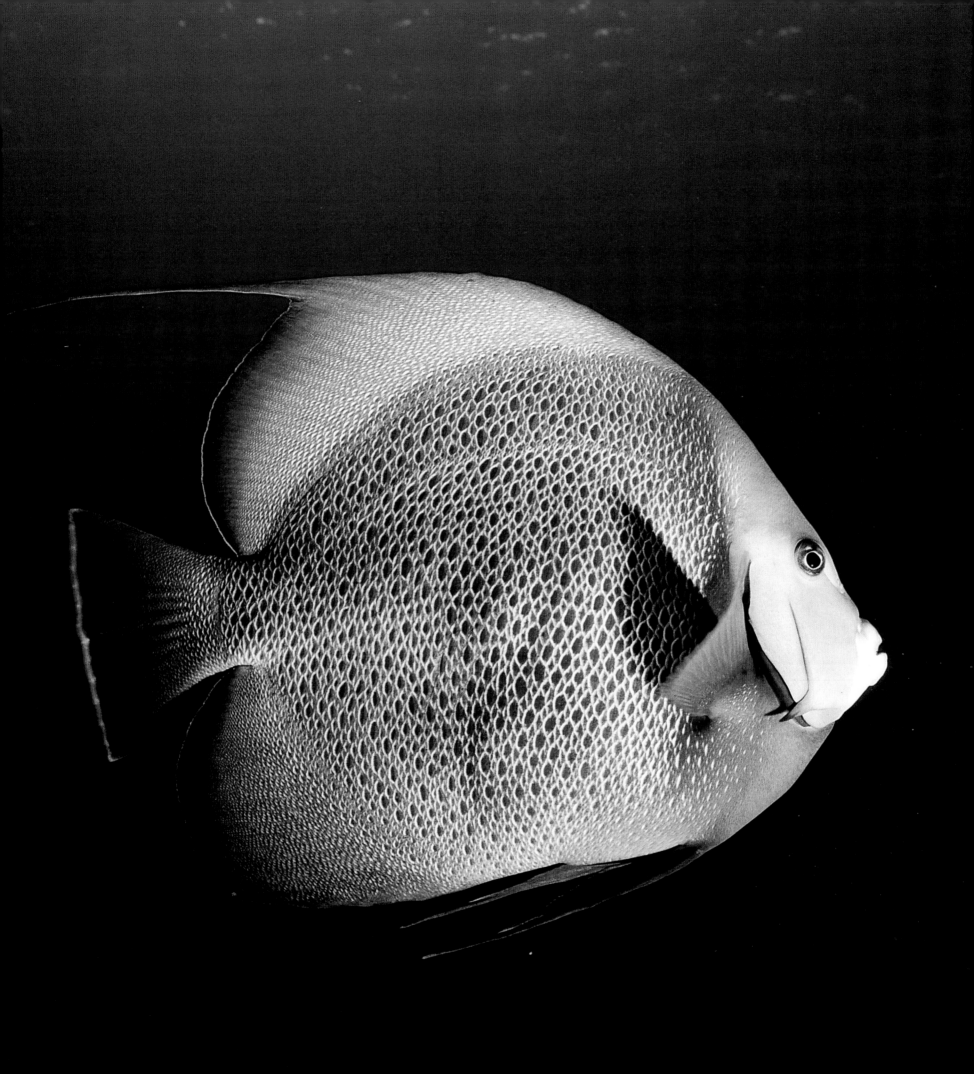

116 ALTHOUGH IT PASSES ITS LIFE ALONE OR IN A COUPLE, THE ELEGANT GRAY ANGELFISH IS ONE OF THE LEAST SHY OF THE SPECIES THAT FREQUENT CARIBBEAN CORAL REEFS.

117 TOP THE SEA SURROUNDING CUBA FEATURES REMARKABLE VARIETY. THE CLEAR WATERS ALONG THE EASTERN COAST ARE IN CONTRAST WITH THE TURBIDITY OF THE DEAD ZONE TOWARD FLORIDA, WHICH IS SATURATED WITH DECAYING MICROORGANISMS. ALL CARIBBEAN WATERS ARE FREQUENTED BY SHARKS.

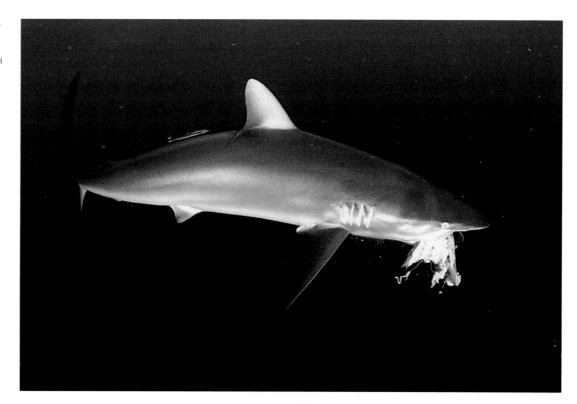

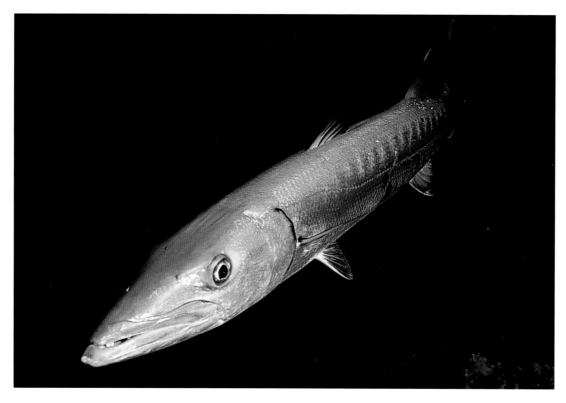

117 BOTTOM A THREATENING, SOLITARY BARRACUDA WAITS PATIENTLY IN THE SHADOWS FOR PREY. A FEARSOME PREDATOR, BARRACUDAS TURN INTO CURIOUS COMPANIONS TO DIVERS.

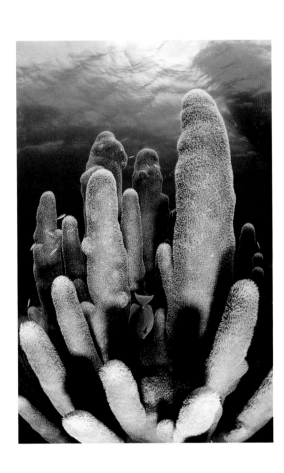

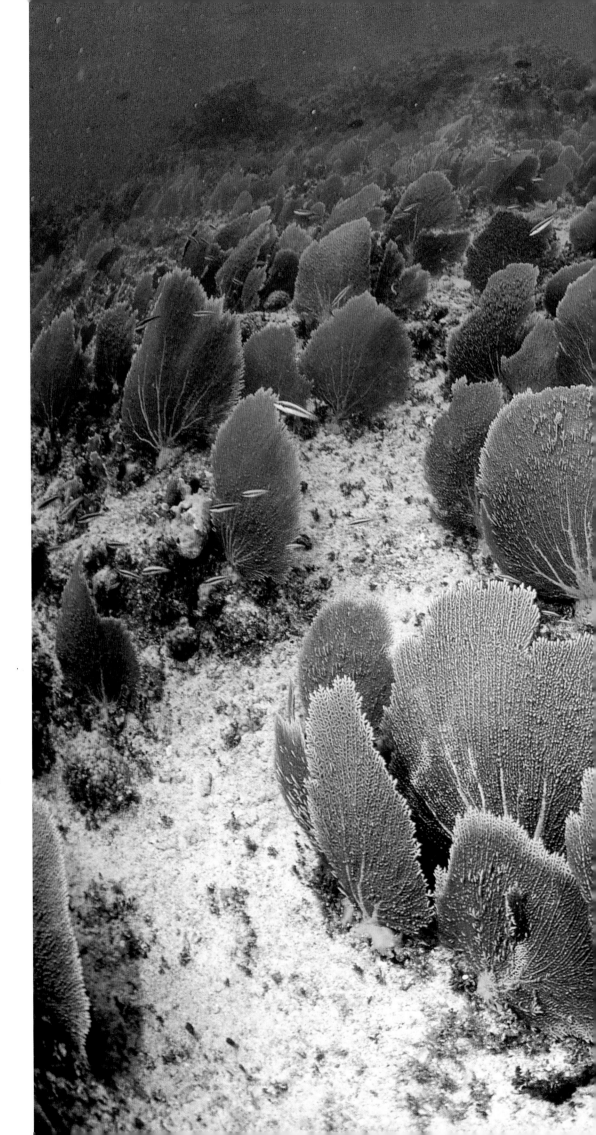

118 OF A DARKER BLUE THAN THE SURROUNDING
WATERS, A SURGEONFISH DIVES INTO A
SPONGE FORMATION.

118-119 HUNDREDS OF SEA FANS EXTEND AS FAR AS THE
EYE CAN SEE ON THE SEABED. THE SURVIVAL OF SUCH
FORESTS, TEEMING WITH INNUMERABLE FORMS OF LIFE,
DEPENDS ON A DELICATE BALANCE. A DIFFERENCE IN
TEMPERATURE OF JUST A FEW DEGREES CAN TRANSFORM
THIS SEABED INTO A STERILE UNDERWATER DESERT.

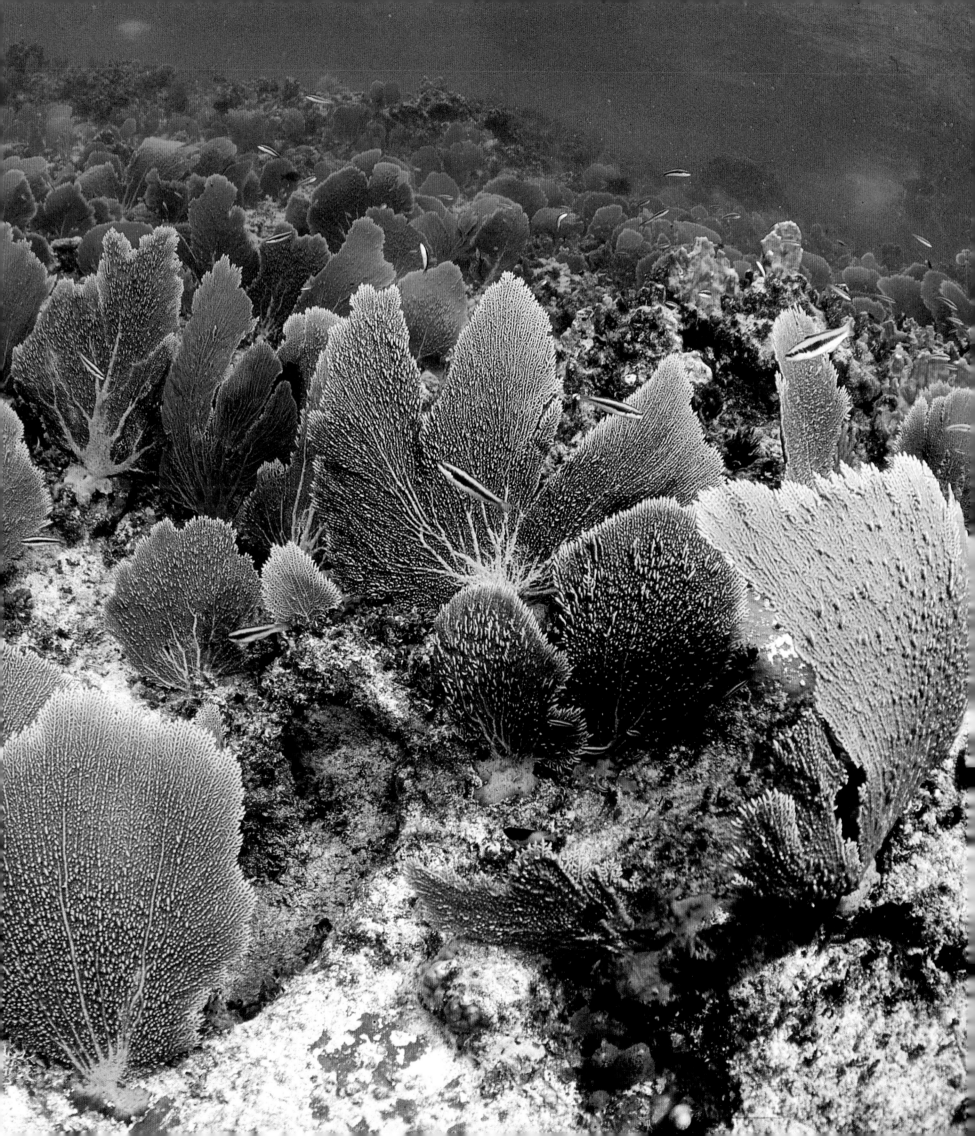

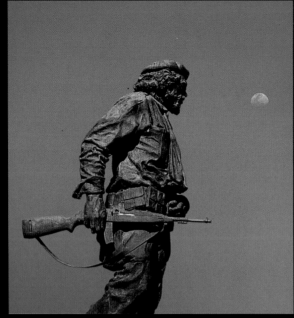
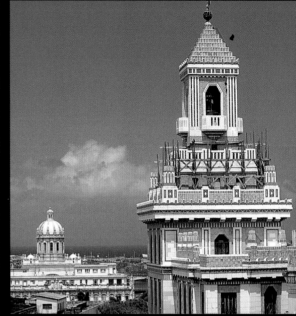

THE COLORS OF THE CITIES

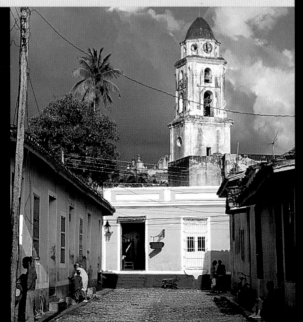

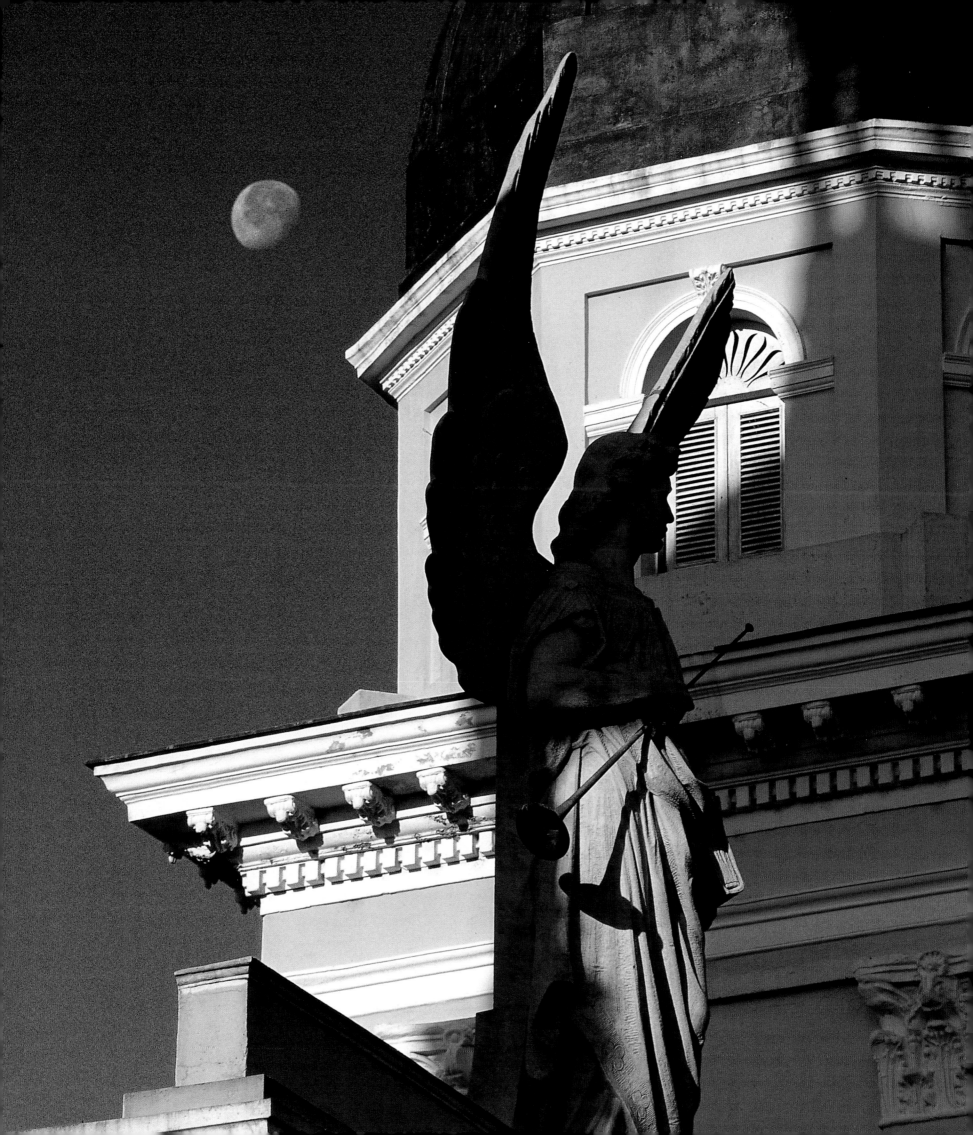

120 (CLOCKWISE FROM TOP LEFT) THE MONUMENT TO CHE GUEVARA AT SANTA CLARA. THE ECLECTIC ARCHITECTURE OF THE BACARDI BUILDING IN HAVANA. NOSTALGIC MODELS AND WILD COLORS. MOTORCYCLES IN PINAR DEL RÍO. THE BELL TOWER OF THE CONVENT OF SAINT FRANCIS DOMINATES TRINIDAD, A UNESCO WORLD HERITAGE SITE.

121 COMPLETED IN 1922, NUESTRA SEÑORA DE L'ASUNCION, IN SANTIAGO DE CUBA, LIES ON THE SITE OF THE ISLAND'S FIRST CATHEDRAL, BUILT IN 1520.

122 THANKS TO RECENT RESTORATION WORK, COLONIAL URBAN ARCHITECTURE HAS BEEN BROUGHT BACK TO LIFE ALONG CUBA'S STREETS.

123 TOP THE ESSENTIAL LINES OF HAVANA'S CAPITOL STAND OUT SHARPLY AGAINST THE ORNATE FACADES OF THE NEIGHBORING BUILDINGS. BUT CONTRAST IS THE ESSENCE OF CUBA.

123 BOTTOM LA CARIDAD THEATER, OVERLOOKING THE PARQUE VIDAL, AT THE HEART OF SANTA CLARA, IS THE CITY'S MOST PRESTIGIOUS BUILDING.

THE COLORS OF THE CITIES

The Republic of Cuba currently boasts a rich urban heritage of over 157 small and medium-sized cities with populations between 5,000 and 500,000. These cities are set in a wide variety of natural landscapes that have historically colored the three main geographical regions of the country: the west, the center, and the east. The thirteen provincial capitals created in 1976 feature a mean population of over 100,000 inhabitants each.

The Cuban archipelago covers an overall surface area of 42,828 square miles and is made up of two main islands: Cuba (105,007 square miles), and its much smaller sister island, the Isle of Youth (850 square miles). Furthermore, the sea off the northern and southern coastlines of the larger island are dotted with a total of 4,195 adjacent cays and islets, covering a total surface area of 1,434

square miles. Because of their beautiful landscapes, natural isolation, and pristinely conserved flora and fauna, some of these islets have been developed as tourist destinations. Others have been declared biosphere reserves and are devoted to scientific research.

Despite Cuba's rather contained land mass, its strategic geographical position allowed the island nation to rapidly develop its own cultural identity, based on a largely agricultural economy that is still being diversified, and to establish trade relations with the farthest corners of the globe.

The island of Cuba and its adjacent islets extend from west to east between the Gulf of Mexico and the Carribbean Sea, closing the arc of the Antilles, and affording easy access from the northern coast—interrupted by picturesque port towns and magnificent bays—to the Atlantic maritime routes leading to the ports of the southern and eastern U.S. as well as eastern Mexico. While the main southern port cities of Santiago de Cuba, Manzanillo, Casilda, and Cienfuegos served seafarers plying to and from the Caribbean coast for close to five centuries, in the twentieth century these same ports also started serving Pacific maritime traffic passing through the Panama Canal.

Most of the country's population of eleven million is concentrated on the island of Cuba. The island looks like a long, narrow strip, measuring 777 miles from the westernmost point, San Antonio Cape, to the eastern tip, the Quemada Point, located in the municipality of Maisí, and 119 miles at its broadest, from Playa de los Tararacos in the north of the province of Camagüey up to Camarón Grande Point, in the province of Granma, both located on the eastern side of the island. As a result of this—with the exception of Havana—the urban population, over sixty percent of the total, is relatively evenly distributed over all the nation's cities, each with its own population density, depending on its economic fabric and function within the country.

The City of Havana is at the same time the national capital of Cuba and the provincial capital of the Province of Havana. With a population of over two million and a surface area of just 289 square miles, it is the most densely populated city in the country. Havana is

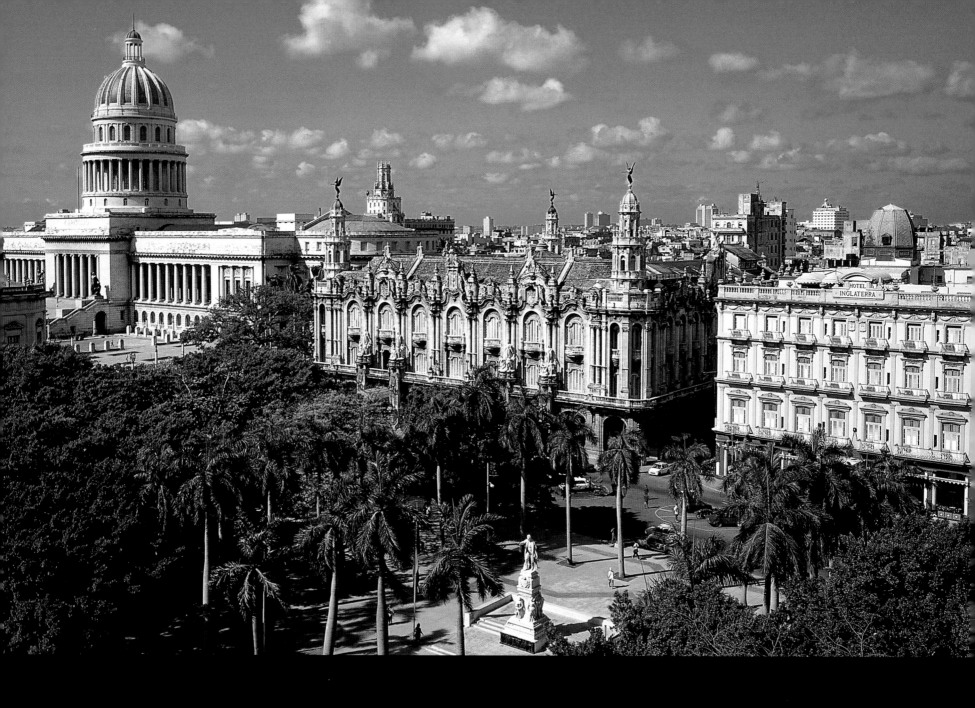

124 LEFT A CITY OF GREAT HISTORICAL AND POLITICAL SIGNIFICANCE, SANTIAGO DE CUBA IS ALSO THE ISLAND'S RUM CAPITAL. IN THE PICTURE: THE FABRICA DON MARTÍN CADO.

124 CENTER WHILE FULLY CONSERVING ITS COLONIAL OUTLOOK, CAMAGÜEY ALSO HOUSES ONE OF CUBA'S LARGEST UNIVERSITIES.

124 RIGHT AT PLACETAS, AS EVERYWHERE ELSE IN CUBA, THE BEAUTY OF COLONIAL ARCHITECTURE CONTRASTS WITH THE OLD-FASHIONED TASTE IN CARS.

125 LEFT THE MALECÓN, HAVANA'S WATERFRONT, FEATURES SPANISH FORTS AT ITS TIPS.

THE COLORS OF THE CITIES

the only metropolis among all the small and medium-sized cities that presently make up Cuba's urban landscape. As a result of the growing influx of immigrants from the Cuban hinterland toward the capital in the 1990s, legal controls and regulations were placed on new residents, aimed at containing the city's population to a maximum of three million over the next ten years. The ultimate goal is to improve the quality of life in the capital, enhance and conserve its rich urban heritage, and to improve the infrastructure and public services in order to offer domestic and foreign visitors a tourist destination featuring the highest standards of comfort and security.

Furthermore, over the past forty years, other provincial capitals,

network is bound to substantially transform the country's image in the near future.

Cuba's urban history dates back to the sixteenth century when European *conquistadores*, led by Diego Velázquez Cuéllar, built the first towns, cities, and villages inhabited by Spaniards and local natives. The aboriginal culture was totally devoid of the complex social entities and institutions that work together within the urban context. Even though human settlements on the island of Cuba date back over seven thousand years, and Arawak immigrants from South America continuously came to settle in the eastern and central parts of the island and established some sort of territorial organization in the form of *cacicazgos* (local chieftainships), none of these advanced beyond the stage of Neolithic settlements.

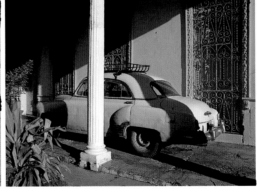

including the Isle of Youth, which enjoys special status and is administered directly by the central government, have increased in population and developed their local economies and urban frameworks. As a result, each provincial capital now boasts specific attractions linked to its local historical and cultural identity, developed over time, depending on the period of foundation of the city, its geographical location, its economic and urban role, along with influences arising from immigration and initial intermingling with the aboriginal population, its relations with other insular or continental regions of the Americas, and the state of advancement of its communications and transportation infrastructure.

The rationalized development, already underway, of the economic, social, and cultural potential of Cuba's overall urban

The towns and villages founded by the Spaniards generally followed the town planning format widespread in Spain at the end of the Middle Ages and the early Renaissance. These towns generally featured an orthogonal street grid, almost always with irregular limits, and a parade ground, which starting in the seventeenth century included the new concept of the "main square" that played an essential role in the social life of the town. Cities featuring particular military or commercial importance, as well as towns providing basic goods and services to the metropolis, were defended by walls. Town planning was closely linked to the local landscape so as to optimize available food and water resources.

No city designed by the Spaniards would be complete without featuring the Catholic Church in the from of parochial churches at various hierarchical levels, monasteries, and sanctuaries that created distinctions between towns, titular sees, and the open countryside.

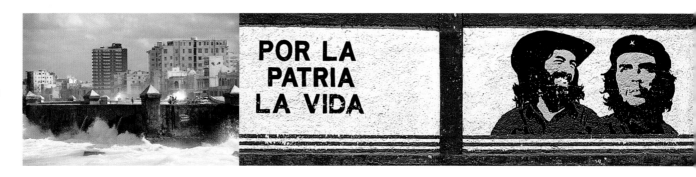

Another compulsory feature was the municipal council that also included "neighbors" who had settled and lived in the town, and that acted as a political link with the central government of the Spanish monarchy and all the defense machinery and institutions promoting economic, social, and cultural development set up under the patronage of the Spanish crown.

The first Spanish towns and cities in Cuba were founded between 1511 and 1518. They were mainly located in the eastern and central area of the island, perhaps because this region was the most heavily populated by aborigines and possessed a certain quantity of valuable minerals, while affording easy access to Hispaniola (Haiti and the Dominican Republic), the main military base of the Spanish *conquistadores* and colonizers at the time.

The large western portion that now includes the provinces of Pinar del Río, Havana, and Matanzas was largely neglected by the Spanish *conquistadores* who only founded the town of San Cristóbal de La Habana in the area. The town's location was changed several times (quite like other cities) between 1514 and 1519, until it was finally established along a splendid pocket bay, initially named *Carenas* by the Spaniards and later baptized Puerto de La Habana. By royal decree, the village of Guanabacoa was set up close to the port for the local aboriginal population.

The arrival of the Spanish *conquistadores* on continental America and the discovery of highly developed cultures that had accumulated fabulous reserves of precious metals once again changed the course of the destiny of the island. In order to keep pace with rapidly expanding Spanish colonization and the resulting increase in maritime traffic, the small town of San Cristóbal de La Habana, practically isolated from the other Spanish settlements on the island, was soon transformed, in 1540, into a strategic port that served as a protective harbor serving fleets leaving for Seville every year, their holds crammed full with the enormous treasures in bullion plundered from American mines.

These developments transformed Havana into a strategically important military base as well as the administrative and political seat of the governor of the island of Cuba, who was also known as the captain general as a result of the military responsibilities attached to the post. Havana also became the main urban hub of trade, production, and major services. Commanding both the Caribbean Sea and the Gulf of Mexico, Havana was the ideal solution to all the needs of the booming monopolistic trade within the Spanish empire.

The maritime trade and the introduction of livestock breeding (pigs, cattle, and horses) soon transformed the island's economy. The aboriginal population was decimated as a result of the wars of conquest and its inability to adapt to the new order imposed by the colonizers. In order to meet increasing demand for manpower, slave labor was imported from Africa and the Canary Islands.

Following the Renaissance trend widespread in Western Europe, urban settlements spread out to cover rural areas. On the island of Cuba, this had a decisive impact on the cultural forms that appeared and gained prominence during the four centuries of colonial rule.

In 1574 the Decrees of Cáceres and the Leyes de Indias imposed town planning and other regulations governing urban life. In 1607, for the first time, the island of Cuba was divided into two administrative districts, known as the Western and Eastern Departments (Departamentos Occidental y Oriental), albeit with rather undefined borders. The capital cities of these districts were San Cristóbal de la Habana and Santiago de Cuba.

It was only in 1878 that the island of Cuba was divided into six provinces, namely, from east to west, Pinar del Río, Havana, Matanzas, Las Villas, Camagüey, and Oriente, and 126 smaller municipalities. The current administrative-political division that overhauled and updated the nineteenth-century layout, resulting in considerable advantages in terms of the political representation of the eastern and central regions of the Republic of Cuba, dates to the new constitution enacted in 1976 under the National Assembly of People's Power (Poder Popular).

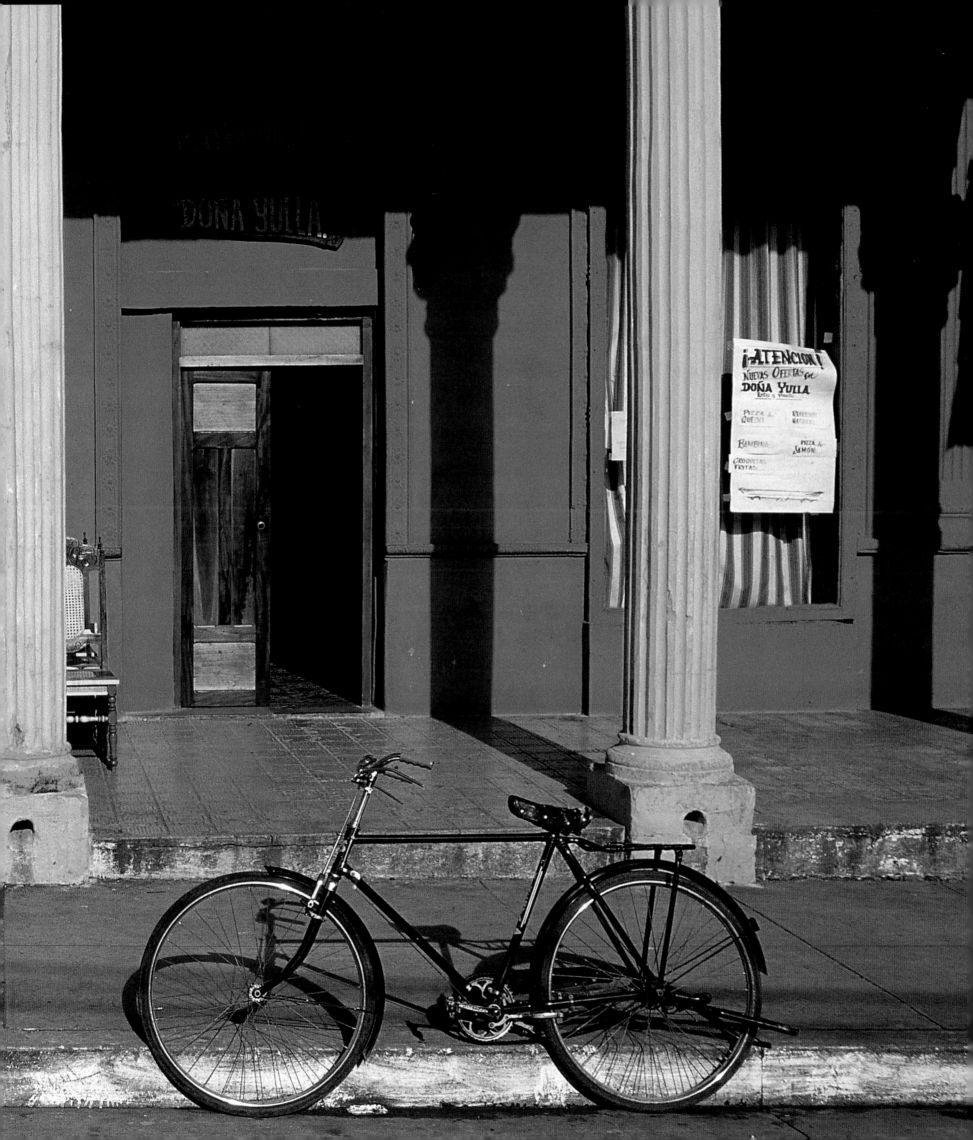

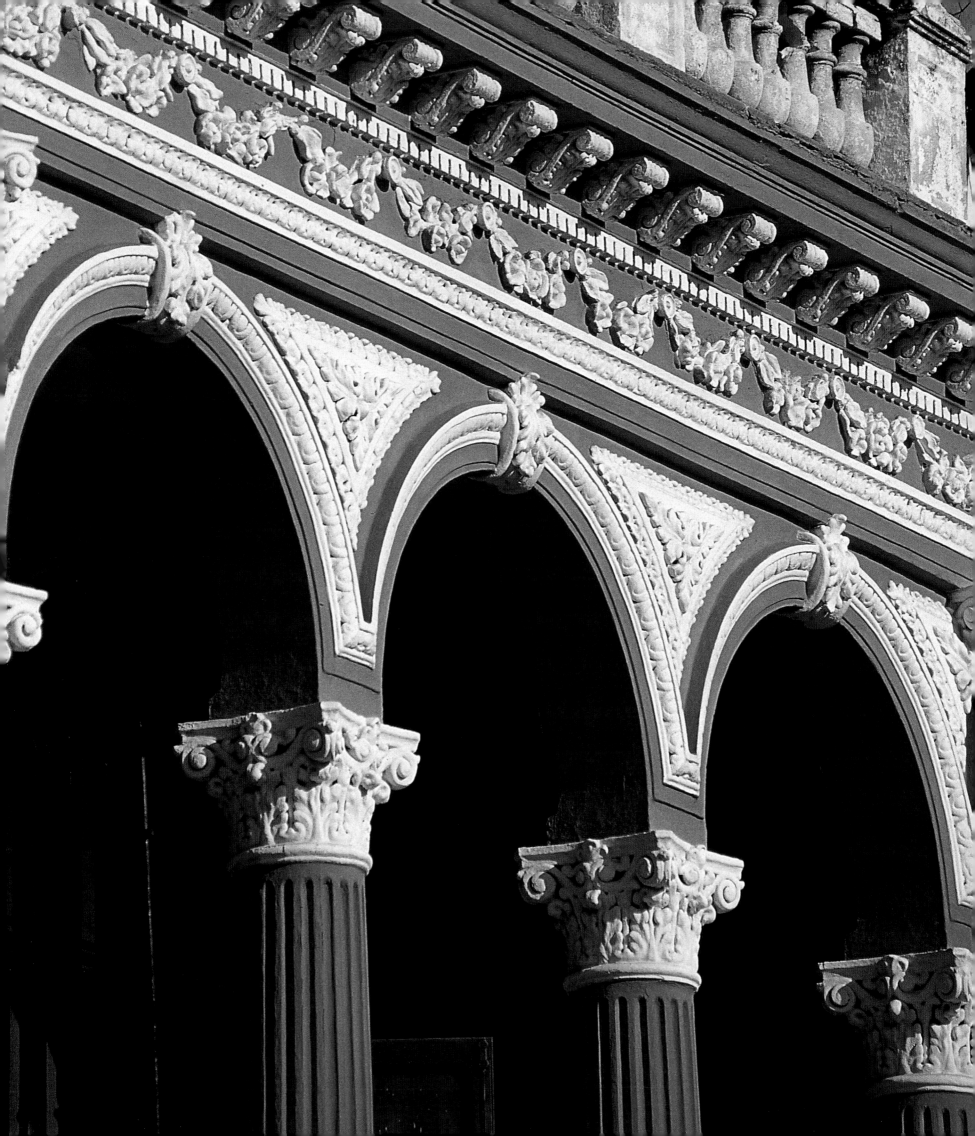

128 On the Paseo de Martí in the center of Havana, the many Corinthian capitals and friezes of the colonial architecture are successfully lightened by the vivacity and chromatic variety that typifies the city.

129 TOP LEFT From Hollywood to Cuba: Cuban celebrities, like the actress Sara Montiel, won a place of importance for their island in the entertainment world, including cinema and music.

HAVANA

THE ENCHANTING CAPITAL

The site of the Port of Havana and the small neighboring town of San Cristóbal was selected on the basis of a whole range of ideal factors—a pocket bay with a long and narrow entrance that was easy to defend, opening up to an expanse of water as large as a small sea and deep enough to accommodate deep-draft vessels, in an area featuring a plentiful supply of materials to service and repair vessels in transit, as well as to build new ships using local wood, and located in front of the strait between Cuba and the Florida panhandle, forming the only passage linking the Atlantic ports and the continental mainland of the Vice-royalty of New Spain (Mexico) that was created in 1525.

Thus, from the beginning of its history, Havana and its splendor emerged from the sea that brought the fleets carrying bullion flocking to its port. Furthermore, a royal tax, known as *situado de México*, was imposed to pay for the armed forces and the construction of forts required to defend this strategic point of the Spanish empire in America against European rivals itching to get their hands on the vast reserves of precious metals, the lands, and newly colonized populations of the "New Continent."

The colonial port that soon became an object of international envy was fitted with fortifications flanking the narrow entrance to the bay, while watchtowers were built at all possible points of attack along its lengthy coastline. The first fort, known as Castillo de la Real Fuerza, was destroyed during the attack by Jacques de Sores in 1554 but was soon rebuilt close to the parade ground, the Plaza de Armas. The best military engineers, architects, and master stonemasons were commissioned by the crown to build the forts of Tres Reyes del Morro and San Salvador de la Punta that secured the entrance to the port. Foremost among these was the Italian engineer-architect Giovanni Battista Antonelli, who completed one of the most ambitious hydraulic engineering projects of the time—the royal aqueduct that for over three centuries supplied the city with water from the distant, but large, Chorrera River, now known as the Almendares.

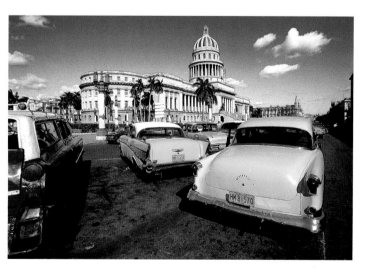

129 TOP CENTER The coat of arms of the Vatican is displayed on the doorway of Havana Cathedral.

129 TOP RIGHT Murals have always been one of the preferred means of political propaganda in Cuba.

129 BOTTOM The Capitol seems to reflect the chromatic exuberance of the famous cars to be seen in Havana. Although they were mainly built in Detroit, these cars are far from the typical concept of consumer products.

HAVANA, THE ENCHANTING CAPITAL

130 José Martí and Che Guevara are central characters in the Plaza de la Revolución. The white statue of Martí (left) is flanked by the monument dedicated to him, which stands 482 feet tall (center). The gigantic, stylized face of Che Guevara (right) stares out from the facade of the Ministry of Home Affairs.

Officially declared the island's capital in 1607, although it had long been the seat of the governors—who were later chosen from among military officers and invested with the title of Capitan General of the Island of Cuba—Havana was gradually enclosed by irregular, high, and sturdy walls in the medieval style, which, when complete, entirely isolated the city and separated it from the bay until 1740. Other nonmilitary buildings were constructed for the city council, including the Aduana, the city's first shipyard, in front of what is now the Plaza de San Francisco. The belfries of the convent churches of the first religious orders to set up houses in Havana, the Franciscans, the Augustinians, and the Dominicans, consolidated the Catholic image of the city, standing out against the architectural landscape of the classical port towns. The colonial city was a bustling metropolis, inhabited by a varied population: Spanish colonizers, families descended from the aboriginal *guanches* from the Canary Islands brought to Cuba as cheap labor, natives, and black African slaves. All kinds of merchants, seamen, priests, and even pilgrims, from Europe or the American continent,

chapel that was later transformed into a parochial church named "Patron of the Port of Havana." Since the nineteenth century, the image has often been confused with the *Yoruba orisha Yemayá*.

The government of Havana was permanently Janus-faced. The metropolitan interests of the king were counterbalanced by those of his rich and powerful "neighbors" who controlled the local city council and constituted an oligarchy that dominated the land and the fruits of agriculture and animal husbandry that sustained both the permanent local population as well as the temporary residents who arrived with the bullion fleets, and still others who merely transited through the port. The monopolistic trade system was based in Havana and tended to ignore the rest of the country's towns and cities, especially since Havana was the only port authorized to trade with Seville and all other trans-Atlantic trade was considered a form of illegal smuggling. In this way, the capital of the colony imposed its economic hegemony over the other inland cities.

In the eighteenth century, after the American gold and silver reserves had been exhausted and the bullion fleets no longer served any purpose, Havana began to consolidate the development of its agricultural system by focusing on cash crops such as tobacco and sugarcane. The tobacco monopoly enjoyed by the Fábrica of

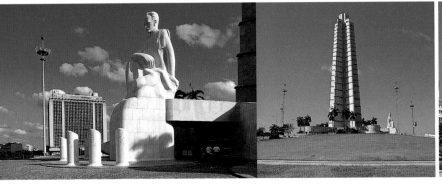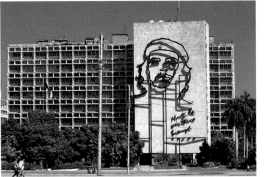

constantly crossing the Atlantic between the Old and the New World, all formed part of the teeming crowds that descended on Havana that served as a backdrop to a real-life *Baroque Concert*, which Alejo Carpentier so vividly describes in his novel of the same title.

In the midst of all this bustling activity, the image of the Virgin of the Rule (the Rule of St. Augustine) somehow reached the port at the end of the seventeenth century, where it was venerated in a humble

Seville gave rise to violent protests and armed insurrections by the main tobacco cultivators, who were peasants descended from laborers brought to Cuba from the Canary Islands. These riots, known as the *vegueros* uprisings, which took place between 1717 and 1723, inspired immediate military action. With the support of King Philip V, a select group of noblemen, major merchants, high-ranking military officials, and royal officials formed a group that controlled the city's political life

and drew up a metropolitan-type plan for Havana in order to ensure the predominance of the Havanan urban culture, in favor of slavery and the continued exploitation of the rural hinterland and its occupants—mainly white settlers from the Canary Islands who, while living in abject poverty, still enjoyed the status of freemen.

The English attack and occupation of the city in 1762 was a crucial turning point that stretched the city's defensive system as well as the courage and loyalty of its inhabitants and defenders to the very limit. The transfer of Havana to the Spanish crown in exchange for Florida and the reconstruction of the city that commenced in 1763 was a watershed in the history of Havana that left an imprint on its urban landscape. The wealth accumulated in a variety of ways was ostentatiously displayed in the princely mansions that, to a certain extent, competed with the new gubernatorial palace of the Captains General, which was built on the Plaza de Armas after it was no longer being used as a parade ground, which had been transferred to the Campo de Marte outside the city's walls. The mainly Creole marquises and counts decorated the facades of their residences with their coats of arms that now also reflected *mestizo* noble titles attached to local lands such as the marquisate of San Felipe and Santiago de Bejucal, or the earldom of San Juan de Jaruco or Gibacoa.

The opulence of the interiors of these mansions with their stained-glass windows providing protection against the tropical sun, the precious woods used and the stately luxury that enthused the social life of the city with its tree-lined sidewalks, its first theater—the Principal, inaugurated in 1773—and its brand-new cathedral, seat of the newly created diocese of Havana (1787) often shocked the governors representing the Spanish crown on the island. In the 1790s, agriculture in Havana, and later in the neighboring area of Matanzas, rapidly developed and transformed into a huge sugarcane industry, the largest in the Caribbean, nurtured by ever-increasing demand in the world market. The economic benefits of the sugar boom, based on slave labor, left an indelible mark on the island's capital.

By 1811, Havana had expanded beyond its original walls to accommodate a population of some 98,000, including 43,000 whites, 27,000 black freemen, and 28,000 African and Creole slaves. The province under its direct jurisdiction featured a population of 252,000 that included all the above categories. The *Political Essay on the Island of Cuba,* written in 1825 by Baron Alexander von Humboldt, who visited the city as a guest of the cream of Havanan society in 1800 and 1804, focused European attention on the progress and problems of the Spanish colony, which together with Puerto Rico was the largest vestige of the former Spanish empire in America. Two years after its publication, the book was labeled as "antislavery" and banned by the Havanan city council.

New summer resorts such as El Cerro, Marianao, and El Carmelo mushroomed in semirural areas falling within the province of Havana during the early nineteenth century. These resorts were dotted by sumptuous country residences mainly in the Neoclassical style. Carrara marble, imported from Genoa, replaced the old ceramic tile on floors and staircases of Havanan residences, and was used for the statues that decorated the interiors, gardens, and courtyards.

The first cemetery outside the city, known as "Espada" in honor of the bishop who founded it in 1805, featured many tombstones of white marble, either imported from Italy or quarried locally at the recently discovered veins of Isla de Pinos, south of Havana. In the 1860s the city's many theaters, chief among them the Tacón, the Payret, and the Diorama, were the rage of the region's high society, featuring billings that included the best Italian opera companies. Riding through the streets in horse-drawn carriages was one of the favorite pastimes of upper-class women, whose style, elegance, and culture filled the gossip columns of the newspapers.

Starting in the 1840s, the tobacco industry—specializing in cigars and cigarillos—became a prominent feature of the city's urban profile. The image of Havana as the city of "*puro habano*" (tobacco) was comparable and perhaps superior, as a result of its pure, untreated tobacco, to that of other industrial cities. Cigar boxes were decorated with artistic engravings that spread the name and the main symbols of

132 The porticoes that face the Paseo de Martí, or Prado, display a surprising mixture of Art Deco, Neoclassicism, and Baroque.

133 TOP In the Castillo de los Tres Reyes del Morro at the entrance to the port stands Cuba's oldest lighthouse, built in 1845.

133 BOTTOM A strictly Neoclassical colonnade leads into the Universidad de la Habana, which educates 30,000 Cuban and foreign students.

HAVANA, THE ENCHANTING CAPITAL

Havana, highlighted in gold dust, throughout the world. After 1886, when slavery was officially outlawed, ushering in a period of peace, the tobacco industry became one of the city's major employers, creating jobs for people of all races, ages, and sexes. This new source of livelihood was reflected in the highly diversified types of housing that appeared in the city's working-class districts, such as Pueblo Nuevo and San Lázaro.

The Wars of Independence did not really devastate the city until the genocidal reconcentration policies enforced by the Spanish general Valeriano Weyler in 1896. Nevertheless, the wars did force a large part of the Havanan population to flee the city, and this exodus was not limited to tobacco industry workers but also included rich groups of Creole oligarchs and industrialists, bent on gaining independence from Spain.

Havana continued to remain the country's capital and maintained its traditional metropolitan role well into the republican era, even after the official declaration of independence in 1902. The modernization of urban infrastructure launched in the nineteenth century took on a frenetic pace, and was boosted in 1925 with the completion of a rail system, a city tram system, the opening of the Albear Aqueduct, as well as the introduction of electricity and gas utilities. Urban development was also encouraged by low real estate prices.

The main arteries that served the area outside the city walls were straightened and the overall plan of the area was streamlined with the opening of public gates in the walls. The construction of these gates also gave rise to charming arcades in the city's traditional business district. Tree-lined avenues and sidewalks as well as gardens of private residences, enclosed by ornate

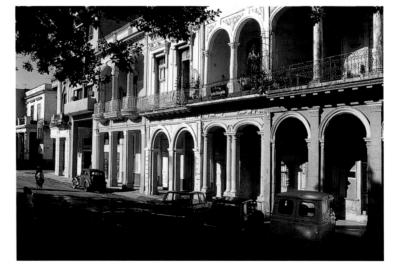

iron railings and built strictly in line with town planning regulations, embellished the new suburbs of the expanding metropolis. These new city districts were designed by distinguished Cuban architects—Pedro Martínez Inclán and Emilio Vasconcelos—as well as renowned foreign experts such as Jean Nicolau Forestier (1926).

The modern architecture of the city, influenced especially by the Liberty style in all its variations, was interpreted to suit all the various types of new buildings, from apartment blocks rising five or more floors, to cinema halls, banks, shopping centers, and elegant restaurants. Apartments were equipped with characteristic blue-hued bathrooms and served by electric elevators. Typical of this period are the López Serrano building, the América building, and the Emilio Bacardí building, all dating to the 1930s. The funerary architecture of the 1930s, seen in the Christopher Columbus Cemetery, which opened in 1871 as a monument in the style of the San Fernando Royal School in Madrid, also reflected modern influence, featuring simple yet elegant vertical lines. A typical example of this style can be admired in the Barò-Lasa family tomb, designed mainly by René Lalique.

The port continued to flourish, creating jobs for the populations of working-class port towns such as Regla, Guanabacoa, Casablanca, and the poorer districts of Old Havana formerly within the walls. Although the walls were removed in 1863, the forty-three city districts that since 1923 fell under the municipality of Havana could not accommodate the city's growing population. By 1950, Havana was transformed into an urban metropolis with over 500,000 people, having incorporated other, smaller municipalities as well as the port towns.

Marianao was the largest new addition to the metropolitan area and was settled mainly by

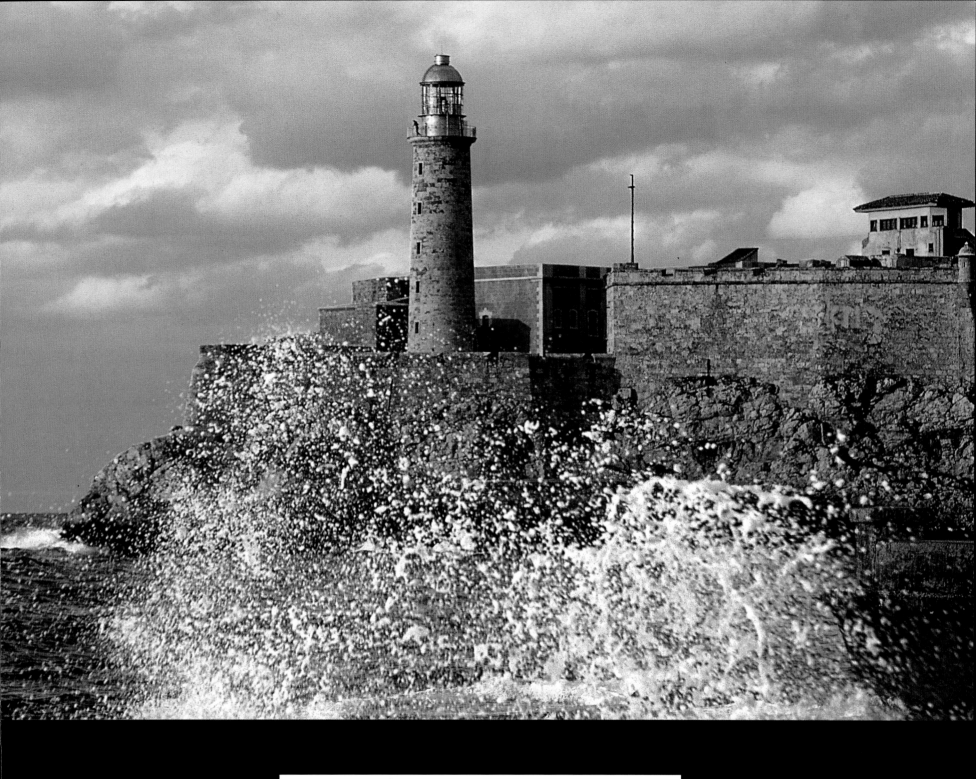
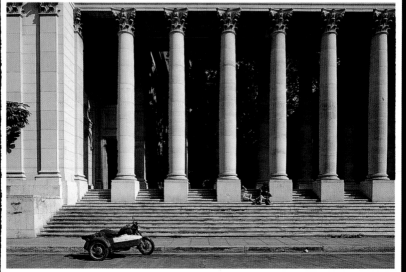

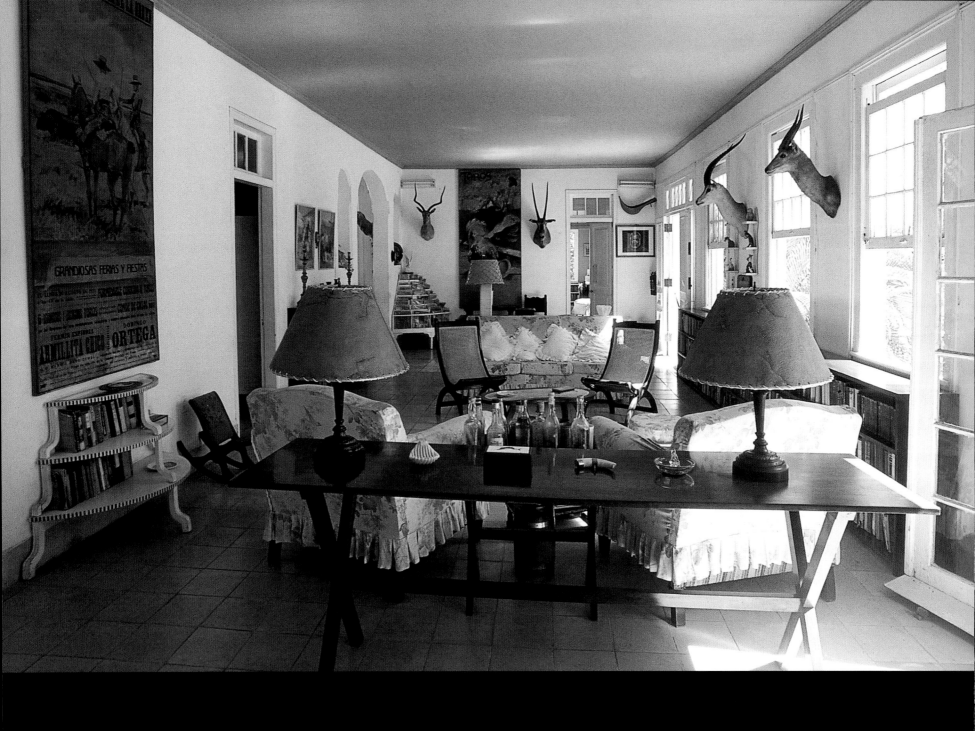

134 AND 135 A RESTLESS SPIRIT ALWAYS IN SEARCH OF NEW EXPERIENCES, ERNEST HEMINGWAY FOUND INSPIRATION IN CUBA FOR ONE OF HIS MOST FAMOUS WORKS, *THE OLD MAN AND THE SEA*. THE HOUSE IN WHICH THE WRITER LIVED, IN THE SUBURB OF SAN FRANCISCO DE PAULA CLOSE TO THE CENTER OF HAVANA, REFLECTS HIS PASSION FOR HUNTING, WHICH, ALONG WITH DEEP-SEA FISHING, BOXING, AND JOURNALISM, WAS ONE OF THE MANY FACETS OF HIS ADVENTUROUS LIFE. TODAY THE HOUSE IS A MUSEUM, AND HAS REMAINED ALMOST EXACTLY AS HE LEFT IT.

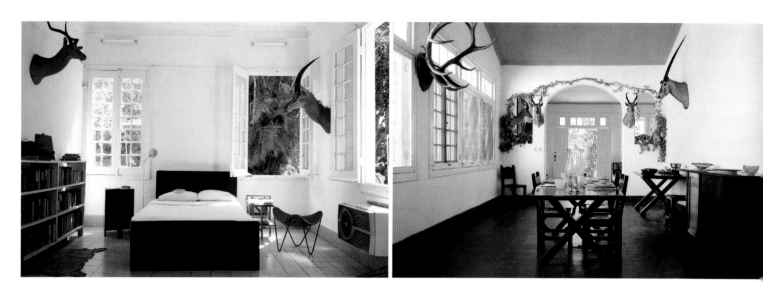

Havana's varied and cosmopolitan upper middle classes. This municipality housed a population of about 250,000 in 1953. Departing from the conventional grid plan, its districts were modern, such as the gardened Country Club (1915) or Miramar (1919) with its highly prized sea view, featuring seafront villas with swimming pools arranged around a central tree-lined axis. Marianao also featured well-organized recreational facilities—cinema halls, yacht clubs, a race course, a modern drive-in theater, and a trendy cabaret with an open-air dance floor, nestled in the middle of luxuriant tropical vegetation, designed by the Cuban architect Max Borges.

South of Havana, the former municipality of the tobacco town of Santiago de las Vegas was converted into an international tourist destination with the 1928 opening of an airport originally managed by Pan American Airways, and now known as the José Martí Airport. Havana's southeastern districts, such as Santos Suárez, Lawton, and La Víbora, are linked to the city's traditional business district by the historical artery Jesús del Monte (Diez de Octubre). The hills of La Loma del Burro and Chaple, on which these districts stand, afford spectacular views of the landscapes rising up from the magnificent bay. Conveniently located close to the large sports center, Ciudad Deportiva, as well as the countryside, these city districts, with their rectilinear grid plan and surrounding natural landscape, have been further enhanced by spacious parks, gardens, and large courtyards planted with fruit trees.

The first Town Planning Regulations for the overall city was drawn up in 1960 on the basis of scientific, topographical, and economic studies. The preservation of the old colonial town center was managed by experts on the National, Provincial, or Municipal Committees for the Cultural Heritage, which worked in concert with the City Historian's Office that was set up in 1940 and initially placed under the historian Dr. Emilio Roig de Leuchsenring, until his death 1967. The city was thus able to conserve its urban and architectural heritage that has since been afforded international protection as a World Heritage Site.

Lying a few miles to the southeast of the center of the capital, the suburb of San Francisco de Paula can boast that this was where the adventurous and contradictory hero Ernest Hemingway spent the last twenty years of his life. The house he lived in, Villa Finca Vigía, has been left intact since 1960, when its famous owner returned to the United States. It is now a museum, though unique in that, for security reasons, visitors are required to look at the rooms and their contents from the outside.

Overlooking the coast to the northeast of San Francisco de Paula is another locality associated with Hemingway, or rather, one of his most famous works. That is Cojimar, the fishing village he chose as the setting for his novel, *The Old Man and the Sea*, that won him the Nobel Prize for Literature in 1954. With the book in hand, here one can find the places and bars described by the author.

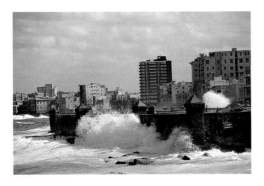

136 **TOP** The famous Havana promenade, the Malecón, joins the three central districts in Havana.

136 **CENTER** Hotels and other modern buildings are to be seen among the more typical low buildings that line the Malecón, yet their presence does not spoil the beauty of this splendid promenade.

136 **BOTTOM** Whether morning or evening, the Malecón is always the busiest street in the capital.

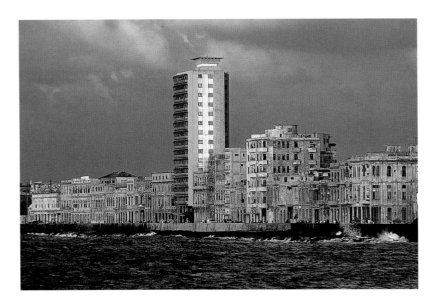

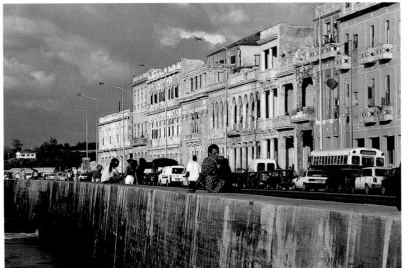

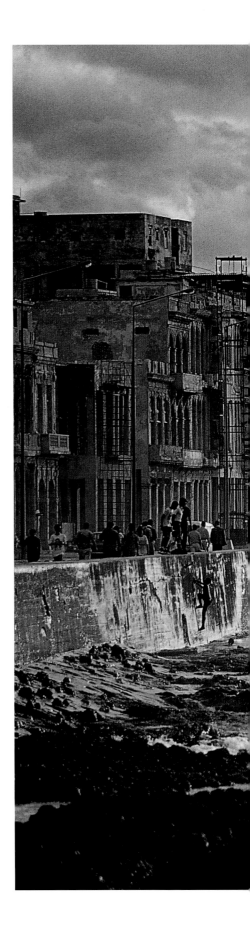

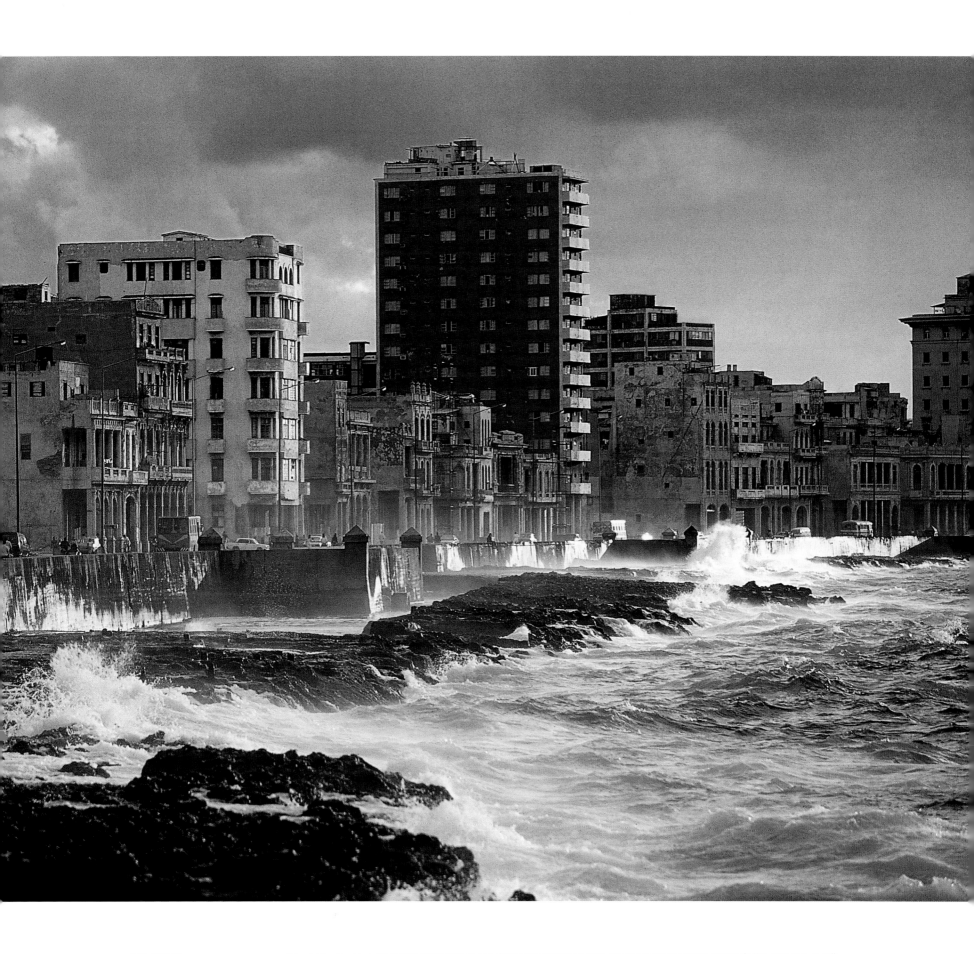

136-137 The three miles of the Malecón pulsate with the daily life of the Habaneros, who refer to the street as the capital's "drawing room."

138-139 The Malecón does not just offer the spectacle of the people who bring it to life; the ocean waves also do their part.

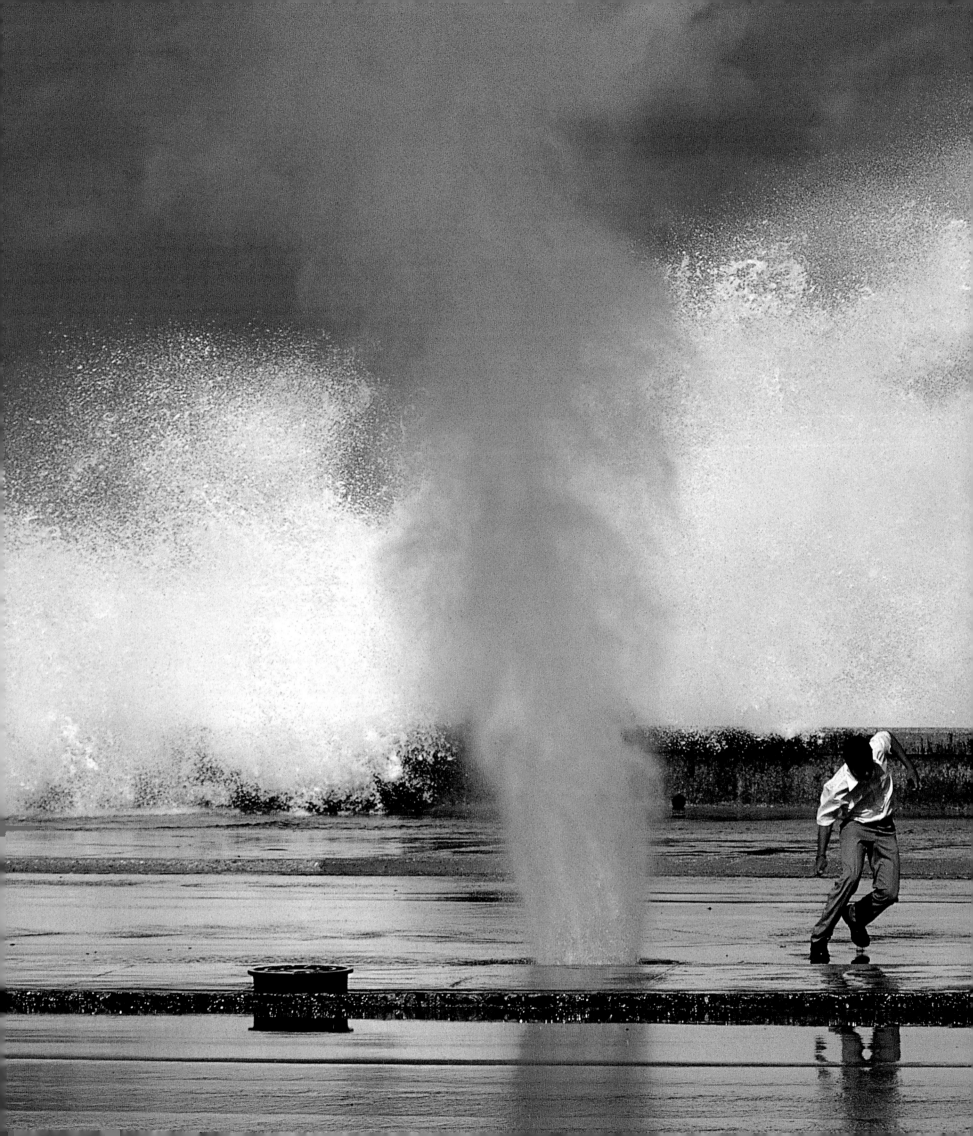

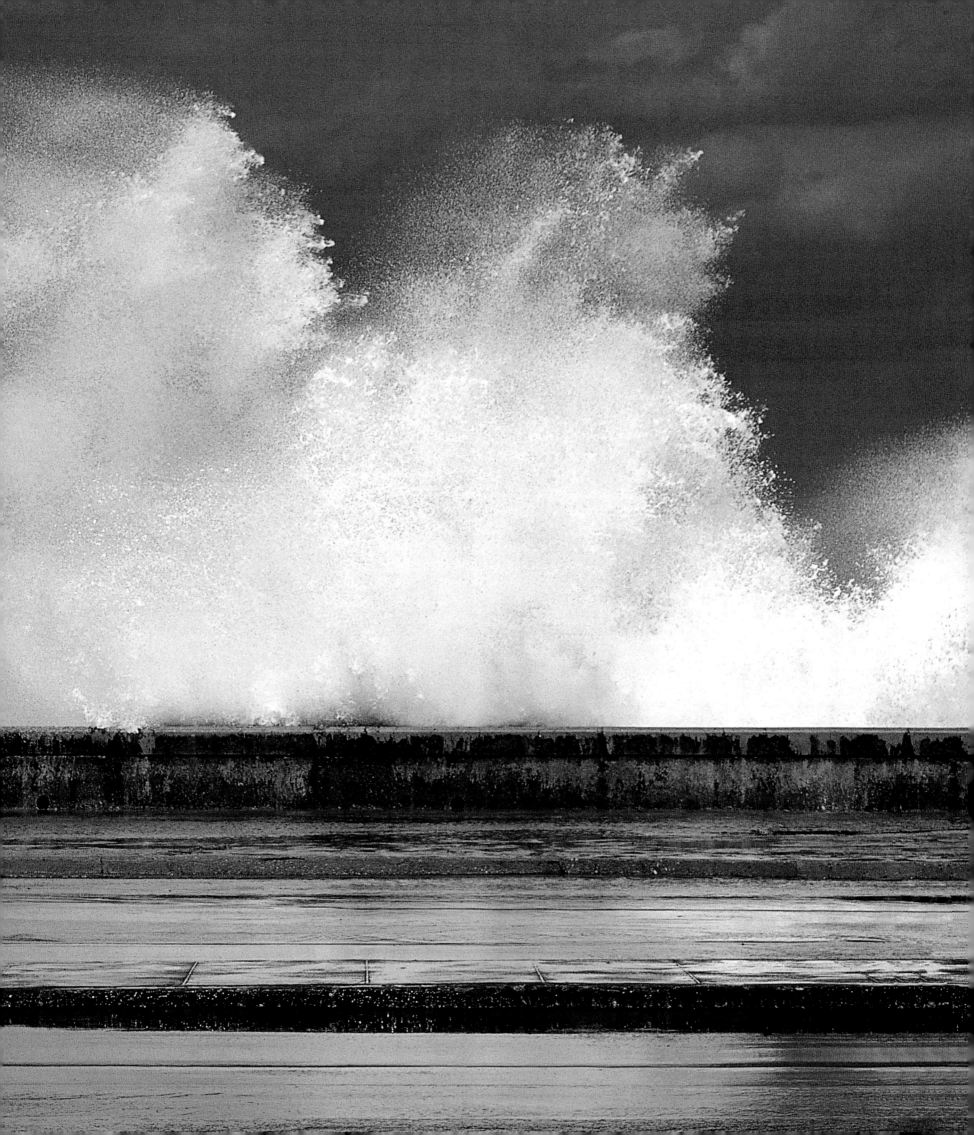

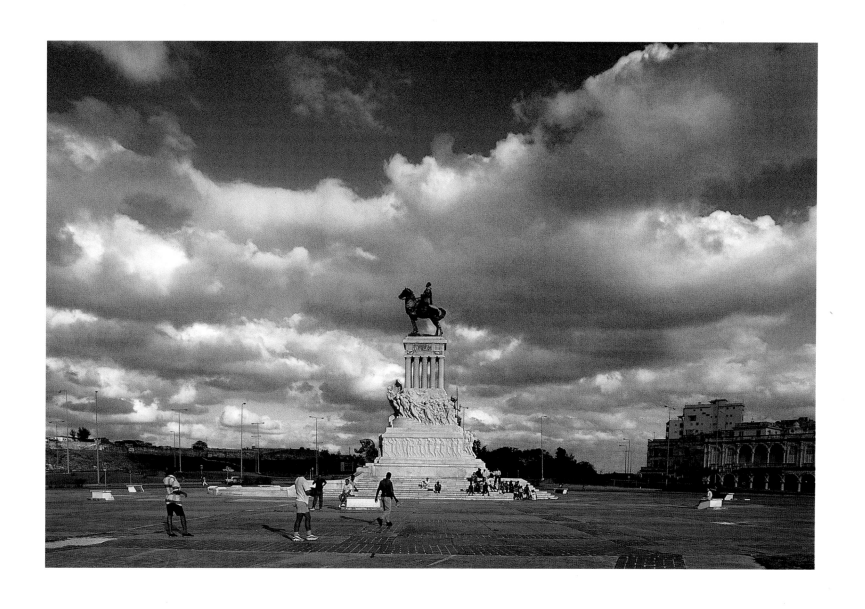

140 MARBLE FIGURES EXEMPLIFY THE CUBAN STRUGGLE FOR FREEDOM ON THE PEDESTAL OF THE MONUMENT DEDICATED TO MÁXIMO GÓMEZ, THE GENERAL WHO FOUGHT ALONGSIDE MARTÍ IN THE FIGHT FOR INDEPENDENCE.

141 SINCE 1935 THE EQUESTRIAN STATUE OF MÁXIMO GÓMEZ HAS OCCUPIED THE CENTER OF A VAST, ROUND TERRACE AT THE NORTHERN TIP OF HABANA VIEJA, NEXT TO THE MOUTH OF THE CANAL THAT FLOWS INTO THE BAY OF THE PORT. UNLIKE THE INTELLECTUAL MARTÍ, GÓMEZ WAS A MAN OF ACTION AND IN THE FRONT LINE DURING THE FIRST AND SECOND WARS OF INDEPENDENCE. HE GUIDED THE REVOLUTIONARY PARTY OF CUBA FROM ITS FOUNDATION IN 1892.

142 TOP Plaza de la Catedrál is a superb example of colonial architecture dominated by the elegant cathedral. Designed in the style typical of Borromini, construction of the church was begun by the Jesuits in 1748 but they were not allowed to complete it. In 1767 the order was expelled from Cuba and the rest of Spanish Latin America.

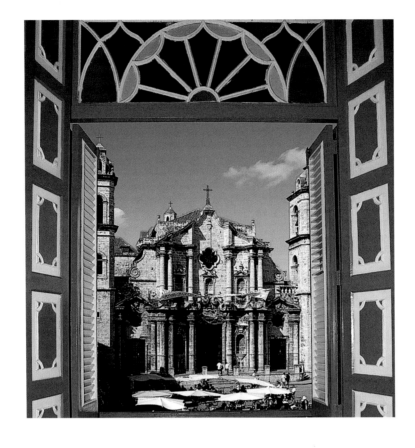

142 CENTER The secondhand book market is held in front of the terraces of the Castillo de la Real Fuerza, which was completed in 1577 and was the seat of the Spanish governors until the last years of the eighteenth century.

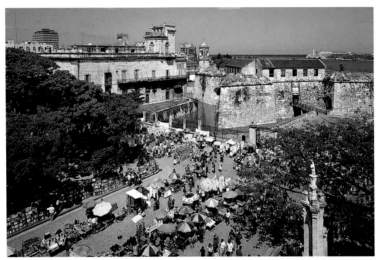

142 BOTTOM The Cuban mix of Socialism and religion is truly peculiar: The revolutionary heroes are also displayed at the market in the Cathedral fair.

143 The straightforward baroque architecture to be seen in Plaza de la Catedrál is softened by the women of Havana dressed in bright clothes.

144-145 Murals are not the only form of political propaganda. More than thirty years after his death, Che Guevara "monopolizes" the reading material of the inhabitants of Havana, judging by the number of works dedicated to him among those displayed in the secondhand book market in Plaza de Armas.

146-147 The monastery of San Francisco de Asís dominates the lovely square dedicated to the saint. In the center there is the Lion fountain, a nineteenth-century work by Giuseppe Gazzini.

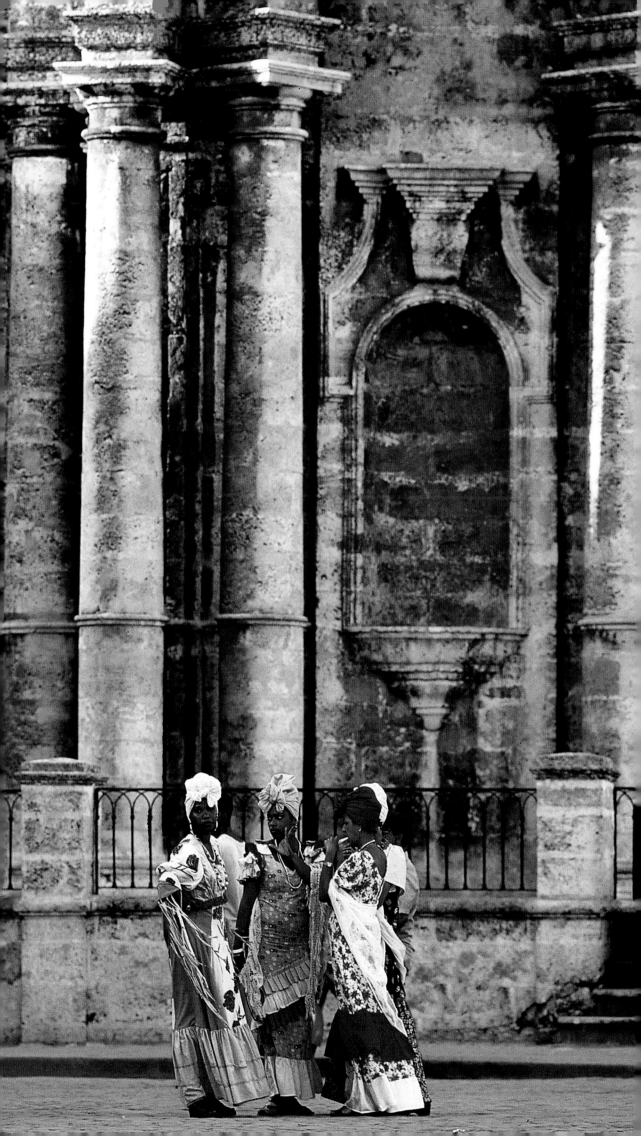

la
co
el C

GION

UN GRAN
DE MA

EDITORIAL CAPITAN SAN LUIS

UN HOMBRE B

Adys Cupull y Froilán C

EL
PENSAMIENTO
ECONOMIC
DE

ERNE
CHE
CU

Carlos Ta

premio
casa
de las américas
198

EL DIARIO
DEL CHE
EN BOLIVIA

LA PRISIO

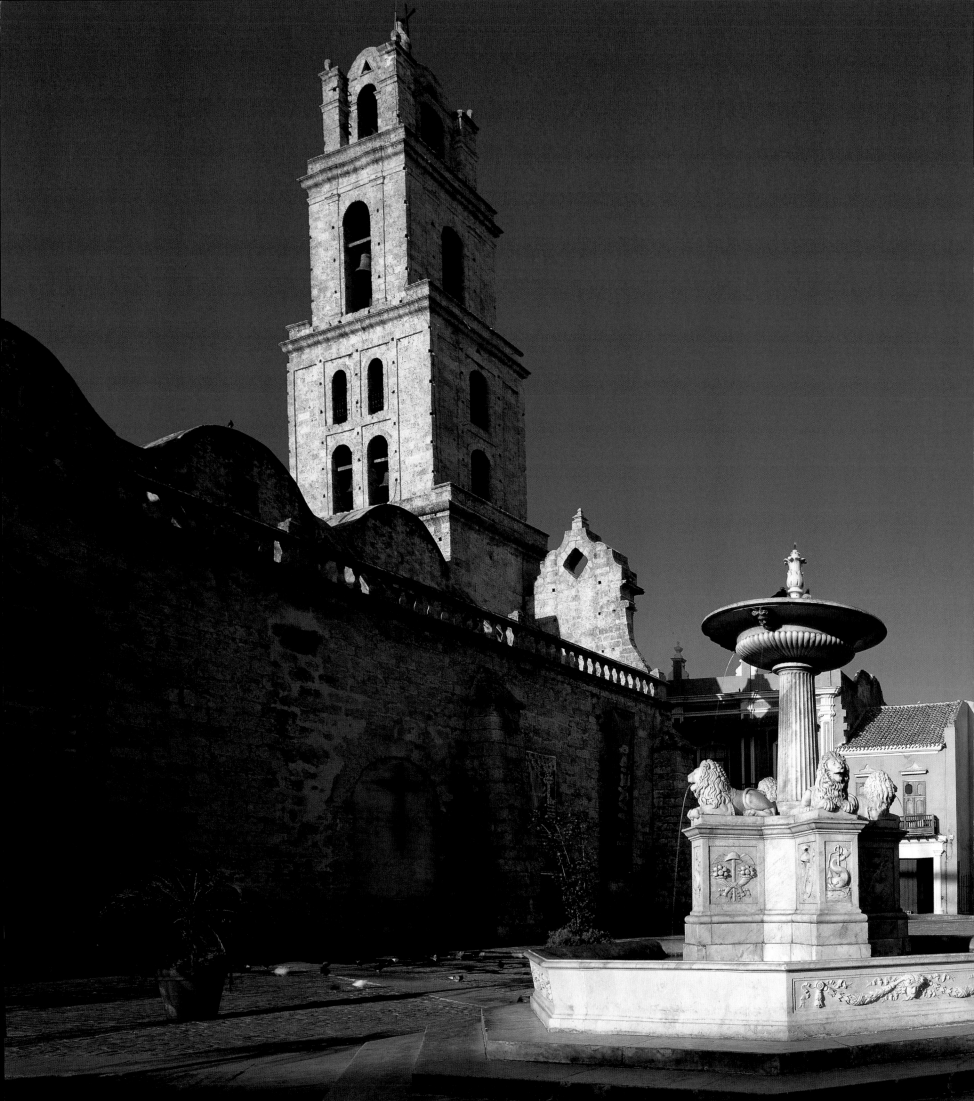

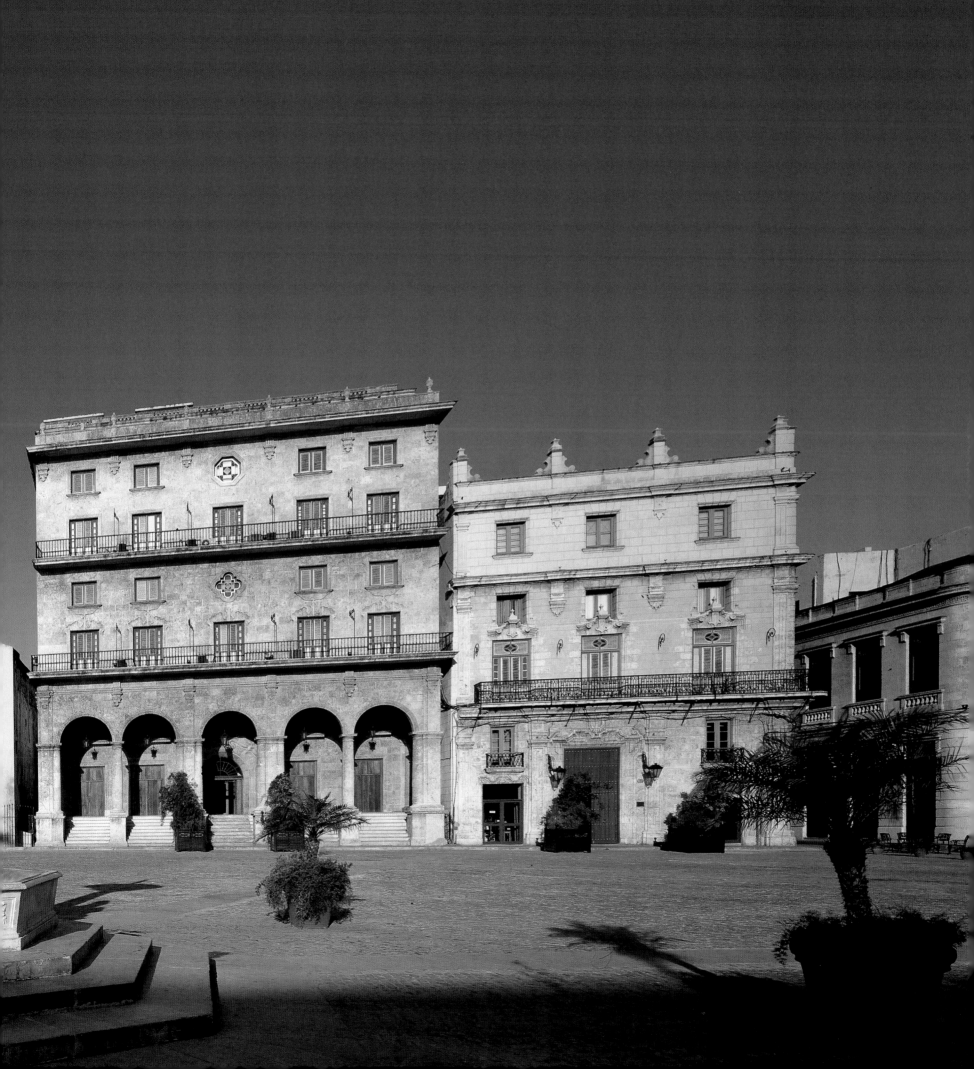

148 TOP WHAT COUNTS IS COLOR: FROM CARS TO CLOTHES, MARKETS, AND BUILDINGS, THE ENTHUSIASM FOR BRIGHT COLORS CAN BE SEEN THROUGHOUT HAVANA. THE SAME CAN BE SAID EVEN FOR DETAILS—FOR EXAMPLE, THIS MAJOLICA STREET SIGN.

148 BOTTOM LEFT AND RIGHT BECAUSE OF THEIR PROXIMITY TO THE SEA, THE OLD DISTRICTS IN HAVANA REQUIRE FREQUENT RESTORATION.

149 DERIVED FROM AN EMINENTLY HISPANIC TRADITION, THE DECORATION USING *AZULEJOS* CONTRIBUTES TO THE ELEGANCE OF HAVANAN ARCHITECTURE WITH ITS VIVACITY.

150-151 COMPLETELY "DECORATED" WITH SIGNATURES, WRITINGS, AND PHOTOGRAPHS OF THE FAMOUS, UNTIL THE 1950s THE BODEGUITA DEL MEDIO WAS ONE OF THE MOST CELEBRATED RESTAURANTS IN HAVANA, THANKS TO THE FAME OF ITS GUESTS. THE AUTHENTICITY OF THE SIGNATURE OF HEMINGWAY (151, BOTTOM) IS, HOWEVER, DOUBTFUL.

152-153 EL FLORIDITA (TOP LEFT AND CENTER LEFT), HABANA CAFÉ (BOTTOM LEFT), AND CAFÉ MONSERRATE (RIGHT) ARE IMPORTANT NAMES IN HAVANA AS THEY ATTRACTED FIGURES FROM THE WORLDS OF SHOW BUSINESS AND CULTURE. HEMINGWAY CAN BE SEEN ON THE FIRST FLOOR IN THE PHOTOGRAPH BELOW, TAKEN IN THE HABANA CAFÉ.

J. RUIZ DE LUNA TALAVERA
ESPAÑA

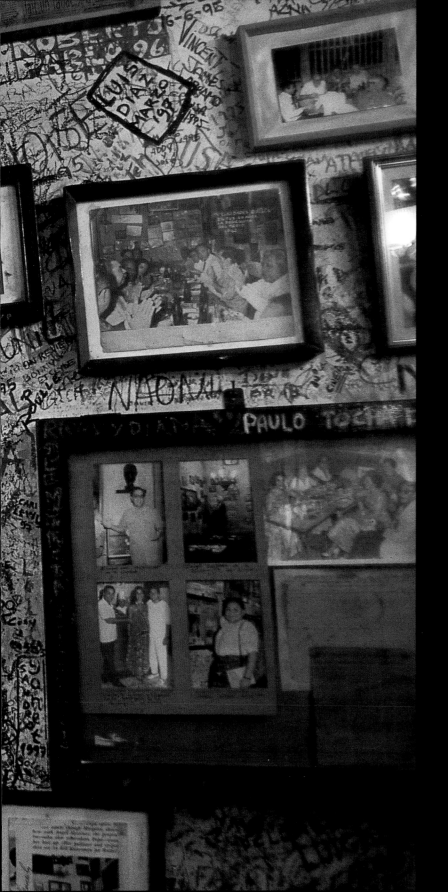

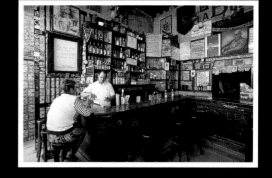

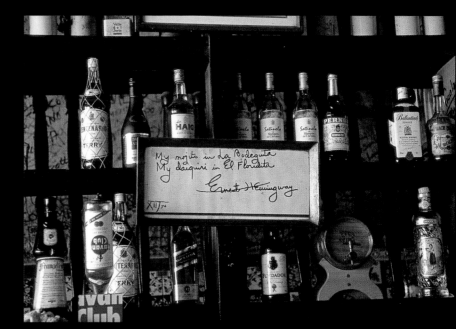

My mojito in La Bodeguita
My daiquiri in El Floridita

Ernest Hemingway

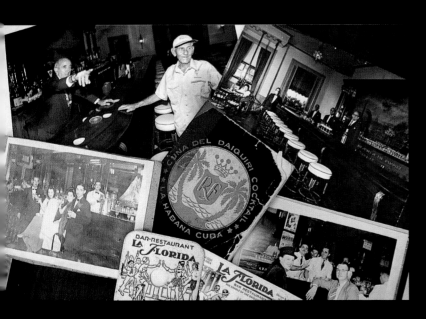

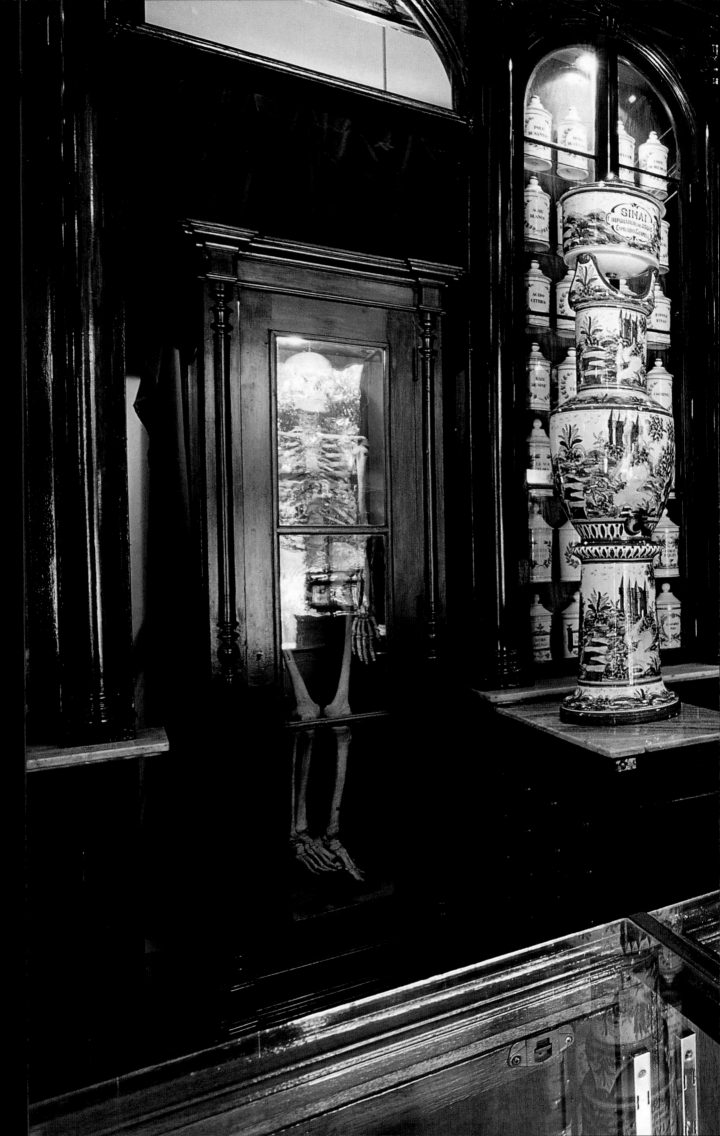

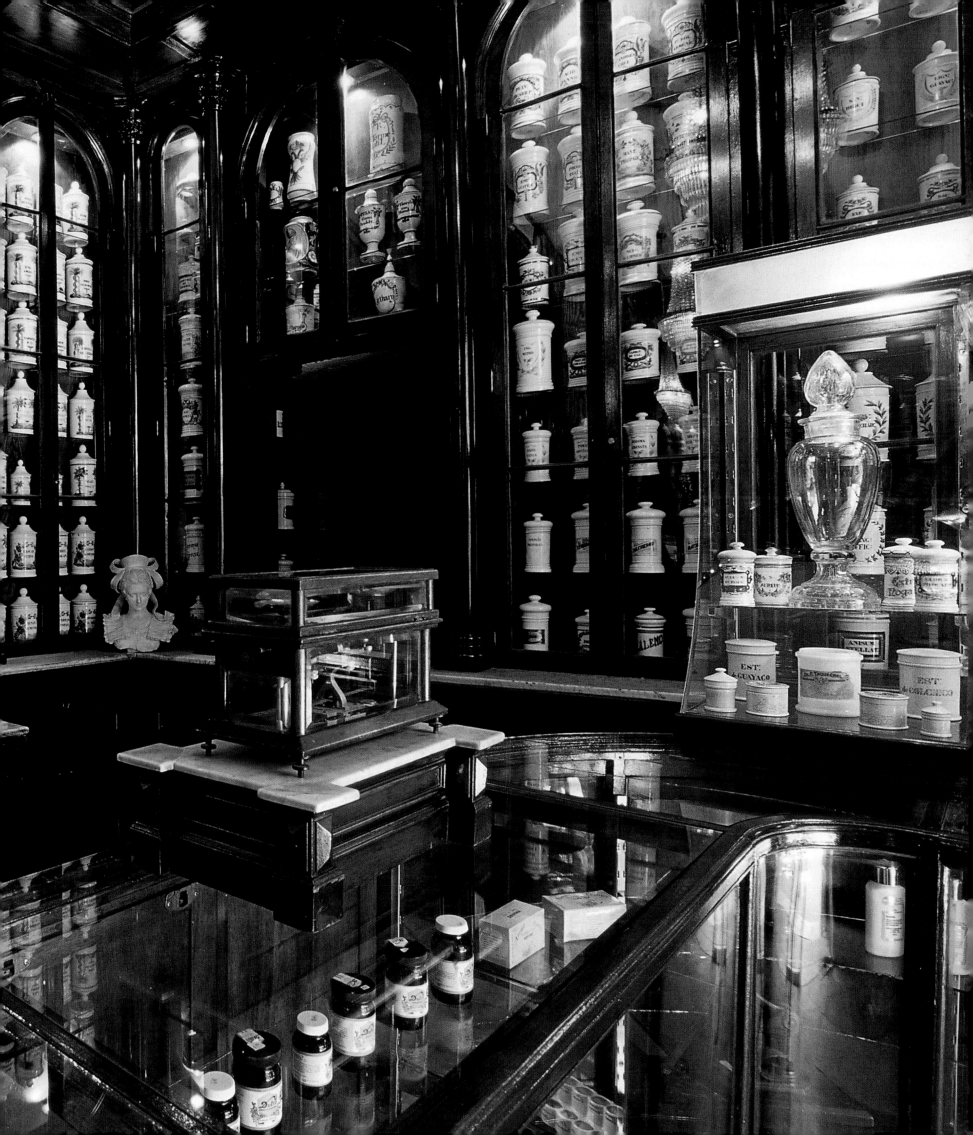

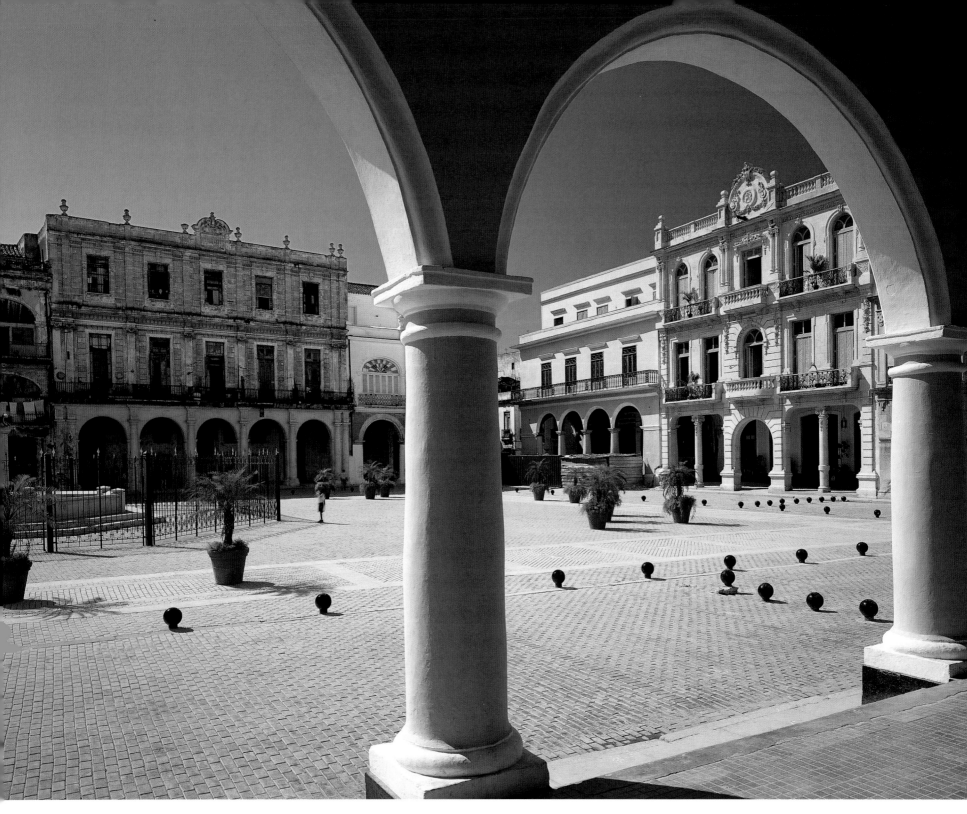

154–155 Like many other shops in Havana, the pharmacy in Calle Obispo has lost nothing of its old-world charm. Each "piece" on the shop's ancient shelves is a collector's item: With its mortars, retorts, and stills, this shop is a "living museum" of the apothecary's trade.

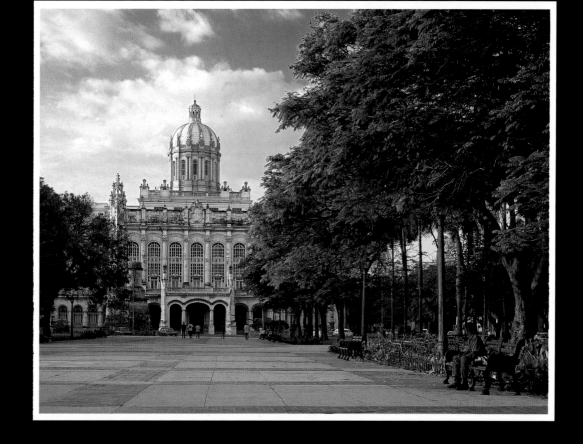

156 TOP AND BOTTOM The open Plaza Vieja, close to the monastery of San Francisco de Asís, dates from the sixteenth century. After being the setting for mostly commercial activities, including a slave market, it fell into decline during the mid-twentieth century, but fortunately the beauty of its buildings inspired the cleaning up and restoration of the entire area recently.

157 The elegant dome of the Museo de la Revolución dominates the former presidential palace in Havana. In 1957 it was here that the dictator Fulgencio Batista escaped an assassination attempt. Now the building houses an interesting collection that tells the history of the island from the colonial era to the revolution.

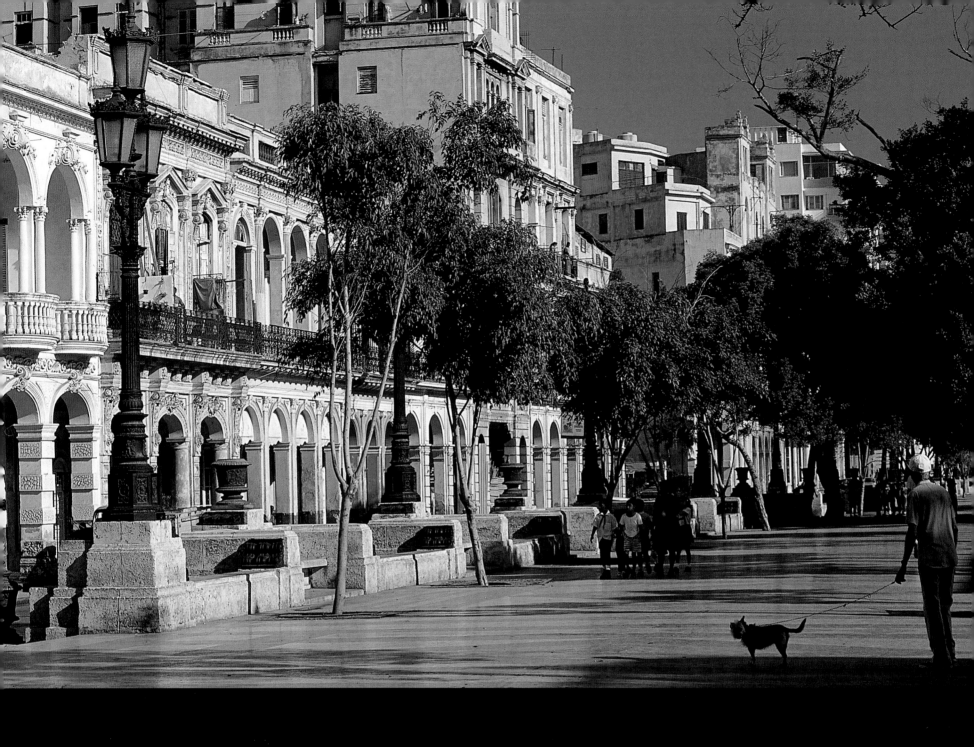

158 TOP The Paseo de Martí, absolutely spic and span, is one of the most interesting streets in the old city. Entirely lined by houses with porticoes, it runs north-south from the Malecón to the Parque Centrál.

158 BOTTOM The rooms of the Hotel Condé Villanueva in Habana Vieja reveal another luminous feature of Havanan architecture—multicolored Art Deco lunettes.

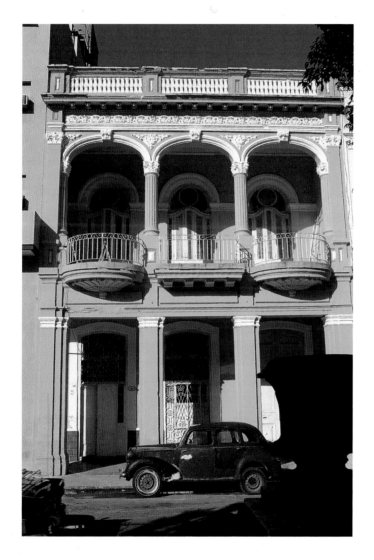 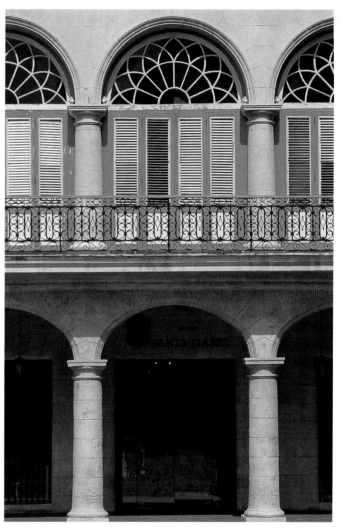

159 LEFT As "old" as the other famous cars of Havana, but notably more rundown and modest, a jalopy forms a strong contrast with the radiant cleanness of a portico on the Paseo de Martí.

159 RIGHT Pale pink, red, and pale and dark blue: These are the colors of the Hotel Santa Isabél in Plaza de Armas, which faces onto the port Canal de Entrada.

160 AND 161 Architectural details and a close-up: From any angle, the Paseo de Martí is an unending source of visual delight.

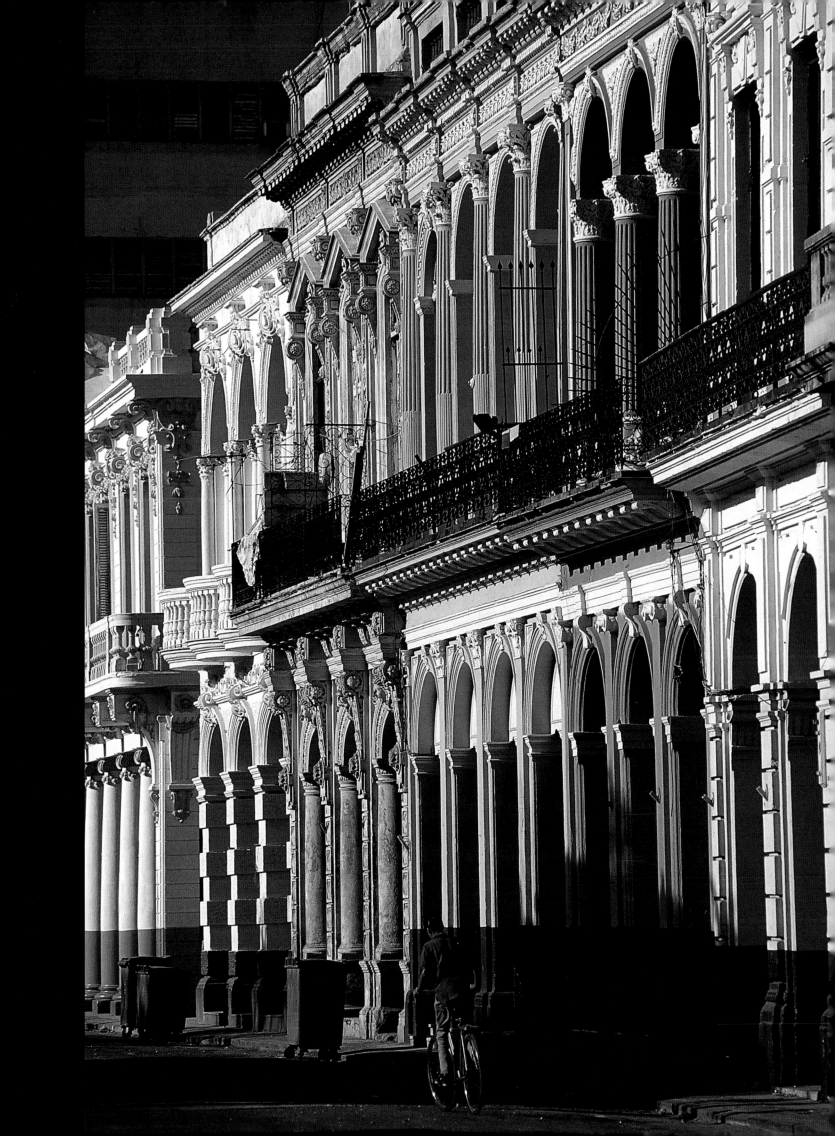

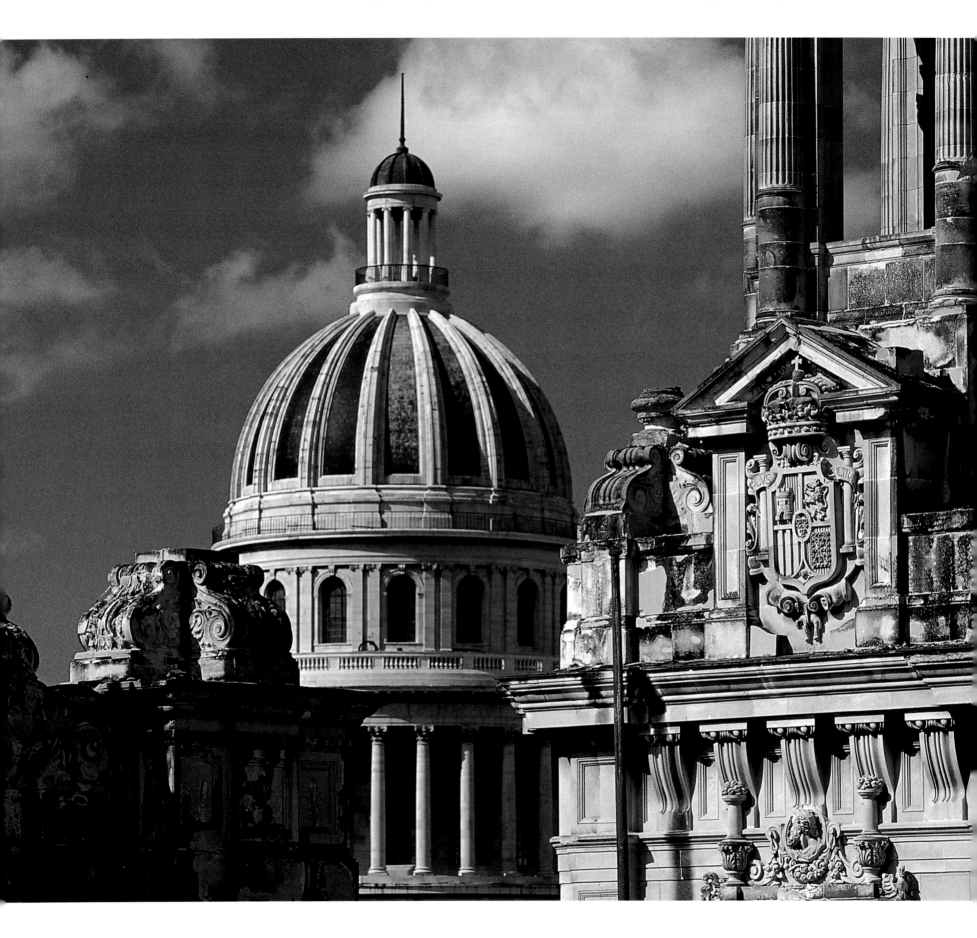

163 TOP LEFT AND RIGHT PLAIN OUTSIDE, THE CAPITOL IS CLEARLY MODELED AFTER THE BUILDING IN WASHINGTON. INSIDE THERE ARE MORE INTERESTING AREAS, FOR EXAMPLE, THE SALÓN DE LOS PASOS PERDIDOS (LEFT) WHICH IS 400 FEET LONG, AND THE PEACEFUL ROOMS OF THE NATIONAL LIBRARY (RIGHT) NAMED AFTER JOSÉ MARTÍ.

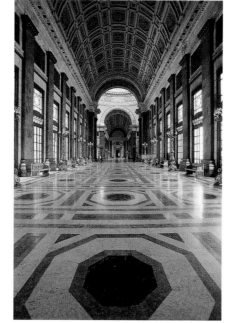

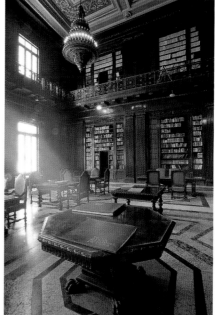

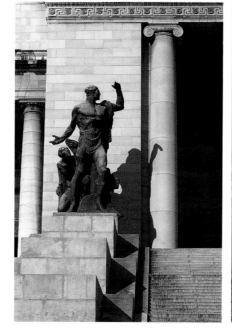

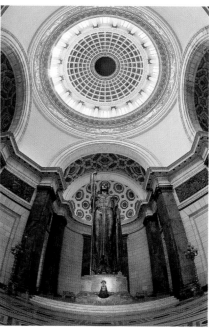

163 BOTTOM LEFT AND RIGHT NO EXPENSE WAS SPARED ON BUILDING THE CAPITOL. THE TWO STATUES THAT FLANK THE ENTRANCE (LEFT) AND, ABOVE ALL, THE EFFIGY OF THE REPUBLIC (RIGHT) BELOW THE DOME (ALL BY THE SCULPTOR ANGELO ZANELLI) ARE VERY IMPOSING. AT FIFTY-SIX FEET HIGH, THE REPUBLIC IS ONE OF THE LARGEST BRONZE SCULPTURES IN THE WORLD.

164 TOP The present Gran Teatro de La Habana is the home of the national ballet company. It was built around an earlier theater, the Tacón, founded in 1834. The auditorium can hold 2,000 spectators.

164 BOTTOM The steps in the Gran Teatro are indicative of the originality of the vast complex, which includes the Centro Gallego, inaugurated in 1915 as a social club for immigrants from Galicia.

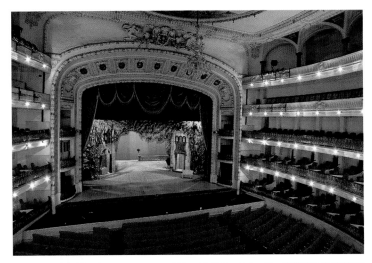

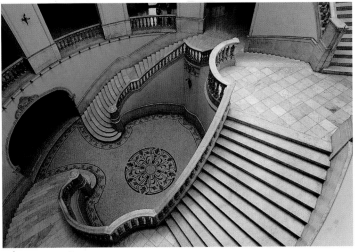

164-165 The highly decorated neo-Baroque facade of the Centro Gallego heralded certain Art Deco themes. The complex was designed by the Belgian architect P. Belau.

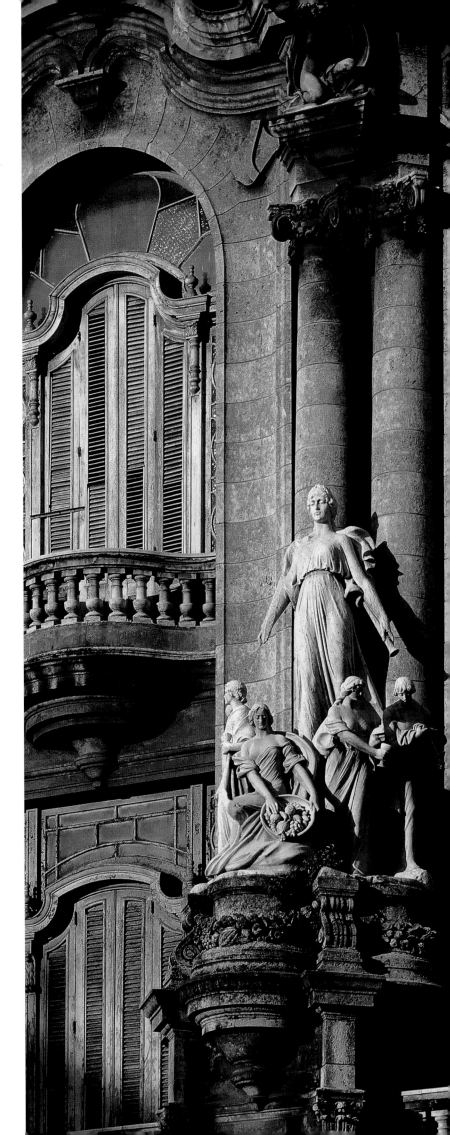

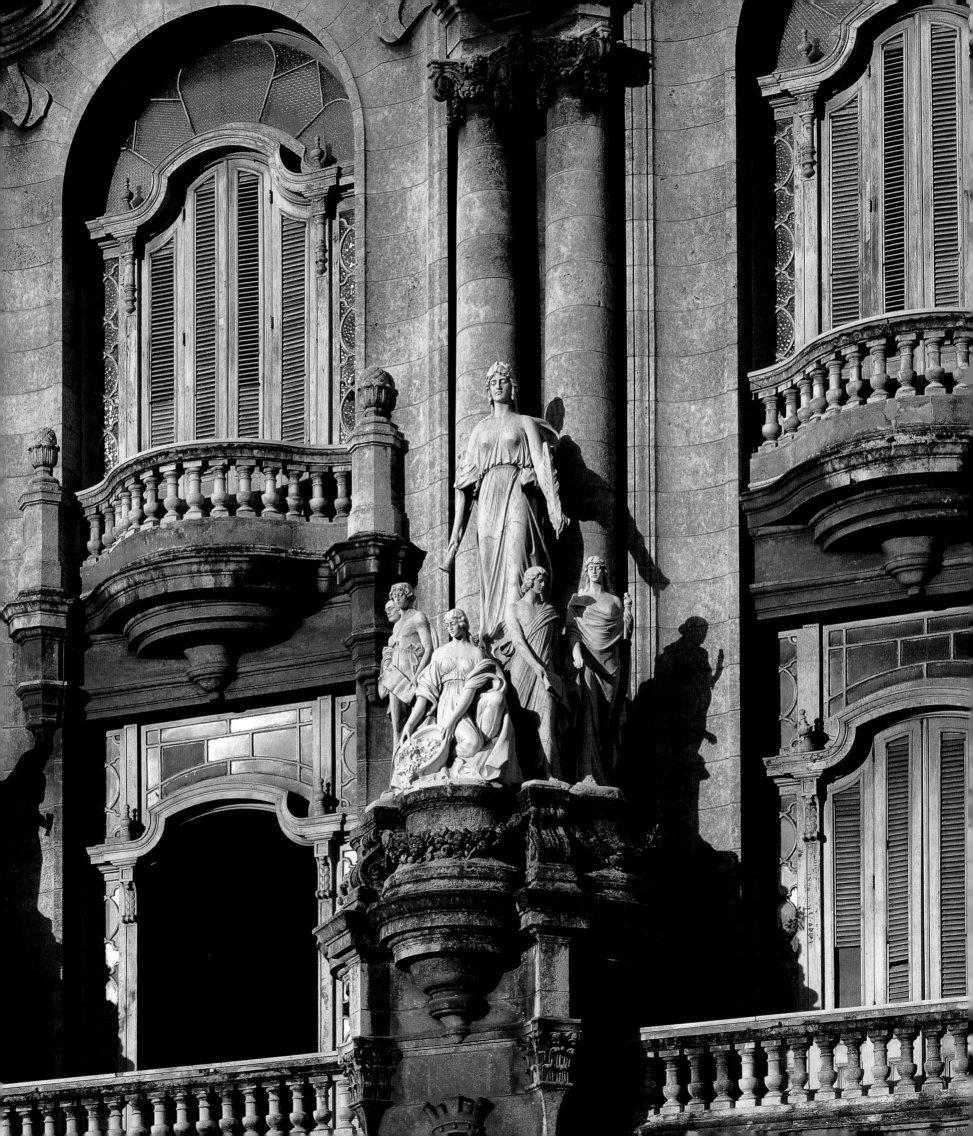

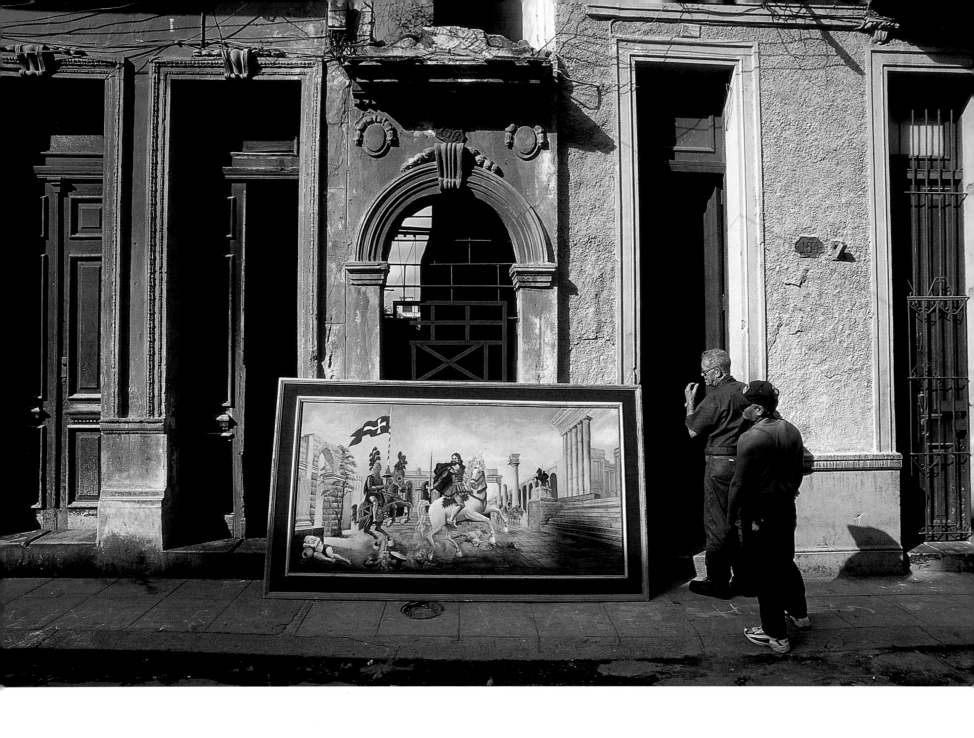

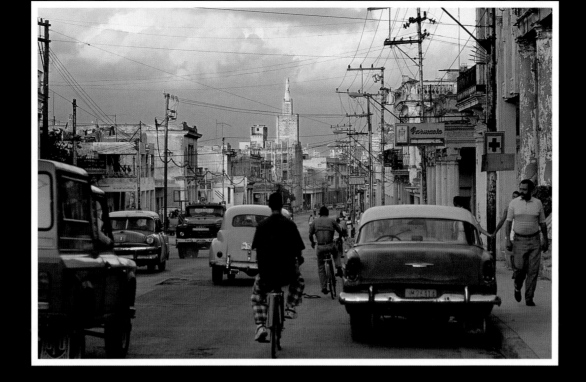

166 TOP *ARS GRATIA ARTIS*: IN CALLE JON DE JAMEL THE CREATIVITY OF THE PEOPLE IS SHOWN LIBERALLY AND TO GREAT EFFECT.

166 BOTTOM A CROWDED BUS IN THE PASEO DE MARTÍ. IN A COUNTRY IN WHICH FUEL IS RATIONED, PUBLIC TRANSPORTATION IS FOR MANY THE ONLY MEANS OF TRANSPORTATION FOR MOVING AROUND THE CITY, WHICH STRETCHES FOR OVER THIRTY MILES ALONG THE COAST.

167 EVENING FALLS IN CERRO, THE QUARTER THAT LIES NEXT TO THE SOUTH SIDE OF CENTRAL HAVANA.

168 TO 175 BRIGHTLY COLORED, SPONTANEOUS ART ENLIVENS THE WALLS IN CALLE DE JAMEL. MURALS ARE AN IMPORTANT MEANS OF CULTURAL EXPRESSION AND SOCIAL CRITICISM BUT CAN ALSO ALLEVIATE THE DIFFICULTIES OF A LIFE THAT FOR MANY HABANEROS IS ANYTHING BUT EASY.

176 AND 177 BUILT AT THE SAME TIME AS THE CAPITOL, THE HOTEL NACIONÁL DISPLAYS THE SAME GRANDIOSE AND "AMERICANIZED" TASTE AS THE FORMER SEAT OF PARLIAMENT, AND THE GALLERY OF CELEBRITIES PAINTED AROUND THE LOGO INEVITABLY REMINDS THE OBSERVER OF THE YEARS BEFORE THE REVOLUTION AND A LIFESTYLE UTTERLY DIFFERENT TO THAT OF TODAY.

178–179 TROPICANA IS HAVANA'S MOST FAMOUS NIGHTCLUB. THE QUALITY OF THE SHOWS IS NOT OF THE HIGHEST, BUT THE SETTING—THE OPEN-AIR STAGE SURROUNDED BY TROPICAL VEGETATION—IS WORTHY OF A VISIT. THE ATMOSPHERE HERE IS PURE RETRO.

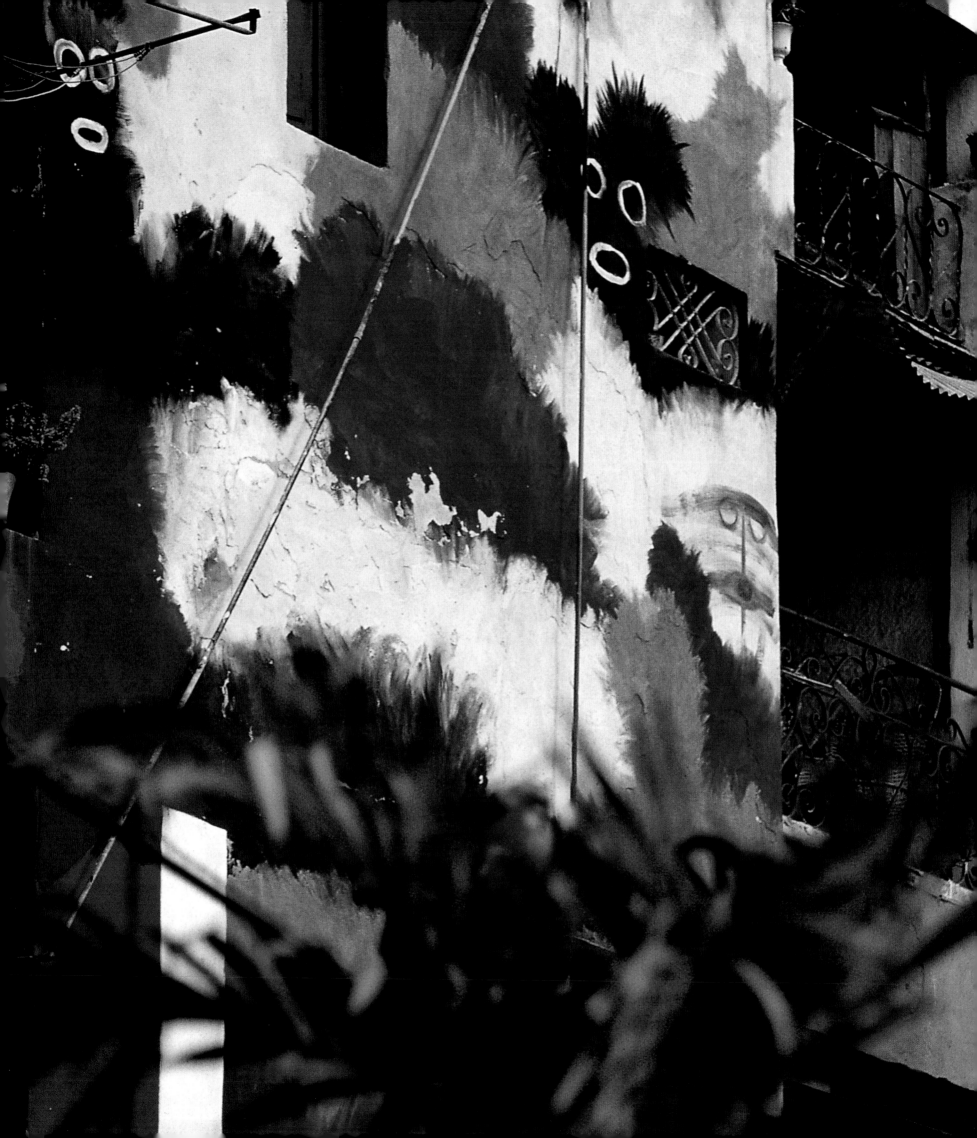

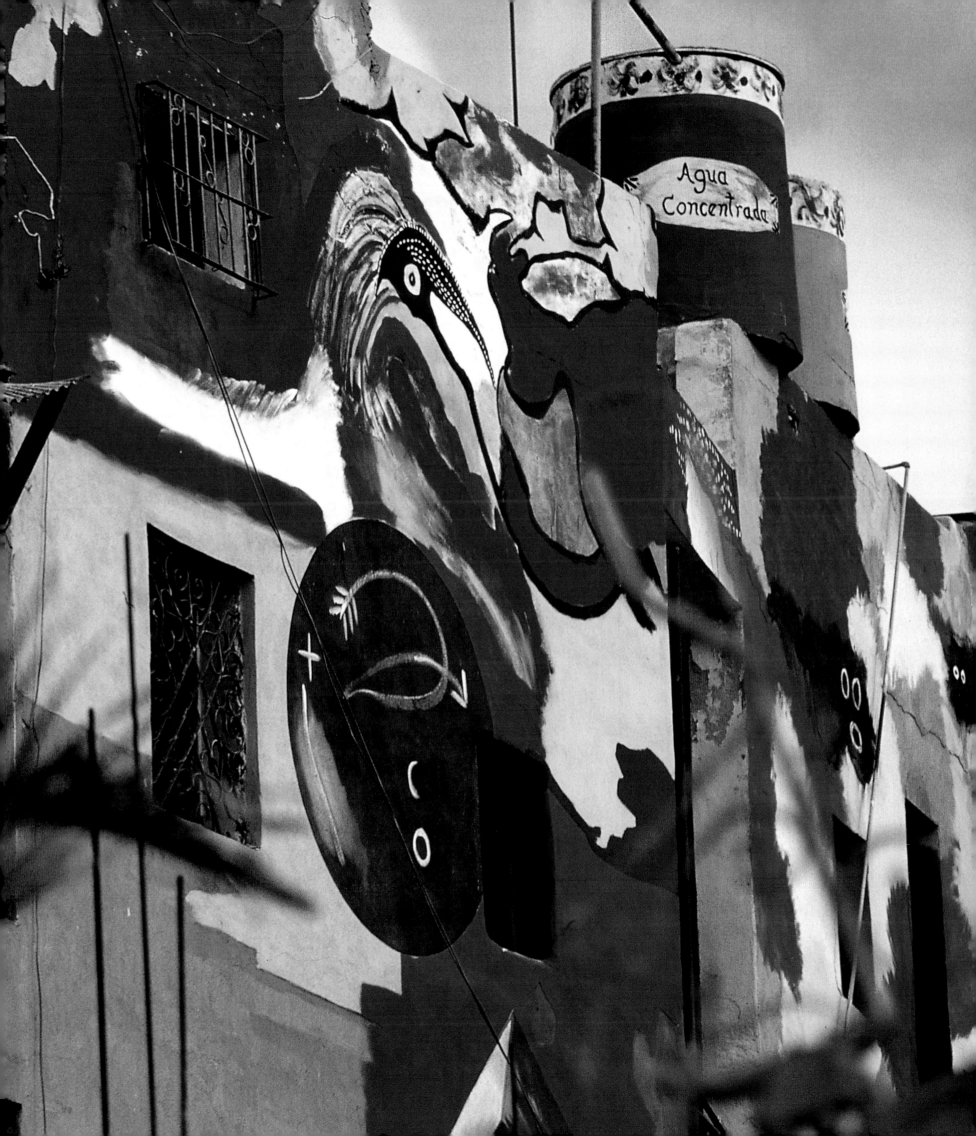

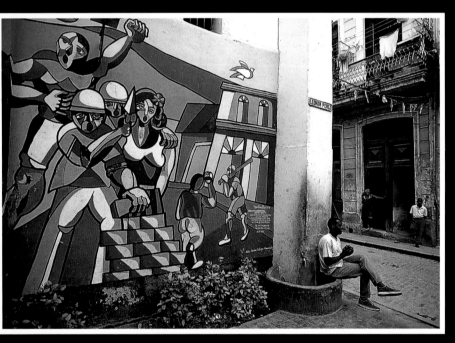
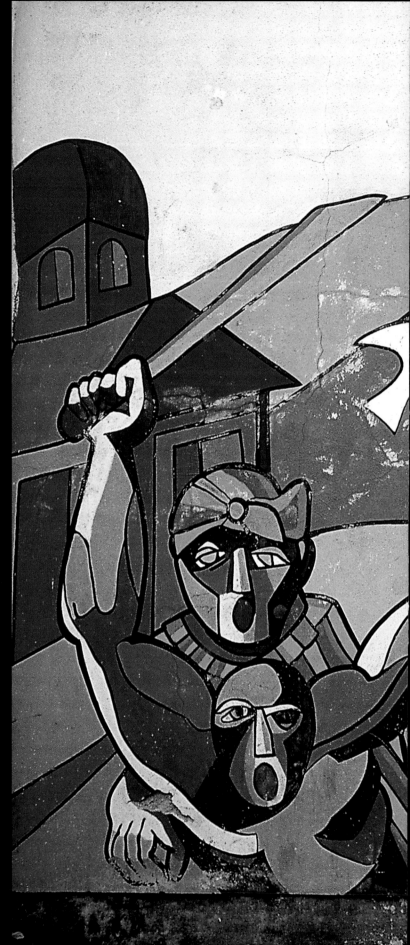

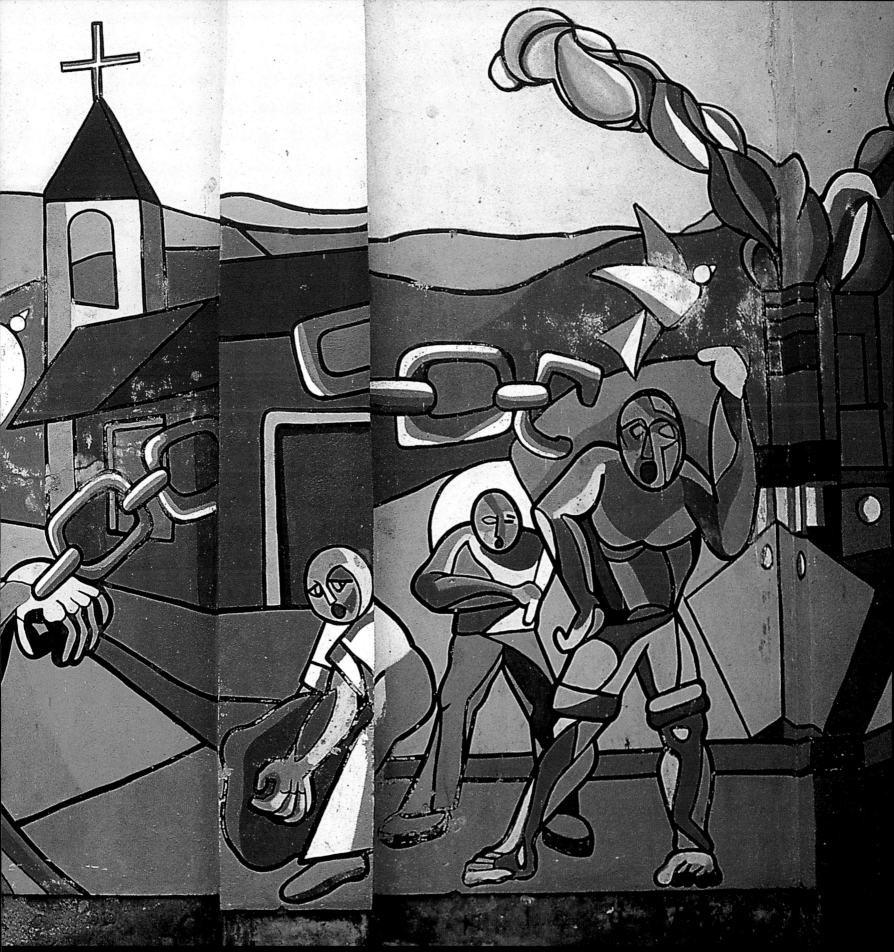

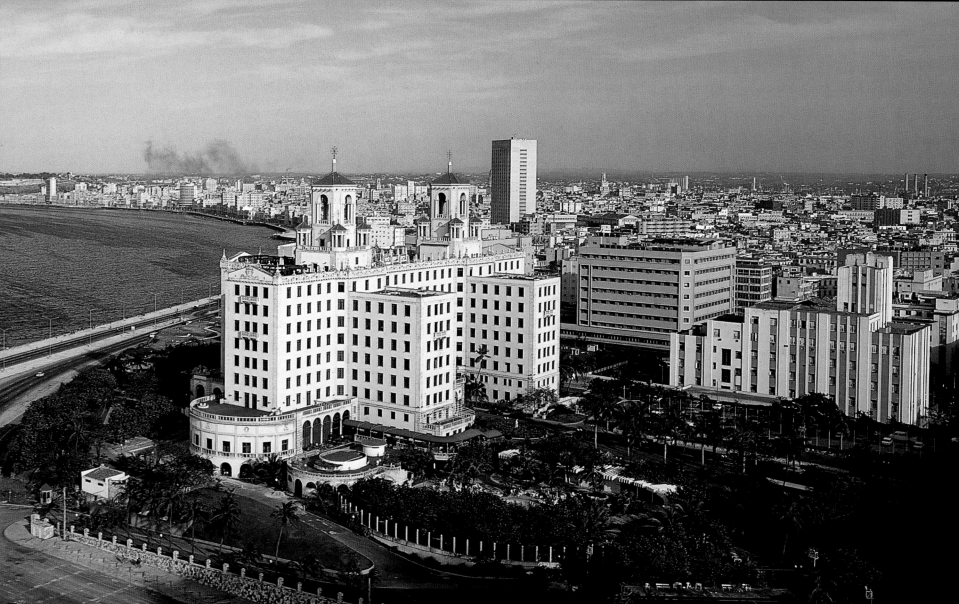

Pablo Casal

Lucho Gatica

Sinatra

Gardner

Mantle

Marlon Brando

Sarita Montiel

Arturo de Cór

Baron de Bornemisza

Yma Suma

Disney

John Wayne

Lola Flores

Porfirio Rubirosa

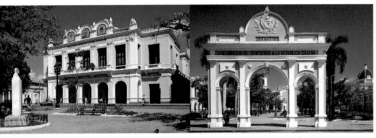
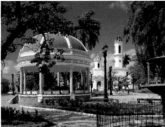

180 TOP THE DESIGN OF THE TEATRO TOMÁS TERRY (LEFT) WAS SUBJECTED TO APPROVAL BY THE FRENCH COMMISSION. IT IS NOT BY MERE CHANCE THAT CIENFUEGOS IS KNOWN AS THE "PARIS OF CUBA." THE TRIUMPHAL ARCH (CENTER) SURROUNDED BY THE MAJESTIC TREES OF MARTÍ PARK, BEARS THE DATE OF THE FIRST RENDERING OF THE CUBAN NATIONAL ANTHEM (MAY 20, 1902) AND IS DECORATED WITH AN ELEGANT, NEOCLASSICAL ROSE WINDOW (RIGHT).

CIENFUEGOS

THE PARIS OF CUBA

Despite the fact that the splendid Jagua pocket bay was visited by Christopher Columbus, who initially named it Puerto de Misas during his second voyage in 1494, as well as by Diego Velázquez in 1514, no attempt was made to settle the northern, more inland shores of the bay. Two centuries later, between 1742 and 1745, the Castillo de Nuestra Señora de los Angeles de Jagua was built at the site. The strategic importance of the area for the defense of the south of the island as well as Havana was highlighted by the Guantanamo Commission (1797–1802), chaired by the Cuban Joaquín de Santa Cruz y Cárdenas, first count of Santa Cruz de Mopox, who commissioned the French engineers, the brothers Félix and Francisco Lemaur, to draw up an urbanization plan for the site, with the goal of turning it into a permanent settlement. The result was the plan for a delightful city located above the Demajagua Peninsula, based on the clearly neoclassical rectilinear grid order, with large avenues and gardens, and located at the shore of the bay opposite the opening to the sea. The plan also included fortifications to reinforce the already existing Castillo.

Unfortunately, this project was never completed and the city now known as Cienfuegos in honor of Don José Cienfuegos y Jovellanos, who served as capitan general and governor of the island until 1816, was founded by Don Luis De Clouet, an immigrant from Louisiana, the French colony that was sold to the U.S. government without consulting its inhabitants. Clouet encouraged French immigrants, generally from Bordeaux, to settle in the new Antillean colony. Despite the difficulties involved in adapting to the new climate, the flourishing sugarcane plantations that nurtured the city's economic growth led to increasing development during the 1860s to the extent that in 1861 the city boasted 9,950 inhabitants, 433 stone houses, and a rail line between the port and the surrounding countryside.

Cienfuegos is marked by a strong neoclassical style with straight roads, perspectives that fade into the clear blue of the bay, perfectly aligned sidewalks and facades, and luxuriant parks cut by tree-lined pathways that dot the urban landscape, offering visitors a shady respite from the scorching sun as well as entertainment at exotic bandstands.

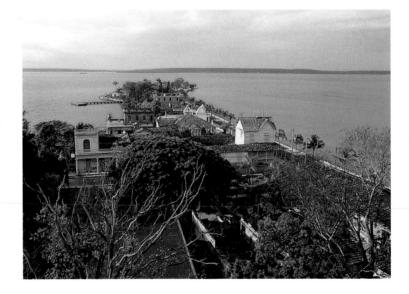

180 BOTTOM CIENFUEGOS OVERLOOKS ONE OF CUBA'S MOST SPLENDID BAYS, REMINISCENT OF HAVANA BAY. IN BOTH CASES THE POCKET BAY ALMOST FORMS AN INLAND SEA.

181 THE PALACIO DE VALLE, BUILT IN 1917 AS A PRIVATE RESIDENCE, SERVED AS A CATERING AND HOTEL MANAGEMENT SCHOOL BETWEEN 1960 AND 1990 AND NOW HOUSES A FAMOUS RESTAURANT.

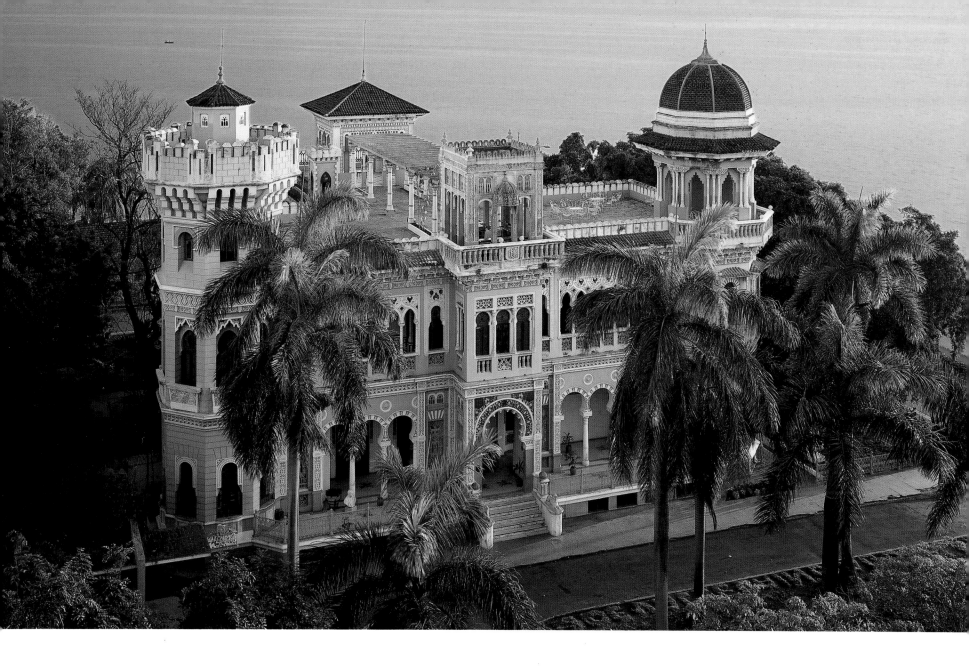

The flat roofs of the houses, crowned by the parapets of rooftop terraces and continuous balconies, highlight the horizontal perspective that prevails in the city's architecture. Iron railings adorn facades, interrupted by elaborate window blinds and openings leading to corridors.

During the twentieth century, Cienfuegos continued to develop as a major sugar-exporting port on the south coast. Some of its old sugar refineries that depended on slave labor have been conserved as monuments of Cuban industrial architecture.

Cienfuegos is rich in gems of colonial architecture, many of which have been declared National Monuments. The neoclassical parochial church of Cienfuegos was built on one of the sides of the main city square in 1869. Another noteworthy architectural masterpiece is the Tomás Terry Theater, inaugurated in 1890 and used for productions by theater and opera companies.

The Botanical Gardens were built in the early twentieth century. It features an astounding variety of species and originality of design.

The Acea Cemetery is of great artistic value. It was meant to replace the old Reina Cemetery built in 1837, the tombs of which were enclosed by decorative bronze or iron railings and fretwork doors adorned with biblical motifs, as well as tombstones in finely cut Carrara marble. These two cemeteries are part of a select group of Cuban funerary monuments, chief among which are the Christopher Columbus Cemetery in Havana and the Santa Ifigenia Cemetery in Santiago de Cuba.

The famous *sonero* musician Beny Moré once crooned in a popular ballad, "Cienfuegos is the city that I love the most." Many tourists spontaneously repeat this popular chorus without knowing what it means. They also feel that Cienfuegos is the "Paris of Cuba." Why? Perhaps because the French influence that lies rooted in its history stands out under the blaze of the tropical sun, as the entire city is enthused with the *joie de vivre* that gushes forth easily when one lives constantly surrounded by beauty, which is ever present in every nook and corner of Cienfuegos.

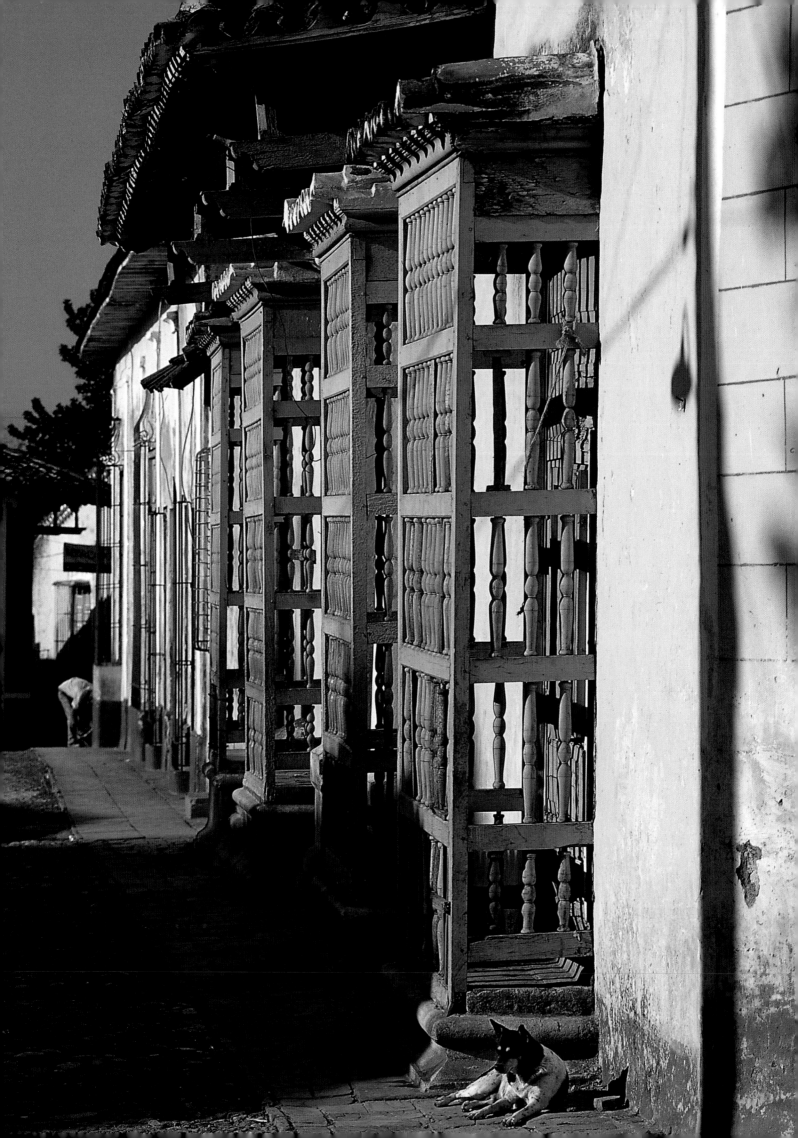

TRINIDAD
THE ROMANTIC CITY

Founded in 1514, Santísima Trinidad remained the political hub of the central region of the island for most of the colonial period. Some of the smaller cities that mushroomed around Trindad over the centuries are of particular value to the national heritage and have been raised to the level of National Monuments. Chief among these is Sancti Spiritus, founded at the same time as Trinidad; others include Remedios, which was established during the same period on the north coast, but did not immediately obtain jurisdictional autonomy and was placed under the patronage of Vasco Porcallo de Figueroa. Santa Clara was founded around 1689, as was Cienfuegos, a jewel of nineteenth-century Cuban architecture.

Trinidad is nestled in the San Luis Valley and sandwiched between the rugged landscape of the Escambray mountain range and the Caribbean Sea, which can be seen in the distance from the Chapel Virgen de la Candelaria

de la Popa (ca. 1740), perched on a hilltop. The city is served by the port of Casilda, about a forty-minute drive away.

The first settlement was shifted to the banks of the Yayabo River, and was based on an irregular plan, organized around a large central square, now better known as the *placita*. In the two centuries following its foundation, the city developed economically mainly because the local cattle farming industry maintained crucial links with the Havana market. The church and convent of St. Francis of Assisi that date to this period, and their large central tower that since the nineteenth century has been an unmistakable landmark in the city's landscape, were converted into Spanish military barracks during the wars of independence and have been recently restored and transformed into a museum.

The influxes of Spanish and French immigrants from Florida, Haiti, and Santo Domingo, at separate periods during the

182 THE LATHED-WOOD AND WROUGHT-IRON GRATES *(REJAS)* THAT PROTECT THE WINDOWS OF TRADITIONAL HOUSES ARE A TYPICAL FEATURE OF TRINIDAD.

183 TOP LEFT AND CENTER
WHETHER SUMPTUOUS OR HUMBLE, TRINIDAD'S HOUSES ARE INTACT GEMS OF COLONIAL ARCHITECTURE.

183 TOP RIGHT THE CHURCH OF THE MOST HOLY TRINITY ON THE PLAZA MAYOR (RIGHT).

183 BOTTOM IN THE NINETEENTH CENTURY, SOME OF THE WOODEN WINDOW GRATES WERE REPLACED BY ROBUST IRON BARS ADORNED WITH CHARACTERISTIC VOLUTES.

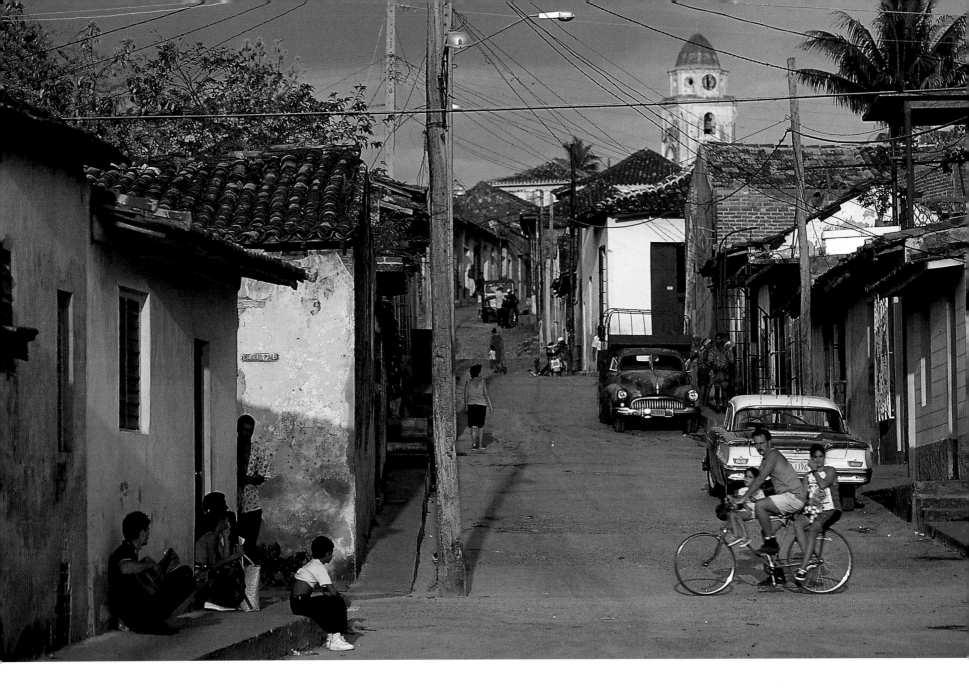

second half of the eighteenth century, rapidly rejuvenated the city's economy. Huge fortunes were made by the introduction of cash crops such as coffee, cotton, and sugar for large-scale export. New cultural ambitions were nurtured, and as a result of all this, Trinidad matured as a city, preferring stone and masonry for its buildings and parochial churches.

Trinidadian architecture encapsulates a large range of peculiar features. With a few rare exceptions, buildings generally consist only of one floor. Facades feature large windows that are apparently supported by a stone ledge (locally known as *poyo*), that holds the window above street level, while also extending into the room, where it serves as a bench. The houses were protected by bars of delicately lathed hardwood, which were replaced by cast iron in the nineteenth century, and crowned by small knobs. The decorative bars and railings adorn the sidewalks of Trinidad, imprinting the city with a unique urban style.

Trinidadian city houses are extraordinarily spacious, with very large and long courtyards that were enclosed or flanked on at least two sides by a low fence in old houses. These old houses are equipped with wells and feature enclosed, lovingly tended gardens that are livened by multitudes of sparrows, which are quite at home in these parts of the houses. A typical example is the current Museum of Architecture, which was inherited by the second Countess of San Antonio, Antonia Domínguez y Borrell, wife of the first Duke de la Torre, the distinguished Spanish politician Franciso Serrano y Domínguez, who served as captain general of the island from 1859 to 1862.

In 1823, Trinidad received its own coat of arms, and housed a small but powerful Creole aristocracy boasting Spanish noble descent, which rivaled with each other in building palatial mansions, fearing no competition from the noble residences of Havana in terms of opulence and size.

184 Life goes on at an easy pace on a street close to the Plaza Mayor, in the reassuring shadow of the bell tower of the Convent of St. Francis.

185 TOP After sundown the yellow walls of the Brunet Palace take on a rich ocher hue. Until 1808, the year in which the first floor was built, even this edifice only had a ground floor, quite like most local buildings.

The architectural gem facing the city square, which was once the residence of the Count of Casa-Brunet, now houses the Romantic Museum.

Unlike in other Cuban cities, architectural influence in Trinidad reached up to the very heart of its economic life, as in the Valle de los Ingenios, so called because the area, dominated by the impressive belvedere of the Torre Iznaga, once housed approximately fifty sugar refineries, nestled in the midst of sugarcane fields tended by African slaves. The area is dotted with exotic villas, replicas of the most refined Italian style, with floors and staircases in Carrara marble and interiors decorated with frescoed murals with motifs from the then-recently discovered ruins of Pompeii. Prime examples of

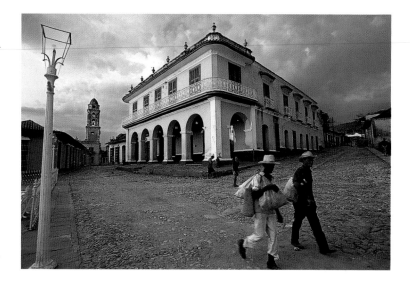

this type of architecture include the magnificent residence of the first Marquess of Guaímaro, which is under restoration.

The capital crisis of 1857, followed a decade later by the beginning of the wars of independence, ruined the Trinidadian economy. At the heart of the war, with a large number of its citizens involved in the fighting, the city quickly fell apart. The neocolonial regime installed after the declaration of independence paid little attention to this part of the country.

Finally, under the National Assembly of People's Power, Trinidad and the Valle de los Ingenios were high on the list of priorities for programs aimed at the conservation of Cuban National Monuments, especially when they were declared World Heritage Sites by UNESCO.

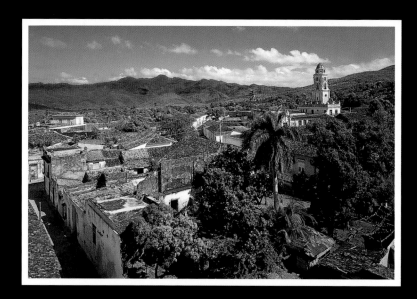

186 STEEPED IN TIMELESSNESS, TRINIDAD FEATURES QUAINT CUSTOMS THAT SEEM COMPLETELY OUT OF PLACE IN THE TWENTY-FIRST CENTURY. ONE OF THE FAVORITE PASTIMES OF TRINIDADIANS WITH PLENTY OF FREE TIME, PARTICULARLY CHILDREN AND RETIREES, IS TO CATCH SONGBIRDS IN THE NEARBY RÍO MELODIOSO, KEEPING THEM TO ENLIVEN THE QUIET SHADINESS OF THEIR HOMES.

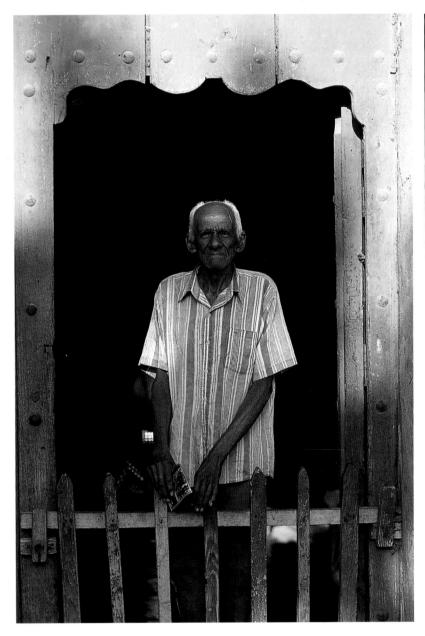

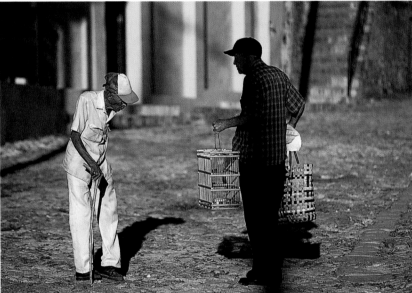

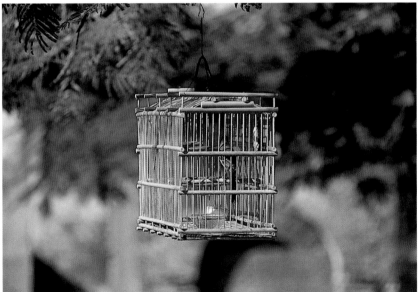

187 THE SPLENDID BELL TOWER OF THE CONVENT OF ST. FRANCIS RISES FROM THE CENTRAL RUA ECHERRÍ. VISIBLE FROM ALL POINTS OF THE CITY, THE BELL TOWER HAS BECOME THE UNOFFICIAL EMBLEM OF TRINIDAD. IT WAS BUILT AT THE VERY BEGINNING OF THE EIGHTEENTH CENTURY AND, TOGETHER WITH ITS BELL, FORGED AROUND THE MIDDLE OF THE SAME CENTURY, IS THE ONLY ELEMENT OF THE ORIGINAL CONVENT STILL STANDING TODAY. THE SURROUNDING COMPLEX, ONCE A SPANISH MILITARY BARRACKS, NOW HOUSES THE MUSEO DE LA LUCHA CONTRA BANDIDOS, DEDICATED TO THE REVOLUTIONARY STRUGGLE IN THE SIERRA DEL ESCAMBRAY.

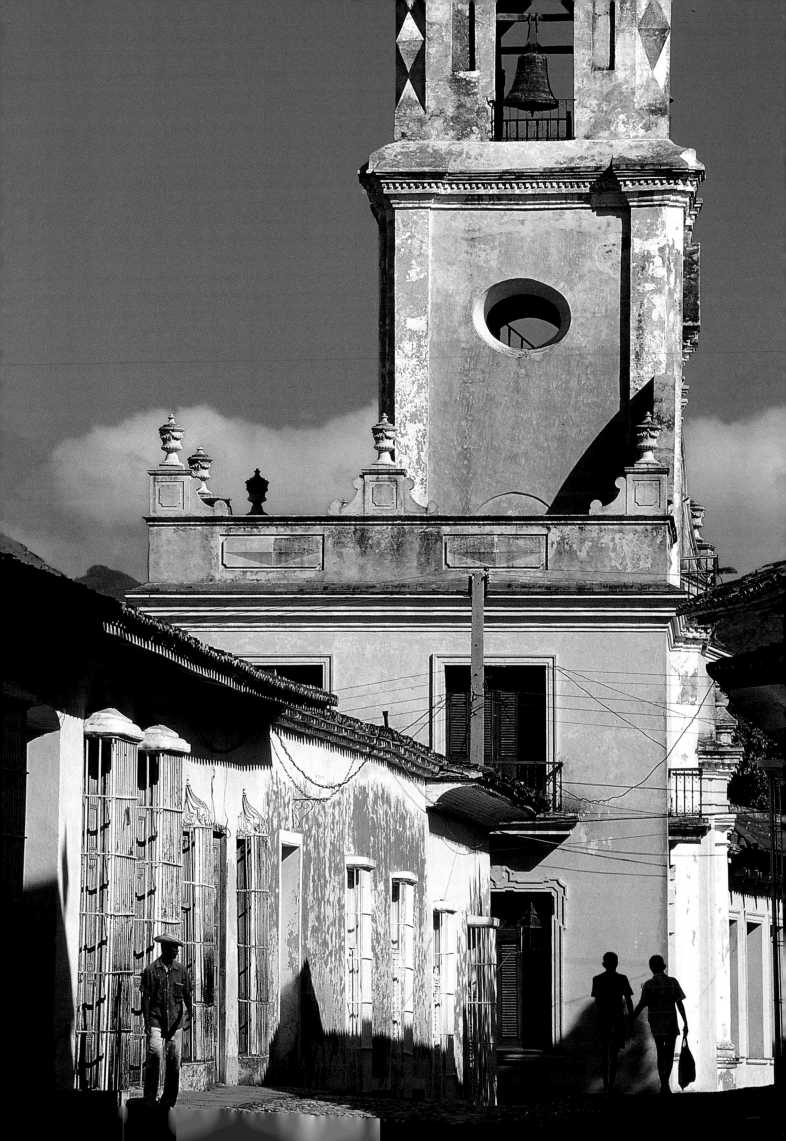

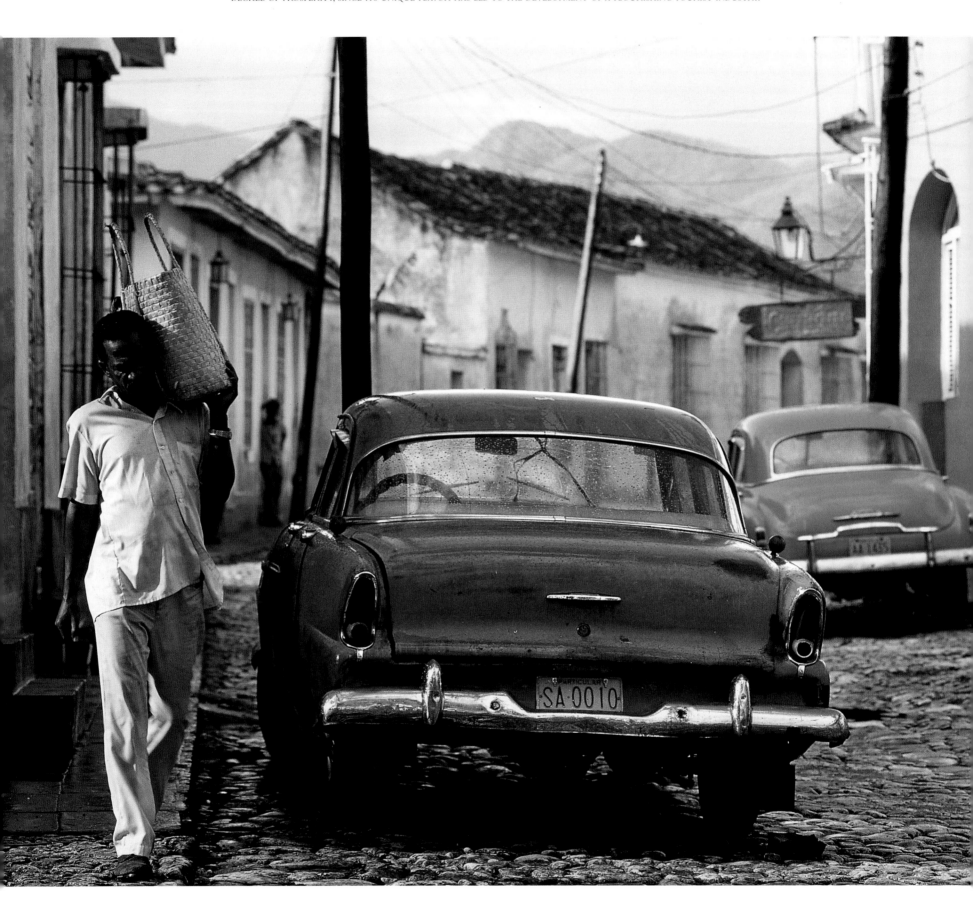

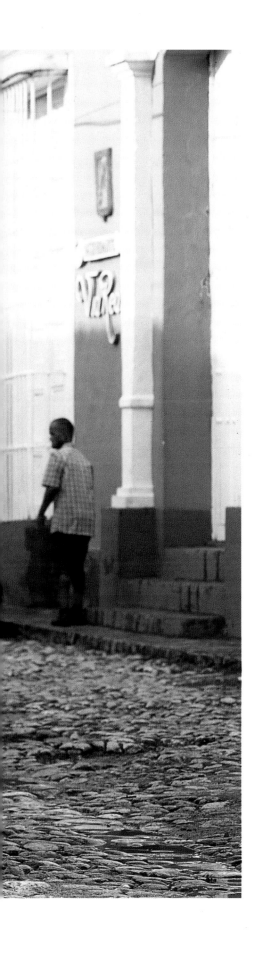

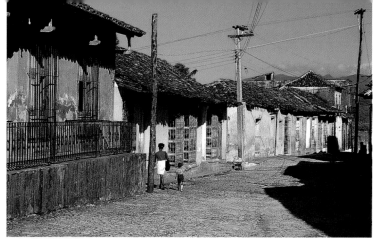

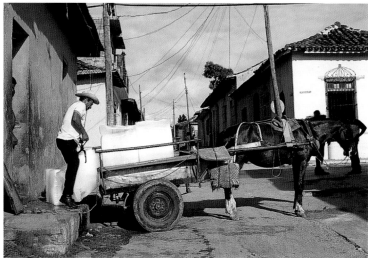

189 TOP A large number of Trinidad's generally cobbled streets follow a sinuous path around the city's central hub, Plaza Mayor.

189 CENTER AND BOTTOM Trinidad's status as a World Heritage Site, declared in 1988, is bound to ensure that the various restoration projects already commenced in several areas of the city will gradually extend to cover the rows of low buildings with rather bare façades that have so far been neglected.

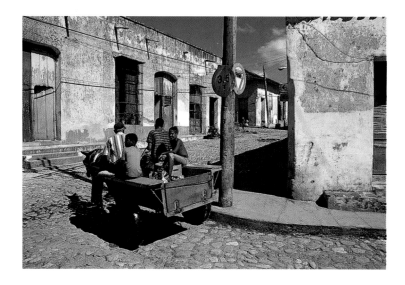

190 AND 191 BUICK, CHEVROLET, STUDEBAKER, FORD, PACKARD, OLDSMOBILE... AND THE MORE THE MERRIER: CUBA'S AUTOMOBILES (THE MOST RECENT MODELS DATE BACK TO 1961 WHEN THE U.S. TRADE EMBARGO WAS DECLARED) ARE MOST CERTAINLY AMONG THE ISLAND'S FOREMOST ATTRACTIONS. BUT IT IS LACK OF MONEY, RATHER THAN THE NOSTALGIA OF CUBAN CAR OWNERS, THAT MAKES MOST OF THE ISLAND'S CARS LOOK LIKE PERIOD PIECES. SINCE, UNLIKE MOST CARS ON THE ROAD TODAY, THESE OLD ROBUST MODELS WERE BUILT TO LAST, WITH THE RIGHT AMOUNT OF MAINTENANCE THEY ARE STILL USED THROUGHOUT CUBA AS ORDINARY MEANS OF TRANSPORT, RATHER THAN TREASURED AS ANTIQUES.

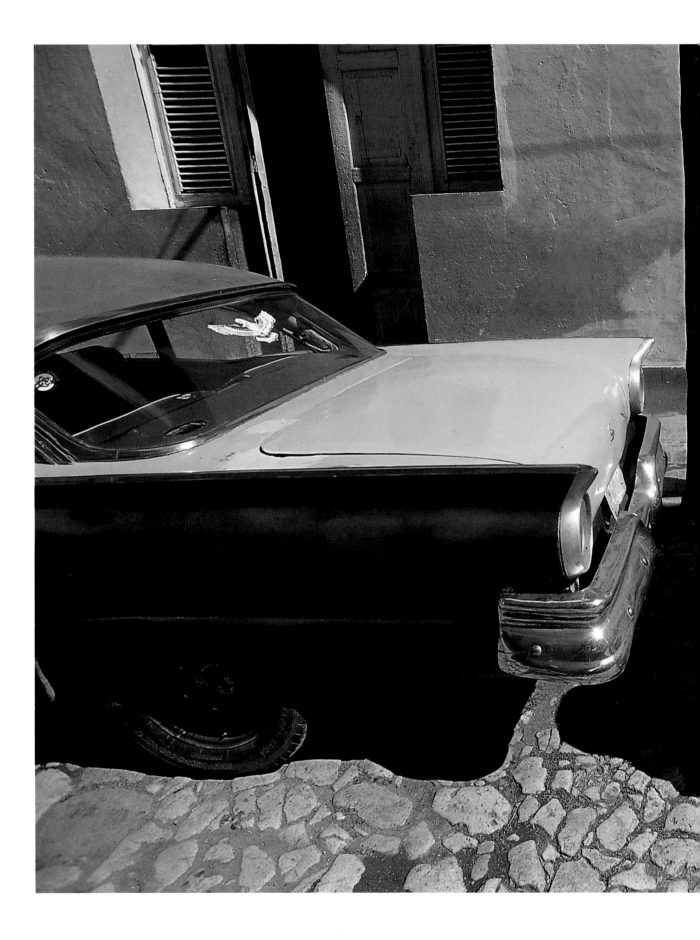

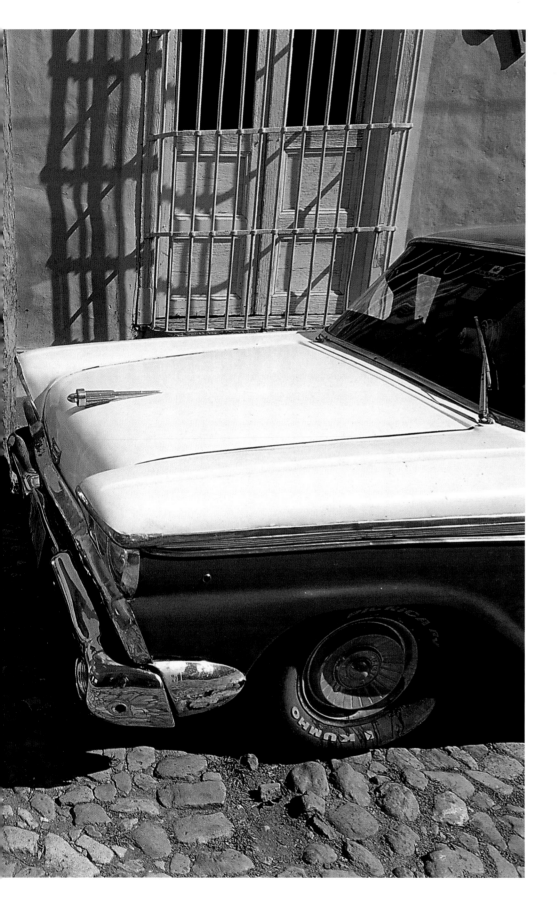

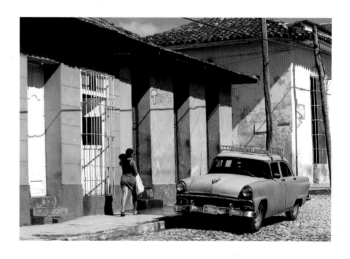

192 AND 193 FACES, GESTURES, AND SMILES SEEP THROUGH THE *REJAS* OVERLOOKING THE STREETS IN DOWNTOWN TRINIDAD. THESE GRATES, ONE OF THE MOST CHARACTERISTIC ELEMENTS OF THE CITY'S LANDSCAPE, ARE A FIXED FEATURE THROUGHOUT TRINIDAD, ALLOWING FOR A QUAINT "EXCHANGE" BETWEEN PASSERSBY AND HOUSE OCCUPANTS. WHILE PASSERSBY CAN STEAL A GLANCE OF OCCUPANTS AND FURNISHINGS, *PATIOS* AND *AZULEJOS*, OCCUPANTS CAN OBSERVE THE GOINGS-ON IN THE STREET FROM THE COMFORT OF THEIR HOMES.

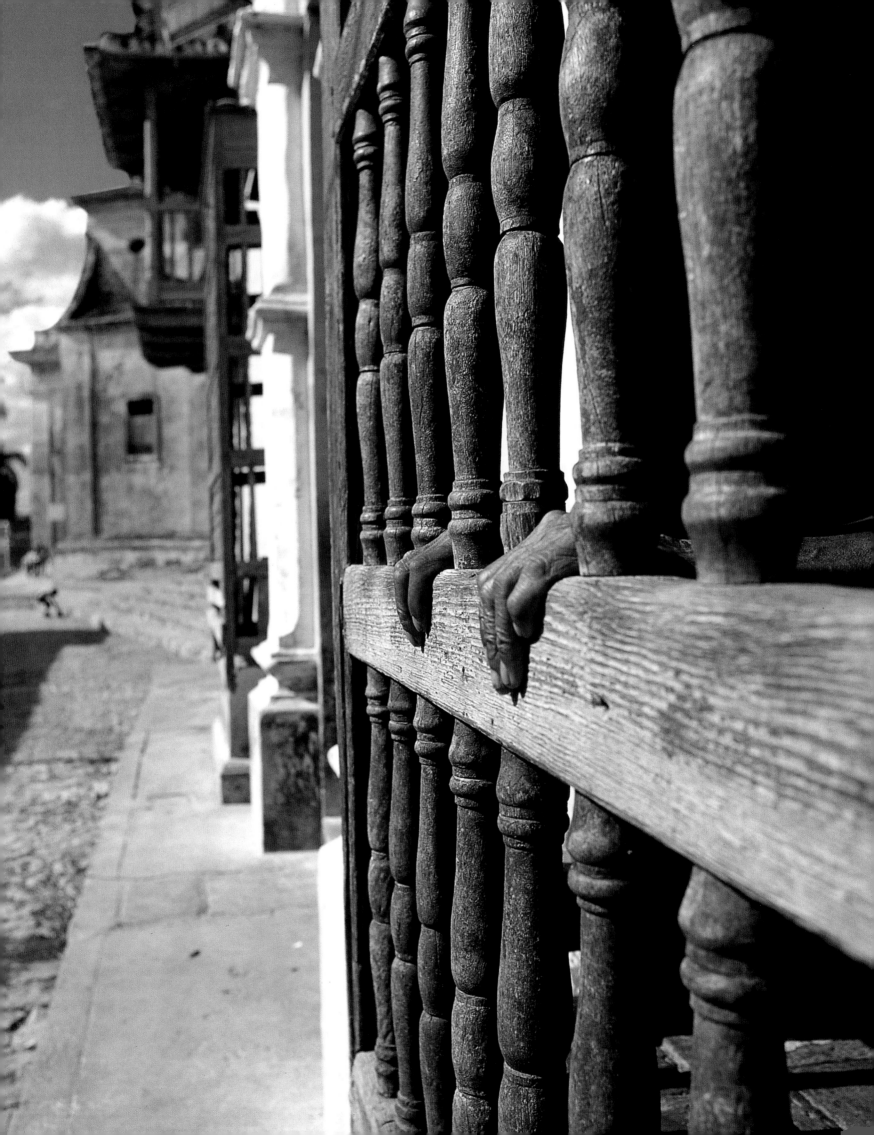

194 THE EFFECTS OF THE RESTORATION WORK CARRIED OUT IN RECENT YEARS ARE EVIDENT ALL OVER
TRINIDAD, BRINGING BACK SOME OF ITS PAST SPLENDOR LOST OVER DECADES OF DECADENCE.
LEFT: A REPAINTED DOORWAY BOASTS AN ANCIENT ENTRANCE DOOR.
RIGHT: ONE OF THE MORE ELABORATE REJAS, OVERLOOKING PLAZA MAYOR.

195 TIME HAS CHANGED MUCH IN THE CITY: TRINIDAD'S SPACIOUS HOUSES ARE NO LONGER OCCUPIED BY THE RICH LANDOWNERS, WHILE THE CROSS MAY WELL MAKE A
COMEBACK AS ONE OF THE MOST-LOVED SYMBOLS OF THE CUBAN PEOPLE (LEFT). RIGHT: ANOTHER, MORE MODEST REJA OVERLOOKING PLAZA MAYOR TAKES ON AN AIR OF
DIGNITY BY BLENDING WITH THE URBAN LANDSCAPE. BOTTOM: WHILE THE ARCHITECTURE IS BARE AND LINEAR, CLEVER USE OF COLOR ENSURES THAT THE CITY'S HOUSES
NEVER SEEM UNDECORATED.

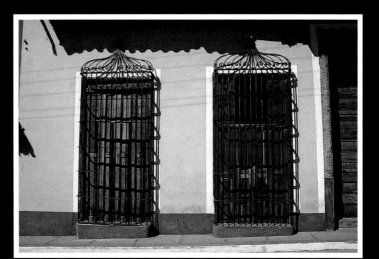

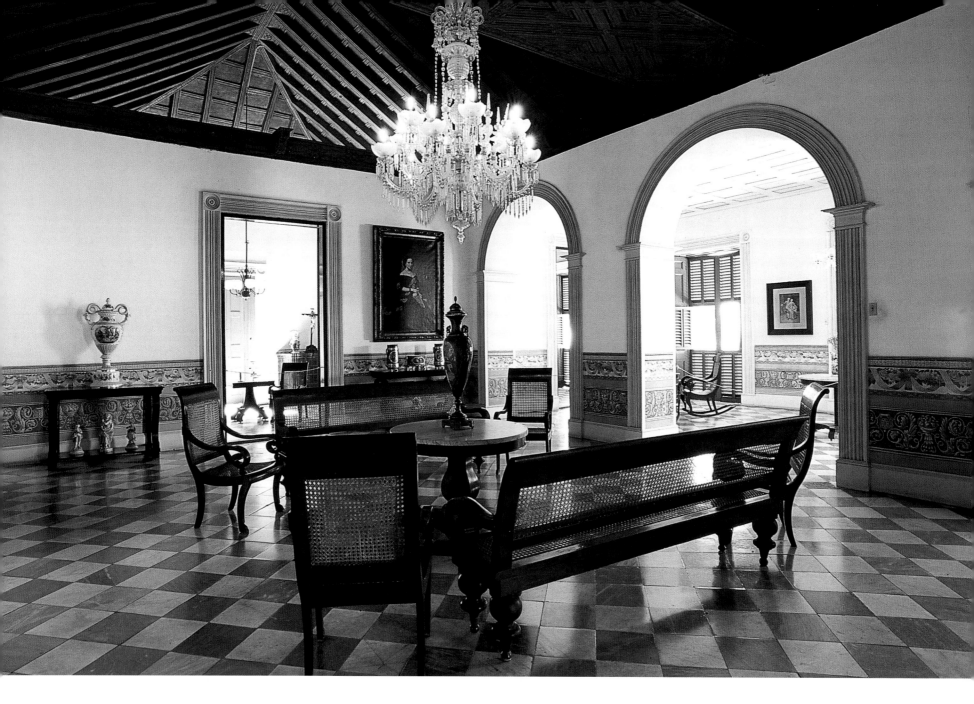

196 The Brunet Palace, built between 1740 and 1808, still maintains its original architecture. It now houses the fascinating Museo Romántico, which covers thirteen exhibition halls. The furnishings and antiques on show at the museum, almost all manufactured in Europe, were collected from various wealthy residences in the city, while the building itself still boasts the original woodwork and marble chosen by its owner, the powerful industrialist Mariano Borrel.

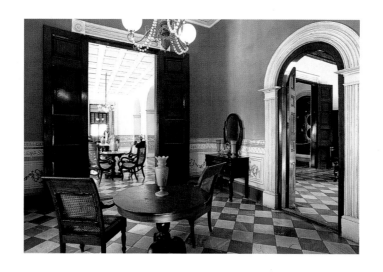

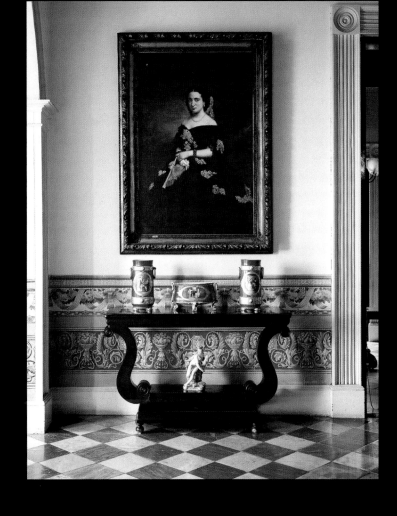

197 **TOP** Abandoned in the early twentieth century, the Brunet Palace owes its splendor to the Trinidadian historian Carlos Zerquera.

197 **BOTTOM** The dining room of the Brunet Palace is ventilated through the sunny patio by abanicos, the "fans" located in the arches of the windows.

198 TOP The eighteenth-century halls overlooking the splendid patio of the Museo de Arquitectura Trinitaria, which covers several annexes, are dedicated to the architecture of eighteenth and nineteenth-century high-society city residences.

198 CENTER The elegant neoclassical halls of the Museo Municipál, once owned by the Borrel family, now house a permanent exhibition of antique furniture and fixtures from the residences of the city's most sumptuous residences.

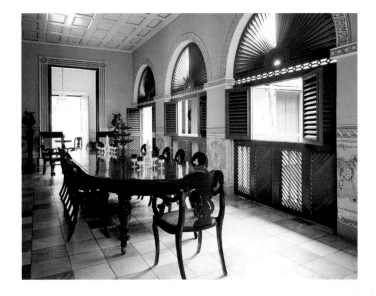

198 BOTTOM A santería altar in a private residence in Trinidad. This worship of African gods in the guise of Catholic saints, which arose with the influx of black slaves, is still very much alive in Cuba today.

198-199 The House of the Crocodile or the Domenican strikes the visitor not just for the reptile it now houses: The original arch that divides the two halls is rather impressive in itself.

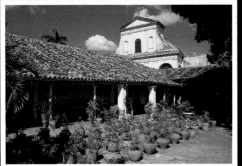

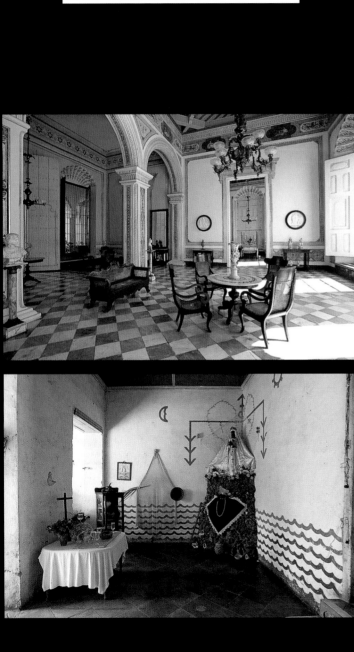

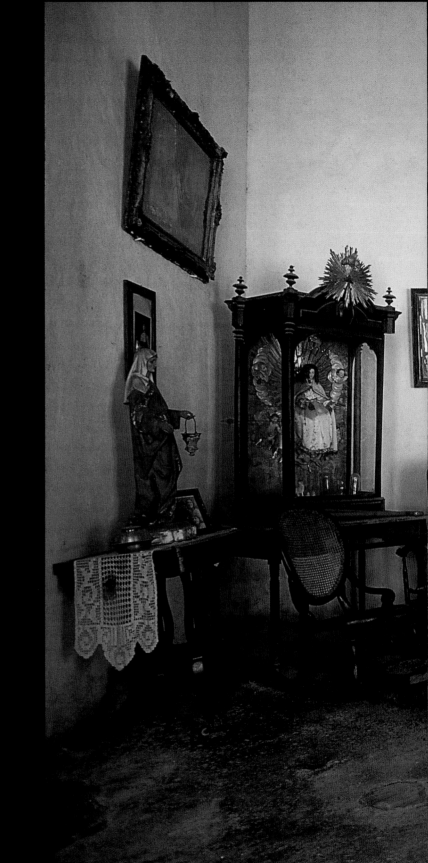

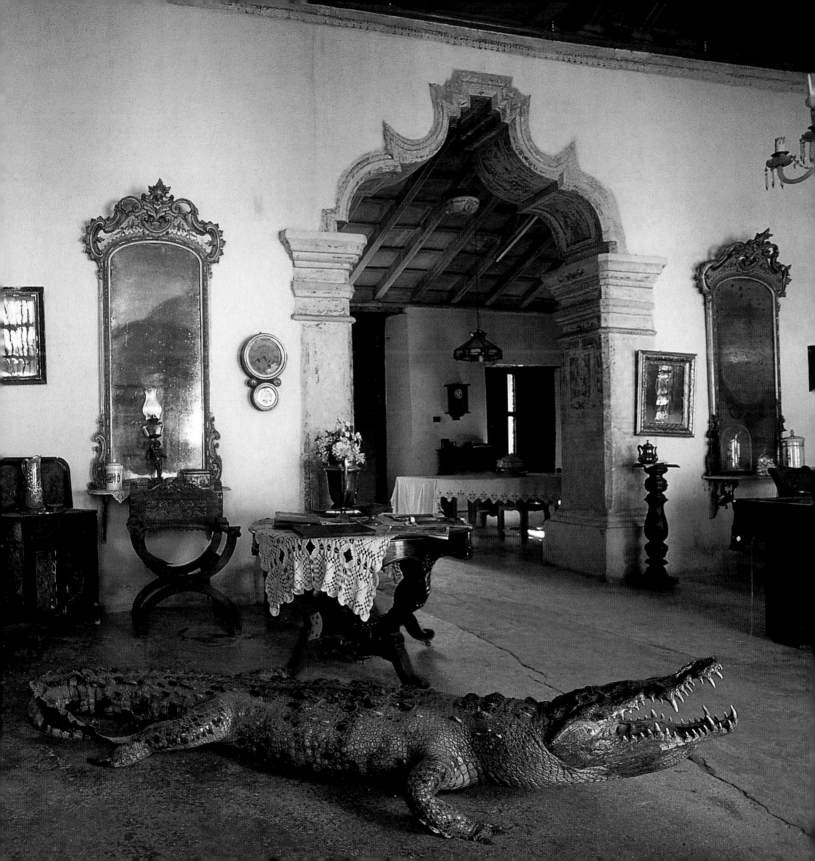

200 TOP DEVOID OF EMPHASIS, PLAZA HONORATO IS DEDICATED TO HONORATO DEL CASTILLO CANCIO, A SANCTI SPIRITUS NATIVE AND HERO OF THE 1868 REVOLT.

200 BOTTOM LEFT WAITING FOR SHOES TO BE SHINED. SANCTI SPIRITUS COMPENSATES BY OFFERING A QUIET GETAWAY FROM AREAS HEAVILY FREQUENTED BY TOURISTS.

Founded in 1514 by the Spanish along the Tuinicú River, at the geographical heart of Cuba, Sancti Spiritus was transferred eight years later to its current site on the banks of the Río Yayabo. The city rapidly grew rich, thanks mainly to the flourishing sugarcane trade and the exploitation of African slaves. Despite its rather backward position in the hinterland, it was sacked by pirates in the seventeenth century, much like other cities such as Trinidad and Camagüey during this period.

The city contributed two great heroes during both wars of independence: Honorato del Castillo Cancio, who died in 1869 during the second year of the conflict, and Serafín Sánchez, who fell in action in 1896. Sancti Spiritus has dedicated a public square to each of its patriots in the city center. The Parque Sánchez in particular, known as the "*salon*" of Sancti Spiritus, is surrounded by several remarkable neoclassical buildings immersed in the

quiet atmosphere that is typical of the city. Administratively more important than Trinidad, Sancti Spiritus is less well known, a feature much appreciated by visitors who want to get away from the ever-present throngs of tourists elsewhere. Despite its low-key profile, the city is well endowed with interesting sights. The Iglesia del Espíritu Santo overlooking Parque Honorato was originally built in wood in 1522 and rebuilt in stone in the seventeenth century after it was destroyed by pirates. According to local legend, the church, which features a magnificent decorated ceiling, is the oldest building in Cuba still standing on its original site. Not far from the church, on the way to the Río Yayabo, lies the beautiful seventeenth-century structure of the Museo de Arte Coloniál, which houses a collection of colonial furniture. A little ahead, one sees the brickwork arches of the Spanish bridge over the Yayabo, Cuba's oldest bridge and a real gem of quiet, pleasant Sancti Spiritus.

SANCTI SPIRITUS

THE CITY OF QUIET

200 BOTTOM CENTER AND RIGHT NEOCLASSICAL BUSTS AND STAINED GLASS, ON SHOW AT THE MUSEO DE ARTE COLONIÁL, WHICH HOUSES MAGNIFICENT PIECES BEARING WITNESS TO SANCTI SPIRITUS'S COLONIAL PAST.

201 TOP SANCTI SPIRITUS HAS UNDERGONE REFURBISHMENT WORKS THAT HAVE RESTORED MANY CITY HOUSES TO THEIR FORMER ELEGANCE.

201 BOTTOM A PEANUT VENDOR.

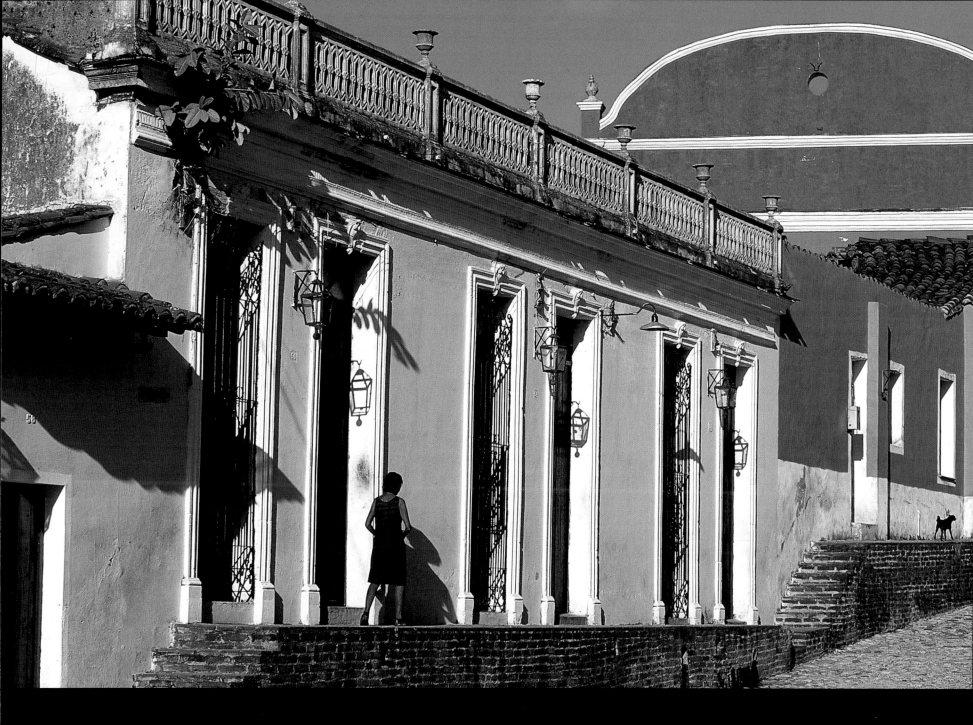
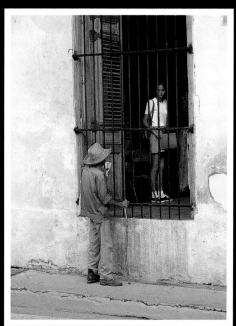

202 AND 203 Shady doorways are just another invitation to discover the secret charms of this seemingly timeless town. The loving care lavished on the smallest of details, such as this simple trompe l'oeil (202-203), magnificently enhances the rather modest architecture.

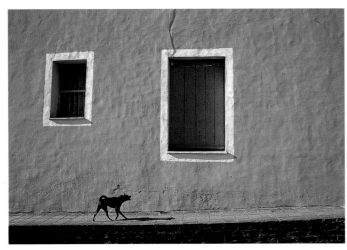

204 TOP In many cases, the refined tastes of the Sancti Spiritus aristocracy compare very well with the elegance of their Trinidadian neighbors (painted glass, Museo de Arte Coloniál).

204 CENTER AND BOTTOM AND 204-205 The square dedicated to Serafín Sanchez, hero of the two wars of independence, is surrounded by sumptuous neoclassical buildings.

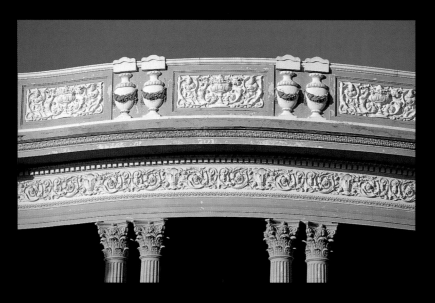

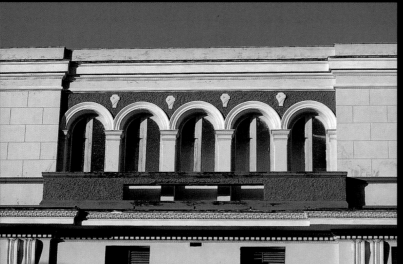

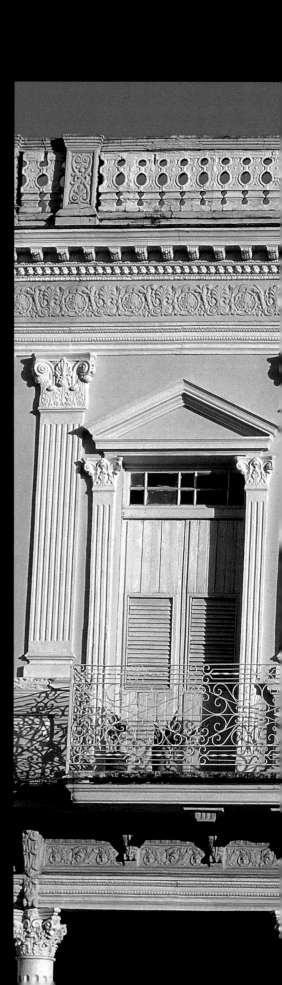

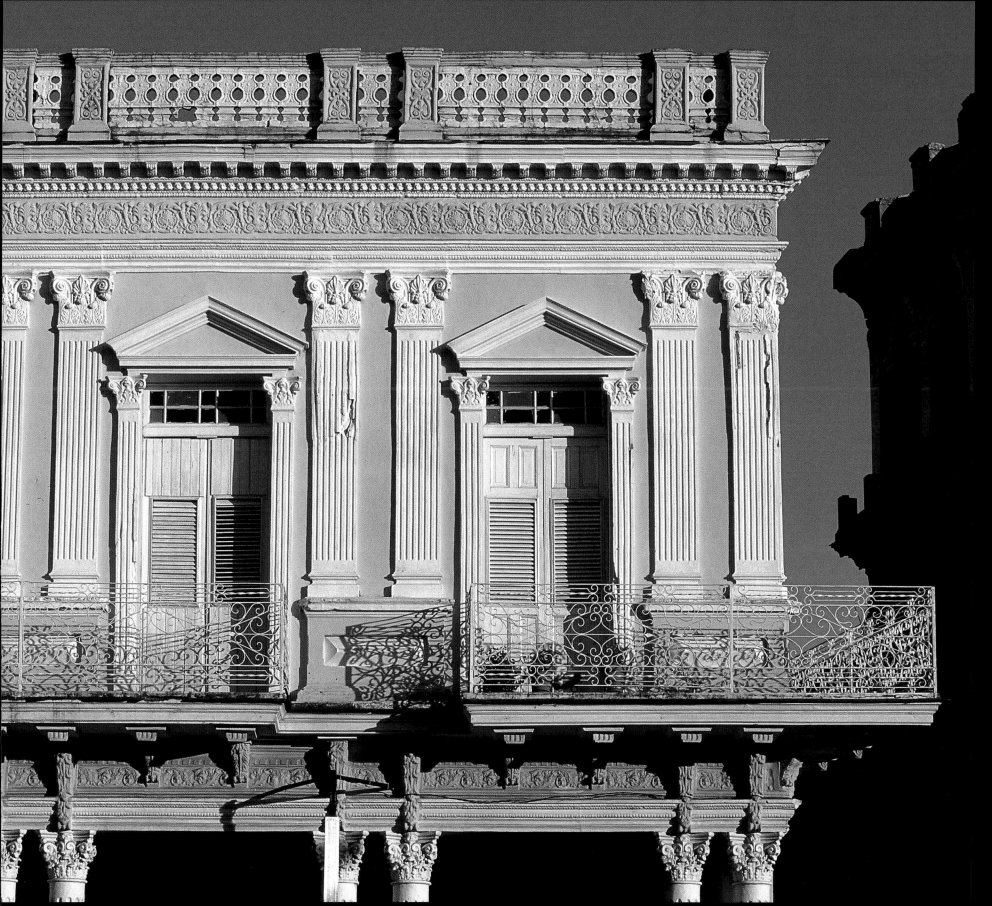

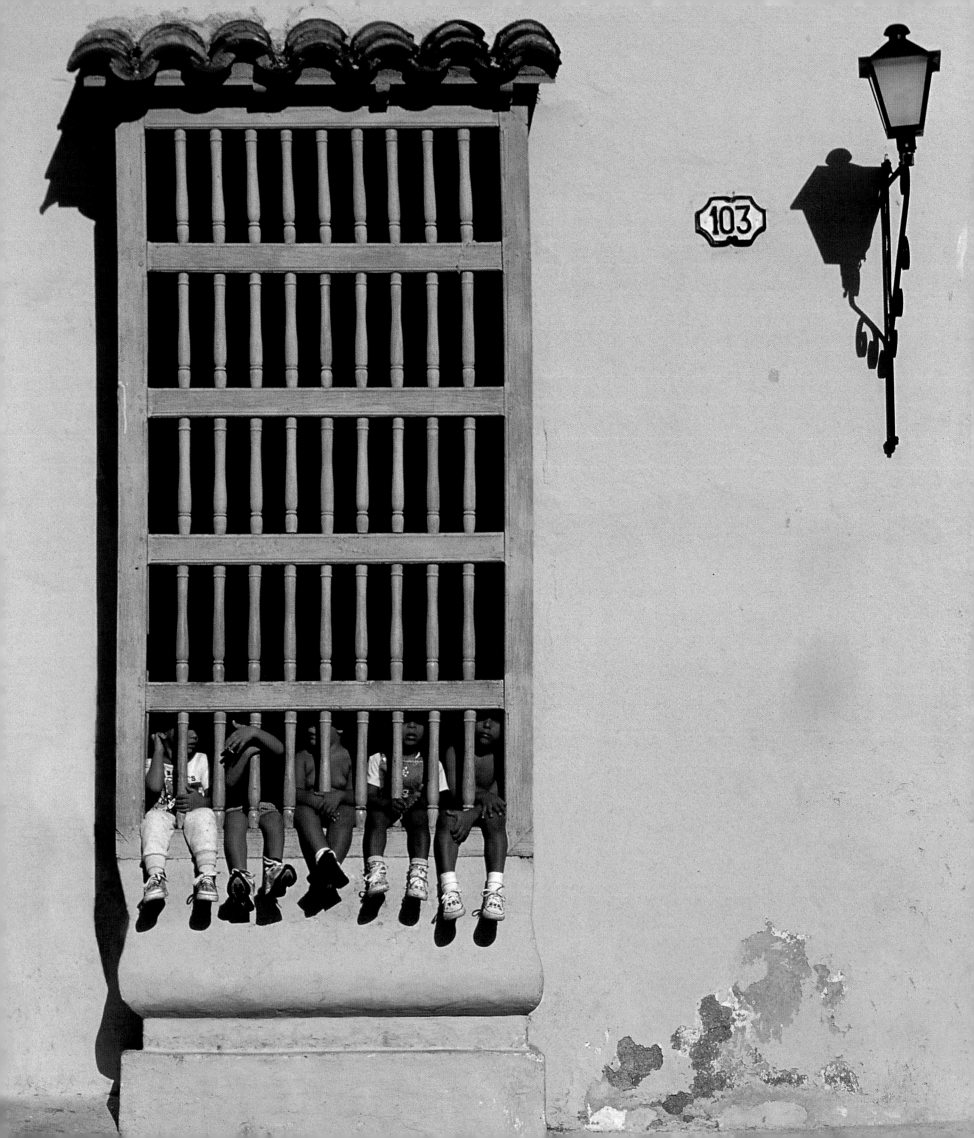

The current province of Camagüey fell under the extended jurisdiction of the old town of Santa María de Puerto Príncipe. Initially located close to the wide Neuvitas Bay, it was later shifted inland, almost to the center of the region between the Tínima and Hatibonico Rivers, for military reasons. Although it features several large squares, the historical city center is rather cramped and labyrinthine, with narrow, winding streets that add to the "Moorish" charm of the urban landscape. Camagüey was raised to the dignity of a city with all the related honors by Ferdinand VII of Spain in 1817.

Camagüey is surrounded by vast, rolling plains and savanna, ideal for cattle rearing and sugarcane cultivation. Side by side with its flourishing economy, Puerto Príncipe—as it was called until 1903—also developed a rich literary and artistic tradition.

The first literary work produced in Cuba, entitled *Espejo de Paciencia* (Mirror

of Patience) was written by a Camagüey resident, Silvestre de Balboa y Troya de Quesada (who was born in Grand Canary around 1563 and died in Puerto Príncipe around 1649). The work is a poetic rendition of historical events that took place in Bayamo and Manzanillo, although the author was a resident of Puerto Príncipe where he worked as a public clerk with municipal council in 1621. Although the book was only published two centuries later, it is the earliest forebearer of the cultural tradition of Camagüey, one of the most brilliant hearths of Cuban intellectual life in the nineteenth century. The poetess and playwright Gertrúdis Gómez de Avellaneda, one of the great figures of nineteenth-century Spanish literature, who was officially honored in Havana in 1860, was born in Camagüey in 1814 and died in Madrid in 1873.

Puerto Príncipe's architecture features

CAMAGÜEY

THE CITY OF THE LARGE JARS

206 RATHER THAN HIDING HOUSE OCCUPANTS FROM VIEW, THE WOODEN, LATHED REJAS HIGHLIGHT THE PRESENCE OF HUMAN ACTIVITY.

207 TOP ECLECTIC ARCHITECTURE ALONG THE ROADS OF CAMAGÜEY.

207 BOTTOM IN CAMAGÜEY, CUBA'S THIRD-LARGEST CITY, THE NATURAL LIVELINESS OF CUBANS IS EXALTED BY THE INFLUENCE OF THE CITY'S INTELLIGENTSIA AND CRAFTSMEN, AND POLITICAL PROPAGANDA IS EVER PRESENT.

208 TOP Camagüey is also famous for its numerous churches, built in the eighteenth and nineteenth centuries and decorated with interesting Baroque frescoes.

208 BOTTOM AND 209 The terraces of Camagüey afford splendid views of the steeples that rise above the city. The imposing tower of the Catedrál de Nuestra Señora de la Candelaria (below), and Nuestra Señora de la Merced (right).

peculiarities that have been recorded in great detail in the *History of Cuban Colonial Architecture* by the Cuban architect, Professor Joaquín Weiss. Mixed-line arches frame the interiors of houses that feature spacious courtyards decorated with large earthen jars, known locally as *tinajones*, used to keep the collected rainwater cool and protected for use during the day. These typical earthenware jars have earned the city the sobriquet of *Ciudad de los Tinajones*, or "city of the earthenware jars."

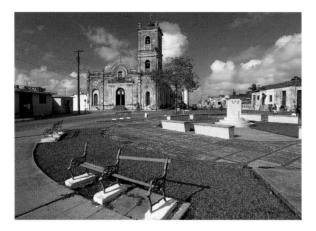

Camagüeyan ceramics craftsmen are renowned for their aesthetically refined products manaufactured using local high-quality clay. The city's ceramics products cover a vast range, from the perfectly practical and functional to the purely decorative. Camagüeyan master craftsmen still use traditional techniques to produce objects of such high quality that some local masters, such as Nazario Salazar, now enjoy well-deserved international acclaim.

Camagüey's cultural jewels include the interesting nineteenth-century Teatro Principal, now taken over by the local ballet company, founded by Fernando Alonso over twenty years ago for performances of mainly contemporary works. The city's long-established reputation as an intellectual hub has also been revived, especially since it was chosen as the seat of the Provincial University, one of the largest on the island.

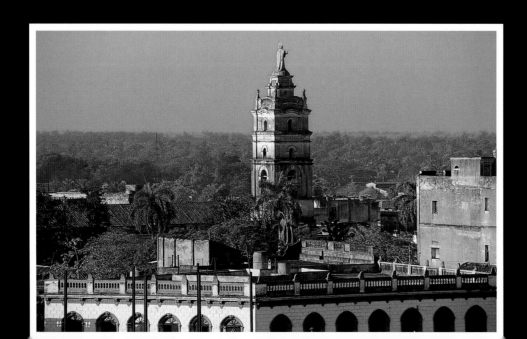

210 AND 211 LEFT Camagüey celebrates the myth of the revolutionary hero, widespread throughout the island. In this case, with the portraits of two famous victims of the freedom struggle—Camilo Cienfuegos (left), who died as he was returning to Havana from Camagüey and, naturally, Che Guevara.

211 RIGHT Decorative exuberance is the norm in Camagüey.

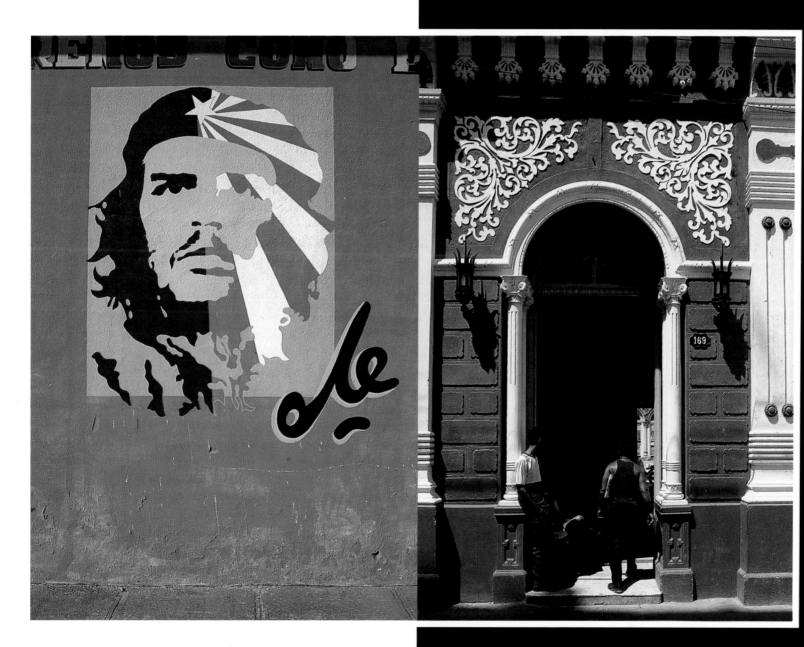

212 A Camagüeño reads *Juventud Rebelde*. Among so many uncertainties, the most positive result of the revolution was free education for all Cubans—the literacy rate today is close to one hundred percent.

213 A young student in school uniform. Cuban schools at all levels focus mainly on useful technical and practical skills. The most obvious shortcoming of a school system that is otherwise very efficient lies in the rather restricted freedom of thought permitted the country's youth.

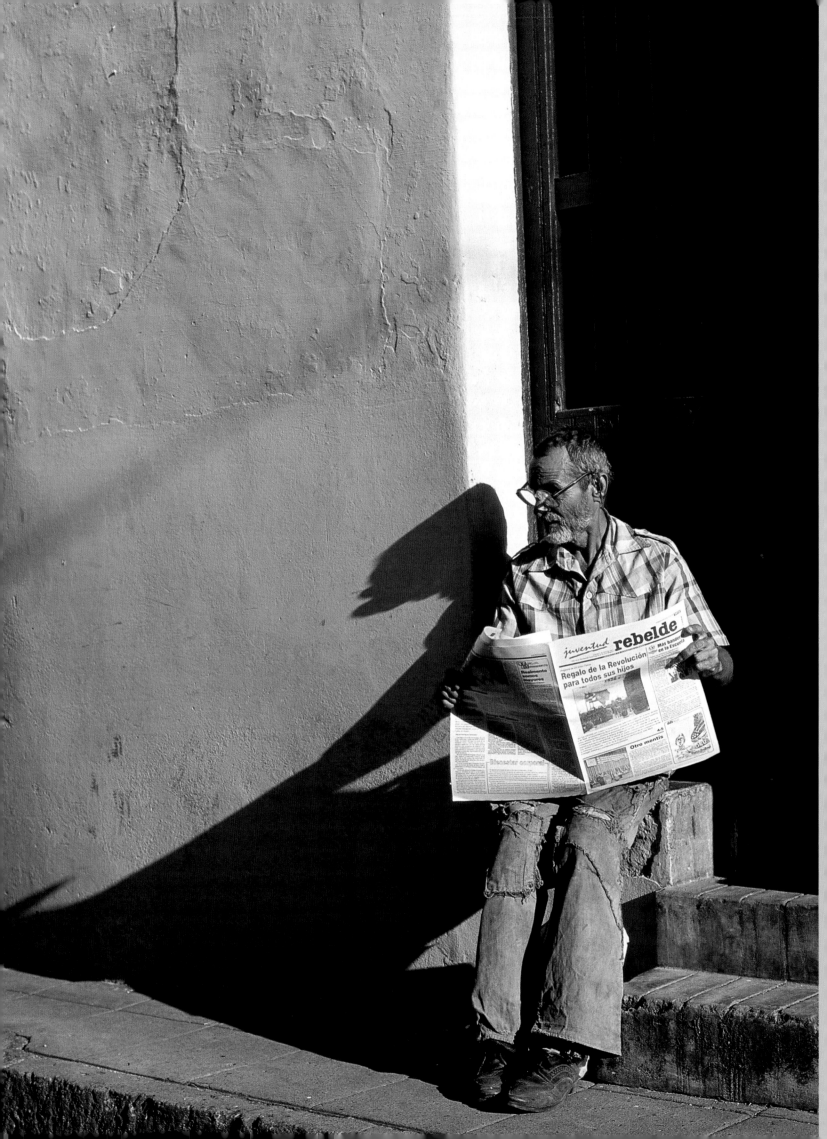

215 BOTTOM An old *CAMPESIÑO* transports the fruits of his labor. While the retirement age in Cuba is relatively low, fifty-five for women and sixty for men, retirees may continue to work and receive a salary in addition to their pensions.

214 AND 215 TOP Intelligent pastimes, quiet small talk, and tolerable traffic. Despite its status as Cuba's third-largest city, Camagüey features an easygoing pace of life that is never too frenetic.

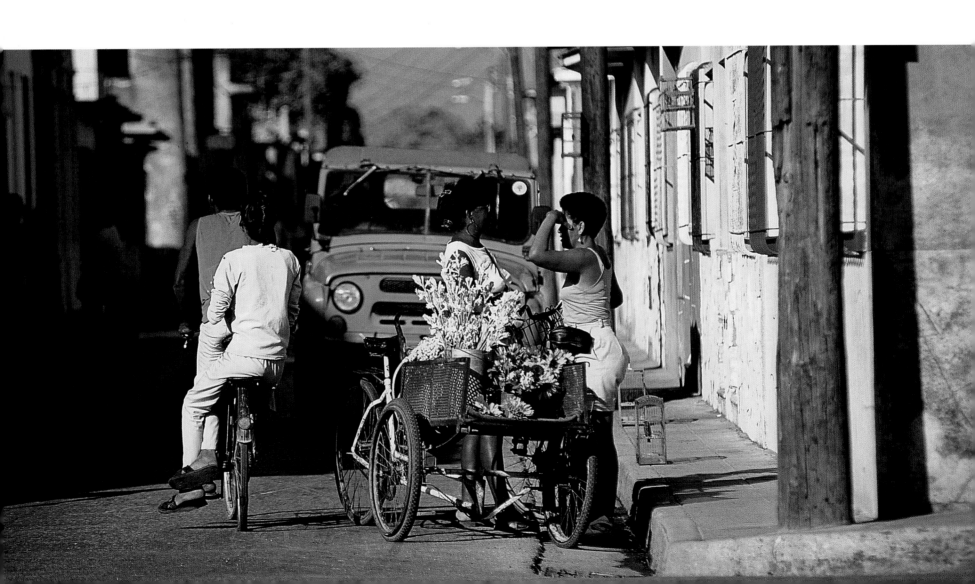

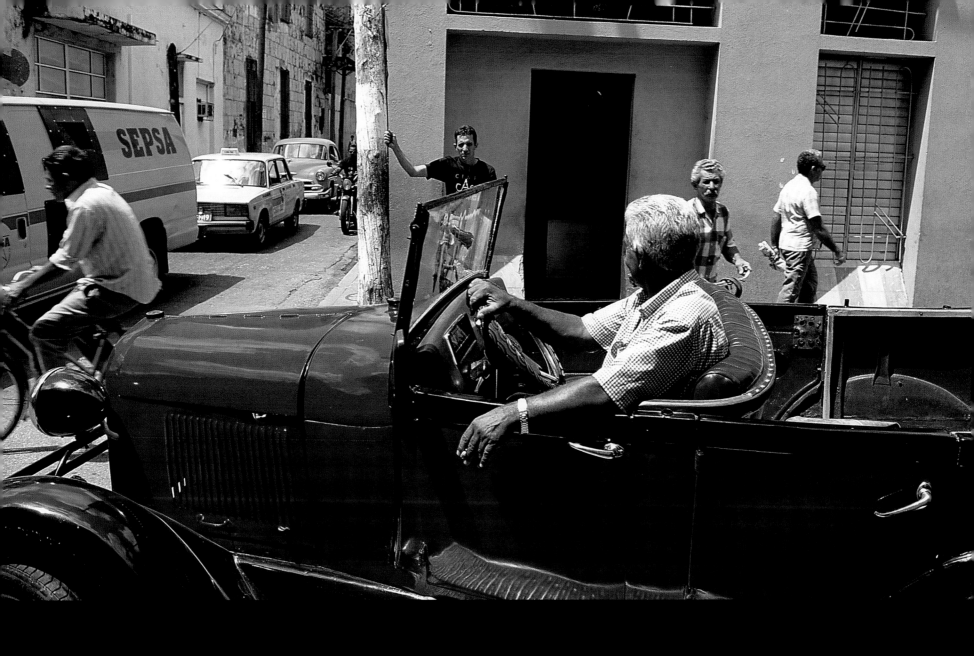
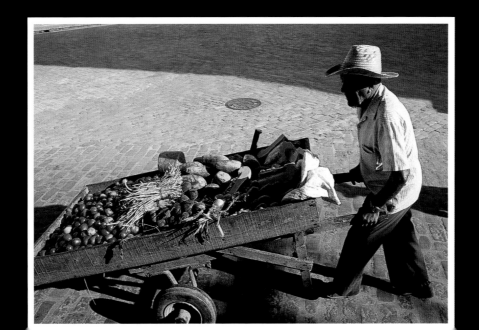

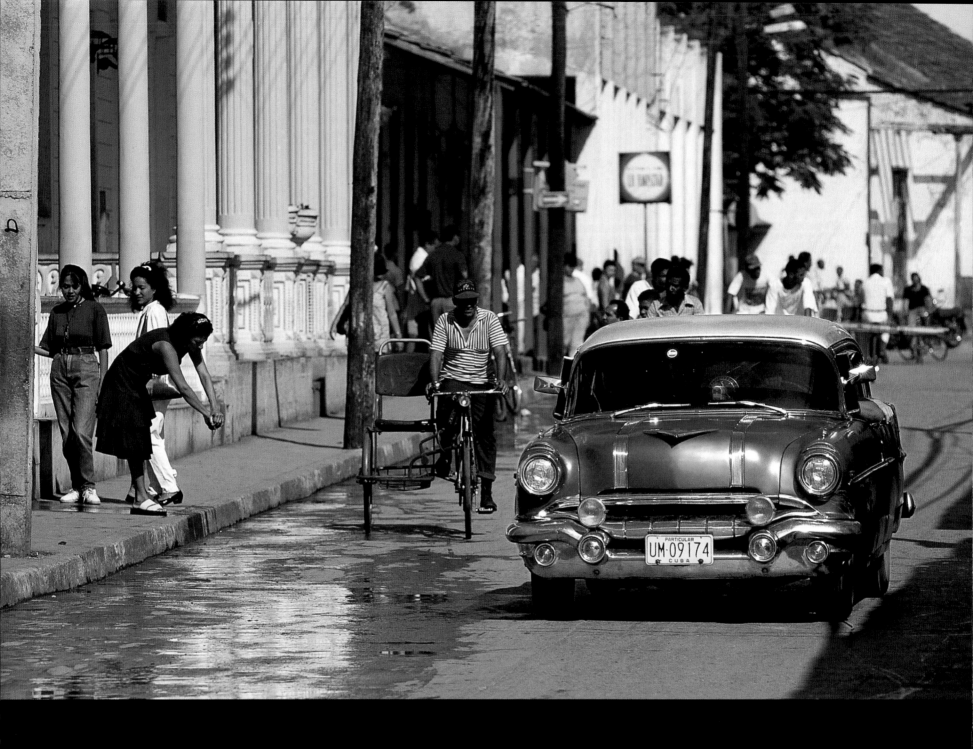
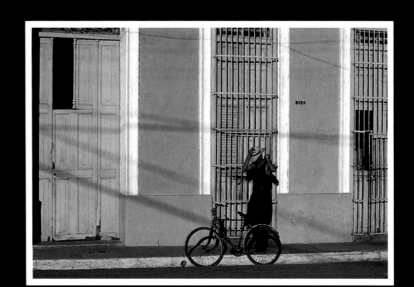

BARACOA

CUBA'S OLDEST CITY

In 1511, Diego Velázquez de Cuéllar and his small band of *conquistadores* founded Nuestra Señora de la Asunción, the first urban center in the new Caribbean colony, in the area until then occupied by the *Taíno cacique* of Baracoa, toward the northeastern tip of the island of Cuba. The origins of the city may, however, be even older—the cathedral still houses the wooden Cruz de la Parra, one of Cuba's best-loved relics, which, according to legend, was brought to the island by Christopher Columbus himself.

Nuestra Señora de la Asunción de Baracoa served as a logistics base for the inland expeditions that contributed to the military conquest of the entire island. Velázquez later built or ordered the foundation of six other colonial towns: San Salvador de Bayamo (1513), Santísima Trinidad (1514), San Cristóbal de la Habana (1514, at its first location on the north coast), Sancti Spiritus (1514), Santa María del Puerto Príncipe (1515), and Santiago de Cuba (1515). With the exception of Baracoa and Santiago de Cuba, the location of these early settlements was changed on several occasions.

Nuestra Señora de la

Asunción de Baracoa was given the title of *Ciudad primada* of the island of Cuba. At Velázquez's request, the settlement was made the first Catholic Bishopric of Cuba in 1516, although the cathedral was never built and its first appointed bishop, Father Bernardo de Mesa, gave up his appointment without ever touching Baracoan soil. At the request of Cuba's second bishop, Father Juan de Wite, who also never set foot on the island, the diocesan seat and the cathedral were transferred to Santiago de Cuba in 1523.

The resistance of the local population to Spanish colonization made Baracoa a rather dangerous place to live. Access by land was very difficult because of the tropical sierra that surrounded the city. This element that, together with the area's maritime access to Hispaniola, initially worked to the advantage of the Spanish offensive, was later transformed into a serious obstacle that hindered the integration of Baracoa into the economic fabric of the eastern region. For these reasons, the region remained isolated for centuries and the development of the local population is a singular case in the history of Cuba. The problem was finally

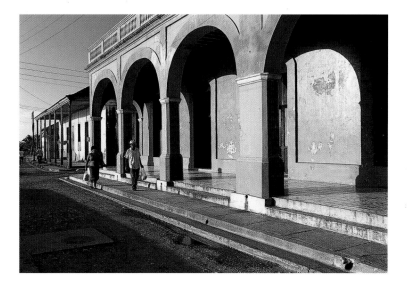

217 TOP BARACOA'S "SECRET" RESIDES IN ITS GEOGRAPHICAL ISOLATION, WHICH OVER THE CENTURIES HAS MADE CUBA'S OLDEST CITY A SPECIAL PLACE, ESPECIALLY IN TERMS OF ETHNIC VARIETY AND FOLK CULTURE.

217 BOTTOM TRINIDAD MAINTAINS A COLONIAL FLAVOR, BUT BARACOA DOES MUCH MORE: HERE ONE CAN BREATHE IN THE ATMOSPHERE OF TIMES PAST AND ADMIRE THE REMAINS OF THE LAST TRACES OF THE INDIGENOUS CIVILIZATION.

218 LEFT FACING THE WINDWARD CHANNEL, THE MALECÓN, BARACOA'S "JETTY," IS MORE EXPOSED TO OCEAN CURRENTS THAN ITS HAVANAN COUNTERPART.

218 RIGHT BUILT IN 1512 AND SACKED BY PIRATES IN THE SEVENTEENTH CENTURY, BARACOA'S HUGE CATHEDRAL IS THE OLDEST CHURCH IN CUBA.

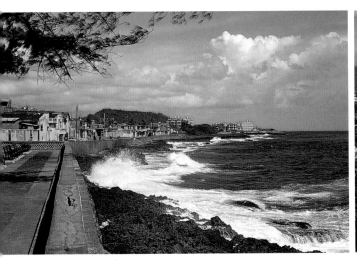
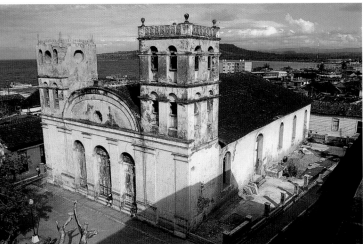

218-219 SLOW-PACED BARACOA IS DOMINATED BY THE UNMISTAKABLE MASS OF THE YUNQUE, THE "ANVIL," A NATURAL FORT THAT, BEFORE THE ARRIVAL OF THE SPANISH *CONQUISTADORES*, HOUSED A TAÍNO SETTLEMENT. WHILE THE ISSUE IS STILL DEBATED BY SCHOLARS, MANY BELIEVE THAT THE YUNQUE IS, IN FACT, THE HIGHLAND DESCRIBED BY CHRISTOPHER COLUMBUS IN HIS TRAVEL JOURNAL AS: "A HIGH MOUNTAIN...QUITE LIKE AN ISLAND."

solved through infrastructure development under the revolutionary government in the 1960s, when work on the new Via Mulata and La Farola highways—this last a world-renowned engineering masterpiece—was begun.

These facts explain why the city of Baracoa is still one of the few examples of Cuban urbanization featuring strong links with the region's agricultural framework and natural surroundings.

Baracoa has its own typical microclimate, a mountainous rain forest, that influences the rural economic landscape. Terraced cultivation of coconut palms provide shady protection to smaller plants such as coffee trees.

Mr. Alejo Carpentier, a famous Cuban author, wrote of Baracoa in his novel *The Consecration of Spring* that when it rains it is without interruption, "for seven, eight, ten days, of soft rainfall, devoid of all violence…" Here, quite like in England, an umbrella is a must during the rainy season.

This small and rather unassuming city, devoid of significant architecture, is cut by several rivers, such as the impetuous Toa and the more sluggish Duaba and Miel, and is dominated by the flat-topped Yunque de Baracoa, an anvil-shaped mountain.

The city is an urban enclave flanked by a beach and an open bay. The bay houses the port that for centuries serviced the fastest and most efficient shipping routes of the region that linked Baracoa to other Cuban, Antillean, and U.S. ports, until the construction of the small local airport in the early twentieth century. The air links were, however, limited to flights to the Antilles and Santiago de Cuba. Baracoans are among the few non-Havanan Cubans who are used to dealing with outsiders, since they often travel to major cities for business, study, or to seek health care.

Baracoan culture is extraordinarily rich. The aboriginal archaeological sites currently under study represent a precious heritage, not only for Cuba but for the entire Caribbean region. Remains uncovered at these sites are on exhibit in an old colonial fort, known as Matachín, which now houses the city's main museum.

Folk music, in the troubadour style, pulses with its typical proud rhythms enhanced by lyrical verse, and comes out in full expression in the Baracoesa. The lively folkloric and cultural landscape is completed by traditional craftsmen who use ancient indigenous techniques to fashion a whole range of items using royal and coconut palm leaves, from *bohíos*, palm-thatched wooden huts, to sandals, mats, baskets, and all sorts of other objects used in the day-to-day lives of local peasants. Today, these handcrafted gems make wonderful souvenirs for tourists.

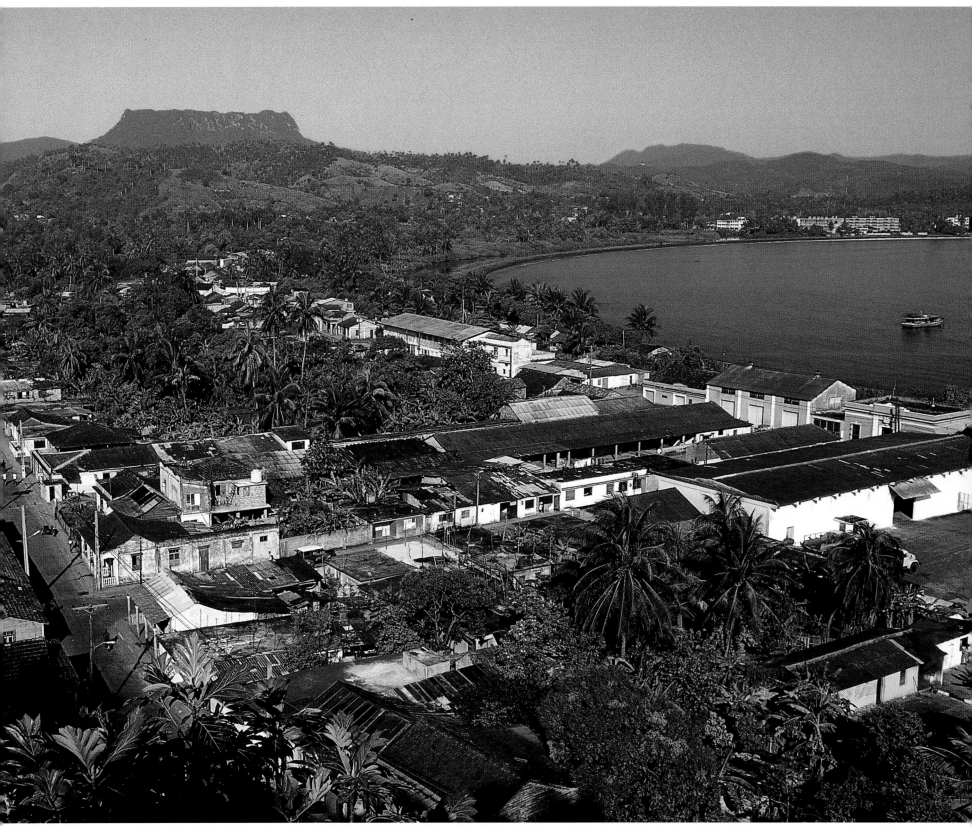

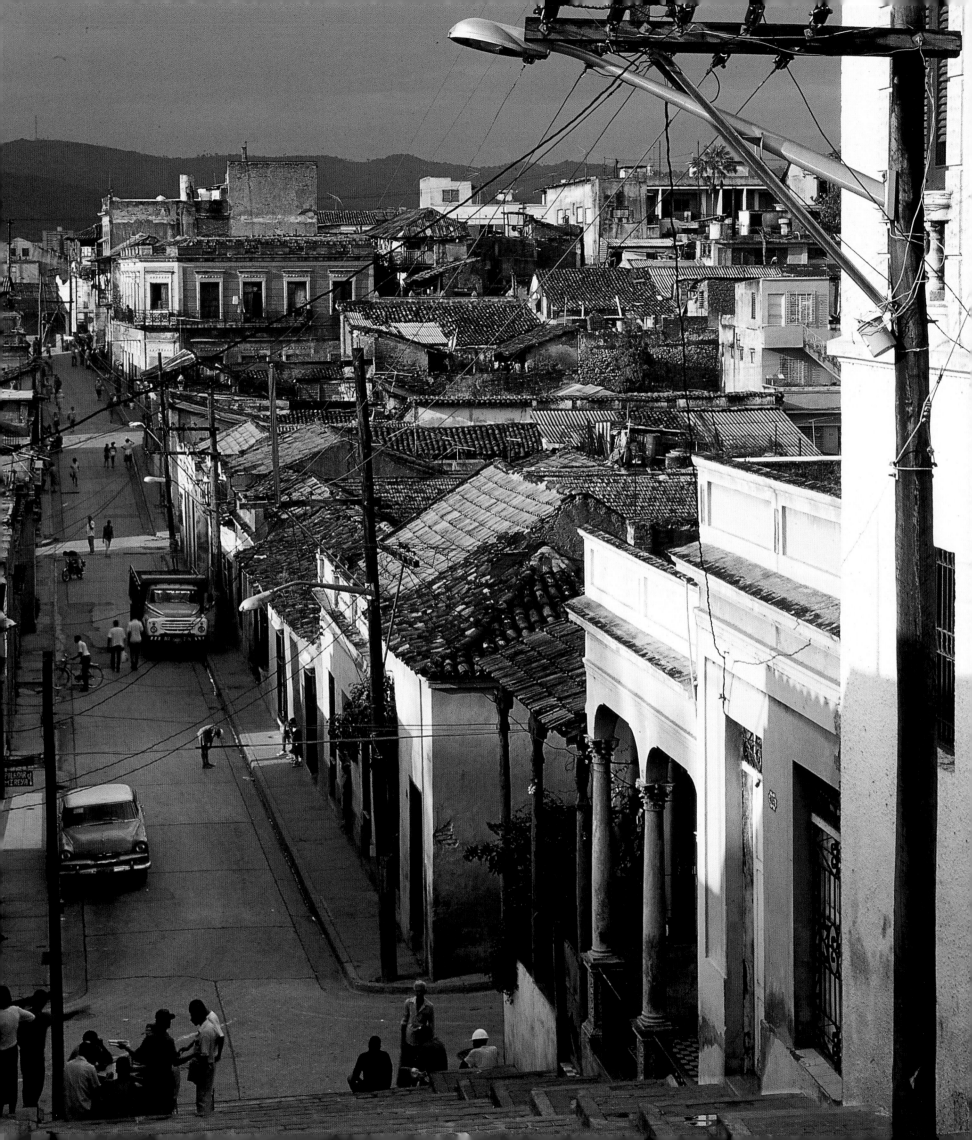

220 The beautiful stairway that interrupts the central Calle Padre Pico is transformed into comfortable "theater stalls" that are used as a public gathering place by the inhabitants of Santiago.

221 TOP LEFT A mural featuring a subject rather rare in Cuba: Santiago was obviously proud of its rich ecclesiastical history.

SANTIAGO

THE **HEROIC** CITY

Santiago de Cuba was the last of the early cities founded personally by Diego Velázquez Cuéllar. In just a few years, from 1518 to 1523, it became the second titular capital during Spanish rule and basically took over the role first assigned to Nuestra Señora de la Asunción de Baracoa. Its first governor was Velázquez himself.

Its hegemony lasted for around thirty years, until the dictates of the economic and political currents underlying imperial Spanish policy shifted the center of power in the island colony to San Cristóbal de La Habana. Santiago remained the capital of the eastern Department when the colony was first divided into two administrative sectors.

The city's magnificent bay is surrounded by highlands, which made it easy to defend. Santiago's old city center that developed around the bay served as a port for fleets carrying metals mined at Baracoa, Bayamo, and Santiago del Prado. The gubernatorial residence used by Diego Velázquez still houses the remains of the third foundry built on the island to cast the precious metals, panned from river and quarry sediment by local natives, reduced almost to a state of slavery, into wedge-shaped ingots, ready for shipping to Spain.

The seat of the new Catholic diocese was shifted to Santiago de Cuba, nestled in a picturesque landscape as a result of the irregularity of the terrain. Construction work on the cathedral commenced in the first half of the sixteenth century. The cathedral underwent several reconstructions and refurbishments over the centuries following repeated natural disasters that hit the city, and took its present form in 1922 when the city was both an Archbishopric and a Metropolitan see. The ecclesiastical history of Santiago de Cuba is well recorded in the precious collection of documents housed in the museum attached to the cathedral, which features the portraits of the first bishops of Cuba and the archbishops of the archdiocese of Santiago de Cuba from the eighteenth century onward.

221 TOP CENTER The dome of the cathedral dates back to the last reconstruction of the building in 1922.

221 TOP RIGHT The Castillo del Morro, designed by the Italian G. B. Antonelli, dominates Santiago Bay from the east.

221 BOTTOM Nuestra Señora del Cobre is named after the copper (*cobre* in Spanish) mines worked by African slaves.

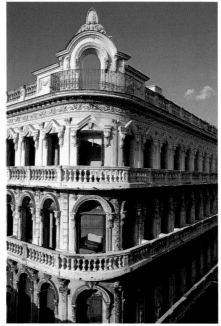

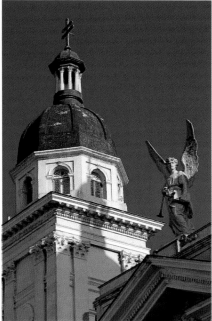

222 BOTTOM THE CATHEDRAL OF SANTIAGO, CROWNED BY THE ANGEL OF THE ASSUMPTION, WAS DAMAGED SEVERAL TIMES BY EARTHQUAKES.

222-223 MONUMENTAL SANTIAGO: THE FACADE OF THE BACARDI MUSEUM AND THE TOWN HALL. FOR CENTURIES, LOCAL STRUCTURES WERE BUILT TO WITHSTAND EARTHQUAKES.

In sharp contrast to the trend observed in Havana, the parochial churches of Santiago, with their elaborate Baroque altars, were more architecturally developed than the convents in the area. Moreover, their flexible structures, built to withstand earthquakes, quite like those found in Bayamo, mark a historical milestone in church architecture.

The apparition of the Virgin of Charity in Nipe Bay on the northern coast of Cuba's Oriente province boosted the importance of Santiago in the religious history of the country. The small image of the Virgin was almost immediately transferred to the parochial church of the mining town of Santiago del Prado, which fell under the archdiocese of Santiago de Cuba. Following this, a modest chapel was built on the hilltop overlooking the copper mine and the huts of the king's slaves, black Africans brought in to undertake the harshest work and local natives employed in other menial tasks.

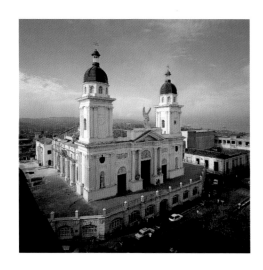

Faith in this Virgin spread rapidly among the aboriginal, African, and black Creole population—including slaves and freemen—as well as among the *mestizos*, and pilgrimages to the site, known since the seventeenth century as the Chapel of the Virgin of Charity of Copper, were organized from Bayamo, Jiguaní, Manzanillo, as well as other neighboring towns and villages. It was as though a regional religious current was born, flowing up to the archdiocese of Santiago de Cuba. During the Cuban Wars of Independence, the Virgin of Charity, in her "Copper" form, was acclaimed the "Rebel Virgin" by all those who fought for Cuba's freedom. In 1916, at the behest of the veterans of the Cuban Army of Liberation, Pope Benedict XV declared her the patron of the Republic of Cuba.

Devotion to the Virgin of Charity and Remedies, whose image was retrieved from the sea by Juan Moreno, a black Creole slave, and two indigenous brothers, Juan and Rodrigo de Hoyos, has been considered typical of Cuba by Don Fernando Ortiz and other reputed historians. The Minor Basilica of the Copper is an example of soberly eclectic religious architecture built in the 1940s.

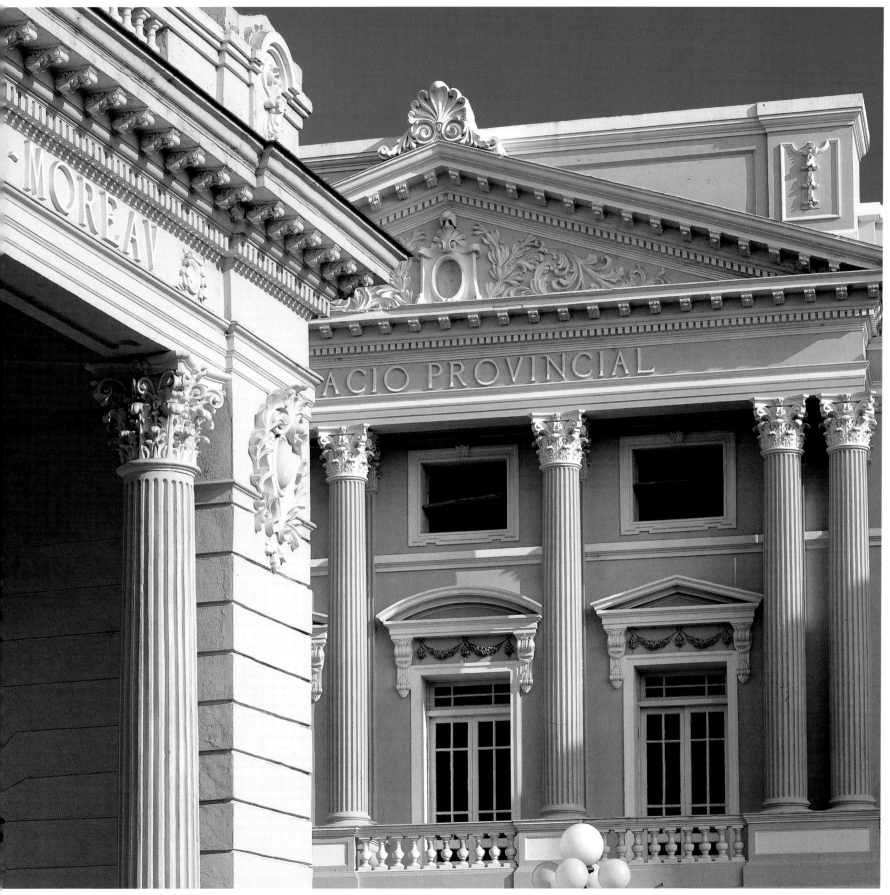

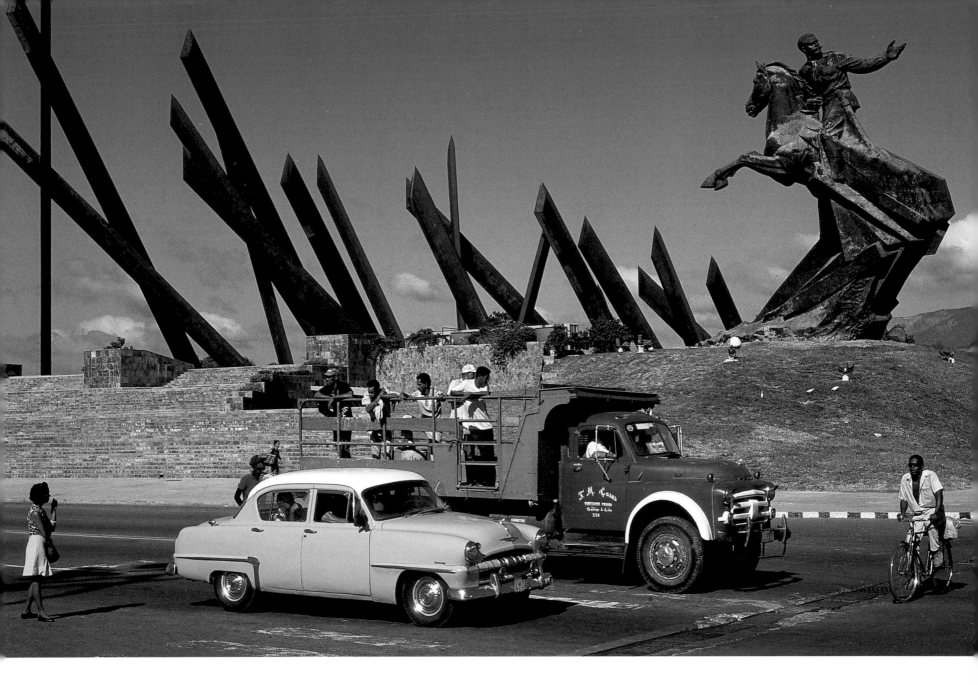

The fort of San Pedro de la Roca, completed in 1690 and located by its architect, Juan Bautista Antonelli, at the highest point of the crag that dominates the entrance to the bay and the port, represents a gigantic feat of military architecture and engineering. It was part of a complex of several other forts: La Punta, La Estrella, Santa Catalina, and San Francisco. It was recently declared a World Heritage Site.

Between the late eighteenth and early nineteenth centuries, Santiago de Cuba felt the impact of immigration, mainly by whites and mulattos fleeing the French Revolution in the Caribbean (for example, following the independence of Haiti), as well as separatist wars in the former Spanish colonies of America.

French cultural influence affected not only the coffee and sugar industries, but also consolidated the refinement of neoclassical architecture and introduced new forms of urban living that considerably enriched Cuba's cities. Even the remotest mountain coffee plantations, where French settlers built their rural homes, reflect

this civilizing influence, which was much more advanced and clearly distinguishable from Spain's cultural contribution. The remains of these French mansions and their surroundings have recently been declared World Heritage Sites.

The Cuban Wars of Independence that lasted for thirty years from 1868 to 1898—interrupted by brief intervals of peace—took a heavy toll on the eastern towns and villages, which were reduced to utter poverty. Urban modernization works underway in Santiago were suspended and postponed until well into the twentieth century in favor of fortifying the city's defenses, since it was one of the most rebellious during the anticolonialist wars.

The naval battle between the North American and Cuban forces against the Spanish navy led to the end of hostilities. This battle took place in and around the Santiago Bay in mid-1898, and this fact, together with the city's location, led to its downfall. The government of the Republic of Cuba that was universally declared in 1902 has

been described as neocolonial, since it labored under constitutional restraints and was subservient to North American interests. Nevertheless, the central and predominant role assigned to Santiago (the second most important city in Cuba at the time) was maintained. The city center was remodeled and enlivened with squares and parks. With the introduction of relatively new architectural styles, sometimes with monumental ambitions, as in the Emilio Bacardi Museum, the city took on a new face, and new buildings appeared in the few residential city districts that housed the urban elite, such as Vista Alegre.

Santiago de Cuba is also known as Cuba's "Heroic City"

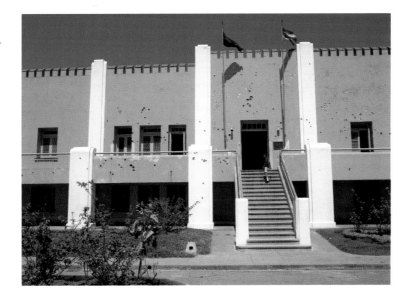

as a result of its role in the patriotic struggle for the country's freedom, starting with the slave uprisings in the copper mines of El Cobre up to the armed insurrection against the dictatorship of Fulgencio Batista, which was sparked by attack on the Moncada barracks in Santiago de Cuba on July 26, 1953. The city fought its rural wars mainly in the Sierra Maestra, with the support of most of the area's urban and rural populations.

The Plaza de la Revolución Mayor General Antonio Maceo y Grajales is located in one of the most spacious areas of the city. The square is dominated by the equestrian statue of that exemplary patriot who was a son of Santiago de Cuba.

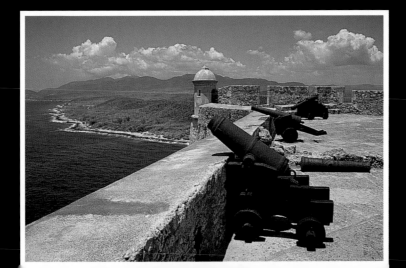

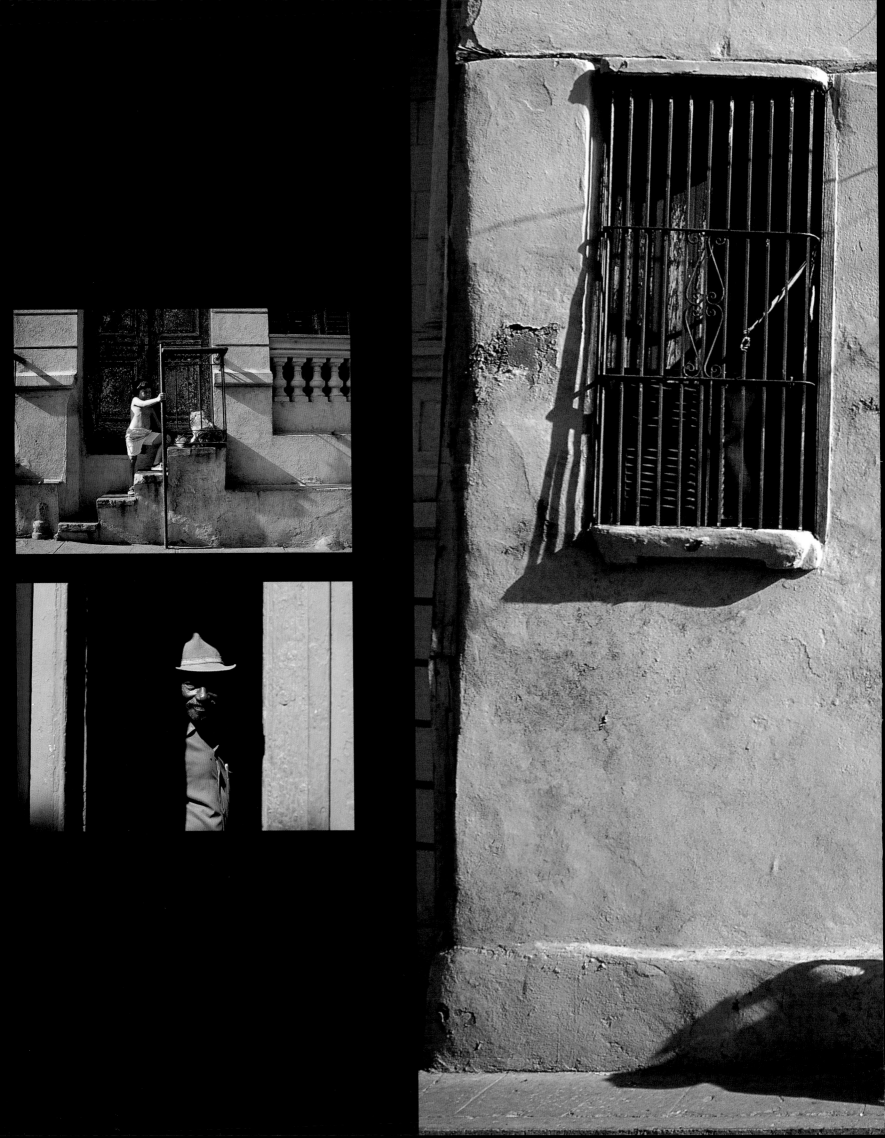

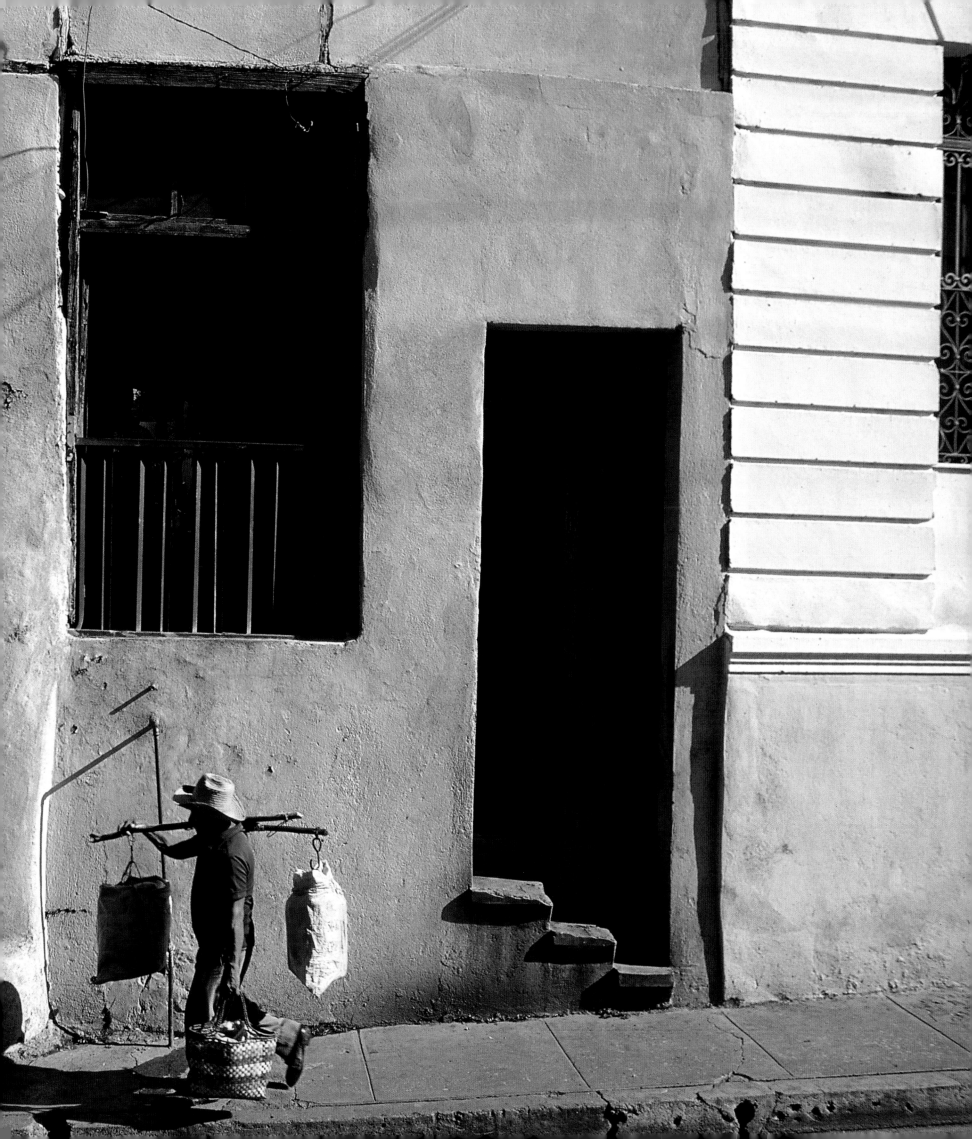

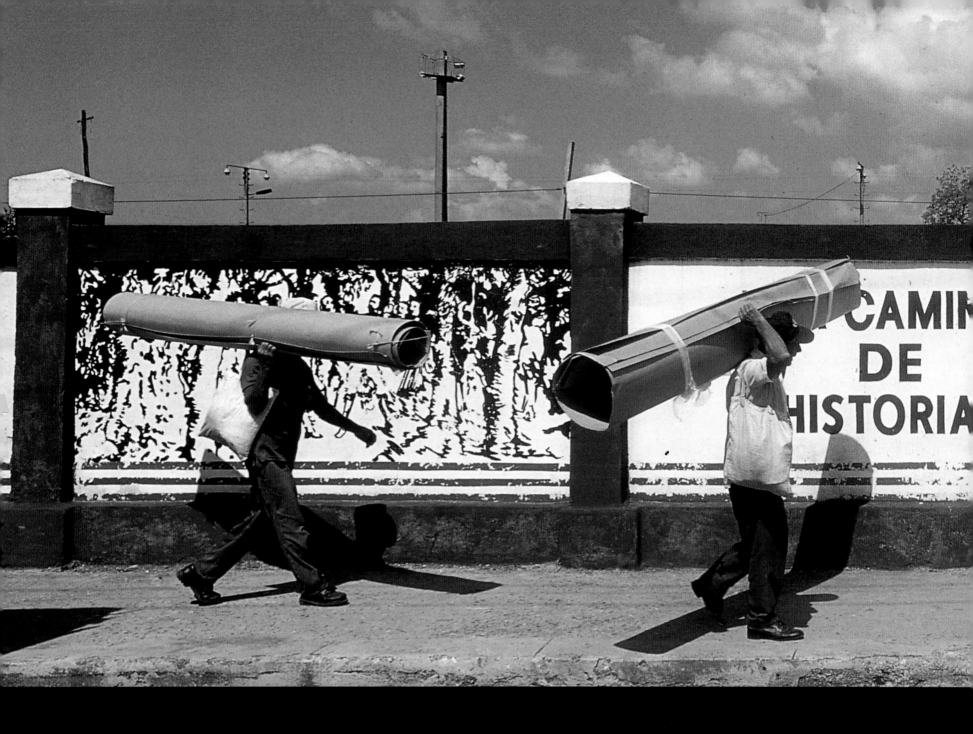
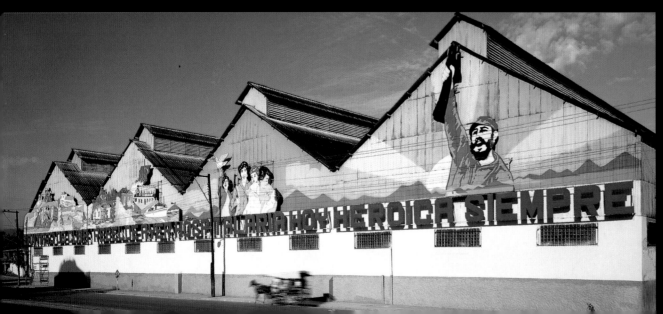

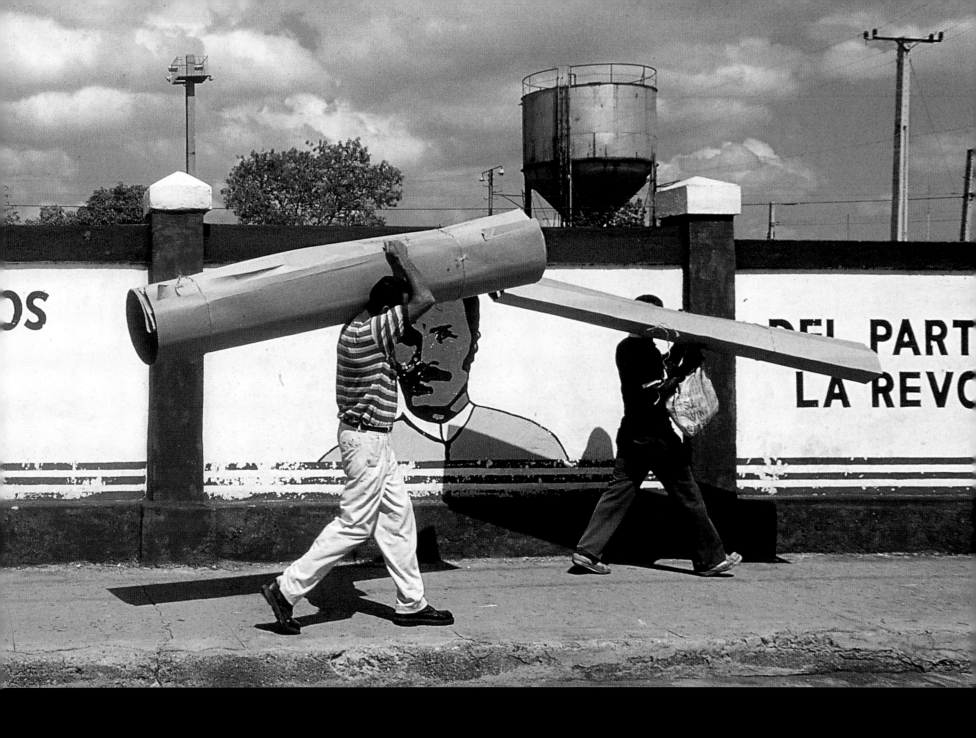

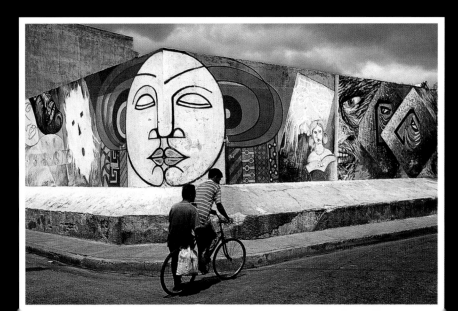

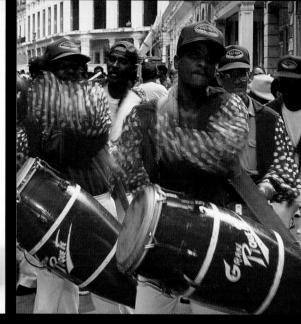

THE SOUL OF CUBA

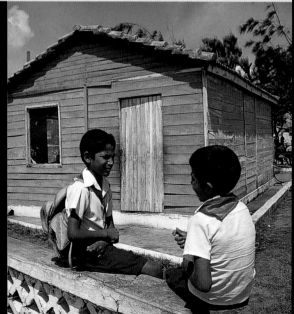

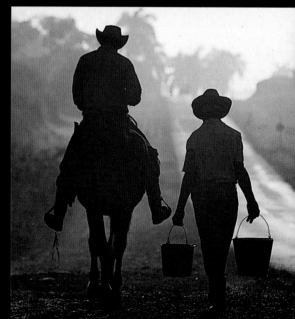

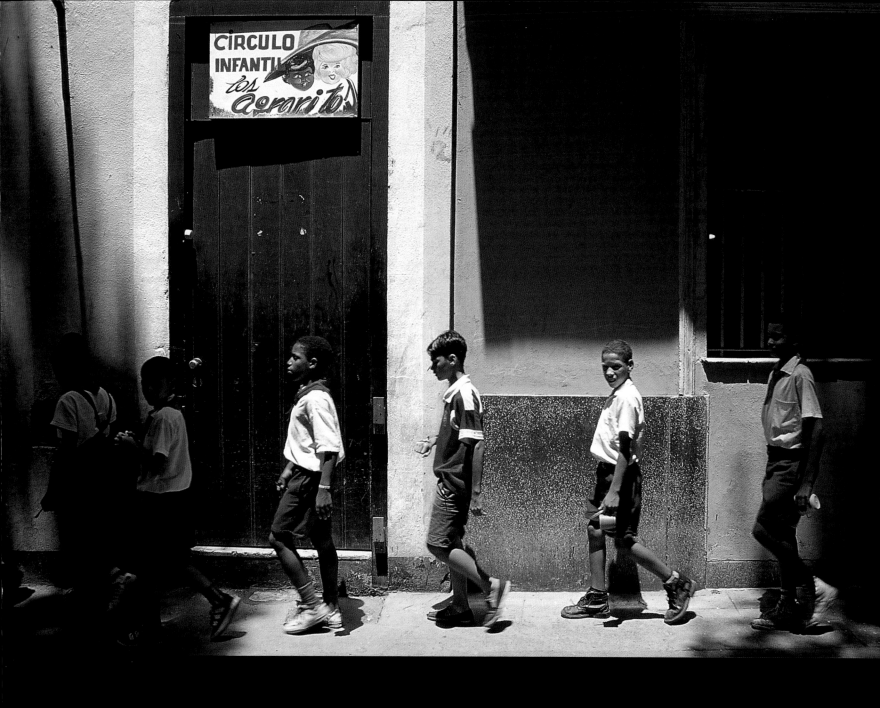

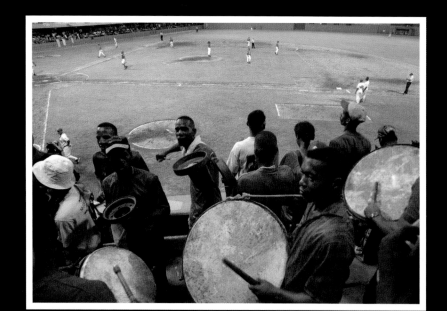

THE SOUL OF CUBA

Over eleven million people live in Cuba—the "Pearl of the Antilles"—and its offshore archipelagoes of small islands. Nearly fifty percent are Afro-Cubans, descendants of slaves that the ruling Spanish shipped from West Africa between the sixteenth and early nineteenth centuries. The Spanish generally married within their own race.

Other elements of the population include descendants of a modest number of Asians (mainly Chinese, with smaller numbers of Japanese) brought in as indentured workers in the late nineteenth century. None of Cuba's original population survives. By 1492 (when Columbus landed on Cuba), the island's earliest inhabitants, the Guanahatabey and Ciboney tribes, had been largely displaced by the Tainos

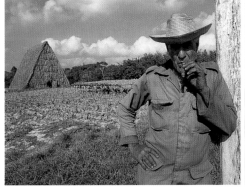 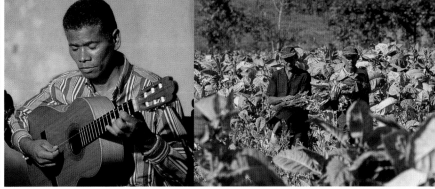

(of Arawak stock), who themselves perished within a half-century of Spanish rule.

Historically, racial discrimination was a fact of Cuban life. Whites of Spanish descent made up the government, ownership, professional, and managerial classes; Afro-Cubans provided the laborers and agricultural workers. The social gap remained strongly defined. Typically, lighter-skinned blacks had greater social mobility than darker-skinned ones. One of the most laudable aims of Castro's Revolution was to put an end to racial discrimination in Cuba. In terms of access to education, career employment, and the professions, great progress has been made. But discrimination has not been entirely eradicated; Afro-Cubans are often underrepresented in the higher economic and social levels. One important initiative is the government's continuing effort to recognize, record, and celebrate the Afro-Cuban

contribution to Cuba's national life, a move that has done much to infuse new pride into the Afro-Cuban population.

Today Cuba's population is more integrated than ever. Over the life of the revolution, the increasing mechanization of agriculture, expanded education at all levels, networks of health clinics *(policlinicos)* and childcare centers *(círculos infantiles)*, an expanded army (which includes *milicianas*), and development of whole new industries (biotechnology and pharmaceuticals among them) have brought many *campesiños* to the cities. Increased intermarriage and the perennial housing shortage have added to the density of the human mix.

Like all great political upheavals, Castro's Revolution promised more than it could deliver. Certainly there was genuine pride in the achievements of the revolution's first decade. The April 1961 Bay of Pigs invasion had been repulsed; in October 1962, the missile crisis was successfully resolved. Great strides were being made in developing and implementing universal education and health-care programs, initiatives that would win much support for Castro's regime. But concurrently, the flight of much of the managerial class, the nationalization of agricultural land and industries, and the prohibition of most private enterprises led to a decline in living standards for millions. Added to this, the American trade embargo led to painful austerity.

234 GRACE AND EXUBERANCE ARE THE DISTINCTIVE FEATURES OF CUBAN WOMEN: A CONVERSATION IN PLAZA DE LA CATEDRÁL IN HAVANA (LEFT); PREPARATIONS FOR THE SUNDAY SHOW AT THE CAPITAL'S GRAN TEATRO (CENTER); CARNIVAL IN BARACOA (RIGHT).

235 INAUGURATED IN 1931, THE TROPICANA DID NOT CLOSE ITS DOORS EVEN AT THE HEIGHT OF THE REVOLUTION AND PROVIDES UNUSUAL INSIGHT INTO THE SPIRIT OF CUBA AND ITS PEOPLE, EXPRESSED WITH A VITALITY THAT EVEN SOME OF THE STORMIEST PERIODS OF HISTORY HAVE FAILED TO QUELL.

THE SOUL OF CUBA

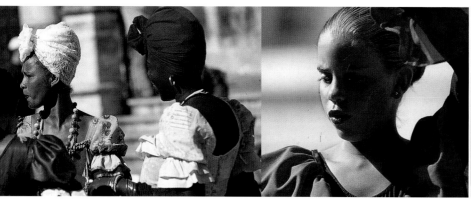 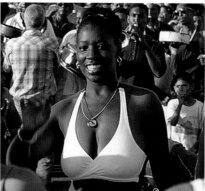

During the 1970s the general sense of stability and slowly improving living conditions were at odds with the visible deterioration of much of the infrastructure and fabric of the country; the physical plant was clearly aging. The necessary investments for progress in the sector of national life invariably shortchanged another. In 1980, the Mariel boatlift saw over 125,000 Cubans brave the hazards of open-sea voyages to leave their homeland. Since then, many others have found ways to leave.

The hardships of daily life increased greatly after the collapse of Cuba's markets in the U.S.S.R. and the Socialist bloc. Yet, despite depressing declines in the standard of living, for the most part Cubans have remained defiantly joyful, shrugging off persistent food shortages and deteriorating apartments, living enthusiastically for the moment.

Life remains sun-drenched, beaches retain their golden sands and azure waters, flowers blossom, and children laugh and play. Health care remains good, malnutrition is comparatively rare, and cultural life is vibrant even in the smaller cities. Somehow, everybody manages.

Cubans have become masters of *resolviendo* (problem solving). Getting to work can be a problem, fuel shortages mean fewer and more crowded trains and buses, erratic food deliveries mean waiting in line in the grocery stores with ration books ready. Modest relaxation of the regulations now allows for the ownership and cultivation of small plots of land and a limited range of private business can be operated. Cuba has not been forgotten. UNESCO named Havana Vieja (Old Havana) a World Heritage Site, and restoration continues, though hurt by a recent hurricane. Political relations between Cuba and other nations (the United States excepted) have improved and greater investment seems likely.

Cuba's expanded tourism industry (now the nation's biggest industry) is heading toward two million visitors and a two-billion-dollar hard currency income within a few years. It is having mixed effects. Visitors expose young Cubans to other cultures and also to hard cash. A subculture of *jiniteros* and *jiniteras* has arisen. The word means "jockey," and refers to young men and women out for a good time with curious and often demanding tourists.

Prostitution is a much-criticized element of this new subculture; it clearly subverts the ethics of the *"nuevo hombre"* of the revolution.

However, for most Cubans, life goes on largely unchanged. For them, the art of living emphasizes maximizing small, inexpensive pleasures. Therefore Cubans dawdle over coffees, watch *beísbol*, or listen to bands in the parks and squares. "Fidel is an old man," they say, "he cannot live forever."

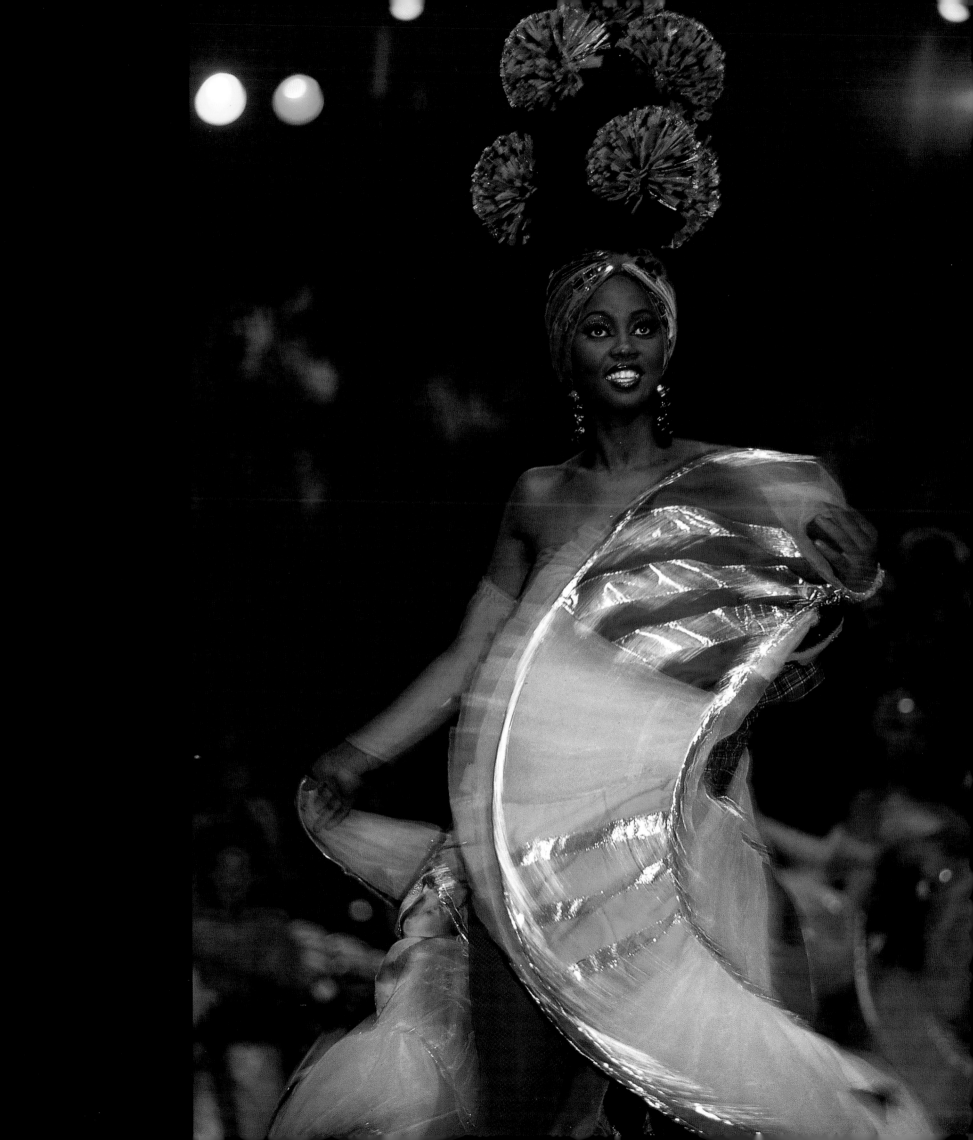

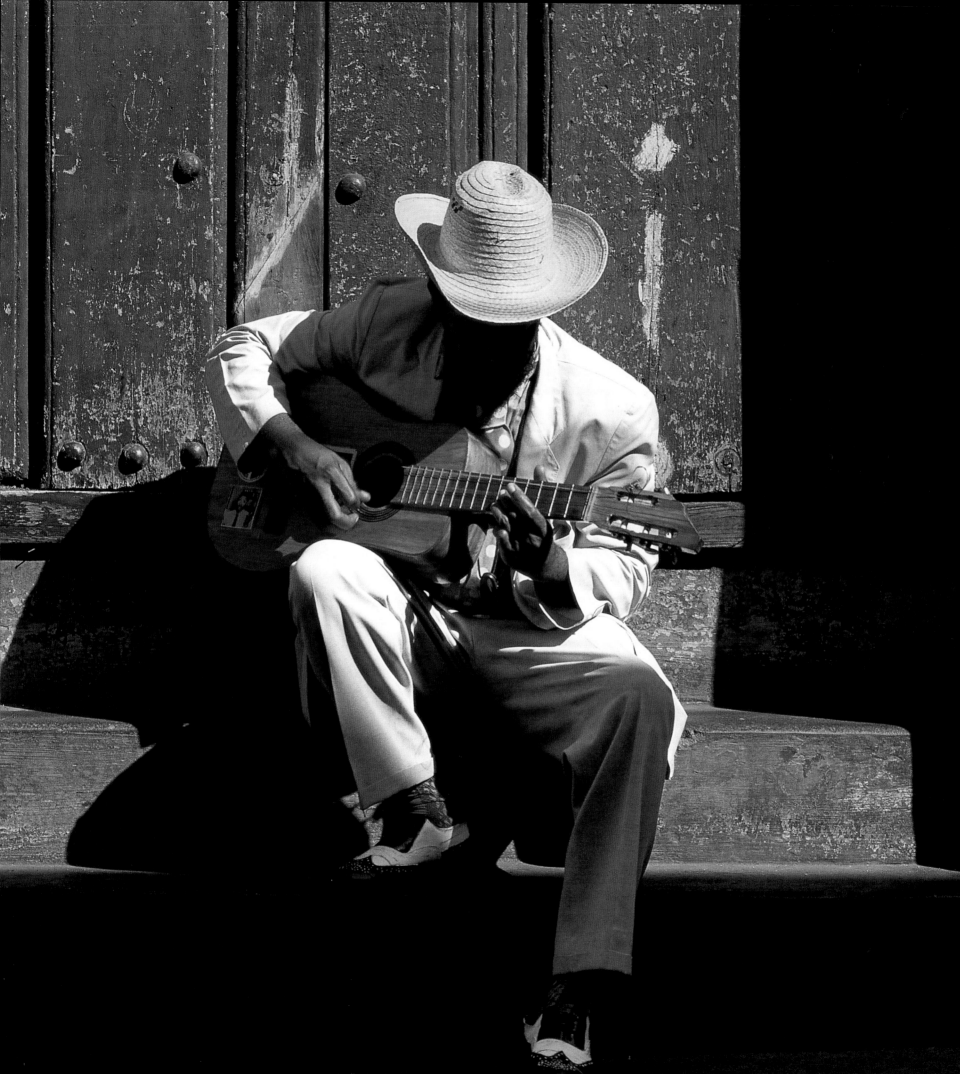

237 TOP In a state of constant creative flux between the physicality of African rhythms and the melancholic spirituality inherited from Spain, Cuba's musicians enjoy a wide expressive spectrum. Left: A salsa guitarist in Trinidad. Center: An Afro-Cuban folk group in Varadero. Right: A son band performs in Santiago, the city of the *Trova*.

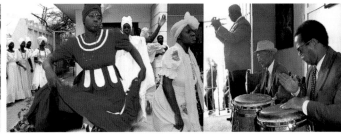

RHYTHMS
AND **SOUNDS** OF CUBA

Cuba's most enduring and pervasive contributions to popular culture are music and dance, gifts from Cuba's soul that she continues to give, enriched by her unique heritage. José Martí (1853–95), the great Cuban writer and revolutionary, spoke of Cuban culture's two equal sources, the Afro-Cuban and the Spanish. Fernando Ortiz (1881–1969), historian and anthropologist, spoke of "the love affairs between the Spanish guitar and the African drum." This gave rise a century ago to *son*, which drew upon both musical heritages. The rumba, with its frequent use of drums and Afro-Cuban dance rhythms, has an equally historic heritage. Nothing was ever static in Cuban music for any great length of time, and modified or new forms developed and entered the mainstream, mambo and cha cha cha among them.

In the Batista era, prior to 1959, the best of Cuban music—*son*, jazz, and other forms drawing upon the Afro-Cuban heritage—enjoyed a high standing among knowledgeable enthusiasts in Europe and the Americas. Concurrently, much of the day-to-day (or rather night-to-night)

music in Havana and other Cuban towns was played in nightclubs for dance- and party-loving tourists. *Guantanamera* was typical: Easy listening meant more than musical purity. Rumba, with its varying speed and intensity, was heard everywhere. With the revolution, "culture" became a weapon in the political armory—music and dance were harnessed to evoke the best elements of Cuba's past and to serve to develop national pride.

The release of *The Buena Vista Social Club* (film and CD) gave Cuba's prerevolution music new life. This tribute featured Ruben Gonzalez, Ibrahim Ferrer, Eliades Ochoa, Omara Portuondo, Benito Suarez, Barbarito Torres, Roberto Garzón, Compay Segundo, Amadito Valdás, and other outstanding artists working their way through numerous musical genres. Other artists acclaimed before the revolution included Pedro Luis Ferrer, famous for lyrics that addressed social issues; Enrique Jorrin, known for his cha cha cha songs; the late Beny Moré ("El Bárbaro del Ritmo"), and Celia Cruz, a salsa vocalist who chose exile. *Bemba Colora* was among her hit recordings.

236 A soloist in Santiago de Cuba. Cuba has long had a decisive influence on the world's pop music.

237 BOTTOM A student practices on the terrace of the Instituto Superior de Arte, founded in 1961 at Cubacanán, a Havanan suburb.

238 MUSIC AT SANTIAGO DE CUBA'S SALSA CLUB. THE SPANISH WORD "SALSA," LITERALLY MEANING "HOT SAUCE," APPARENTLY ALLUDES TO THE "HEAT" OF THE RHYTHM AND ITS MIXED ORIGINS THAT ARE ROOTED IN A WIDE RANGE OF MUSICAL STYLES, FROM THE BOLERO TO THE MAMBO.

239 THE PERCUSSIONISTS OF A DANCE SCHOOL IN SANTIAGO (TOP) PLAY A RUMBA, THE MOST OBVIOUSLY AFRICAN STYLE IN CUBAN MUSIC, WHILE A BAND AT A TRINIDAD CLUB (BOTTOM) PERFORMS A SON, ONE OF CUBA'S MOST TYPICAL SOUNDS.

The revolution launched an enduring duo, Silvio Rodríguez and Pablo Milanés, whose *nueva trova* ("new ballad") songs won wide following. In the 1980s, Carlos Varela began enjoying substantial popularity through songs that voiced a measure of social criticism and critical comment. More recently, contemporary salsa rides high. The durable Los Van Van ensemble and Issac Delgado and his colleagues are perhaps best known among salsa bands. The Irakere group, eclectically employing domestic and foreign jazz traditions, is also much appreciated. Other popular artists include Carmen Flores, Carmen Gonzalez, Selma Reis, Omar Sosa, and Bebo Valdés. Successful ensembles include Cuarteto Caridad Hierrezuelo, Septeto Cubanas, Septeto Nacional Ignacio Pineira, and Conjunto Casino.

In founding the National Recording Institute for Music in the mid-1950s, Castro's government initiated a serious attempt to capture and categorize Cuba's rich musical heritage. During the 1950s, the Conjunto Nacional Folklórico (The National Folkloric Ensemble) was formed and did much to popularize Afro-Cuban music, including traditional Yoruba music used in *santería* rituals. No need to fear the eclipse of Cuban music—rhythm is in the island's blood and every town has a *casa de la trova* (music hall), and carnivals and band-led processions *(comparsas)* ensure the warm relationship between musicians and audiences.

Dance also has a distinguished history in Cuba. At the time of the revolution, ballet had attained the highest levels of art and professionalism in Cuba, and continued to maintain them. For this achievement, thanks are due to the remarkable husband-and-wife team of the Alonsos. With his wife Alicia, Fernando Alonso, primarily a great teacher, founded a progressive but unpretentious ballet school in Havana in the 1950s. He believed that all children should come to ballet early in life and that their experience with dance was liberating, a means of developing the whole person. Before the revolution, Alicia Alonso was the prima ballerina with Cuba's leading ballet company. After the revolution, she led the restructured company, now named the Ballet Nacional de Cuba. While not neglecting the classical repertoire, the company aggressively sought new ballets and, among other works, premiered Alberto Alonso's politically charged new ballets, *Vietnam: The Lesson* and *Conjugacíon,* which dealt with the life and death of Che Guevara.

The pantheon of prerevolutionary Cuban writers include José Martí, Nicolás Guillén, and Fernando Ortiz. All recognized the current limitations and future possibilities of a richly endowed Cuban people. Recent writers have run up against censorship. Two older literary giants went into exile: Alejo Carpentier (1904-80), known for *Explosion in a Cathedral* (1962), a densely detailed novel dealing with eighteenth-century Caribbean life, and *Reasons of State* (1974), about a dictator in decline; and Guillermo Cabrera Infante (b. 1929), whose exuberant, picturesque *Three Trapped Tigers* (1965) and *Infante's Inferno* (1979) have retained a readership. The poets Heberto Padilla and Armanda Valladares were both victimized. Recent, younger writers include established figures such as Reinaldo Arenas, the novelist Antonio Benitez Rojo, and the poet Miguel Barnet. Other talented writers include Arturo Arango, Carlos Olivares Baró, Onelio Jorge Cardoso, Lourdes Casal, Leonardo Padura Fuentes, Miguelina Ponte Landa, Miguel Mejides, Angel Santiesteban Prats, and Valdés Severo.

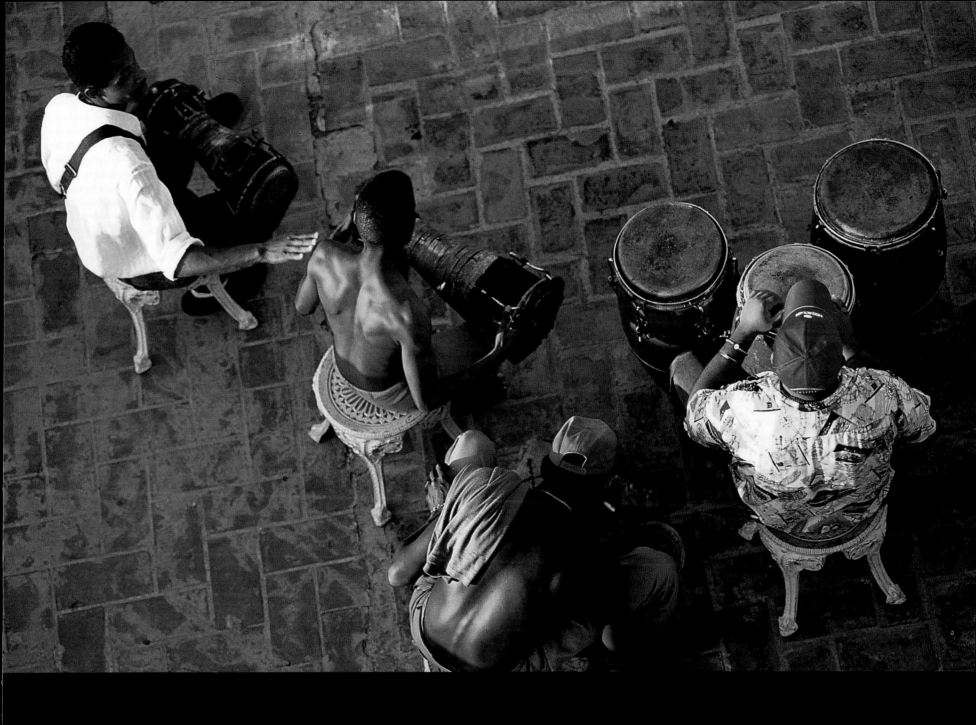
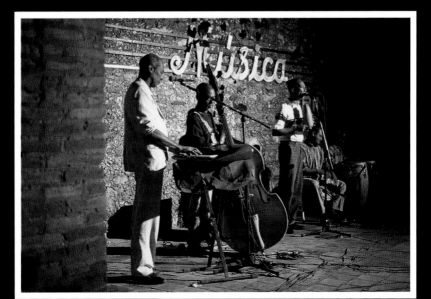

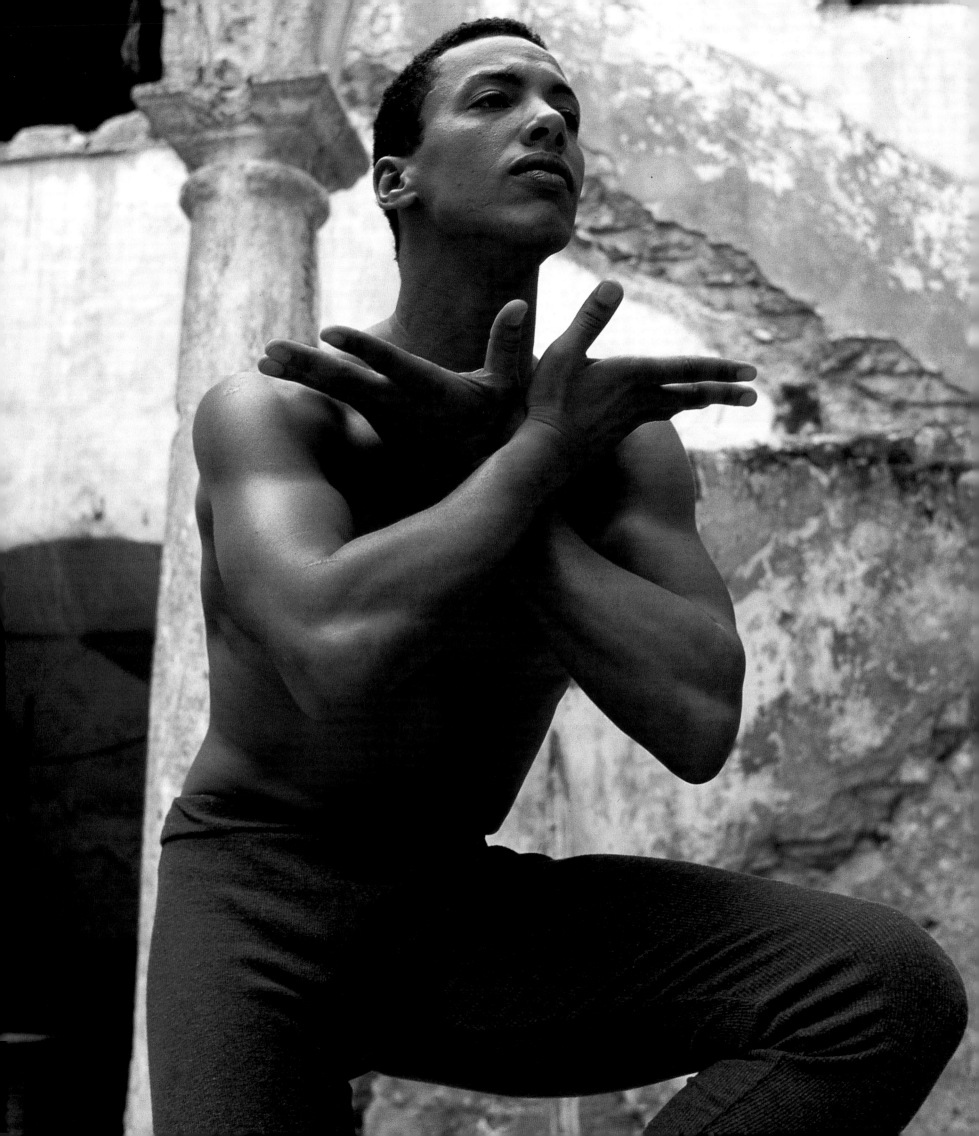

240 DANCE IS NOT MERELY A PASTIME IN CUBA, IT PLAYS A KEY ROLE IN THE COUNTRY'S CULTURE. STUDIED AS A SEPARATE SUBJECT IN SCHOOLS, IT OPENS THE DOOR TO EXCELLENT JOB OPPORTUNITIES. IN THIS PHOTO A DANCER AT THE TROPICANA.

241 TOP, THE BALLET NACIONÁL REHEARSES A PERFORMANCE AT HAVANA'S GRAN TEATRO. BOTTOM, SIXTH-LEVEL STUDENTS OF THE ELEMENTARY BALLET SCHOOL PERFORM FOR A VISITING DELEGATION FROM THE WASHINGTON BALLET.

242 AND 243 CONGA PLAYERS WITH A DANCER IN ACTION DURING THE INAUGURAL PARADE OF HAVANA'S CARNIVAL. BY DEFINITION, THE CARNIVAL IS A PERFECT COMBINATION OF MUSIC, DANCE, AND "PAGAN" MYSTICISM, THE VERY FOUNDATIONS OF THE CUBAN SOUL.

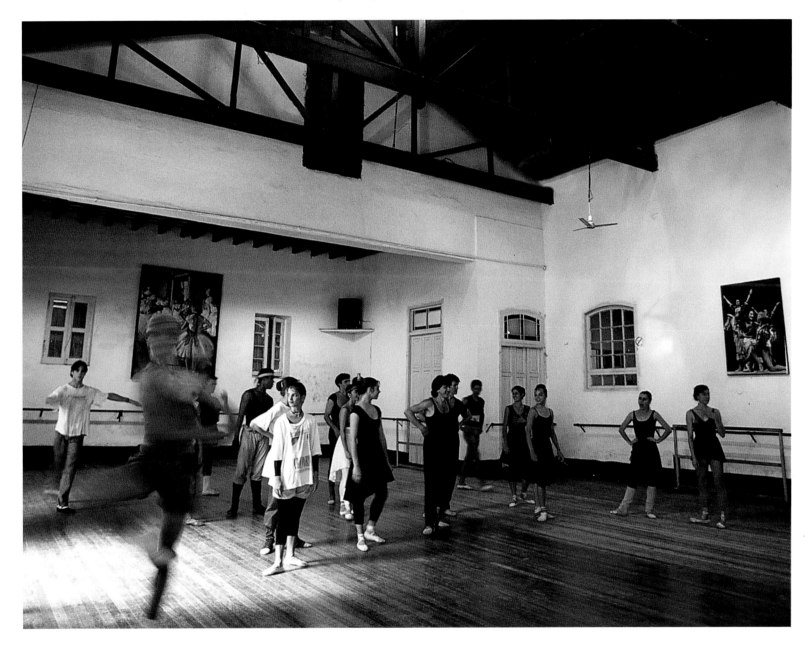

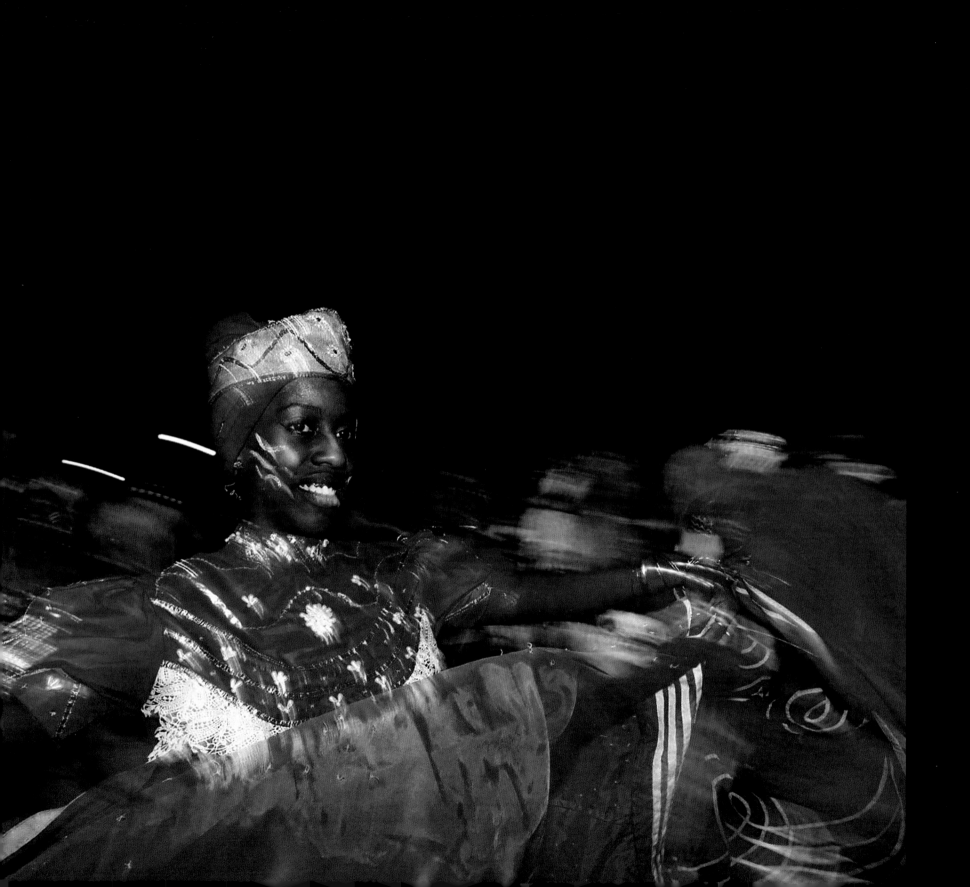

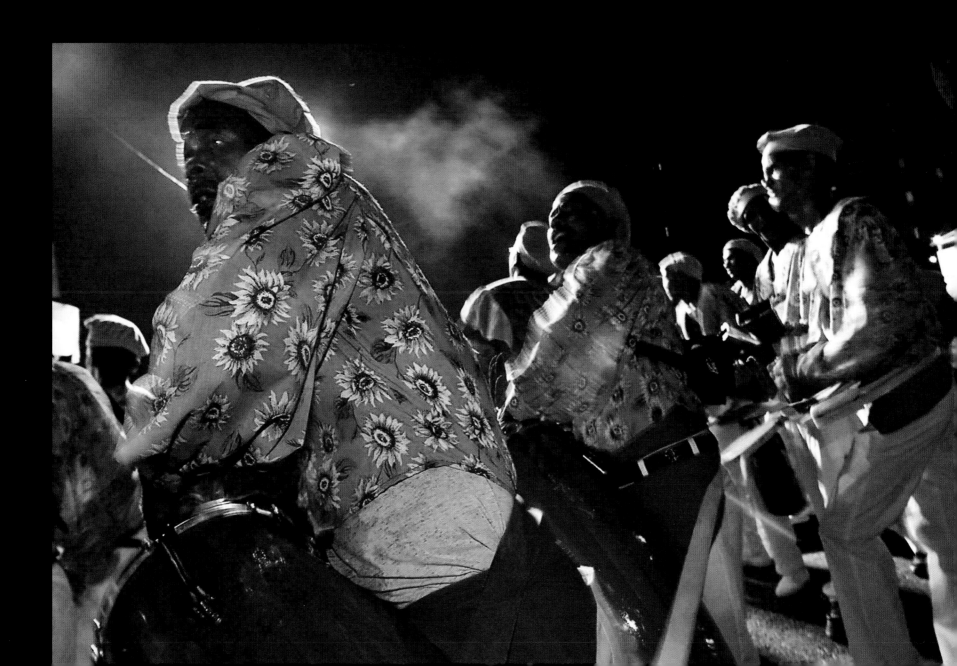

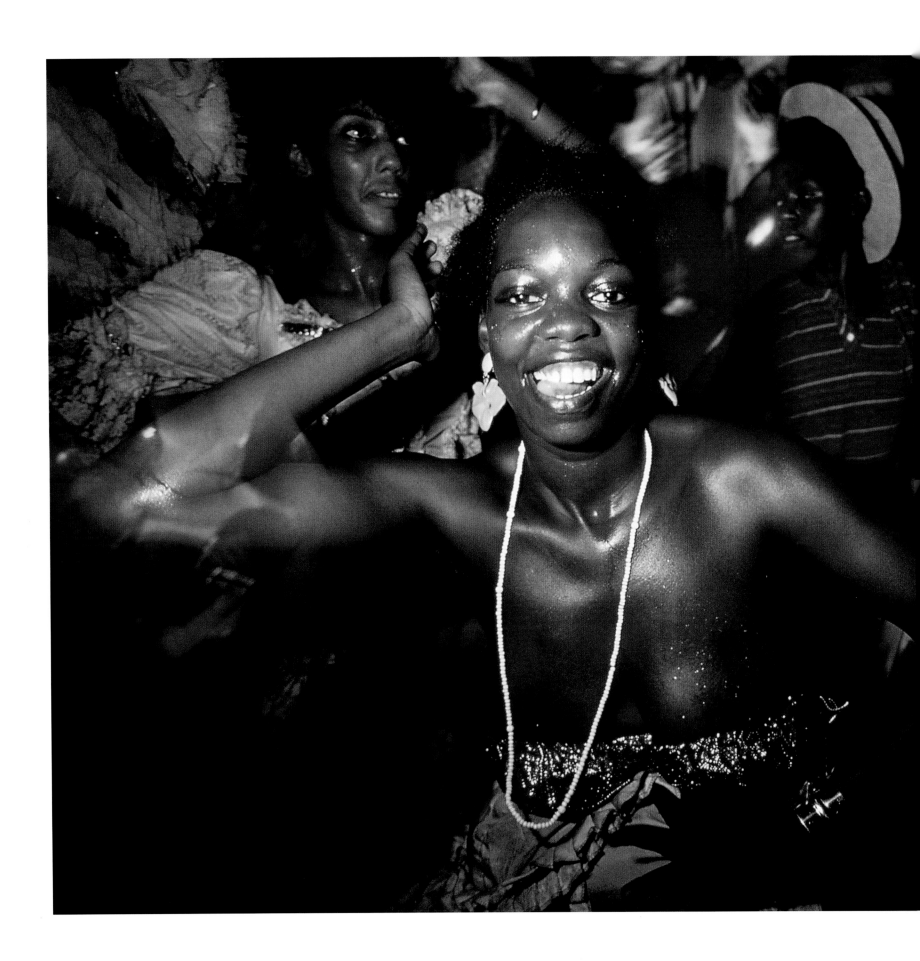

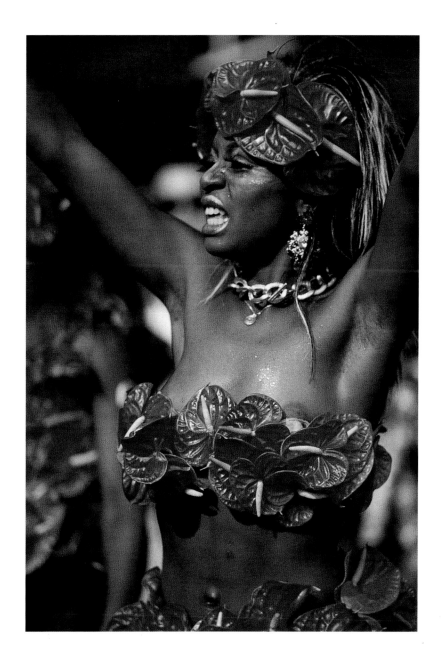

244-245 THE CUBAN CARNIVAL IS AS JOYFUL AND NOISY AS ANY IN LATIN AMERICA, ALTHOUGH THAT IS WHERE THE SIMILARITIES END. THE CUBAN CARNIVAL IS CELEBRATED IN THE SUMMER.

246-247 ORGY OF LIGHT AND COLORS IN THE NIGHT AT THE TROPICANA, THE "TEMPLE" OF MUSIC AND DANCE. WHILE FALLING FAR SHORT OF HIGH CULTURE, THE TROPICANA IS WELL APPRECIATED BY HABANEROS AND FOREIGNERS ALIKE AND IS PART AND PARCEL OF THE CHARM OF CUBA.

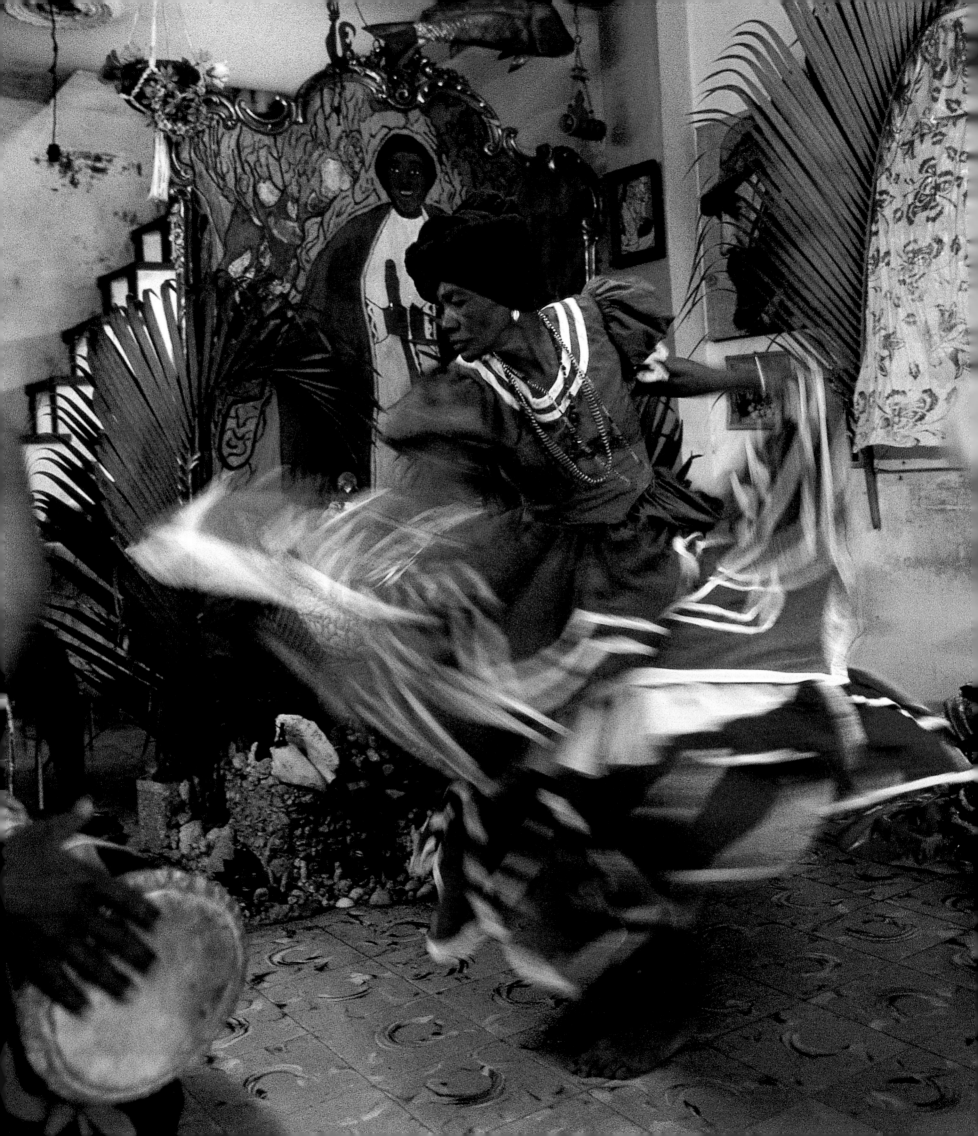

 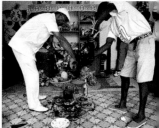

SANTERÍA

THE EXILE OF AFRICAN GODS

For many, the word "santería," like "voodoo," conjures up images of the colorful, exotic rites that used to feature frequently in the travel adventure genre so popular until the mid-1950s, when personal travel became much easier and travel writing became significantly more concerned with accuracy. Santería may be termed the superimpostion or grafting of African deities onto Roman Catholic saints and their worship within the broad patterns of Catholic ritual. But santería does not end there; it has its own rituals that believers practice outside the church, and many of these scarcely connect to any Catholic practice.

Santería was synchronous with the settlement and development of Cuba. Wherever the Spanish brought West African slaves into their colonies in the Caribbean and Latin America, the victims of this barbarous practice clung to and maintained their traditional religions. Their masters saw this as a threat to their control of the slaves, who generally outnumbered them, a situation not divorced from danger. Attempts to coerce the slaves into forgoing their age-old beliefs and practices and to adopt Catholicism—and thus become obedient to the local Catholic priest—were frequent, though only intermittently and superficially successful. Instead, another process set in, never exact or easily measured but nonetheless genuinely transformative.

The Afro-Cubans' identification of their captors' best-known saints as Christian versions of their tribal deities was part of a much more complex process. Beliefs and gods are never symmetrical or fully interchangeable. No "who's who" serves to identify all superimposed or merged identities definitively; much depended on a community's African tribal and regional background, and an Afro-Cuban community was often mixed by the vicissitudes of the slave market and subsequent marriages and lines of descent. After the abolition of slavery in 1866 and with the urbanization of the twentieth century, Afro-Cubans mixed significantly more with the Spanish people and urban Catholicism, with further evolutions in santería, the resulting "mixed" or "compounded" faith.

In Cuba the predominant transported African peoples were the Yorubas (from Nigeria) and the Arará (from Dahomey), and their tribal deities, languages, and names were therefore dominant in the "renaming" of Catholic *santos* (saints) and the evolution of santería. Most potent and feared in the Yoruba pantheon is Olofi, the unspeakably powerful source of all creation, approachable through the four great orishas (deities): Changò, the osha of drums, lightning, and warlike powers, is female and is worshipped as Santa Barbara; Obatala, a female deity, is the orisha of peace and is worshiped as the *Virgen de las Mercedes*; Oshùn is the deity associated with love and passion and is worshipped as the *Virgen de la Caridad*; Yemayá is the mother goddess and is also associated with waters and harbors. She is worshipped as the *Virgen de Regla*, a township across the harbor from Havana. Other orishas include Orula, the goddess of wisdom; Ellegua, the messenger, orisha of the roads and guardian of the portals of Purgatory; Oja, the orisha of graveyards; Ogun, the orisha of the farm and its tools, worshipped as Saint Peter; Ochosi, the orisha of the hunt, with his bow and arrows; and Babalù Ayé, associated with hardship and worshipped as Saint Lazarus.

Santería rituals *(toques)* take too many forms to count. Some are part of the Catholic faith's calendar of public festivals; many are small gatherings in private homes or chapels; others are held in simple rural huts or in the open. Music is an integral part of the ceremony, and dances specific to the various *santos* are frequently

performed within the ceremonies, which are led by *santeros* or *babalaos* (santería priests). The ritual drums *(batás)* are valued as sacred objects. The drumming achieves a rhythmic intensity that leads some participants into a trancelike state. This may allow for visions of the future or indications of lines of action. Formal divination systems can be used, such as use of the *opkele*, a chain of coconut-shell fragments that form patterns when thrown down. In the countryside, other aspects of santería are more noticeable. Trees have a sacred significance, and dolls or small symbolic offerings are placed in the junction of the trunk and a branch.

It is difficult to define accurately the role santería plays in modern Cuban life. Prior to 1900, when Cuba was almost entirely agricultural and daily life was plantation, farm, or village-based, the Catholic festivals were welcome breaks in routine. Santería was vibrant and vigorous and the Church could do little about any of its more pagan rites when practiced in private. In 1948, with the issue of Celina González's record, "Santa Barbara (QueViva Changó)," santería made its mark in popular song. Then in 1960, the government condemned "cultists" along with other types of hooligans and undesirables. As santería reflects the role of Afro-Cubans in shaping Cuba's culture and its ceremonies draw tourists and don't threaten the Partido Comunista de Cuba, the religion flourishes.

Typically, the more educated a person, the more likely he or she is to claim to adhere to rational beliefs rather than any involving santería. Yet public positions are often at odds with private actions and maintenance of a household shrine; recourse to a santero may persist among even the most strongly self-professed rationalists.

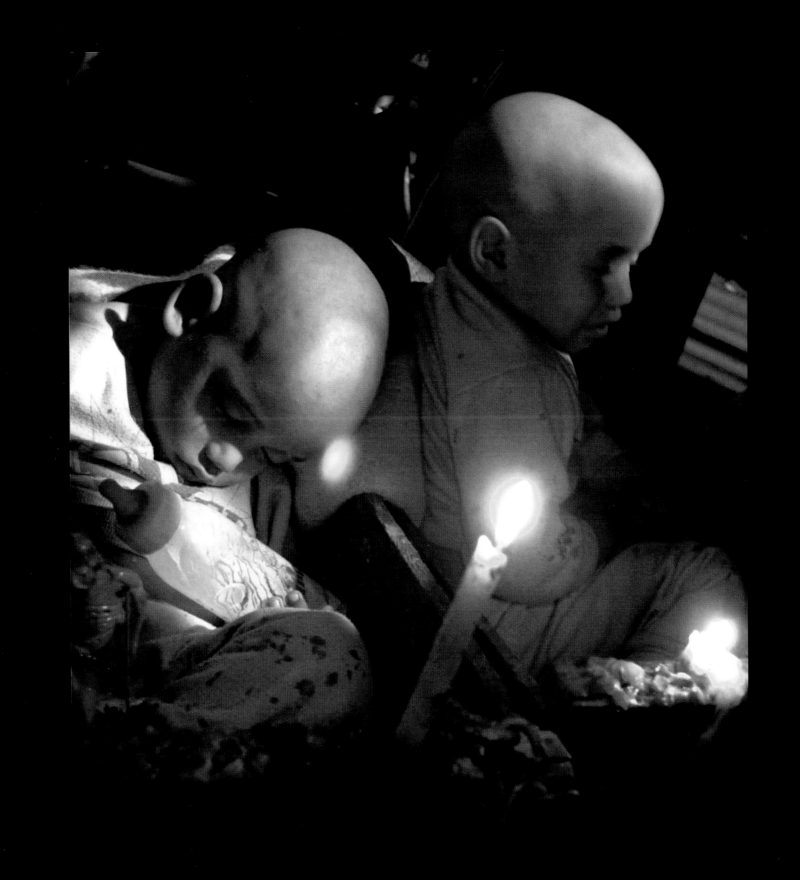

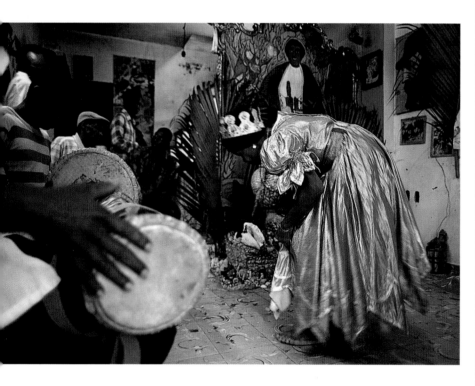

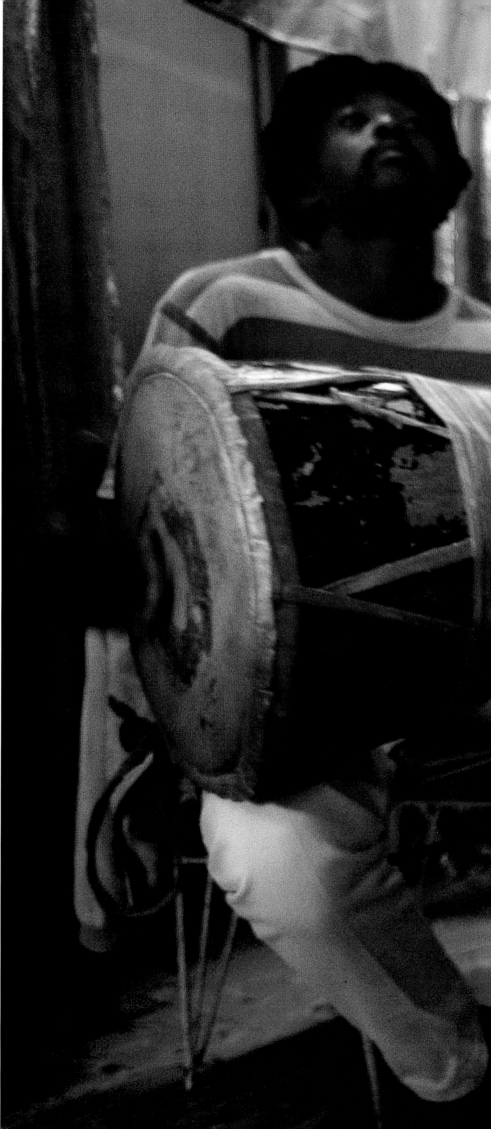

252 EVOCATION OF OCHÚN, ORISHA OF LOVE AND STREAMS, IDENTIFIABLE BY HIS GOLDEN VESTMENTS. THIS IMPORTANT FIGURE IS ASSOCIATED WITH THE VIRGIN OF COBRE, THE PATRON OF CUBA.

252-253 ELEGGUÁ, RED AND BLACK ORISHA OF HUMAN DESTINY. AFRO-CUBAN CULTS ARE NOT ONLY RELEGATED TO THE RELIGIOUS SPHERE BUT ARE ALSO EVIDENT IN THE LOCAL LANGUAGE. A LARGE NUMBER OF COLLOQUIALISMS AND NEARLY ALL CUBAN PROVERBS ARE ROOTED IN THE JARGON OF THE SANTERÍA.

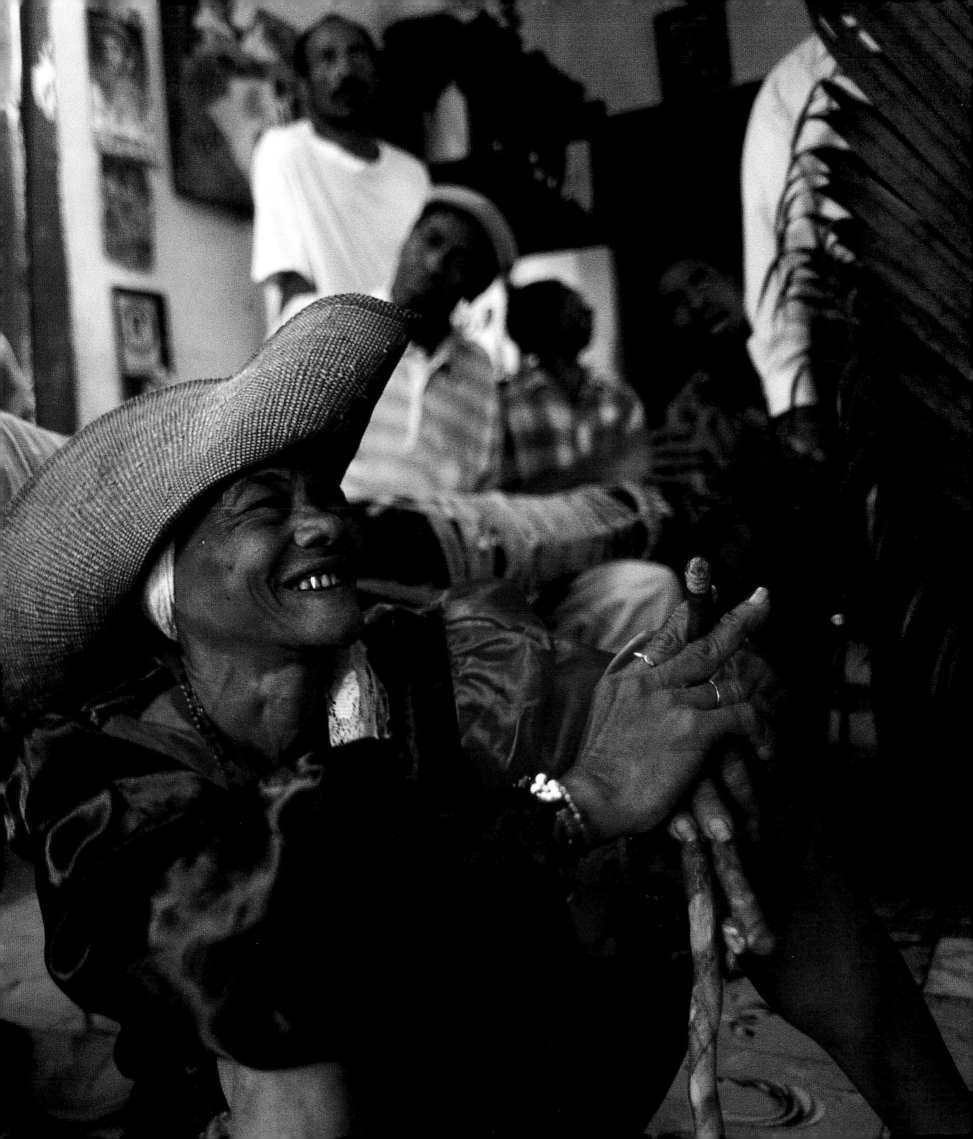

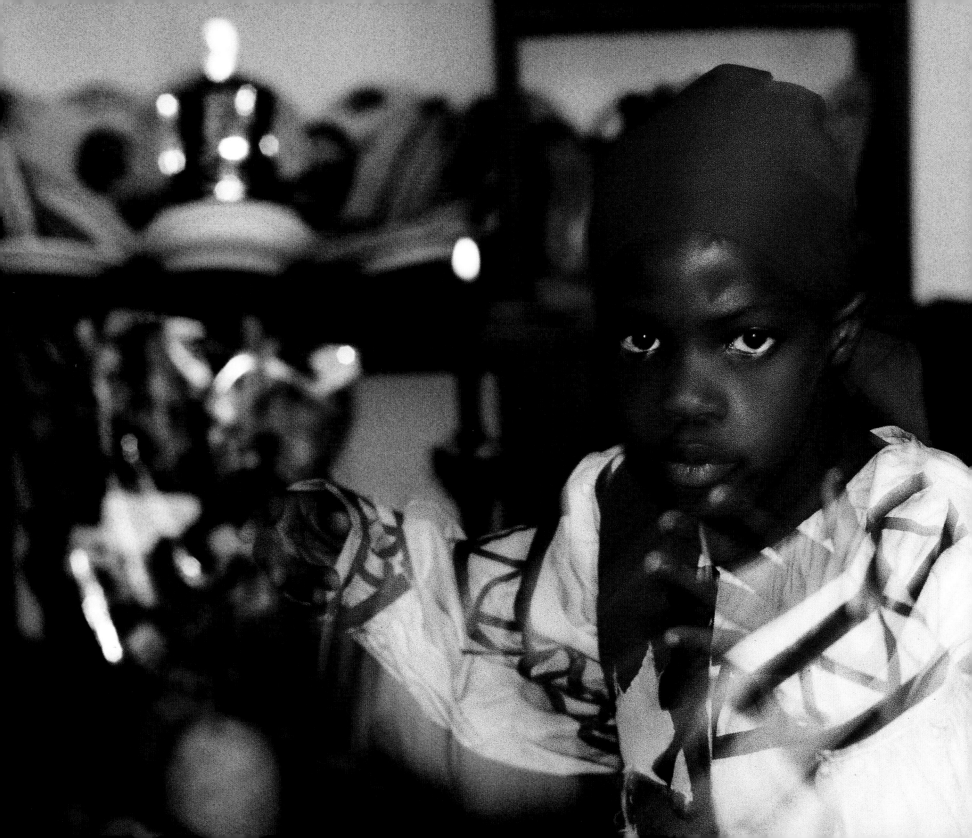

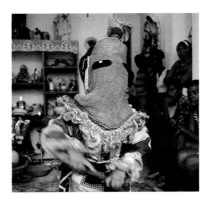

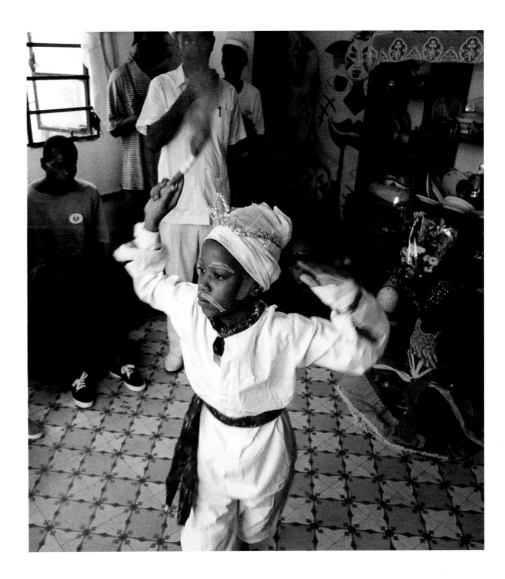

254-255 A CHILD IMPERSONATES THE WARMONGERING CHANGÓ, WHO, PERCHED ON TOP OF ROYAL PALMS, ALSO GOVERNS LIGHTNING. DESPITE APPEARANCES, THE SANTERÍA IS NOT ESOTERIC INSOFAR AS WHOEVER WANTS TO WITNESS A CEREMONY IS WELCOME.

255 BABALÚ AYÉ (ABOVE) AND OBBATALÁ, THE ORISHAS OF HEALTH AND HARMONY, RESPECTIVELY. THE CUBAN GOVERNMENT HAS ALWAYS BEEN MORE TOLERANT TOWARD THE REGLA DE OCHA THAN THE CATHOLIC CHURCH, WHICH, FROM AN AFRO-CUBAN VIEWPOINT, IS SEEN AS NOTHING OTHER THAN A SPANISH FORM OF SANTERÍA.

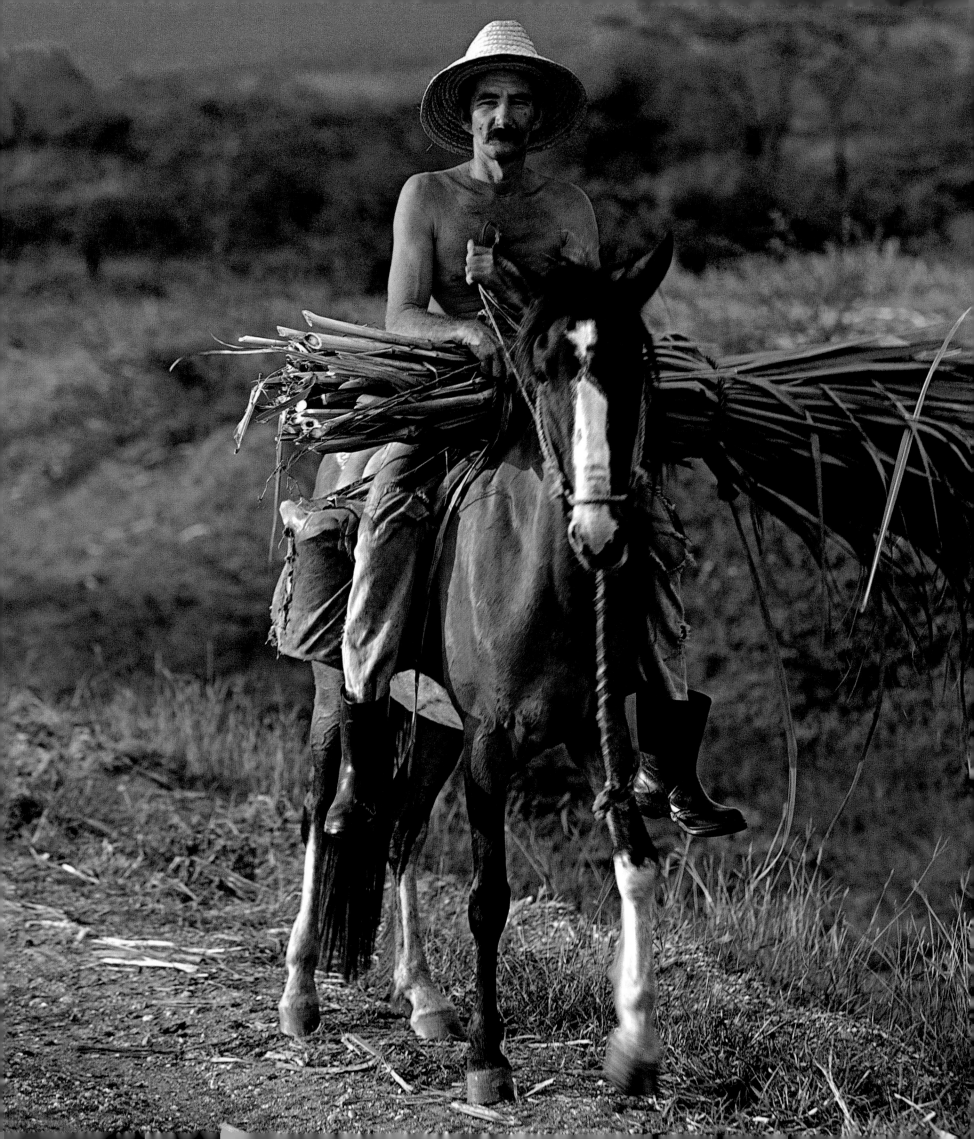

257 TOP THE HORSE (LEFT, VAQUEROS AT MATANZAS) IS STILL THE MOST
CONVENIENT MODE OF TRANSPORTATION IN RURAL AREAS, ESPECIALLY SINCE
SNAKES AND OTHER DANGEROUS CREATURES ARE COMMON ON
PLANTATIONS. THE GROUND MUST BE PREPARED BEFORE THE PLANTING OF
SUGARCANE SHOOTS. MAINTENANCE OF AN ANIMAL-DRAWN AGRICULTURAL
MACHINE, BEFORE THE HARVEST.

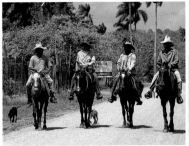
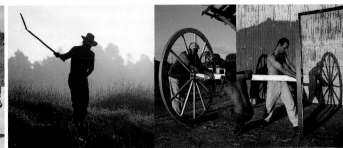

SUGAR

A BITTERSWEET RESOURCE

"SIN AZÚCAR, NO HAY PAÍS"—

"Without sugar, there is no country."

Sugar was both Cuba's bounty and bane until displaced by tourism; it was the primary money-earning crop that the island nation relied upon but resented. From modest origins in Cuba's early history, sugar came to change the island's racial makeup, to reshape landholding patterns into ever-larger plantations, to distort employment, and to skew the economy, dominating national life. In the bumper years of the 1960s, harvests topped 7.5 million tons and brought in over $800 million in foreign currency. In the 1990s, planned diversification of agriculture coupled with unplanned bad weather resulted in years that produced only half the previous tonnage and income.

Within a decade of Diego Velasquez's conquest of Cuba in 1511, the Spanish realized the strategically important island was not rich in gold, but that income could be derived from sugar destined for the burgeoning Spanish market. The British conquest of Cuba in 1762 was followed by an attempt to make sugar production a major industry. With the casual brutality that marked the era, 10,000 African slaves were immediately shipped into Cuba to support expanded planting and harvesting. Within a year, Britain had ceded the island back to Spain, but the slaves remained.

For three centuries the industry expanded. Long gone are the *trapiches* (sugarcane plots), the small estates with their *bohìos* (thatched huts) where the *colonos* (estate laborers) lived, and the modest *centrales* (sugar-processing mills) with their mounds of *bagasse* (crushed cane). By 1900, through relentless consolidation, plantations grew to hundreds of thousands of acres. Nothing changed in the backbreaking toil of the January through March *zafra* (harvest)—this still required armies of machete-swinging laborers, moving through the plantations to cut and de-leaf the cane, chop it into manageable lengths, and load it onto carts bound for the *central*. By 1959, the year of Castro's takeover, Cuba was the world's largest sugar producer. The crop required over forty percent of the island's agricultural land and a labor force of some 500,000 workers. Yet it was by no means a

256 A PEASANT RETURNS FROM WORK
IN THE FIELDS OF MANICAGUA (SANTA
CLARA). THE SUGARCANE HARVEST,
ZAFRA, TAKES PLACE IN THREE
SEPARATE PHASES BETWEEN
JANUARY AND EARLY JUNE.

257 BOTTOM A HORSE AMONG THE
SUGARCANE IN THE FIELDS OF
CIENFUEGOS. PLANTATION WORK IS
ONLY PARTIALLY MECHANIZED IN FLAT
AREAS. MECHANIZATION IS MAINLY
LIMITED TO HARVESTING TASKS.

258 TOP IN CUBA, RUM, PERHAPS THE MOST UNIVERSALLY APPRECIATED OF ALL THE MANY PRODUCTS DERIVED FROM SUGARCANE, IS CELEBRATED IN THE MUSEO DEL RON AT HAVANA THAT PROVIDE A VERY SPECIAL PERSPECTIVE IN RECONSTRUCTING THE HISTORY OF THE ISLAND.

259 FROM THE FIELD TO INDUSTRY: TOP, A WORKER CHECKS THE GRINDING OF THE PRODUCT IN THE REFINERY "30 DE NOVIEMBRE," IN THE REGION OF PINAR DEL RÍO. BOTTOM, HUGE LOADS OF SUGARCANE BOUND FROM THE VALLE DE LOS INGENIOS FOR THE REFINERIES: THIS PHASE MUST BE VERY QUICK, SINCE SUGARCANE DOES NOT RESIST THE HEAT WELL.

"Cuban" industry; Americans owned nine of the ten largest plantations and about forty percent of the industry.

Castro's Revolution nationalized the sugar industry and projected a new future. He hoped to end Cuba's dependence on sugar, freeing land and labor for diversified crops and raising livestock. At the same time, investments were made in improving cane-cutting machines, which—if they could be made reliable—would end the arduous task of cutting cane by hand. This would be a great psychological victory, ending Cubans' subordination to the machete, the broiling sun, and aching backs.

Despite the best of intentions, Castro did not succeed in lessening

sugar's role in the Cuban economy. The defeat was primarily ideological. The United States, angered at Castro's declaration of communism, prohibited the import of sugar and the export of oil. The Soviet Union stepped in, taking the entire Cuban sugar crop at a preferential valuation and supplying oil at the same value, while allowing Cuba to sell any surplus oil for hard currency. Cuba thus married itself to sugar, with no possibility of divorce in sight. Nonetheless, there was a worthwhile victory in labor terms. By scheduling replanting and staggering harvesting, Castro's Sugar Ministry lengthened the employment season, reduced peak labor demand, and decreased the *tiempo muerto* (the post-zafra dead time). Successful efforts were made to modernize the centrales and to utilize the sugarcane by-products. Increasingly, the bagasse was used as a basis for paper and cellulose products and some of the molasses runoff

generated during the refining stage was used in cattle feed and in the distillation of alcohol.

Cuba's new marriage to sugar became ever more demanding. With the continuing emigration of the managerial and skilled classes, the decline of Cuba's economy, and the closing of many external markets, the sugar-for-oil exchange with the U.S.S.R. had to be exploited to the maximum. The larger the sugar export, the larger the oil import, and the greater the surplus for hard currency sales. In 1970, Castro announced a zafra target of ten million tons. More cane was planted, the zafra commenced earlier and lasted longer, and a huge labor force was mobilized. All to little avail—the zafra yielded well under nine million tons, coupled with massive economic dislocation.

Worse was to come. With the weakening of the Soviet economy and the end of the oil-for-sugar agreement, Cuba was plunged into hardship, with Castro instituting a Special Measures in Peacetime Program in an attempt to meet Cuba's basic needs.

Bad weather, poor harvests, aging centrales and equipment, and lack of vehicles, fuel, and spare parts combined to lower income from sugar. No divorce was possible—profit per acre from sugar far exceeded that of any other agricultural commodity, and sales still provide Cuba with much-needed foreign currency. The thrust for modernization in the sugar industry goes on despite the difficult economy. But success remains elusive. Even if plantation terrain were leveled to allow for use of mechanical cutters, the question of paying for the combines and needed spare parts remains an issue. Similarly, the centrales need additional cash in order to operate. On the plantations, the cane needs scheduled replanting, and during the zafra, fleets of vehicles and hundreds of thousands of laborers are needed, depleting other industries. The desperately needed annual billion dollar fix remains elusive, at risk to such factors as weather, world demands, and prices set in distant marketplaces.

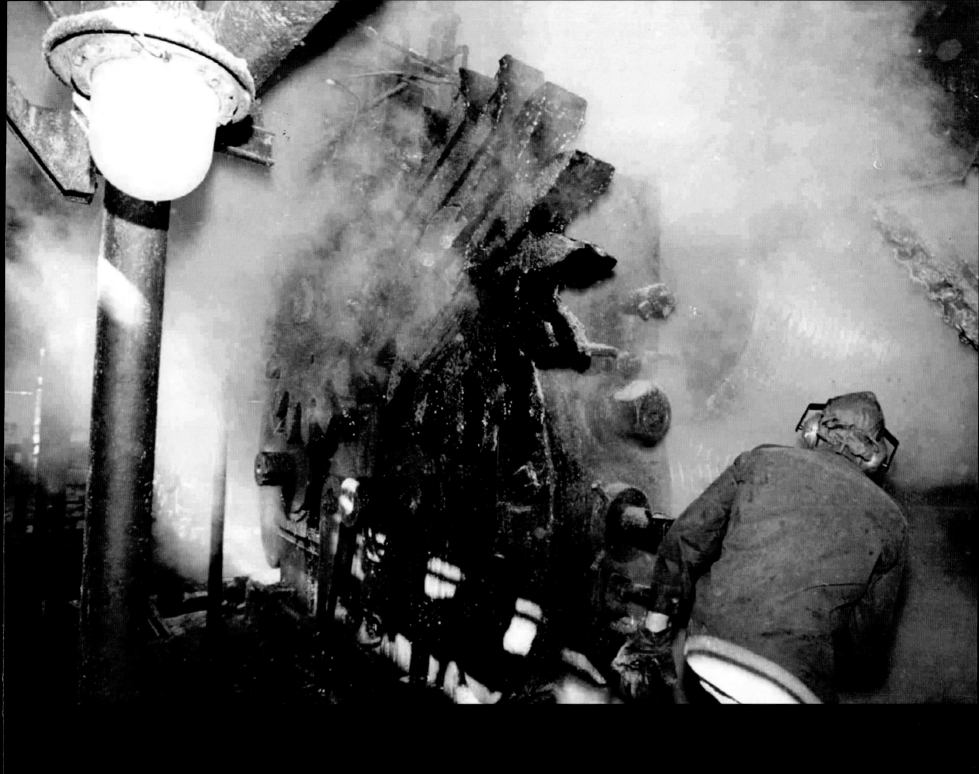
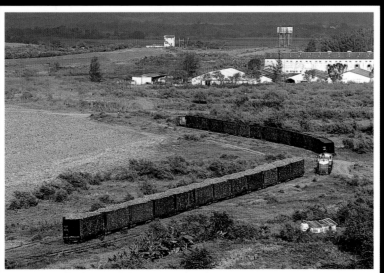

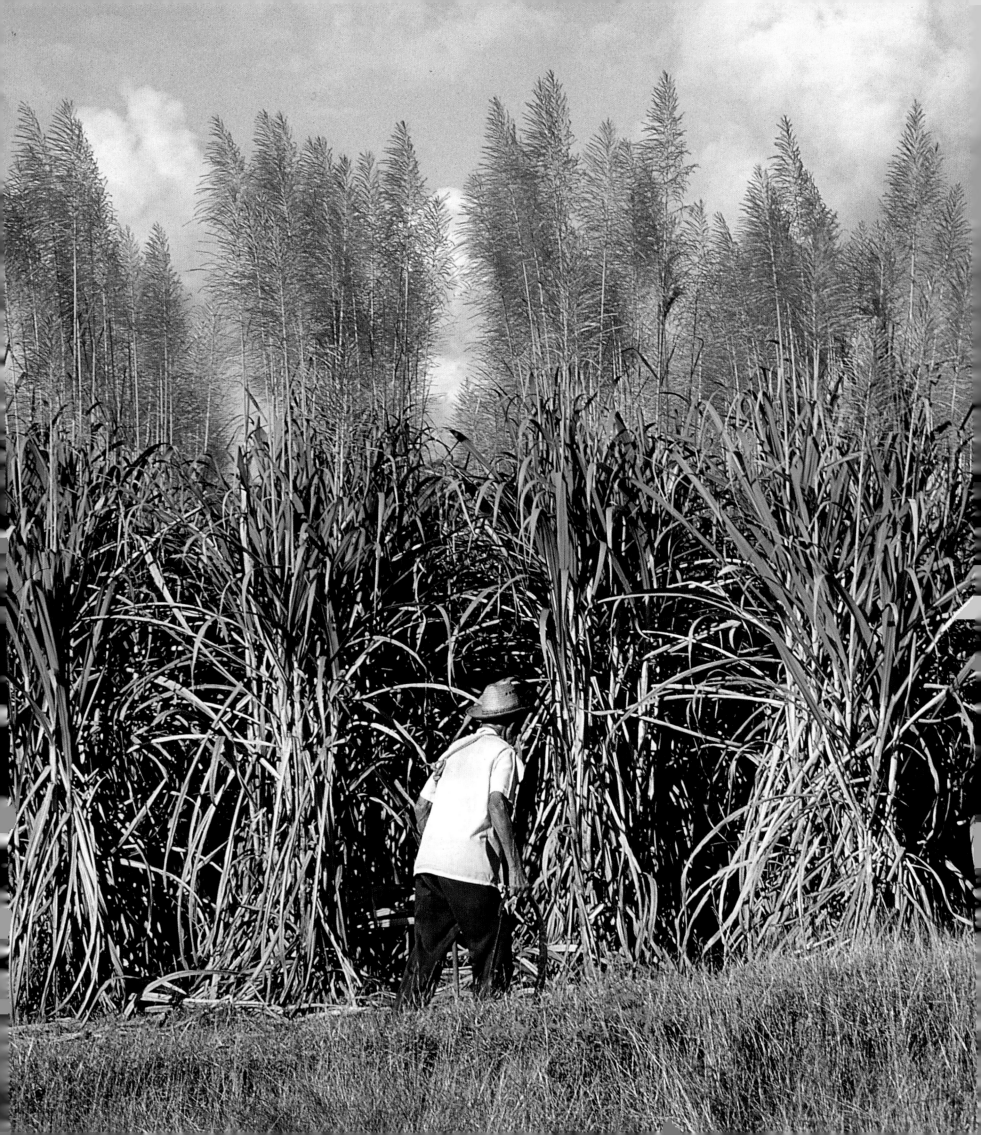

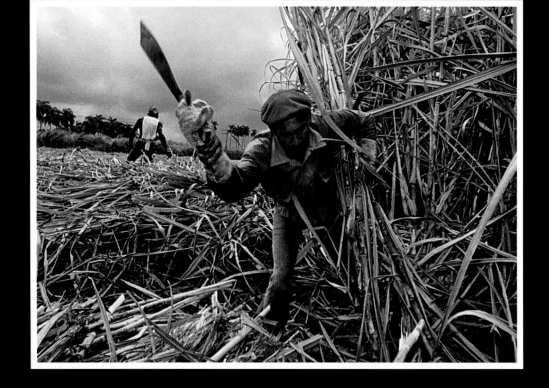

260-261 Sugarcane plants, reaching up to sixteen feet in height, are now ripe for harvesting: the harvest season extends from January to May.

262 *Machetero* in action: A great deal of skill, precision, and speed goes into harvesting sugarcane. In order to preserve the quality of the crop and avoid waste, the cut must be made using a specific technique.

263 TOP A mechanized harvester in the Camagüey plantations. First introduced in the 1970s, during the crisis in the 1990s mechanized harvesting was seriously hindered by fuel shortages.

263 BOTTOM Cooperative society workers are paid in kind. The sack contains agricultural products for his family.

264-265 Harvesting in the plains north of Camagüey. Unlike tobacco and coffee, sugarcane is a high-yield crop that can be almost entirely transformed into a variety of products from sugar and molasses to rum and low-cost fuel.

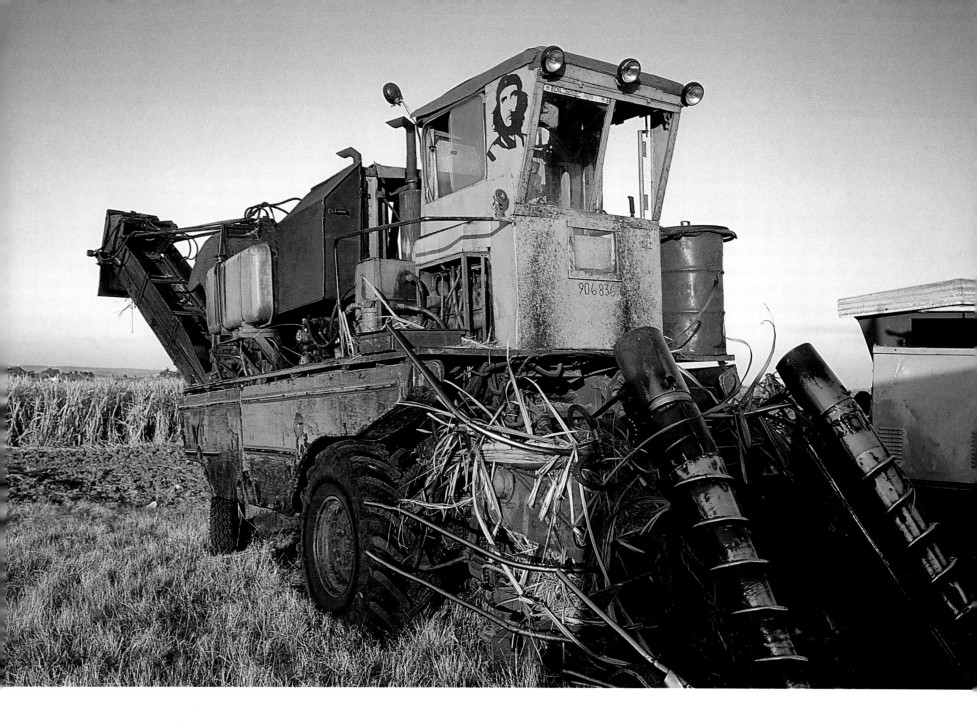

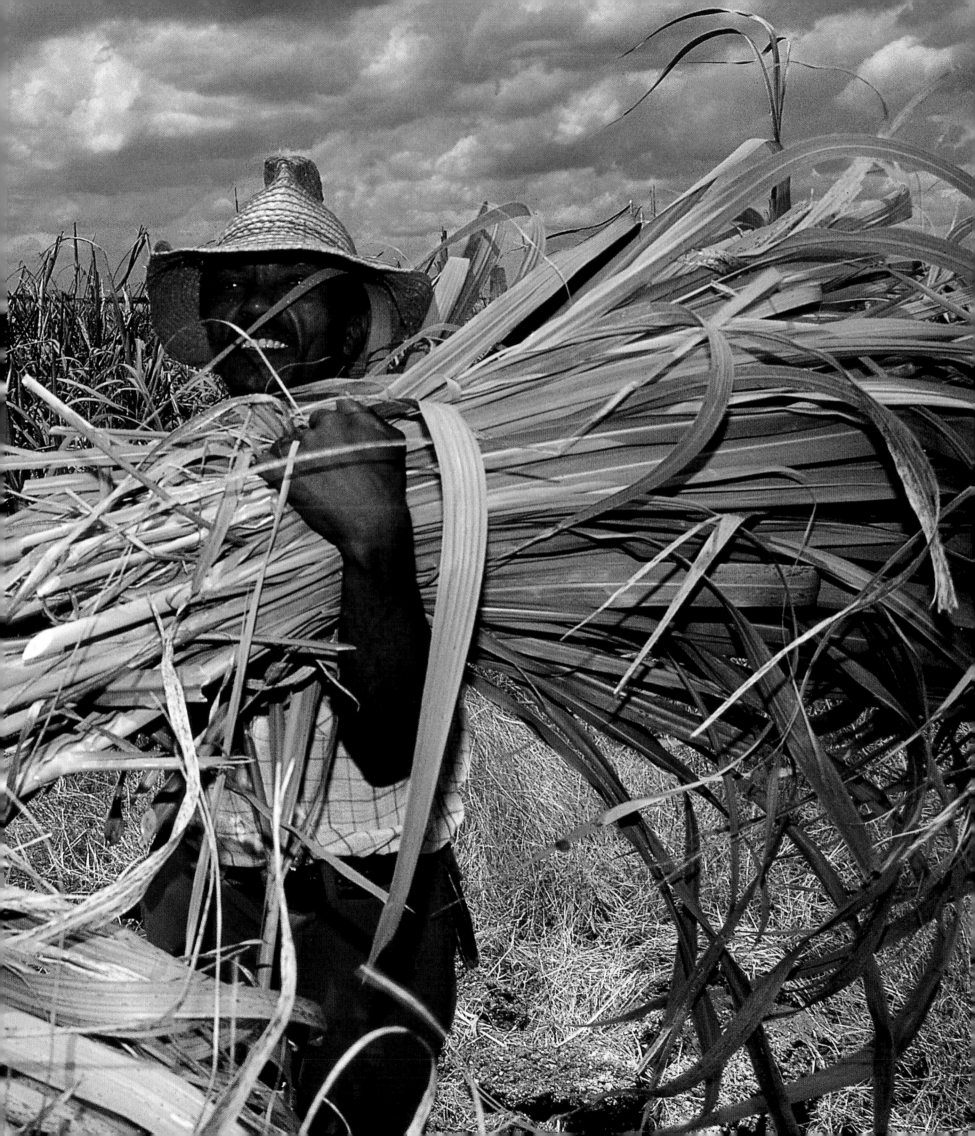

266 TOP Dozens of brands of Cuban cigars, all of which are excellent. Certain Cuban cigars have earned their niche in history, from Che Guevara's Lancero, to the Trinidad, produced exclusively for Fidel Castro, and the Cohiba, much appreciated by none other than Saddam Hussein.

TOBACCO

CUBA'S UNIQUE SCENT

"A WOMAN IS ONLY A WOMAN, but a good cigar is a smoke"—Rudyard Kipling.

Say "Cigar!" and any bon vivant American will think "Cuba," and be filled with regret because, on account of trade embargoes, the much-appreciated Cuban cigar *(a tabaco)* is not legally available in the United States. Hence the pre-Christmas trips that a number of well-heeled aficionados make to Canada or Mexico each year. Cubans themselves do not do well in indulging their taste, as the finest cigars are destined for the hard-currency export markets, and Cubans cannot easily make overseas trips in pursuit of them.

Like sugar, tobacco has a long history in Cuba, and over the centuries has built an enviable worldwide reputation. The first generation of Spanish conquistadores reported on the smoking habits of Cuba's natives and quickly took to the habit. The tobacco industry grew rapidly. While it never threatened the primacy of sugar, it traditionally held second place in the

Cuban economy for numbers employed and the value of the crop.

In recent years the emphasis has been on the quality rather than quantity of tobacco, and the *hecho a mano* (handmade) cigars produced from an annual crop of between thirty and forty thousand tons per year generally earn over $150 million in foreign currency.

The finest tobacco is grown in the broad, sheltered valleys of the extreme western province of Pinar del Río and in the Vuelta Abajo and Semi-Vuelta regions, with high-quality leaves also being grown in the Matanzas and Las Villas provinces (central Cuba) and in Oriente. Unlike the hardy, perennial sugarcane, the tobacco plant is delicate.

Each year the *vegueros* (farmers) must raise tobacco seedlings in trays and then in late fall transplant them into the fields. To ensure the finest leaves, the growing plants must be protected from excessive sun, rain, and wind by muslin or cotton awnings or *tapados* (tents). Tobacco plants require careful handling and an experienced eye at every stage of the growth cycle to

266 BOTTOM If cigars are consumer products, albeit at a very high level, their bands are highly prized by collectors. Cigar bands are officially listed and are often very expensive.

267 The boxes used to package cigars, by far Cuba's most prestigious export, are covered by highly decorative labels and are made from local scented cedar.

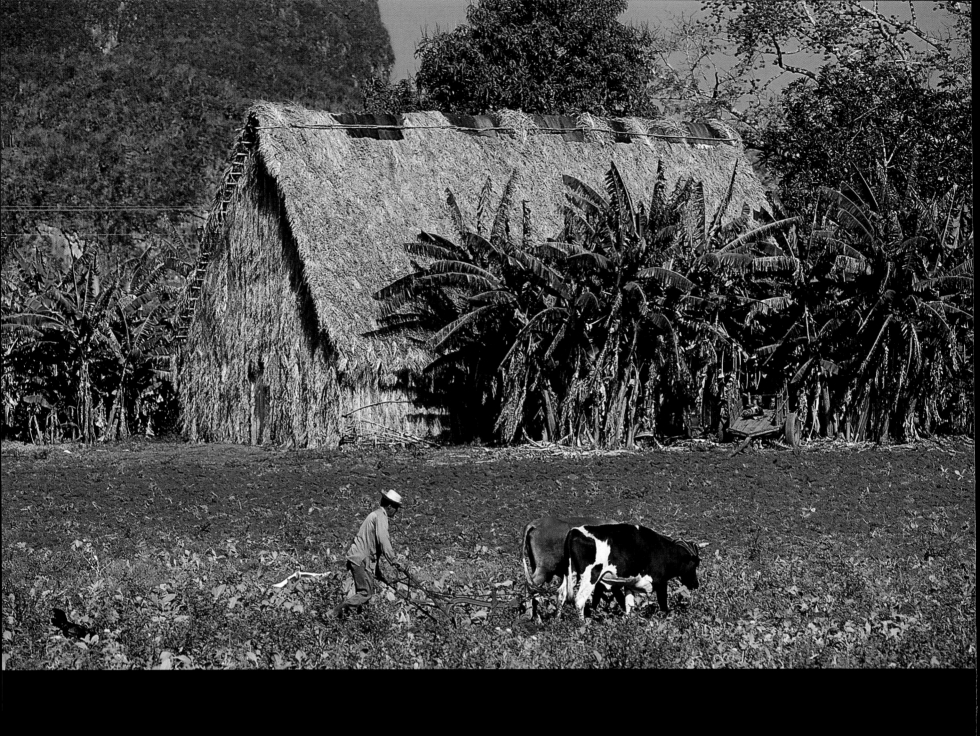

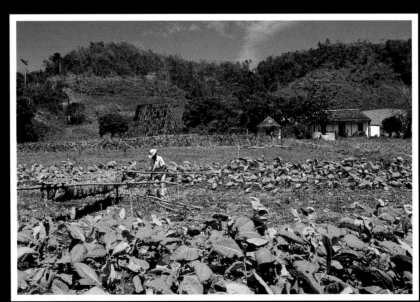

268 TOP A TOBACCO FARMER, OR VEGUERO, INTENT ON PLOUGHING IN THE VIÑALES VALLEY. THE STRUCTURE IN THE BACKGROUND, AT THE FOOT OF A *MOGOTE*, IS A TRADITIONAL DRYING SHED, WHERE TOBACCO LEAVES ARE LEFT TO DRY FOR MONTHS.

268 BOTTOM MODERN-DAY *VEGUEROS* (IN THE PICTURE, A PEASANT IN THE PROVINCE OF PINAR DEL RÍO) USE 500-YEAR-OLD AGRICULTURAL TECHNIQUES.

269 THREE PHASES OF TOBACCO CULTIVATION IN THE PROVINCE OF PINAR DEL RÍO: TRANSPLANTING, PLOUGHING, AND FIRST DRYING. ALL THE WORK IS DONE BY HAND.

ensure a successful harvest at the right moment. Gentle hands are called for in the skilled work of picking and sorting the leaves—there is no place for hastily mobilized brigades of eager harvesters manhandling the crop.

Curing the tobacco leaves is basically a three-month controlled drying process. As the leaves are brought to the curing sheds, the *rezagudos* (categorizers) sort the leaves by color, which provides an indication of flavor strength. Drying is done through a controlled ventilation process that modifies and finally stabilizes the leaves' internal chemical balances and thus the final flavor. After a two-year storage period, the cured leaves are brought to the *galeras* (the cigar-rolling rooms), often in long-established *fabricàs* (small factories) in Havana. Here the *tabaqueros* (rollers, who are now frequently *tabaqueras*) employ their *chavetas* (curved knives) in the task of cutting the leaves, a basic step in making the tabacos. An experienced tabaquero can

roll about one hundred cigars a day. Each requires a mix of leaves from separate parts of the plant—the *coronas* (upper leaves) for flavor and strength, leaves from other sections of the stem for the body, and leaves for the outer wrap. Not all meet the criteria set for a premium cigar—after all, cigars are sold in sealed boxes and sampling is not possible.

Since the 1850s, it has been the custom to have a *lector* read to the tabaqueros, often shifting from newspapers to novels as the day progressed. Hence the traditional credit given to the tabaqueros for being well-informed with a keen and effective interest in wage and employment issues. Historically, cigar-making was a freeman's work; slaves would not have the training or commitment to the skills that cigar-making demanded. Until the 1950s, smaller workshops were the norm in the cigar-making industry. A patriarchal, conservative environment was the norm, with a master and his experienced employees and young apprentices working together, the reader providing contact with the wider, more active world outside. Women, with their patience and sensitive hands, were valued in the cigar-making workshops and often outnumbered the male *torcidos*.

Cigars have always had an unrivaled mystique, and the true aficionado disdainfully considers the mass-produced cigarette to be little more than a waste by-product. King James I of England's *Counterblaste to Tobacco* (1604) is one of the few major attacks on the cigar-smoking habit; most commentators agreed with the words of the more worldly Richard Burton. In 1641, in his *Anatomy of Melancholy*, he wrote, "Divine, rare, super-excellent tobacco … goes far beyond all the panaceas, potable gold, and philosopher's stones … and is a sovereign remedy for all diseases."

Cuba continues to honor the cigar and its heritage, carefully advancing the science of cigar-making while maintaining the art and the mystique. The process appears seamless; tradition is visibly maintained. The official names of some of the historic old fabricàs have changed, but anyone going to Havana and looking for H. Upmann, Partagas, Antonio Maciedo, and other great establishments will have no trouble finding them. The finest cigars, the connoisseurs' delights, will be thoughtfully offered—the Cohiba Robusto, the H. Upman Monarch, the Sancho Panzo Belicoso, the Partagas Serie D No. 4, and the Bolivar Royal Corona among them. Casual conversation will span continents as true believers discuss Winston Churchill's favorite cigar, or President Kennedy's or Fidel Castro's, and wonder why the world's problems cannot be quietly settled over a good cigar.

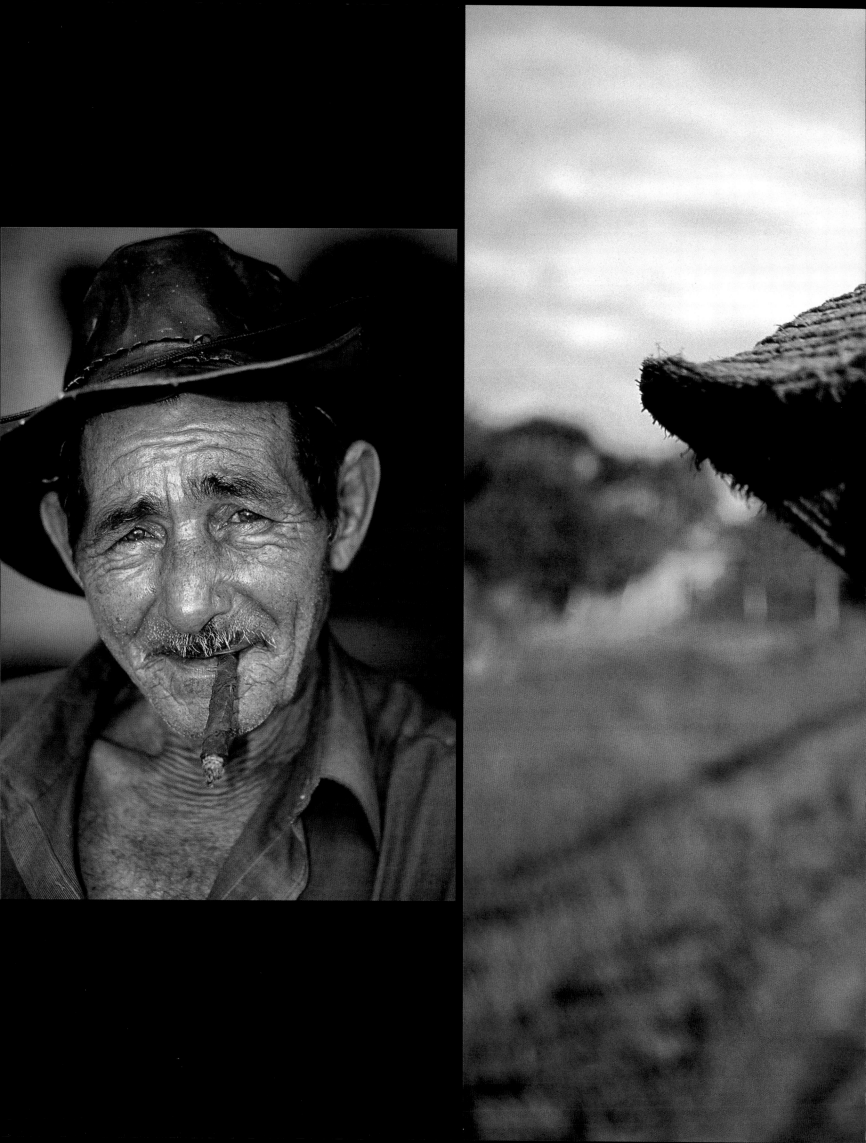

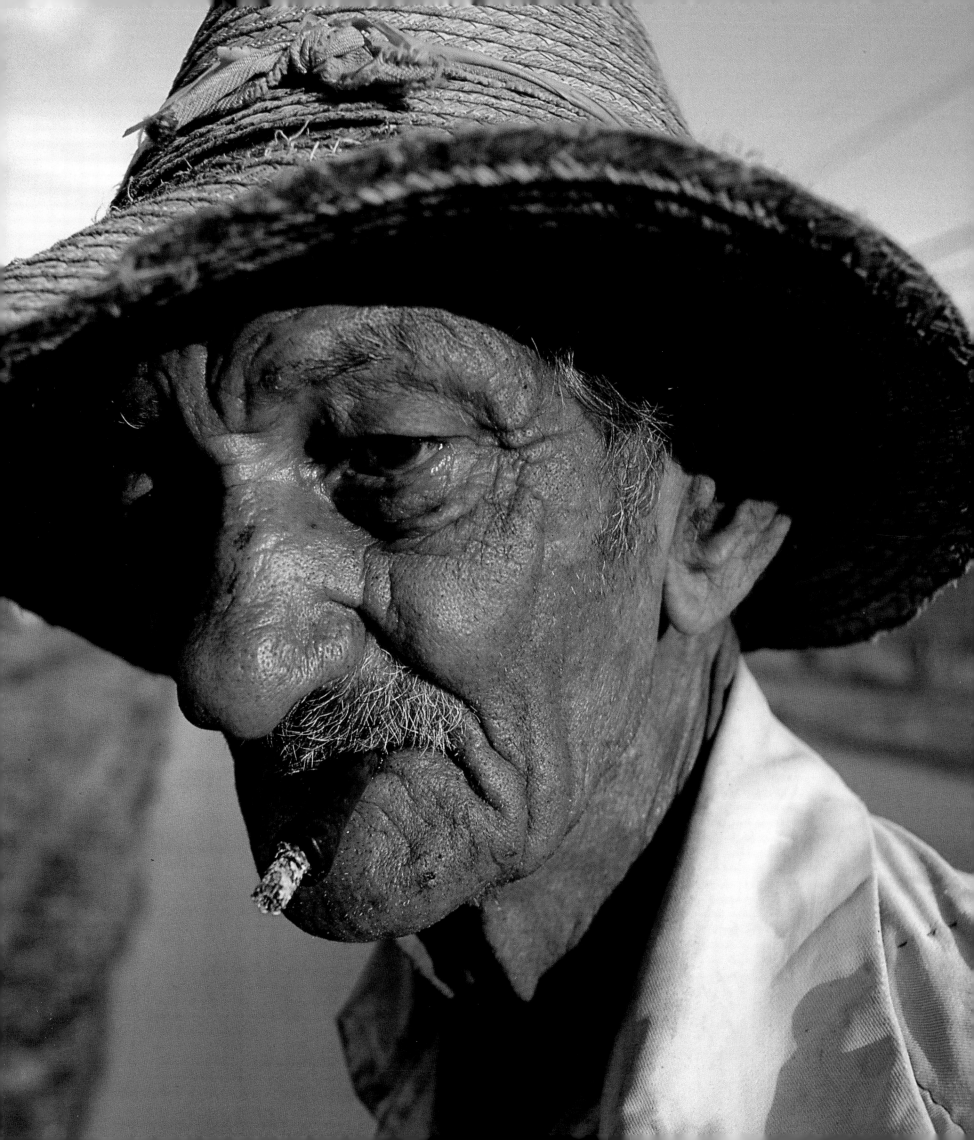

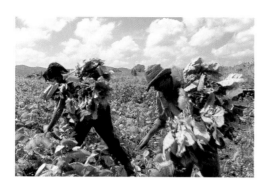

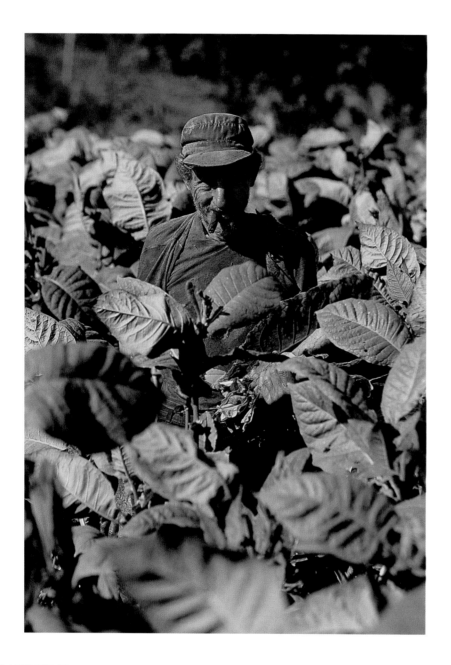

270 AND 271 The *VEGUEROS*, THE FIRST TO TRY THE FRUIT OF THEIR LABOR, ARE ARTISTS AT CULTIVATION. TOBACCO IS IN FACT A LABOR-INTENSIVE CROP, AND ALL THE WORK IS DONE BY HAND, JUSTIFYING THE HIGH PRICE OF THE FINISHED PRODUCT.

272 AND 273 A SINGLE TOBACCO PLANT PRODUCES SIX DIFFERENT TYPES OF LEAVES THAT ARE CUT AT DIFFERENT TIMES, A FEW DAYS APART FROM EACH OTHER, STARTING FROM THE BOTTOM.

274-275 HARVESTTIME IN THE VIÑALES VALLEY. AFTER TRANSPLANTING, TOBACCO GROWS FAST AND IS HARVESTED ABOUT A MONTH AND A HALF LATER.

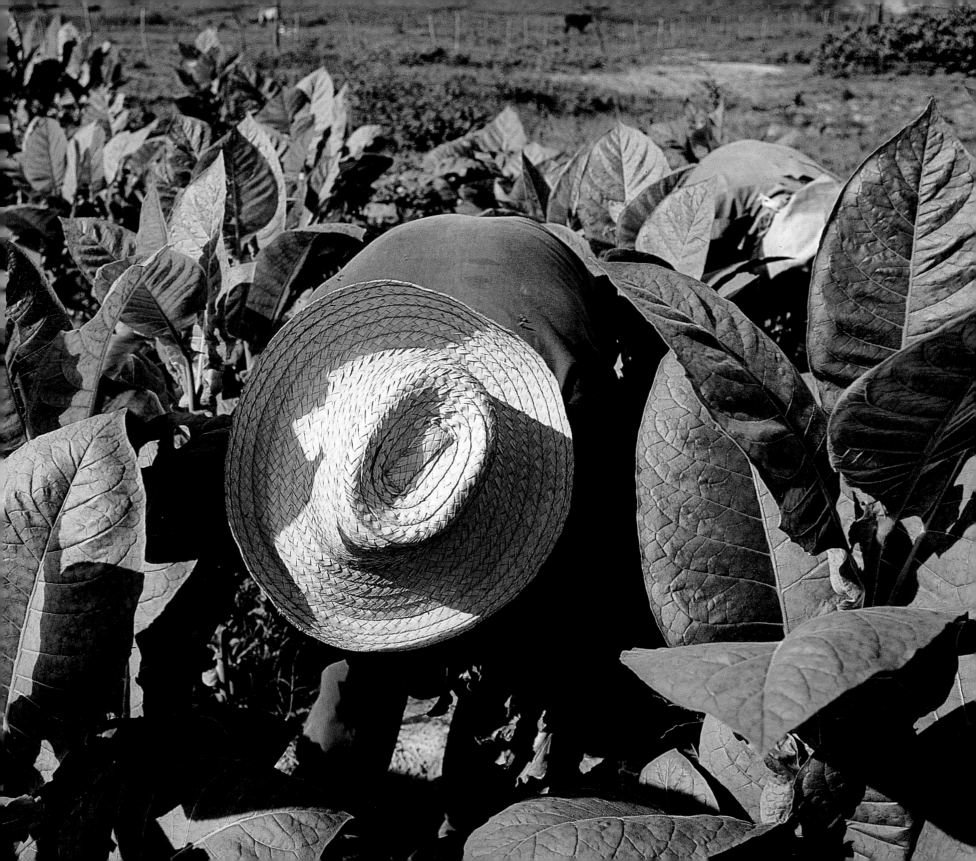

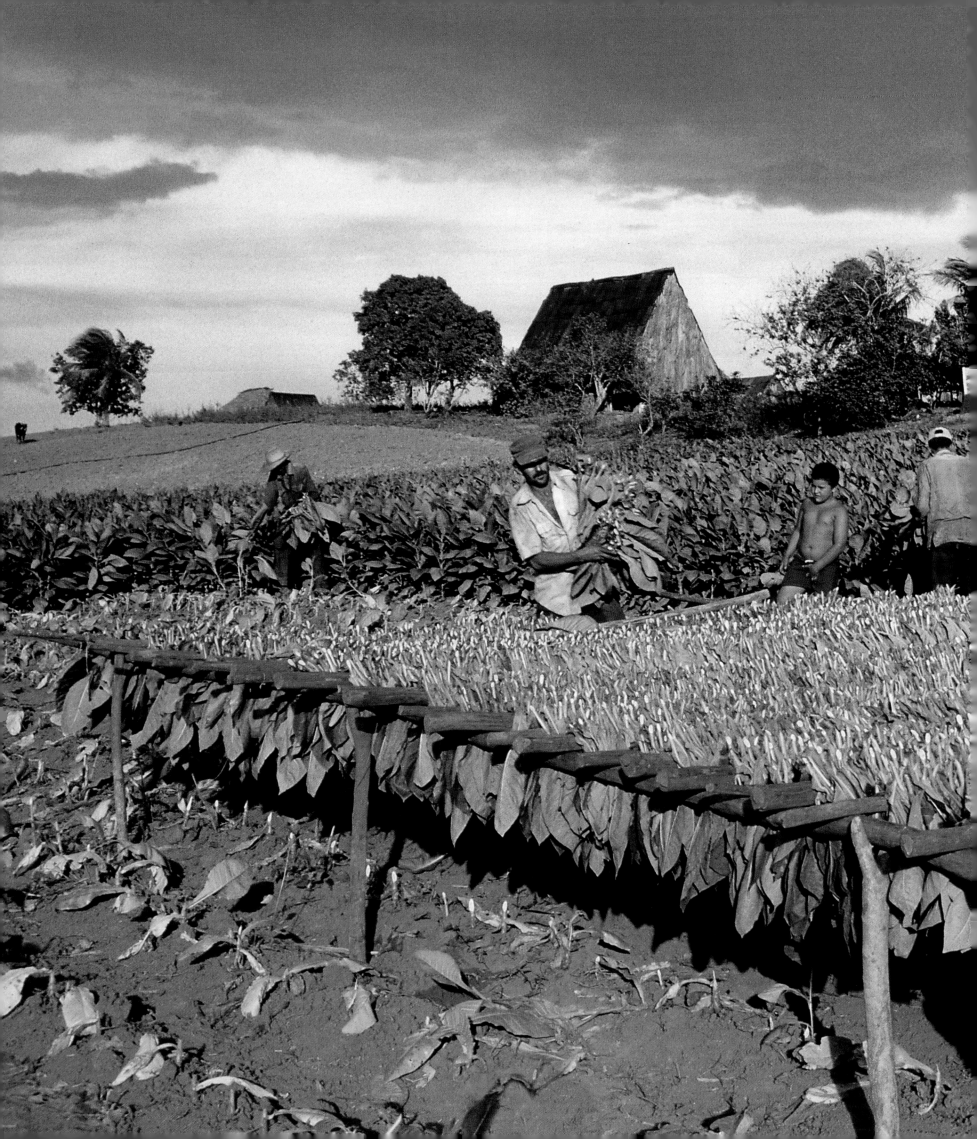

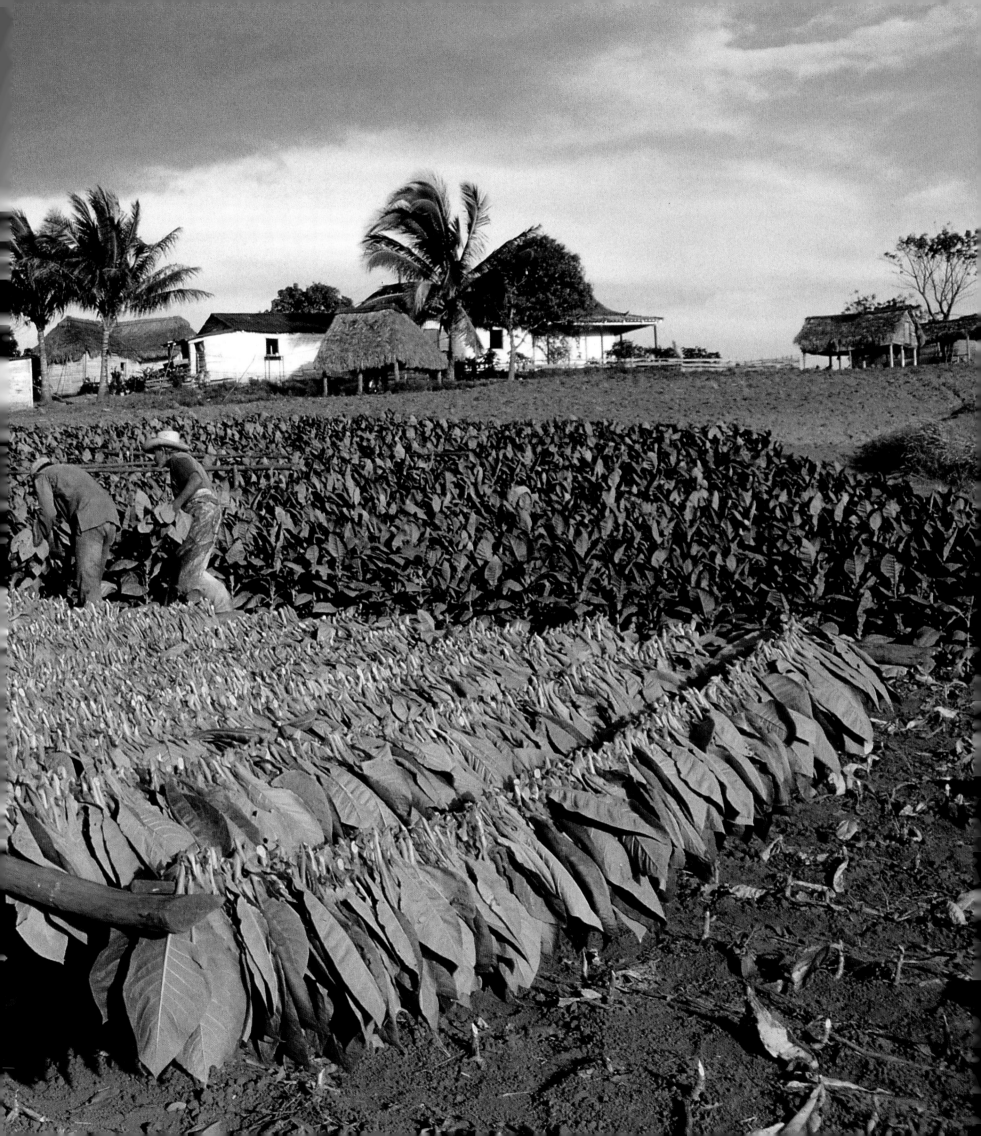

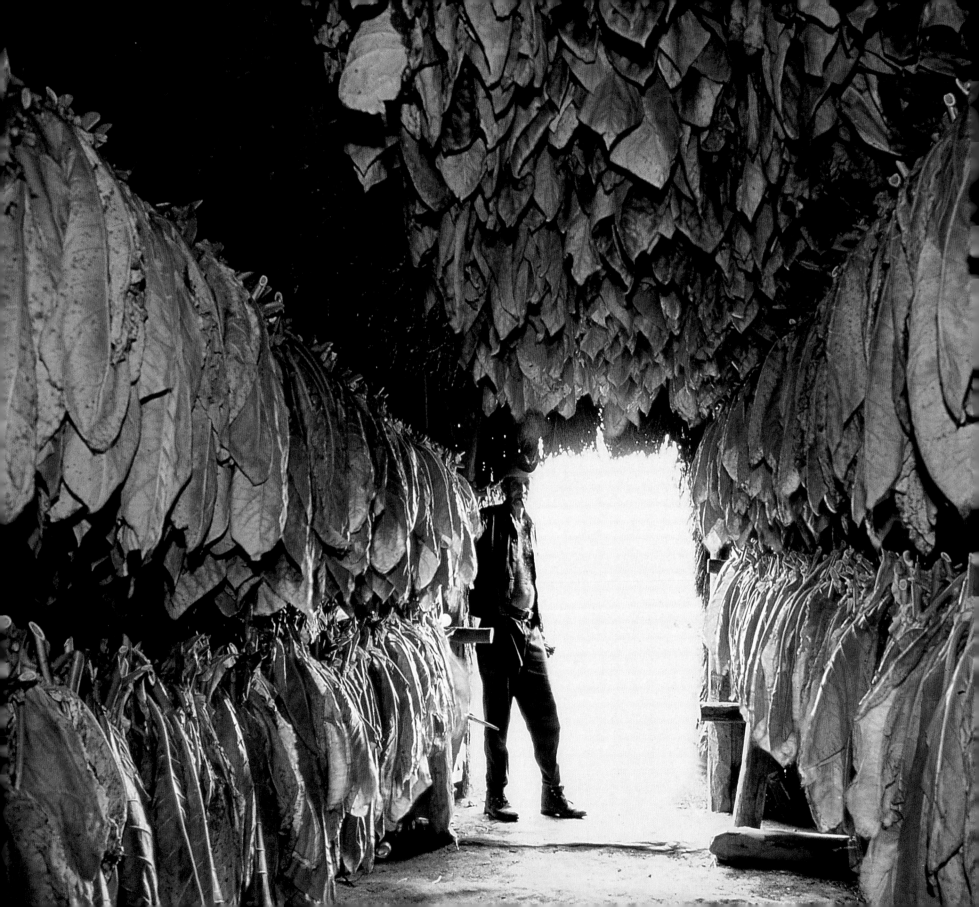

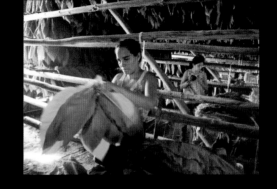
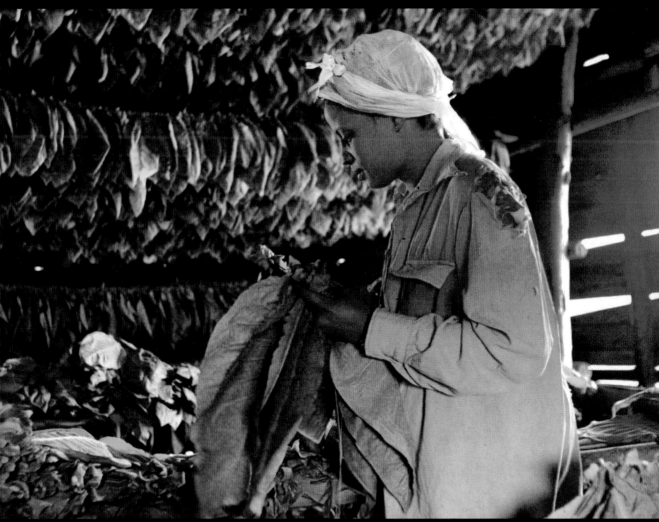

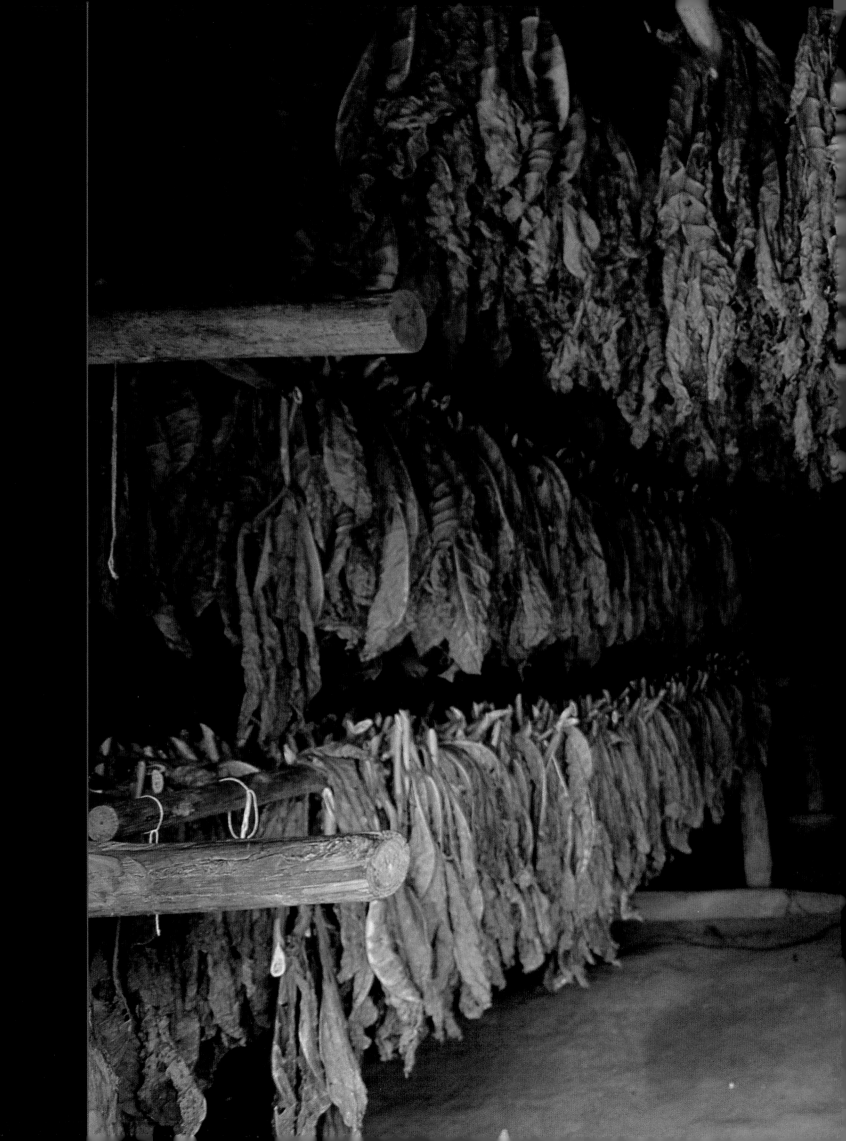

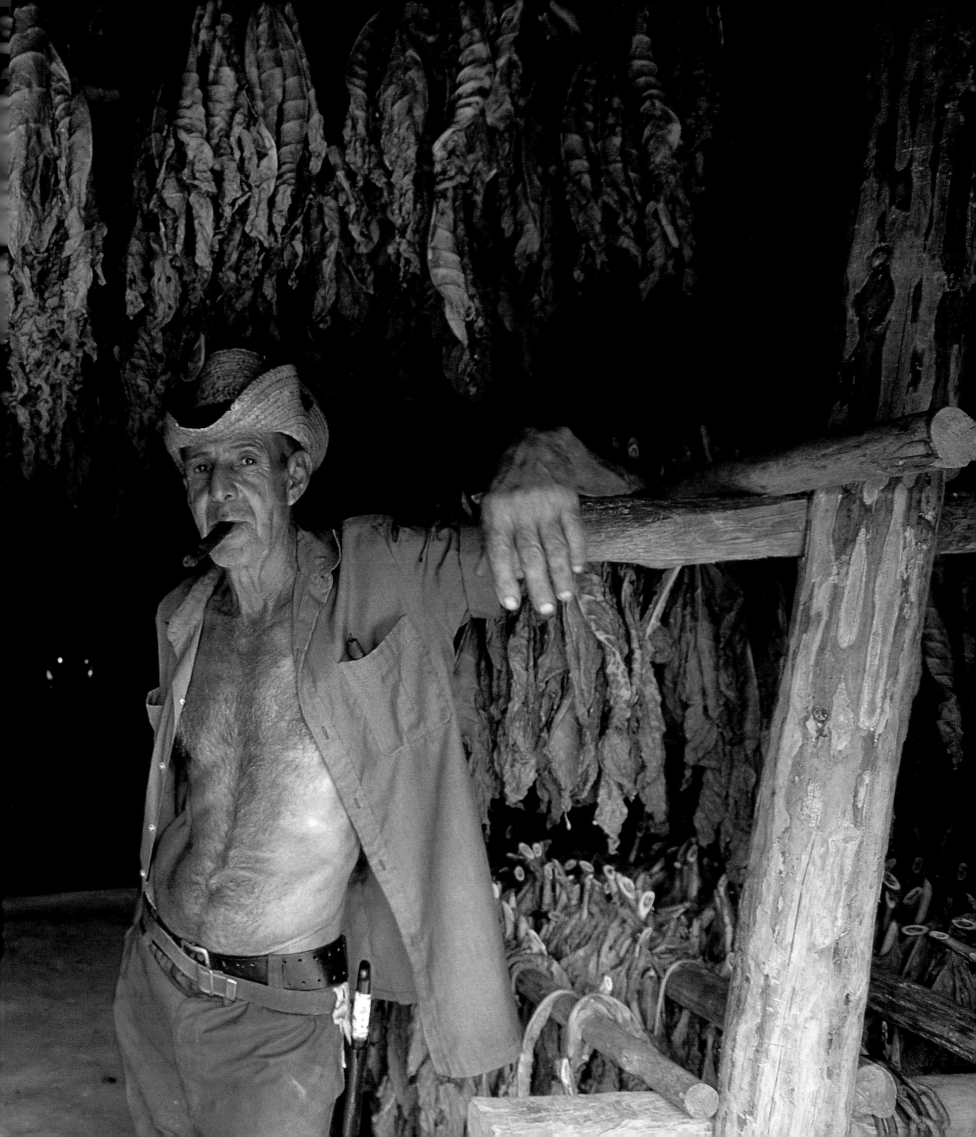

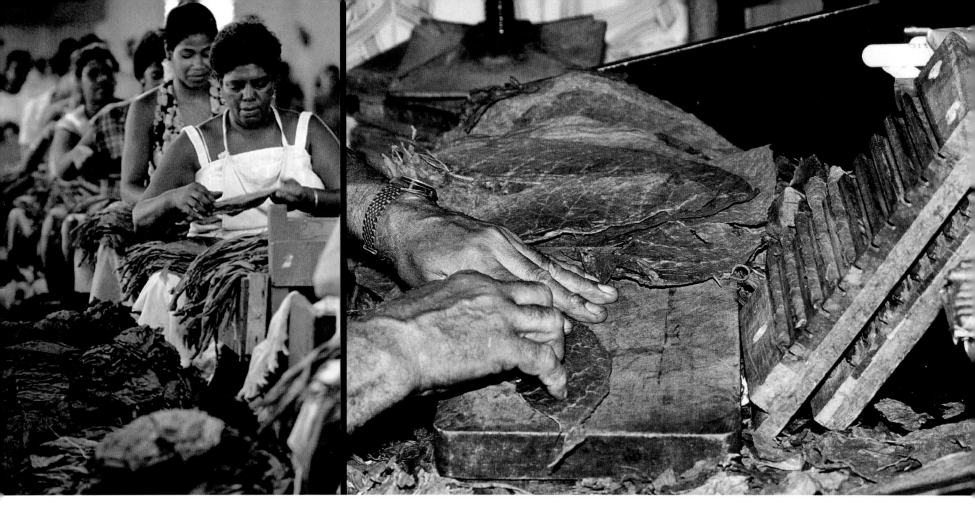

276-277 In the shady *CASA DEL TABACO*, the leaves dry further. It is at this stage that fermentation sets in, without which the leaves would not be "smokeable" because of their high nicotine content. The dried and fermented leaves will then be aired before shipping to the laboratories, where the complex cycle is brought to its close.

277 TOP AND BOTTOM Young workers prepare the green leaves that have already been dried in the open air, before placing them in the casa del tabaco. During the preparation phase, the leaves are stitched or tied together based on their position on the plant.

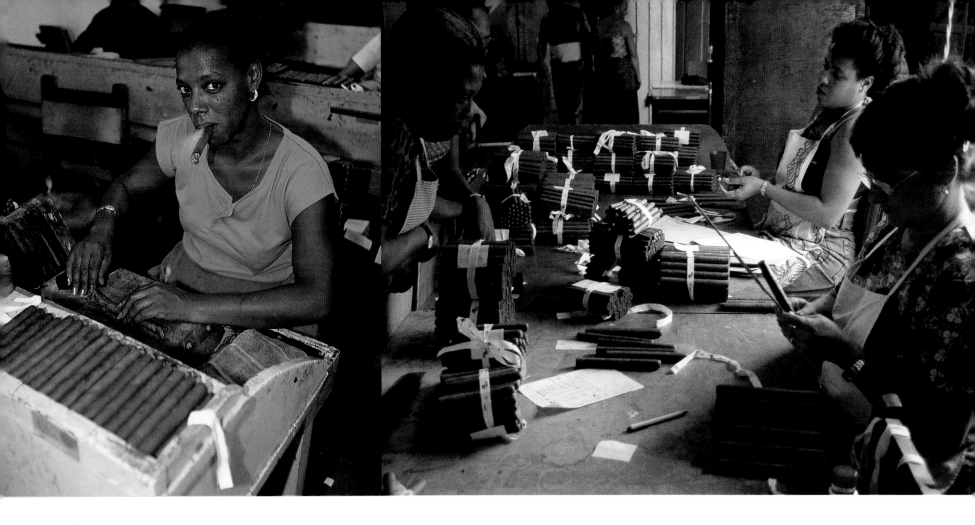

278-279 AFTER ONE TO THREE MONTHS, THE LEAVES TAKE ON THE CHARACTERISTIC BROWN COLOR OF THE FINISHED PRODUCT. TEMPERATURE,
HUMIDITY, AND THE CONSTANT CARE OF THE VEGUERO ARE DECISIVE ELEMENTS IN THIS NATURAL PROCESSING PHASE.

280 AND 281 THE LAST PHASES BEFORE MARKETING. FROM LEFT TO RIGHT: THE SELECTION OF LEAVES IN FUNCTION OF COLOR AND QUALITY;
THE PACKAGING OF CIGARS, DONE COMPLETELY BY HAND AND QUICKLY; EXPERT TABAQUEROS; AND STORAGE. EACH CIGAR IS
CAREFULLY REGISTERED BEFORE PACKAGING.

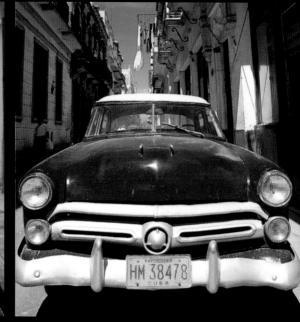

AUTOMOBILES IN CUBA

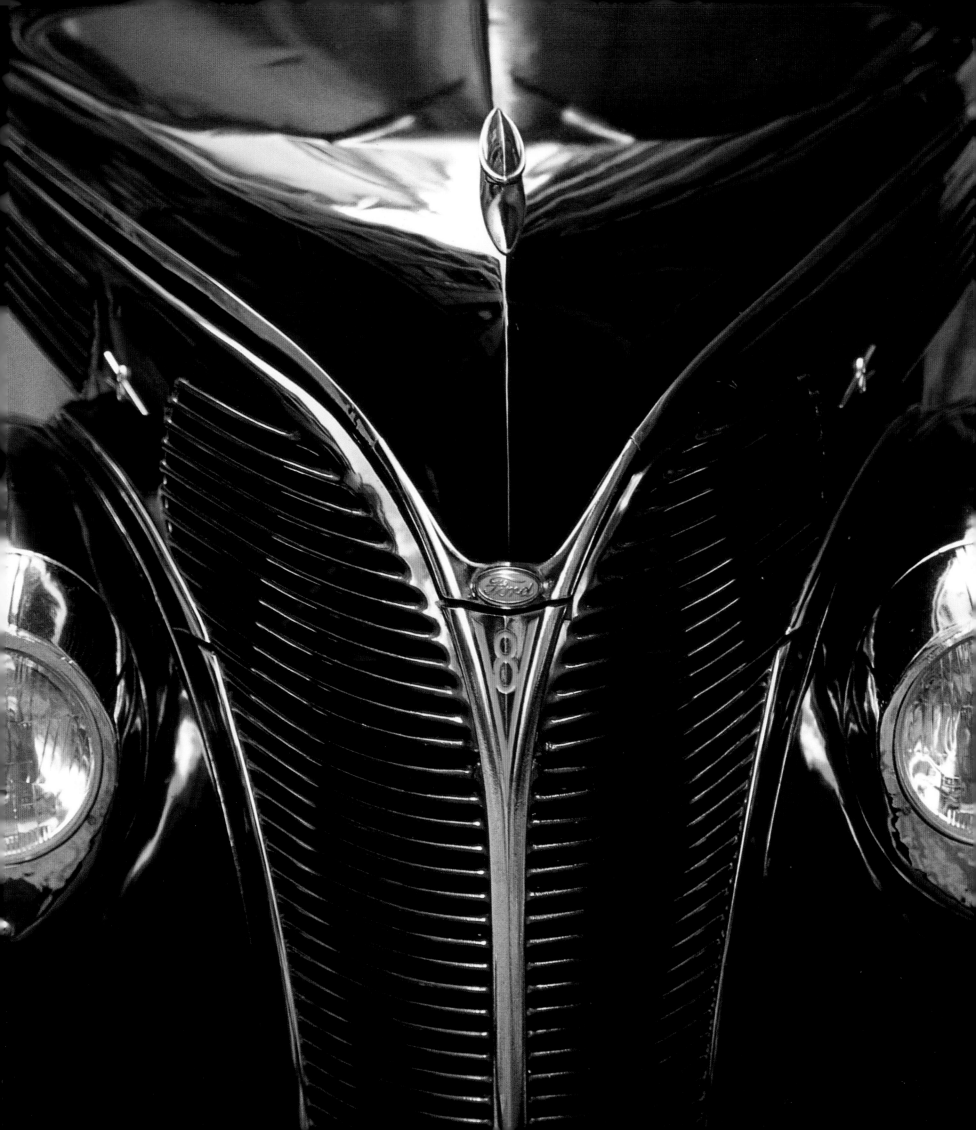

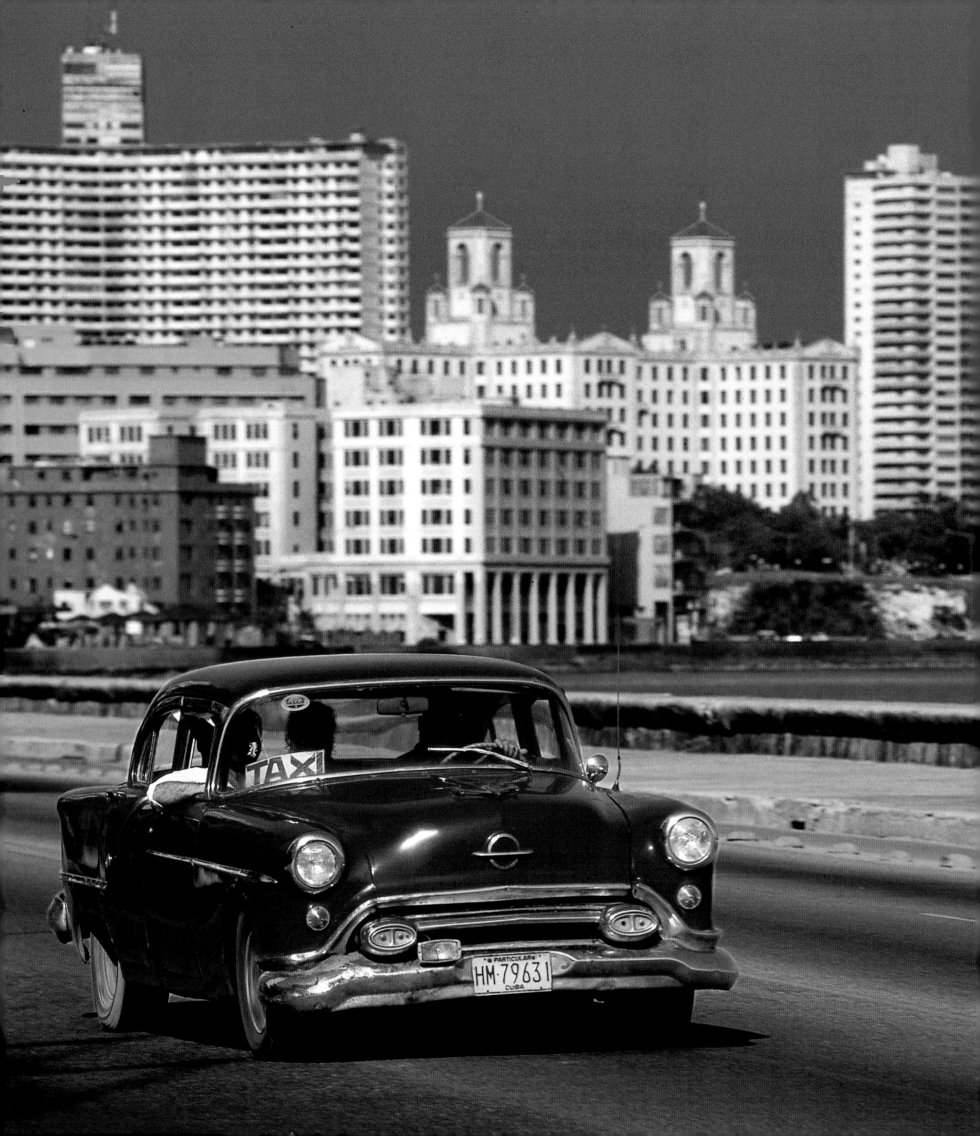

282 AND 283 The cars of Havana are reminiscent of the American way of life from the end of World War II up to 1961, the year of the embargo.

284 A massive, aggressively painted De Soto, used as a taxi, rumbles along Havana's Malecón.

285 Most of the cars on Cuba's roads are either American, such as the classic, period-piece Chevrolet to the left, or Soviet, like the gaudy motorcycle with sidecar, center. Swans are a very popular decoration motif (right).

AUTOMOBILES IN CUBA

WHILE THE SLOGAN "*CONSEGUIR E RESOLVER,***"** or "to find and to solve," does not appear side by side with solemn and reassuring portraits of the nation's revolutionary heroes that adorn the walls of Cuba's towns and villages, it nonetheless highlights an essential value of the delightful people of this surprising country.

In an island nation that chose freedom over prosperity, alienating the favor and support of the rich and powerful who for too long had decided its destiny, the art of making do with little or nothing goes beyond mere material necessity to become a full-fledged cultural phenomenon in its own right. Although the practice of stretching scarce resources to their utmost pervades many areas of Cuban life, it is most evident in the field of mechanics, from industry to agriculture, and throughout the private and public transportation sectors to the extent that "to find and to

solve" could well be one of the main canons adopted by the surprising characters that Martino Fagiuoli, a keen observer of all things Cuban, has called the "wizards of *hojalata*" (tin), the thousands of mechanics who tend to Cuba's cars with passion and imagination.

The cars on Cuba's roads are famous in an ambivalent sense. They are famous for their brand names, which are bound to evoke nostalgia in any visitor who, after having admired the automobile beauties on show in American museums, now sees them plying the island's roads. Subjected to skillful and almost always "artistic" or imaginative maintenance since 1961, when the U.S. embargo deprived Cuba of everything including fuel, automobiles, and spare parts, these antiques have managed to remain roadworthy, often for over half a century.

It was sheer necessity that inspired Cuba's mechanics to find ways to maintain these old Buicks, Chevrolets, Studebakers, and Oldsmobiles on the roads despite extreme shortages of spare parts and

other materials. Because necessity is the mother of invention, they have indeed done a fine job in keeping these antiques not only roadworthy and efficient, but often in splendid physical shape.

To reduce such a colossal mechanical achievement to merely the result of a general lack of money and material would, however, be grossly unfair to the Cuban people. These ancient relics could never have been maintained so splendidly without uncommon technical skills, a more than justified sense of pride, and an aesthetic intuition capable of transforming the ugly, obsolete, and mediocre into a unique, living creation overflowing with color.

A large percentage of Cuban cars were inherited from the last years of the pro-U.S. dictatorship. Once their rich and haughty owners fled, their abandoned vehicles were taken over by people who would otherwise never have been able to afford one. For several years after the embargo began, the abandoned stocks of spares left on the island were sufficient to keep the cars roadworthy, but at a certain point car mechanics had to improvise in order to keep the fuel-guzzling beasts running, even in the face of the extreme fuel shortages caused by the embargo. Furthermore, Cuba, with its tropical climate and the ever-present sea, did not provide the ideal environment for the long-term conservation of these classic American cars, which, unlike today's vehicles, were made entirely of metal.

As spares became increasingly hard to come by, Cuba's mechanics started adapting the cars themselves to suit the new, austere conditions.

286 To restore period cars to their past glory down to the smallest detail, Cuban bodywork artists are forced to come up with original and ingenious solutions: chrome plating is obtained using tin and aluminium, while paints are produced using whatever materials are on hand, and applied in ovens, with excellent results.

287 Cuban license plates indicate the category of the vehicle: Particular, for instance, distinguishes private vehicles, while Empresa is used for company vehicles, Protocolo for ministerial vehicles, and Alquiler for rental vehicles.

The complete range of changes and adaptations introduced by the island's highly skilled and capable mechanics is so vast that it deserves to be treated as a full-fledged, independent form of craftsmanship. The delicate, often perfect chrome finish is actually achieved using humble strips of tin. While the paints used for car bodies are obviously not produced by the original manufacturers, the results are nevertheless

spectacular. Nothing is overlooked—even the tires, obviously not originals after decades of wear and tear, are carefully reconstructed right down to the smallest detail with the distinctive white stripes of the originals, re-created by gluing bands of white rubber onto the "new" tires. Any attempt to identify the original car manufacturers by their logos or radiator grilles is useless since these accessories have long since been replaced by handcrafted pieces more in keeping with the car owners' personal tastes.

These are only the outer aspects of the vehicles. The real surprise, which reflects the technical genius of Cuba's mechanics, lies under the hood, where spares have often been "invented" using materials that in many cases have little to do with the models in question.

Some help in this department came from the Soviet Union, Cuba's sole trading partner after the 1961 missile crisis, which obligingly provided the island nation with a modest fleet of relatively more modern and reliable Ladas. These vehicles were, however, designed for much colder climes and, under the tropical conditions in Cuba, were soon transformed into items of exchange on the barter market or mines for spare parts. Even the Cuban government used Ladas in this way—realizing that the sale of Cuba's automobile relics to avid Western collectors was a potential gold mine, the government offered to buy them back in the 1970s against cash or a Lada. The leaders of Cuba's revolution were not immune from the old-fashioned and, in a certain sense, the genuinely Cuban macho charm of these shiny automobiles. Castro used to go around town in an Oldsmobile and Che Guevara's Chevrolet is now on show at Havana's Automobile Museum. Be that as it may, the collapse of the Soviet Union in the 1990s put a stop to Russian aid and brought the curtain down on Ladas.

Not all of Cuba's cars belong to this mythical, albeit obsolete, fleet, and not all period cars are in good shape. Many are nothing but heaps of rusted scrap beyond repair, while new models have only recently reached Cuba from Japan, Korea, and Europe. It is therefore quite common today to come across more or less new Nissans, Mercedes-Benzes, and Fiats cruising side by side with antique Buicks and Mercurys on the island's roads.

These old and mammoth American cars also represent a precious source of desperately needed, but officially banned, income for the increasing number of car owners who hire out their antique relics as taxis for ferrying tourists—and locals, on special occasions such as weddings—across the length and breadth of the island.

While the ongoing U.S. embargo and the decline in Russian aid and trade has inflicted far more suffering on the Cuban people than their fun-loving nature and hospitality would allow one to believe, recent political developments indicate that the country is slowly but surely moving toward the light at the end of the tunnel. Despite the many obstacles along the path to recovery after decades of stagnation and isolation, Cuba can once again face the future with a smile, relying on the innate optimism of its people who, besides being natural artists, have perfected the fine art of "*conseguir e resolver.*"

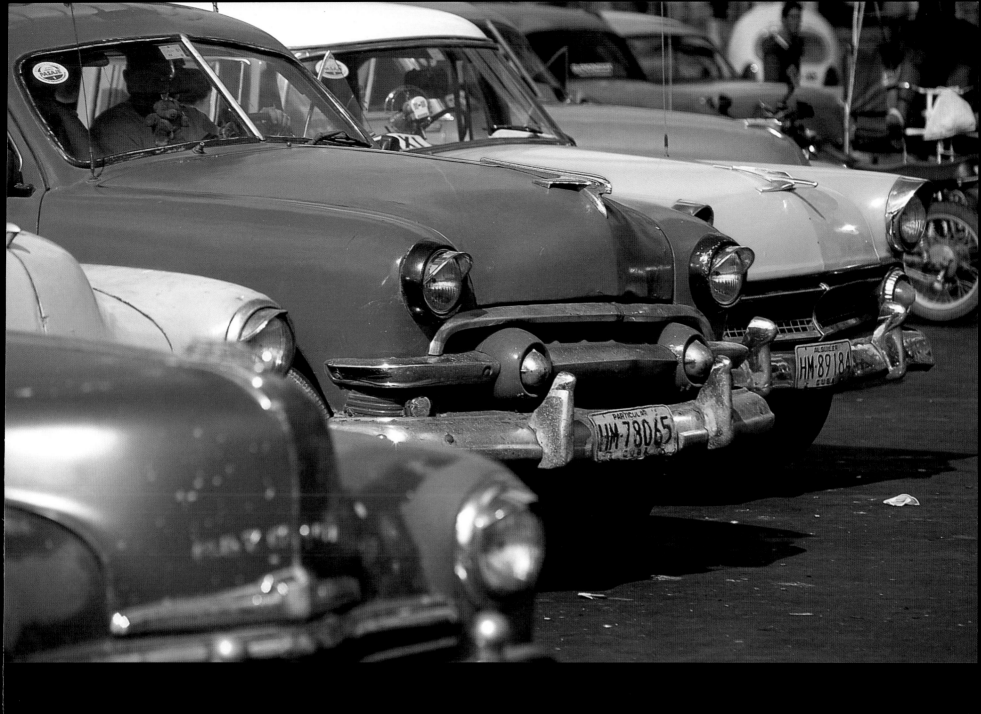

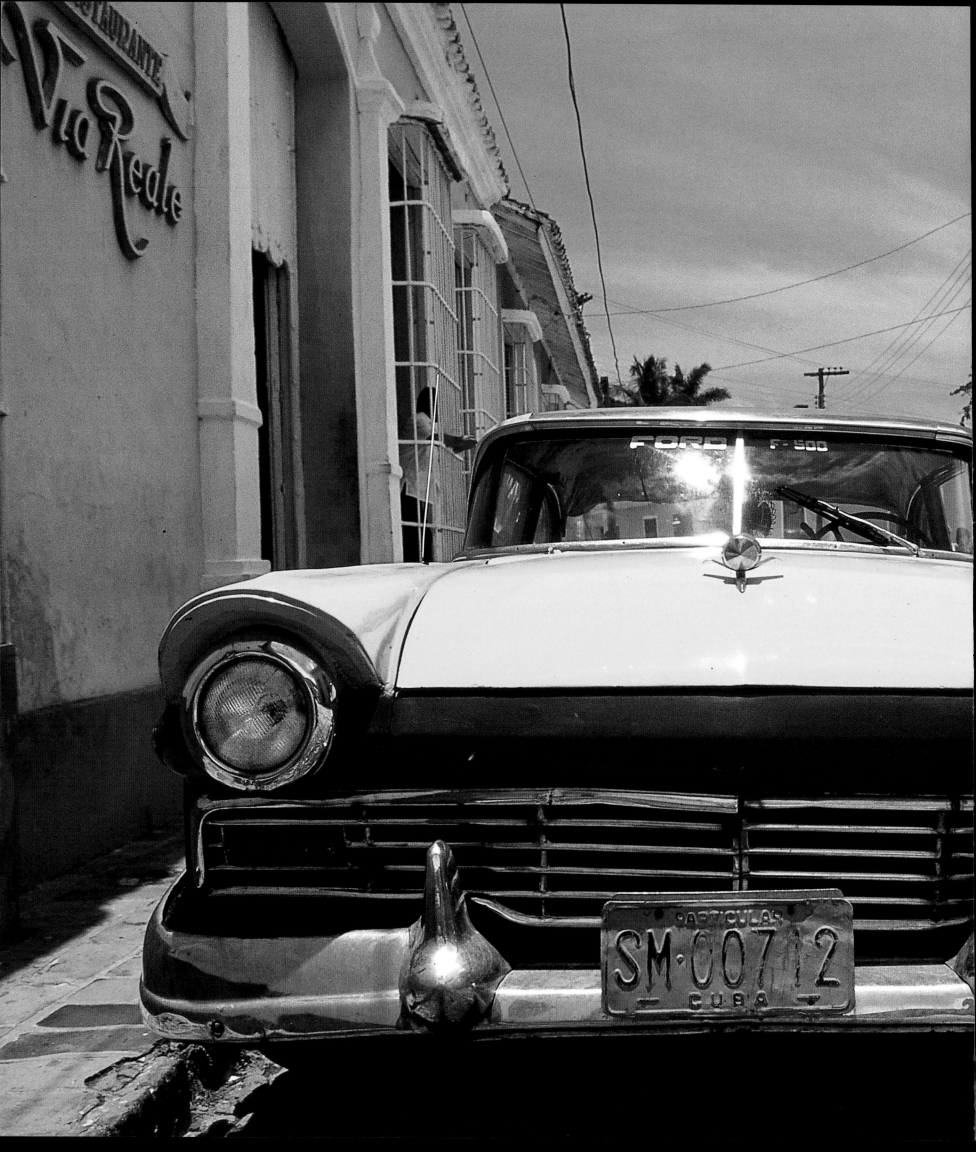

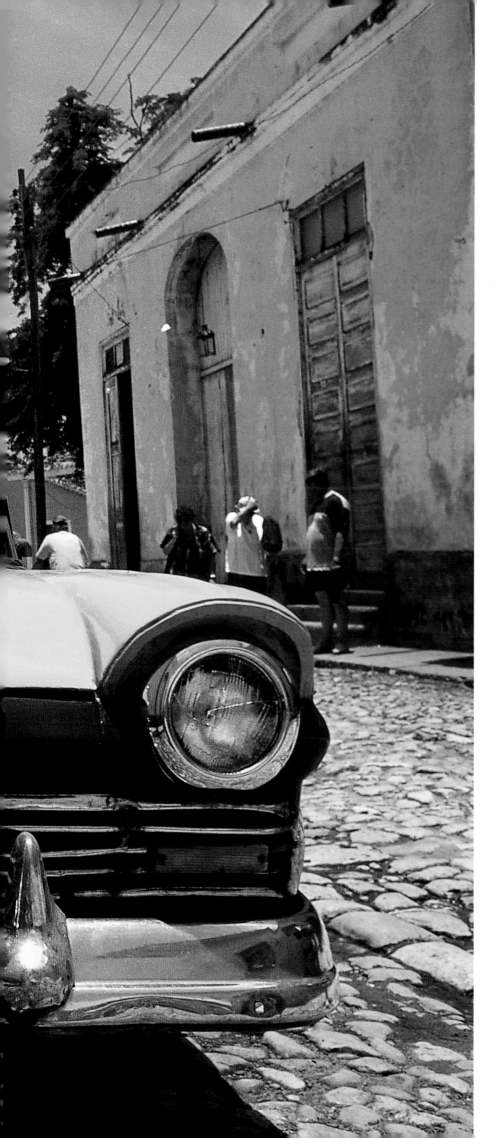

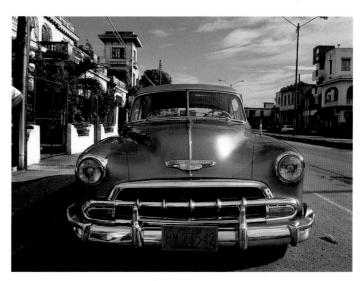

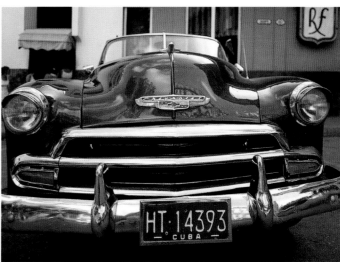

288-289 The finesse of the finishing of an automobile depends on how much its owner is willing to spend and on what material the bodywork garage has on hand. The total unavailability of paints produced or recommended by the original car manufacturers is just another excuse for Cubans to give vent to their creative, fun-loving nature with colorful hues.

289 Aggressive-looking radiator grilles shine proudly in the streets of Havana. Even Cuba's revolutionary leaders fell prey to the charms of these American beauties: Fidel Castro's favorite set of wheels was an Oldsmobile, while Che Guevara preferred a Chevrolet.

290 AND 290-291 WHILE COUPLES AROUND THE WORLD SHELL OUT HEAVY SUMS TO HIRE AN ANTIQUE CAR FOR THEIR WEDDING, MOST CUBANS CAN REST ASSURED THAT THEIR WEDDING CAR WILL INEVITABLY BE AN AUTHENTIC PERIOD PIECE.

292 AND 293 ORIGINAL BRAND MOLDINGS (RIGHT) ARE AT RISK TO THEFT AND DAMAGE, BUT THEIR CUSTOM-MADE REPLACEMENTS, OFTEN FEATURING WINGS LIKE THIS SWAN (RIGHT), HAVE NOTHING TO BE SHY ABOUT.

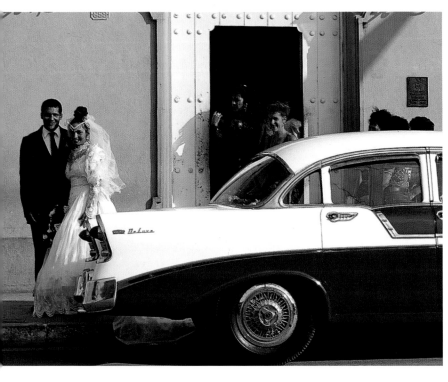

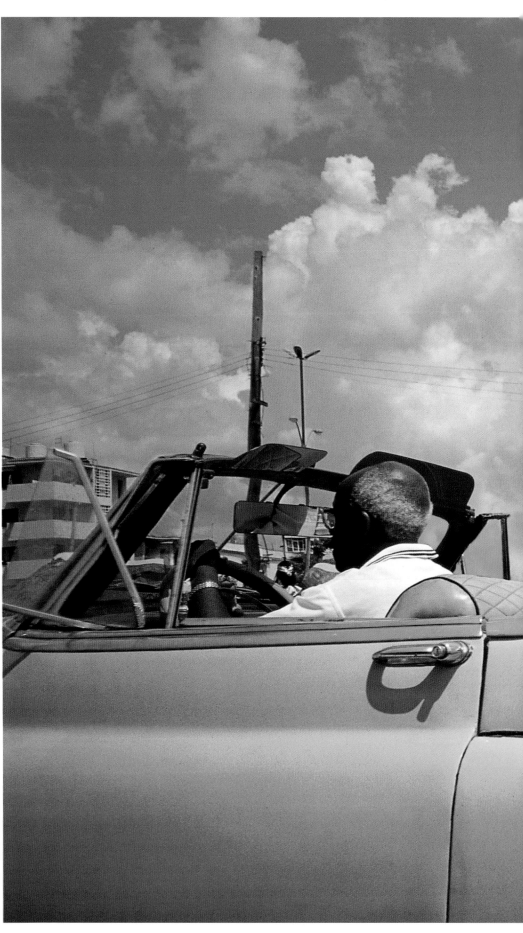

294 CHEVROLETS OF VARIOUS MODELS AND IN VARIOUS STATES OF REPAIR ARE AMONG THE MOST WIDESPREAD AMERICAN DREAM CARS IN CUBA, AND SOMETIMES ONE CAN COME ACROSS A RARE JEWEL SUCH AS THE FAMOUS BEL AIR.

295 AMATEURS CAN NEVER HOPE TO ACCURATELY GAUGE THE AGE OF A CAR IN CUBA, ALTHOUGH IT CAN BE FUN TO SPOT FEATURES THAT PROVIDE CLUES TO A CAR'S YEAR OF MANUFACTURE. FOR INSTANCE, A CAR WITH TAILFINS MUST HAVE BEEN MANUFACTURED AFTER 1949, THE YEAR IN WHICH CADILLAC INTRODUCED THIS DESIGN FEATURE.

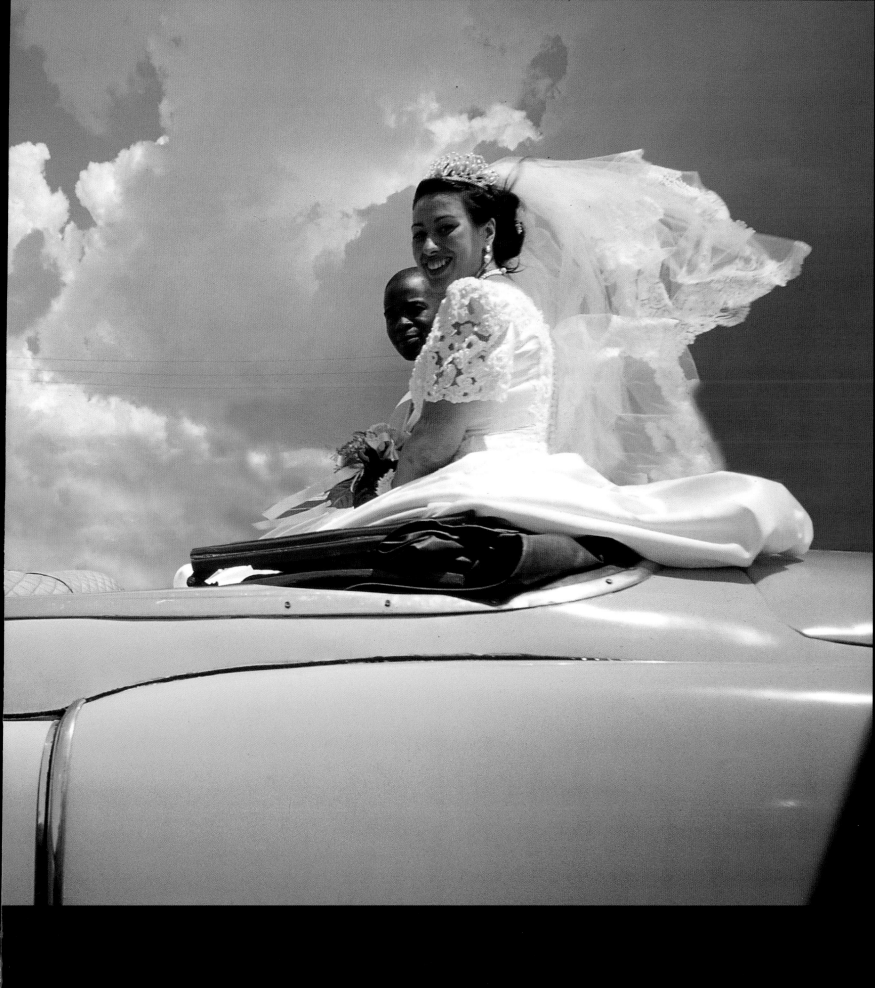

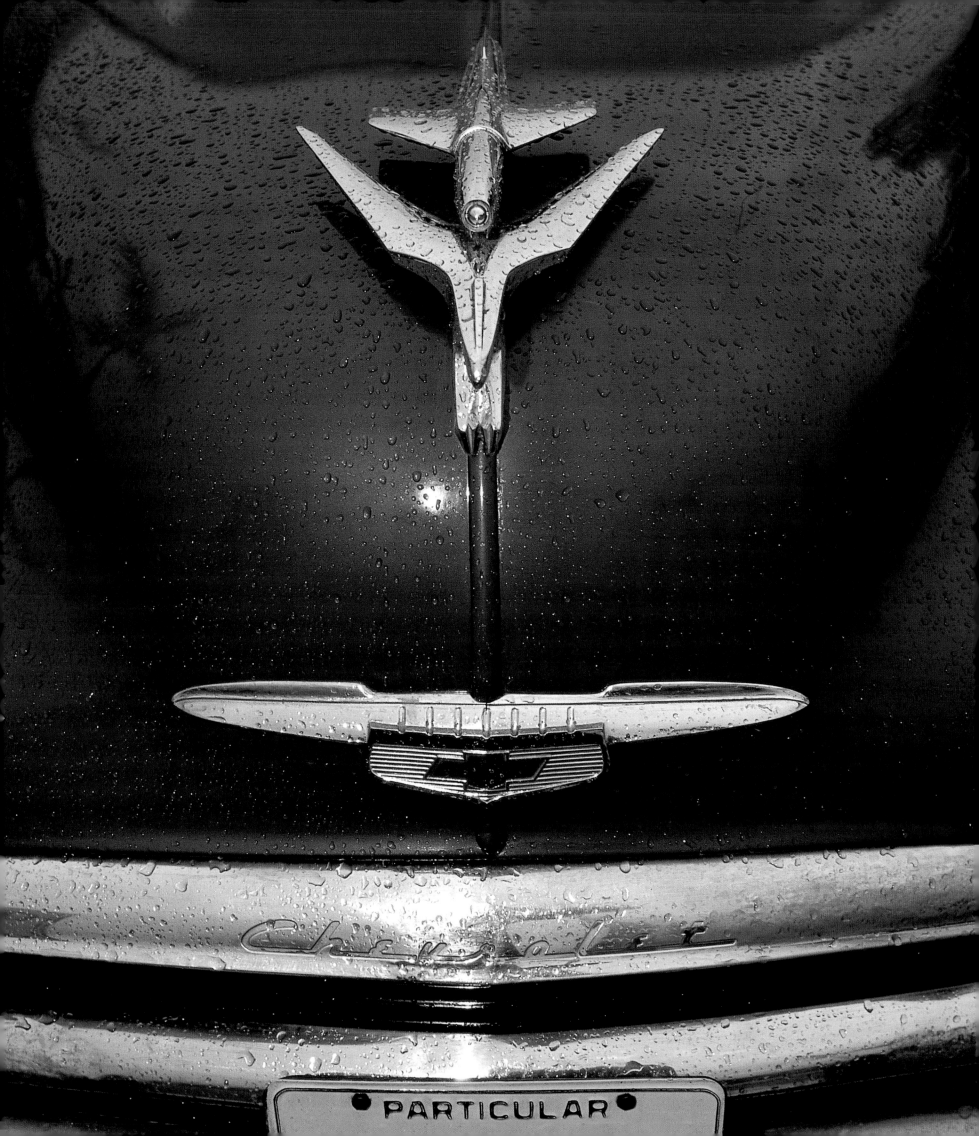

PARTICULAR

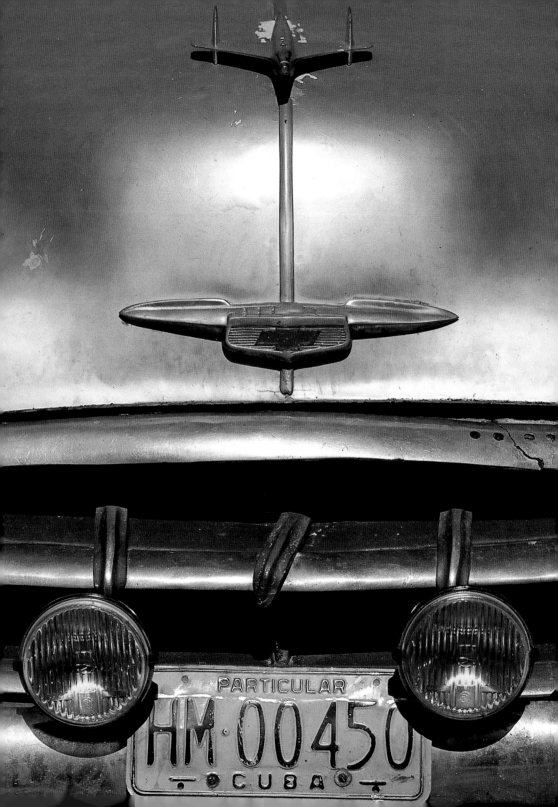

INDEX

PHOTO CREDITS

300 The Isla Grande counters the massive exodus of Cubans in the 1990s with the future of its youngest children. With a life expectancy of over 75 years, free schooling, and the traditional values of patriotism and a love for freedom, the Cubans of the twenty-first century are well positioned to ensure a secure future for their tiny island nation.